"This is the book I have been waiting for . . . highly readable and forward looking, providing a coherent overview with enough specifics to be of genuine practical value, delivered from the inside perspective of a scholarly television executive currently working at the highest level."

—**Nick La Terza**, Adjunct Professor and Lecturer in Law, UCLA School of Law, University of Miami Law School, and UCI Law School; Partner with law firm The Point Media; Former Senior Legal/Business Executive for Largo Entertainment, New World Pictures, and Alliance Atlantis Entertainment

"Ken Basin has created a timely and unique book that perfectly balances a big-picture view of the dynamic television industry with practical details about its business and legal processes. This is an essential reference source for anyone studying or engaging in professional activities related to television production and distribution for all media platforms."

—**Stuart Brotman**, Howard Distinguished Endowed Professor of Media Management and Law and Beaman Professor of Communication and Information, University of Tennessee, Knoxville; Nonresident Senior Fellow in the Government Studies Program, Center for Technology Innovation, The Brookings Institution

"Ken Basin has given us a great primer in the nuts and bolts of the rapidly evolving television business—told with insight, brevity, and wit. Basin's experience on both sides of the buyer/seller equation really shows through, and makes this book a valuable tool for anyone who wants to understand the business side of the shows we love to watch."

—**Dan Scharf**, Head of Television Business Affairs, Amazon Studios

"In the fast-changing environment of the television business, it's never been more important to understand how things are, how they used to be, and where they are going next. This book covers all you need to truly grasp the business of making great TV."

—**Amy Powell**, President, Paramount Television

"With *The Business of Television*, Ken Basin has created a powerful tool for people of all levels of experience in the television business. In an industry where the rules are being re-written daily, Ken has found a clear through-line that delivers a foundation of knowledge that you can use to jump in and begin to re-write the rules yourself."

—**Chris Parnell**, Co-President, Sony Pictures Television Studios

"This book would not make a good TV show. It is, however, about as comprehensive and readable a guide to how television gets made as you can find. I'll admit, after over a quarter of a century in the business, there are things in here I didn't know. With an insider's perspective and a lawyer's clarity, Ken Basin lays it all out (even the technical stuff). It is an essential reference book, both dictionary and encyclopedia, for anyone interested in the serious business of television."

—**Chris Keyser**, Writer and Executive Producer;
Creator, *Party of Five*

"A masterful job! Basin provides a readable and comprehensive guide to the uninitiated, while offering knowledgeable insiders a valuable and incisive analysis of this ever-evolving industry."

—**Bert Fields**, Entertainment Attorney, Partner, Greenberg
Glusker Fields Claman & Machtinger LLP

"EVERYONE hates Business Affairs people - but NO ONE hates Ken Basin. That's because he's smart, honest, and helpful, and because he behaves with honor. Turns out, he writes that way, too. I thank him for explaining the future to me."

—**Billy Ray**, Writer, Director, and Executive Producer;
Creator, *The Last Tycoon*

"As a practicing lawyer, producer and now professor teaching film artists, this book is a wonderful combination of real workplace knowledge with an understanding of how the television industry functions; an accessible and brilliant book."

—**Barbara Boyle**, Associate Dean, Entrepreneurship and Special
Initiatives, UCLA School of Theatre, Film, and Television

"I never knew how much of the television business I didn't know until I read this book! This is THE comprehensive how-to manual on the business."

—**Jamie Erlicht**, Head of Worldwide Video
Programming, Apple Inc.

"In *The Business of Television*, Ken has found a way to encapsulate the knowledge that has taken me 40 years in the industry to learn. If every producer, manager, agent, and lawyer in our industry took the time to read Ken's book and really invest in understanding each step in the process of making a great TV show, we could all save a lot of time and pain."

—**Steve Golin**, Founder and CEO, Anonymous
Content LLP

"Ken Basin has a talent for explaining the TV industry in a way that makes sense to lawyers and laypeople alike. *The Business of Television* is the essential reference guide for creative professionals."

—**Josh Berman**, Creator, Writer and Executive Producer,
Notorious, Drop Dead Diva, and *The Mob Doctor*

"It takes a keen analytic mind and experienced dealmaker like Ken Basin to craft this indispensable guide to anyone looking to navigate the increasingly-complicated world of TV prod."

—**Andrew Wallenstein**, Co-Editor-in-Chief, *Variety*

THE BUSINESS OF TELEVISION

In this book, esteemed television executive and Harvard lecturer Ken Basin offers a comprehensive overview of the business, financial, and legal structure of the U.S. television industry, as well as its dealmaking norms. Written for working or aspiring creative professionals who want to better understand the entertainment industry—as well as for executives, agents, managers, and lawyers looking for a reference guide—*The Business of Television* presents a readable, in-depth introduction to rights and talent negotiations, intellectual property, backend deals, licensing, international production, and much more. The book also includes breakdowns after each chapter summarizing deal points and points of negotiation, a glossary, a list of referenced cases, and a wealth of real-world examples to help readers put the material into context.

Ken Basin currently works as Senior Vice President, Business Affairs at Paramount Television, where he is responsible for dealmaking with talent, producers, and licensees in support of Paramount's broad slate of premium original television programming. Prior to joining Paramount, Ken served as Vice President, U.S. Business Affairs for Sony Pictures Television, and before that, Co-Head of Business Affairs for Amazon Studios. Ken is also a published scholar, as well as a long-time speaker and commentator, on entertainment and intellectual property legal matters. Since 2014, he has been a Lecturer on Law at Harvard Law School, where he teaches Entertainment and Media Law, and has previously served as an Adjunct Professor at UCLA School of Law and Southwestern Law School.

THE BUSINESS OF TELEVISION

Ken Basin

Routledge
Taylor & Francis Group

NEW YORK AND LONDON

First published 2019
by Routledge
711 Third Avenue, New York, NY 10017

and by Routledge
2 Park Square, Milton Park, Abingdon, Oxon OX14 4RN

Routledge is an imprint of the Taylor & Francis Group, an informa business

Library of Congress Cataloging-in-Publication Data
Names: Basin, Ken, author.
Title: The business of television / Ken Basin.
Description: New York : Routledge, 2018. | Includes bibliographical
 references and index.
Identifiers: LCCN 2018007727 | ISBN 9780815368649 (hardback) | ISBN
 9780815368663 (pbk.) | ISBN 9781351254182 (e-book)
Subjects: LCSH: Television broadcasting—United States.
Classification: LCC PN1992.3.U5 B355 2018 | DDC 384.55/40973—dc23
LC record available at https://lccn.loc.gov/2018007727

ISBN: 978-0-8153-6864-9 (hbk)
ISBN: 978-0-8153-6866-3 (pbk)
ISBN: 978-1-3512-5418-2 (ebk)

Typeset in Bembo
by Apex CoVantage, LLC

CONTENTS

DISCLAIMER

The information in this book concerns an industry that is changing so quickly. Much of the material it discusses may have evolved significantly between the time the author submitted the manuscript to his publisher (in early 2018) and the time you picked it up off the shelves. Therefore, now might be a good moment to see whether a more current edition of the book is available. Go ahead, we'll wait right here.

Also, while the information contained in this book is intended to inform (and perhaps even entertain), it is not intended to be, and should not be relied upon as, legal advice. The information is all of a general nature, and how it applies to any particular individual or situation may vary significantly depending on the facts. The author is a lawyer, but the author is not *your* lawyer, and nothing about this book creates an attorney-client relationship between you and the author. If you need advice about a specific situation, you should probably go hire a qualified, experienced entertainment lawyer of your own. There are many fine ones out there.

Finally, while this work is largely based on the author's years of experience as a practicing attorney and business executive, it was created by the author entirely in his capacity as an individual scholar and observer of the entertainment and media industries. Although the author has received valuable input from many sources, for which he is most grateful, ultimately, all of the observations, opinions, and predictions set out on this book belong to the author alone and should not be understood to represent the positions or interests of any of the author's past or present employers, colleagues, clients, or academic institutions.

Sorry for that. Again, this book was written by a lawyer. What did you expect?

HOW TO USE THIS BOOK

This book is written to provide information and insight of value to a variety of audiences, including law students, business students, film and television students, lawyers, agents, managers, entertainment executives, and active and aspiring creative professionals. While any reader is invited and welcome to start on page 1 and read all the way through to the end, different sections of this book are likely to provide particular value to you, depending on your specific position, interests, and level of prior understanding.

Chapters 1 ("A Beginner's Guide to the Television Industry") and 2 ("The Life Cycle of a Television Series") are designed to provide a broad introduction to television *as an industry*. In other words, they look to answer questions like: what is television, as an industry and a medium, and what are its defining characteristics? Who are the major players in the television industry, and how do they interact? How does a television series move from a one-line idea to a fully produced series? How does a company maximize the value of, and derive profits from, the distribution of a television series? How do tax incentives work, and how have they impacted the creative and business landscape of television? These chapters examine the television industry from an altitude of 30,000 feet and provide an important foundation for the information that follows—but one which may be less critical for readers who have prior direct experience within the industry.

Chapter 3 ("The Intellectual Property Context of Television [Or, When Do You Need to Acquire Underlying Rights?]") is a miniature legal treatise. It provides a foundation in the basic elements of copyright, trademark, defamation, rights of privacy and publicity, and First Amendment law that shape the market for television adaptation of existing intellectual property. It is by far the most legally technical section of the book. Lawyers with particular knowledge and experience in these areas may find this chapter unnecessary, although it can

serve as a helpful refresher even for practicing attorneys who have not recently revisited these legal concepts. Non-lawyers may find this chapter to be a helpful window into the world of law . . . or they may want to avoid it altogether.

Chapters 4 ("Underlying Rights Agreements"), 5 ("Talent Agreements"), 6 ("Backend"), and 7 ("Exclusive Studio-Talent Relationships") offer detailed point-by-point breakdowns of the key substantive terms of a variety of agreements entered into between studios, on the one hand, and talent (i.e., writers, producers, directors, and actors) and rightsholders, on the other hand, in connection with the development and production of original scripted television series. If Chapters 1 and 2 examine the industry from an altitude of 30,000 feet, Chapters 4 through 7 do so at ground level, discussing not just the critical areas of negotiation in these deals, but also the typical ranges of outcomes. These chapters are likely of greatest use to individuals who may need to actually negotiate or personally enter into these types of agreements (although, to reiterate from the disclaimer, they are no substitute for experienced, high-quality representation). Once a reader has familiarized him or herself with these sections, a series of "Quick Reference Guides" offers simple bullet-point summaries for several of the key deal categories. These Quick Reference Guides may be of particular use to young practitioners and negotiators.

Chapters 8 ("Network and Streaming Licenses and Studio Co-Production Agreements") and 9 ("Sample Economic Model") continue the ground-level examination of the industry, but with a focus on the licensing and distribution (rather than development and production) of original scripted television series. Like Chapters 4 through 7, Chapter 8 discusses the critical areas of negotiation and range of typical outcomes in deals between major corporate studio and network entities. Chapter 9 synthesizes the abstract deal points discussed in Chapter 8, as well as the more general concepts outlined in Chapters 1 and 2, to present the business of television in hypothetical hard dollar terms. These chapters are of greatest interest to individuals who work (or are interested in working) at a studio or network-type organization, as well as to those who have an interest in the large-scale economics of television production and licensing.

Chapter 10 ("Unscripted Television") attempts to encapsulate the same types of topics covered in Chapters 4 through 9 but with focus on the unscripted television business (which is otherwise largely excluded from the balance of the book). This chapter may not be a substitute for a dedicated full-length book about the unscripted television business, but it provides a useful introduction. It does so, however, primarily by comparison and contrast with corresponding concepts in the world of scripted television, and so this chapter should ideally be read after Chapters 4 through 9.

The Introduction observes key trends that have characterized the television industry over the last five years, while the Conclusion predicts what trends will dominate the industry's next five years.

Finally, the Glossary offers a helpful and detailed introduction to, or refresher on, the language of the business.

One last note: for a true industry deep dive, read the footnotes, which are chock full of explanatory material, additional defined terms, historical lessons, and occasional lawyerly hedges.

PREAMBLE

Making television entertainment is a team sport. The process of developing, producing, and distributing original television programming is a collaboration among literally hundreds of individuals—producers, directors, writers, actors, artisans, craftspeople, drivers, and more. And behind those individuals are a series of executive teams employed by the studios and networks behind those shows—development executives who help craft the story and creative direction of a proposed series; "current" executives who foster the show's creative direction once in production; production executives who help set and manage budgets and translate a creative vision into a physical production plan; lawyers who help document agreements and identify and manage risks; accountants and finance executives who measure and manage money flows; research, marketing, and programming executives who help the show find an audience; distribution executives who monetize the produced show in other markets; and others. Entire books can be (and have been) written about the issues facing any one of these types of contributors.

This book is written primarily from the perspective of the U.S. television studio business affairs executive.[1] To understand the significance of and reasons for that particular point of view—beyond the fact that, self-servingly, the author

1 In addition, unless otherwise noted, this book also primarily represents the perspective of a *scripted* television business affairs executive. While there is naturally some overlap between scripted and unscripted television, unscripted television presents a host of distinct business and legal issues—a small sample of which is discussed in Chapter 10. Outside of that chapter, while much of the information contained in this book may be instructive, in part or by analogy, for unscripted television, it should not be considered a directly adaptable guide. News and live sports programming are also subject to unique legal issues and norms around dealmaking, production, and distribution, and are not covered at all in this book.

is a U.S. television studio business affairs executive—it is helpful to break down each part of the phrase (albeit out of order).

The "television studio" is the entity responsible for the financing, development, production, and distribution of television productions, and the core rightsholder for such productions, typically controlling every facet of their worldwide exploitation. Through a mix of relationships with talented, independent freelance creative service providers and salaried full-time employees, the studio is the factory that churns out television product (for the most part, well outside the view or understanding of the general public). As described in greater detail throughout this text, the studio is uniquely at the crux of television dealmaking, both up the chain of development (with rightsholders and service providers) and down the other side (with co-producing studios and network licensees). Hence the focus on the unique role of the *studio* business affairs executive, rather than the network executive or talent representative. The studio's key "hub" position in the industry's dealmaking chain makes it an ideal perspective from which to evaluate the industry overall.

A "business affairs executive" is an individual, usually (but not always) a lawyer with years of dealmaking experience, who negotiates the substantive terms of all of the agreements to engage, acquire, or otherwise incorporate the major elements that transform a show from a nascent idea to a produced series debuting on a television network. In the simplest terms, when a creative executive points at something—a book to adapt, a script to develop, an actor to hire, a network to sell to—and says "I want that," the business affairs executive's job is to get it for them on commercially sensible terms. Yet this description understates the role of the business affairs executive, who, in successful practice, is not only a dealmaker but also a problem solver, who must use a combination of business and legal acumen to reconcile the needs and desires of competing (and sometimes single-minded) constituencies into something resembling a feasible course of action.

While business affairs, as a function, is sometimes combined with an explicitly legal role (i.e., "business and legal affairs"), the "business affairs" viewpoint is conceptually distinct from that of "legal affairs" (which is concerned primarily with the drafting and negotiation of paperwork reflecting previously negotiated substantive terms) or of "counsel" (which, to the extent separate and distinct from "legal affairs," concerns itself with other risk management and legal compliance issues). Taking the "business affairs" perspective here is valuable for a variety of reasons. The essential legal principles of contracts, tort, intellectual property, and other blackletter legal areas apply consistently in television as they do in other fields. The business context of the industry, however, is defined more by custom and practice than by abstract legal principles, and the industry's key substantive deal structures reflect the particular characteristics of the television medium. This drives this book's focus on conventionally "business affairs," rather than "legal affairs," issues. The one exception here is Chapter 3, which provides an overview of key legal issues informing the dealmaking context for underlying rights.

Finally, it is important to emphasize the "U.S." portion of the phrase "U.S. television studio business affairs executive." The television industry in the United States is characterized by a number of extremely particular customs and practices, not all of which are applicable in other markets. For example, television production outside the United States is often characterized by shorter production runs (both in terms of the number of episodes produced per "season" of programming, and the total number of seasons a successful series will run); increased reliance on a single writer to provide all or substantially all of the scripts for a given series; and substantially less control, in the form of options and exclusivity, exercised by studios over talent. In addition, many international television industries are defined in large part by the dominant influence of government-owned or subsidized national broadcasting services (such as the British Broadcasting Corporation in the United Kingdom, Australian Broadcasting Corporation in Australia, and comparable organizations worldwide). By contrast, the U.S. television industry is a federally regulated but essentially private market. The distinct cultures and histories in these territories give rise to different economic models and dealmaking norms, which are not discussed in detail in this book.

INTRODUCTION

In August 2015, John Landgraf, the Chief Executive Officer of FX Networks, stood up before a room full of entertainment reporters at FX's semiannual presentation to the Television Critics Association and declared: "There is simply too much television."

The audience could be forgiven its surprise to hear the well-respected CEO of one of television's biggest success stories of the past decade make such a pronouncement. After all, since taking over the network in 2004, Landgraf had focused FX (a network whose early years were characterized primarily by reruns of *Married . . . With Children* and basic cable exhibition of major theatrical action films) on developing daring new original content, in substantial volume, and with great success. Bold shows like *The Shield*, *Nip/Tuck*, and *Justified*—characterized by high production values, edgy themes, flawed and complicated protagonists, and complex serialized storylines—helped define the prevailing style of premium television programming throughout the late 2000s and early 2010s. Landgraf had guided FX from relying primarily on outside suppliers to fill its programming hours to an integrated network/studio operation through which FX developed and produced much of its own best content (thereby reaping even greater financial rewards from its shows' success). He even helped launch a companion network, FXX, as a home for some of FX's more off-beat shows (and a means of expanding the network's available inventory of prime timeslots to bring new shows to market). At the time of Landgraf's 2015 speech, FX's brand was one of the strongest in television, and its approach to programming had proven highly influential on both traditional basic cable rivals such as AMC and upstart digital platforms like Netflix and Amazon.

And yet here Landgraf stood, warning an audience of expert entertainment journalists and other key industry figures of impending doom (or at least an

impending slog through a painful period of slow deflation). By Landgraf's esti-
mates, in 2015, the number of scripted original television series on the air in the
United States would "easily blow through the 400 series mark," compared to a
bit over 200 original series in 2009. The staggering supply of television options,
Landgraf predicted, would overwhelm audiences, diminish quality control in
series production, and lead to an eventual "messy, inelegant process" of Wall
Street overreaction and industry weaning, in which only the largest companies
with the most-watched shows, strongest brands, and deepest pockets could con-
tinue to thrive. (To be clear, Landgraf identified his own FX as one of a small
number of players with enough high-quality series, brand equity, and financial
wherewithal to weather the coming storm.)

Landgraf's August 2015 TCA is remembered today for one key phrase that the
executive coined to describe the current era of overwhelming options: "Peak TV."

In the years since then, Landgraf's semiannual TCA address has become a high-
light for its regular "Peak TV" updates, and Landgraf has continually updated and
refined his data. According to estimates he presented during FX's December 2017
presentation, between 2002 (when FX launched *The Shield*) and 2010, the number
of scripted original television series on the air in the United States had grown rela-
tively modestly, from 182 to 216. By 2017, that figure had ballooned to 487 series.[2]
Strikingly, these data exclude unscripted series such as documentary, game, and
reality competition shows, which have not enjoyed FX's careful regular tracking,
but have certainly also expanded over the last ten years as basic cable networks such
as Bravo, E!, A&E, and TLC have invested heavily in the genre.

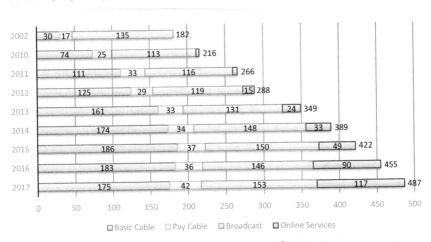

CHART 1 Volume of Original Scripted Television Series Production

2 That 2017 count also included exactly zero series from Apple, which declared its own entry into
the market with a bang in June 2017, by hiring well-regarded executives Zack Van Amburg and
Jamie Erlicht away from Sony Pictures Television to launch its new original content division. Apple is
expected to start distributing new original series sometime in early to mid-2019.

In a May 2016 article clearly inspired by Landgraf's "Peak TV" addresses, entitled "The Business of Too Much Television," Vulture's Josef Adalian and Maria Elena Fernandez described the new normal in Hollywood as follows:

> As so many networks and producers scramble again and again to make television that's great, finding standout ideas and then turning them into actual shows has perhaps never been more difficult. The effort that goes into securing top writers, actors, crew members, and soundstages these days is almost as challenging as coming up with the idea for the next *Mr. Robot*. Overall spending is way up, but like the broader national economy, the wealth isn't being distributed equally. Movie stars are getting offered $5 million to do a single ten-episode season of a show, even as studios slash budgets for lower-level actors. Writers have plenty of job opportunities, but shorter seasons has meant more career volatility. Experienced showrunners are in high demand, yet they're unlikely to ever become as rich as a Dick Wolf or Norman Lear. Then there is the lingering fear, heard frequently in Hollywood conversations, that it could all go away at any moment.

Adalian and Fernandez provided a compelling on-the-ground account of how the "Peak TV" era was impacting talent, creators, and crew throughout the industry. Taking a broader birds-eye view, the era of "Peak TV" has a few key hallmarks worth expanding upon further here:

The first hallmark, emphasized by Landgraf and others, is volume. There have never been more television series being produced and exhibited in the United States (or, likely, the world) as in this moment. This is a function of having more platforms and networks producing original content than ever before, and also of having more original series per network or platform than ever before. This extreme volume directly informs many of Peak TV's other key characteristics.

The second hallmark is fragmentation. Simply put, the rate at which the supply of new television series has grown over the last decade—125% growth between 2010 and 2017, by Landgraf's estimates—has far outpaced population growth in the United States over the same period (about 5%, according to U.S. Census Bureau projections). And there certainly are not any more hours in a day than there used to be. The emergence of streaming platforms as major original content destinations (which happen not to publish their viewership data) has pulled eyeballs away from traditional broadcast and cable television series. The result, at least for those traditional series for which data are publicly available from Nielsen, has been shrinking audiences on a per-show basis, including among the most-watched programs. For the 2009–10 broadcast season, television's top series was Fox's *American Idol*, with 22.97 million average total weekly viewers, and an 8.35 average Nielsen rating (Live + SD) in the coveted adults 18-to-49 ("A 18–49") demographic (the most valuable demographic for advertisers). For the 2016–17 broadcast season, that title was held by CBS's *The Big Bang Theory*, with 14.03 million total viewers and a

3.10 rating in the A 18–49 demographic—a roughly 39% drop in total viewers, and 63% drop in the key ratings measure, compared to just seven years prior. For further comparison, for the 1996–97 broadcast season (before HBO premiered *The Sopranos*; before Netflix, Amazon Prime Video, or Hulu existed; and before basic cable networks began investing heavily in original series), television's top series was NBC's *ER*, with 33.91 million viewers and an 18.13 rating in the A 18–49 demographic. To explain these figures another way, the types of viewer counts and ratings that would put a show in first place in 2017 would have left the show at great risk of cancellation in 1997.

The third hallmark has been the emergence of the television blockbuster. In order to break through the clutter, networks and studios have continually sought to deliver more and more premium programming experiences. In practice, this has meant embracing higher budgets and production values, more beloved underlying source material, flashier talent in front of the camera, and more acclaimed writers and directors behind the camera. When Netflix debuted the first season of *House of Cards* in February 2013, its all-star offering of Academy Award winning actor Kevin Spacey (well before his subsequent fall from grace in the wake of serious sexual misconduct allegations in 2017) and A+ list writer/director/producer David Fincher was one-of-a-kind in television, and the show's reported estimated budget of $100 million over twenty-six episodes (about $4 million per episode) turned heads. By the time the series premiered its fifth season in May 2017, Spacey had been joined on the small screen by Hollywood luminaries such as Woody Harrelson, Matthew McConaughey, Nicole Kidman, Reese Witherspoon, Dwayne "The Rock" Johnson, Tom Hardy, and Susan Sarandon; prominent theatrical writer/directors such as Guillermo Del Toro, Steven Soderbergh, and Baz Luhrmann had followed Fincher to television; and $4 million per episode sounded like a steal next to the reported $10 million per episode spent on new series on Netflix and HBO. When the first *Lord of the Rings* film, based on the beloved series of fantasy novels by J.R.R. Tolkien, premiered in 2001, the idea of seeing such an iconic (not to mention visually extravagant, world-building-intensive) property on television might have been laughable; by 2017, Amazon was reported to have paid in excess of $200 million just for the right to produce a television series set in Tolkien's Middle Earth (excluding the further costs of actually producing that series). Television may have once been perceived as film's dorky younger brother industry, a less glamorous waypoint for theatrical stars and creators on the upslope or downslope of their careers, but certainly not a home for them in their primes. No longer.

This arms race has played out most starkly and dramatically among subscription-based services, such as Netflix, Amazon, Hulu, HBO, and (most recently) Apple. And one key factor driving their activity has been "cord cutting," the phenomenon of consumers canceling their traditional cable and satellite subscriptions in favor of consuming content through a variety of free over-the-air and Internet-based subscription services. While cord cutting continues to accelerate, the prevailing

assumption is that consumers will only be willing to bear so many monthly subscriptions. These services are therefore rushing to amass as many subscribers as possible while there are still open subscribers in play. And their ongoing competition to secure the best projects and lure the most desirable talent has, in turn, driven up budgets and fees across the industry.

The fourth hallmark is essentially the inverse of the third, in the form of low-budget production and growing nichification. Not every player in the market has the resources to compete with the blockbuster strategy embraced by networks such as HBO, Netflix, and Amazon. And in a world where, as discussed above, the market is more fragmented (and amassing a huge and diverse audience is more difficult) than ever, some networks and producers have instead opted for a "moneyball" approach, favoring smaller production budgets and creative content which is meant to, and only needs to, appeal to more limited, specific audiences. As comedian and TruTV's *Billy on the Street* host Billy Eichner warned in a January 2018 Tweet ironically (and fictionally) quoting Dr. Martin Luther King, Jr.: "There are too many shows now. Your streaming or cable show, while critically well received, is ultimately too niche to sustain." "Unless," he might have added, "you can make it for really cheap." Any breakout hits from this category, such as unscripted television phenomena like *Shark Tank* (ABC), *Top Chef* (Bravo), *Duck Dynasty* (A&E), and *Toddlers and Tiaras* and its spinoff *Here Comes Honey Boo Boo* (TLC), can be regarded as windfalls.

Finally, the Peak TV era has been one of significant disruption and innovation in business and exhibition models. Technology companies with overwhelming financial resources, such as Google, Amazon, Apple, and Facebook, have sought to establish themselves as content companies, using television as their primary medium of choice. Advertising's long-time power as the dominant economic driver of the television industry has eroded, as technology has enabled many viewers to limit their exposure to ads, while other viewers have embraced the commercial-free environments of streaming and premium cable services. Netflix has built itself on the open infrastructure of the Internet, creating a subscription-based business while avoiding entanglements with traditional cable and satellite providers that other networks had historically relied upon to reach consumers. Amazon followed a similar route, but bundled its video subscription as part of a broader package of its retail, publishing, music, and other services. HBO, a more entrenched player that had long served a key role in the traditional cable and satellite television ecosystem, sought its own disintermediated relationships with consumers through its HBO Now offering. Netflix introduced the concept of the "binge viewing" experience, releasing all episodes of each new season of its original series at once rather than staggering their releases on a weekly, episodic basis. Amazon and Hulu experimented with hybrids of the new binge and traditional weekly episodic model. This experimentation has, in turn, impacted production schedules, as they evolve to meet new exhibition patterns that eschew traditional broadcast calendars. Exposure to streaming offerings has instilled in

viewers a taste for on-demand viewing (in lieu of the traditional "appointment viewing" of linear network broadcast calendars), and traditional platforms have sought to develop technological solutions and business partnerships to respond to these evolving consumer preferences. And all of this experimentation has fundamentally challenged the traditional ways companies measure their return on investment in this space.

It is in this context of growth, disruption, peril, and opportunity that this book seeks to offer some measure of insight and clarity. Television may play a central role in millions of Americans' lives, but to the average viewer—and even to many professionals working within it—the industry's inner workings are obscure and opaque. This book seeks to demystify those inner workings by providing a clear understanding of the roles of the industry's key players; the life cycle of a television series; the key intellectual property issues impacting television development and production; and the essential deal structures that glue the industry's key players together. It may, at times, provide a handy "how to" guide for practitioners in the field. But more than that, it is meant to be a deep and broad resource to students and academics, current and aspiring professionals, and curious observers who want to better understand how the shows we love get made, and how they make money for the people and companies that create them.

1

A BEGINNER'S GUIDE TO THE TELEVISION INDUSTRY

A. What Is Television?

What is television?

As a threshold matter, understanding the business and law of television requires a working definition of the term. And while the general notion of "television" is no doubt familiar to everybody, a functional definition can prove surprisingly elusive.

Is television a technological medium? In its earliest iteration, television could be understood in essentially technological terms—a telecommunications medium for transmitting audiovisual information via radio frequency electromagnetic waves, typically in the "very high frequency" (VHF) or "ultra high frequency" (UHF) spectrum ranges. Yet from very early in the history of the television industry, alternative transmission media, starting with "community access television" (CATV) systems and later developing into cable and satellite systems (which rely on coaxial cable and microwave transmissions, respectively), challenged the completeness of this purely technical understanding of the term.

Is television definable as a creative medium with certain specific, consistent elements? Certainly, there are creative and production trends which are common to television programming, yet these trends vary and evolve across television platforms and over time, with lines that tend to blur. Program lengths vary. The line between comedy and drama is fluid. Shows may be serialized or episodic. Unscripted television both adopts and challenges traditional notions of television storytelling. "Second screen" experiences delivered via modern consumer electronics now do the same. Television has proven unsusceptible to an all-encompassing creative definition that is responsive to the medium's evolution over the years. At the same time, the rise of online video distribution, encompassing programming

of all types and lengths, generated by a mix of established entertainment powers and individual upstarts, has further challenged any effective effort to contain "television" in a single box.

When commercial television broadcasting began in the early to mid-twentieth century, it was an ephemeral, unrecordable experience; broadcast over the airwaves; covered only a few hours a day (remember test patterns?); featured three principal sources of original content; displayed low-resolution, black-and-white images; and relied on boxes half the size of a refrigerator with screens barely larger than an iPad boasts today. Today, consumers take for granted virtually unlimited viewing options from virtually unlimited sources of content; recording, time shifting, and on-demand consumption; high-definition images sharp enough to see the pores on an actor's nose; and viewing devices ranging from pocket-sized smartphones to 75-inch high-definition screens with theater-quality sound. How does one unify these wildly different experiences in a single working definition?

This book will use, as its foundation, a brief but expansive definition of "television": the distribution of audiovisual content to individual consumers, at times and locations and on devices of their own choosing.

This vitally distinguishes television from, for example, theatrical feature film distribution, which essentially requires viewers to go from where they are to the content, rather than the other way around. Yet by this definition (and intentionally so), a YouTube video viewed on a smartphone and a Netflix original series viewed on a computer are no less television than a traditional one-hour drama broadcast on CBS and viewed on a television hooked up to a rooftop antenna.

Beyond the foregoing definition, there are three key consistent characteristics of television programming which are essential to understanding the web of deal structures that bind the television industry together.

First, television is a writer-driven medium. To understand the meaning of this statement, it is helpful to compare the role of the writer in television to that of the writer in the theatrical feature film industry. In television, in the vast majority of cases, the lead creative force behind a series (the "showrunner") is a writer. This is in contrast to feature films, where the director is typically the "auteur" creative force behind a production. In television, most of the credited producers of a series are writers, who shepherd the project throughout its life-cycle. In feature films, on the other hand, the writer's role is generally performed entirely during the pre-production phase, and writers have little or no ongoing role in the actual production of their scripts. In television, a pilot script is usually (though not always) written by a single individual or writing team, who conceptualizes the world of the series and takes the studio and network's notes throughout the series development process. This, too, is at odds with the feature world, particularly that of big-budget studio films, where writing is often effectively done by committee, with new writers commonly being hired to rewrite the work of previous writers, without working in direct collaboration with one another. Finally, in television,

a pilot[1]—and sometimes even a series—is typically greenlit to production on the strength of a pilot script and the reliability of the writers and producers, with actors and directors being hired after the threshold decision to proceed to production has been made. This is also a major difference from feature films, where the attachment of one or more key actors (and typically a director, as well) is virtually always the necessary component that pushes a film project from development into production. The dominant role played by writers in the television industry manifests itself in the process, and the deals, that bring a series to life.

Second, television is a serialized medium. This may or may not be the case in a creative sense—some dramas, such as AMC's *Breaking Bad* or HBO's *Game of Thrones*, involve complex, arced storylines which unfurl over a period of years (and require that the viewer watch from the beginning of the series to truly follow along), while other types of shows, such as game shows, talk shows, multi-camera comedies (e.g., *Two and a Half Men*), and procedural dramas (e.g., "cop shows" such as *Law and Order*) integrate some serialized character or situational development, but can generally be understood and enjoyed in single-episode viewings. But from a production perspective, a successful television series is always an ongoing project, which requires creative and production continuity over a period of years (as distinct from a theatrical feature film, in which cast and crew together come together once, usually over a continuous or semi-continuous period of time, to produce a single closed-ended project). Consequently, the dealmaking framework of television protects the ability of parties to maintain continuity of production and distribution over a period of years.

Third, television as a business relies on a dual revenue model. In general, entertainment economics can be divided into two categories—"direct pay" and "advertiser-supported." The classic "direct pay" system is the theatrical feature film, in which viewers go to a movie theater and pay for a ticket in order to gain access to the product, with a one-to-one relationship between viewers and tickets. The classic "advertiser-supported" model is exemplified by terrestrial radio, in which entertainment is made freely available over the airwaves and collecting user fees is virtually impossible, so the money that makes the industry run comes from advertisers, who pay for the opportunity to convey their messages to customers.[2] The modern television ecosystem, however, features a combination of "direct pay" (in the form of transaction and subscription fees from viewers) and "ad support" (with advertising remaining a dominant presence on most

1 For the avoidance of doubt, a "pilot" (sometimes also referred to as a "prototype") is a standalone episode of a television series that is used to establish and demonstrate the style and content of a proposed television series, and to persuade a network to order production of a full season's worth of episodes for that series.

2 The classic, pre-cable broadcast television industry of the mid-twentieth century United States was similarly a fully advertiser-supported business. An alternative model can be found in the United Kingdom, where the government taxes television owners to support public broadcasting services. However, this public taxation system does not amount to a traditional "direct pay" system, in that television owners are taxed equally based on television ownership, without regard for the specific programming (or volume of programming) those device owners actually consume.

television platforms). In the long term (and as explained in greater detail in the chapters that follow), regardless of its initial distribution platform, virtually every piece of television content produced today is made viable through a combination of "direct pay" and "ad-supported" revenues.

B. Who Are the Players (and How Do They Interact)?

Who made the successful television series, *House of Cards*?

If you answered "Netflix," you would be wrong. Netflix exhibits *House of Cards* throughout most of the world, but the show was actually produced (and owned) by a company called Media Rights Capital, which is known primarily for its feature films such as the raunchy talking-bear comedy *Ted* (2012) and science fiction epic *Elysium* (2013). For *House of Cards*, Netflix acts in the role of a "network," while Media Rights Capital functions as a "studio" and "production company." This distinction is one of the centerpieces to understanding how television is created and monetized.

Like many other industries, the television industry is comprised of a series of independent actors with specialized roles who engage in transactions by which, collectively, they develop, produce, market, and distribute a product to consumers around the world. And, as in many other industries, the precise role played by all of the players is sometimes opaque to the consuming public. The following chart visualizes the major categories of entities in the television industry and the essential types of agreements that bind them to one another:

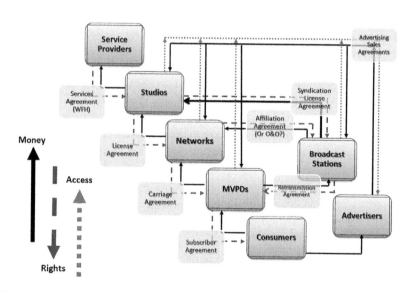

CHART 2 Structure of the Television Industry

(Note: All aspects of this chart will be explained in the sections that follow.)

In Chart 2, money generally flows upwards (via the solid black lines); intellectual property rights generally flow downwards (via the dark grey dashed lines); and access to the consumer (both via traditional advertising and more contemporary methods, such as product integration) is provided to advertisers (via the light grey dotted lines).

While the television industry (and its product) is certainly unique in many vital respects, it can also be substantially understood by analogy to the development, production, and distribution of traditional manufactured goods—for instance, a smartphone.

i. Service Providers (Talent)

Actors, writers, directors, producers, and other service providers—which, for purposes of this book, will be referred to collectively as "talent"[3]—are the day-to-day workers of the television industry. While the names and/or faces of the most prominent of these individuals may be familiar to viewers at home, most of these individuals are largely unknown to the general public (though, of course, many aspire to greater recognition and acclaim). In the smartphone analogy, they are the workers on the factory line.

The day-to-day work of developing and producing television content is generally performed by dozens or hundreds of freelance workers who are engaged to lend their expertise and labor to the production process. The most recognizable among these "workers" are so-called "above-the-line" talent—actors, writers, directors, and producers who centrally influence and guide the creative process, and whose names and images may be central to the public's interest in and recognition of a piece of content.[4] In broad, structural terms, however, these high-profile individuals occupy the same type of role as that played by editors, camera operators, electricians, carpenters, and the dozens of other types of crew members who participate in production (generally known as "below-the-line" crew). They are hired and paid for their creative and physical labor, generally on a show-by-show (or even episode-by-episode) basis. They primarily contribute their effort (and the creative fruits of that effort) to a project without making any direct personal financial investment. Consequently, while they may enjoy a

3 In the entertainment industry, the term "talent" is sometimes used to refer more narrowly to actors, and "talent agents and managers" to refer to agents or managers who specialize in representing actors, as distinguished from "literary agents and managers," who specialize in representing writers and directors. Unless specifically noted, this book will use "talent" to refer more broadly to any high-level creative service provider, including writer/producers, non-writing producers, directors, and actors.

4 The term "above-the-line" refers to the traditional format of budget "top sheets," which are summary pages outlining the major categories of expenditure and total costs of a production budget. Historically, costs associated with these high-level individuals, as well as writing and underlying rights fees, were displayed above a literal line on the budget top sheet, with the balance of physical production costs being displayed below that line.

financial interest in the success of a project (i.e., "backend") via a defined "contingent compensation" or "profit participation" formula (discussed in detail in Chapter 6), they generally have no ownership interest in the final product (even if they personally came up with the idea for it).

This category includes not only individual service providers, but also a variety of corporate actors, from physical asset vendors (such as caterers and equipment rental companies) to creative services vendors (such as visual effects companies) to so-called "production companies." Within this last category, companies may focus primarily on physical production (meaning the day-to-day management of all of the human and physical resources that go into the production process) or creative development (identifying, developing, and selling ideas or intellectual property as the basis for production). In many instances, such creative production companies are closely aligned with, or may even be a mere "vanity shingle" for, prominent individual members of the talent community. For instance, Amblin Entertainment is the production company founded and controlled by director Steven Spielberg, Smokehouse Productions by multi-hyphenate George Clooney, and Appian Way by actor Leonardo DiCaprio. Other prominent production companies such as Anonymous Content, 3Arts, and Brillstein Entertainment Partners are primarily talent management companies with deep rosters of successful writers as clients, which often results in these companies (and/or their principals) becoming attached as producers to their clients' projects. Although these companies may invest a limited amount of capital in their own salaries/overhead, or in preliminary development activity, they seldom provide direct at-risk production financing for projects, and often lay off their overhead costs onto studio partners[5] while recouping development costs from production budgets when projects actually proceed to production.[6]

These parties are generally in direct contractual relationships with studios, and although the details of these deals vary depending on the role these parties play in the development and production process (with some examples discussed in detail in Chapter 5), the unifying thread is that the studio that engages and pays a service provider is the owner of the results and proceeds of the service provider's efforts, as a work-made-for-hire under copyright law.[7] This status effectively empowers the studio to do whatever it wants with the product, in perpetuity.

5 This is often in the context of first look or exclusive overall deals, which are discussed in detail in Chapter 7.

6 The major exception here is Anonymous Content, which has partnered with Paramount Television as a co-producing studio on several projects.

7 The "work-for-hire" or "work-made-for-hire" is a concept arising under U.S. copyright law, which designates the employer of a party or parties creating intellectual property (e.g., writers, directors, and actors) to be the legal author and owner, from inception, of the copyright (and other intellectual property rights) of the employees' work. This concept is sometimes abbreviated as "WFH" (which abbreviation appears in Chart 2).

ii. Studios

Studios may be the most important players in the television industry that consumers know little or nothing about. These companies are at the center of the development and production of television content—sourcing ideas for shows from the talent marketplace, hiring and paying service providers, financing and managing production of shows, and generally owning the resulting intellectual property—but cultivate little relationship directly with consumers. In the smartphone analogy, they are the Chinese factories/manufacturers of the smartphone (e.g., Foxconn, the Taiwan-based manufacturing company which owns and operates the factories that produce Apple's iPhone).[8]

Studios operate a high-risk/high-reward business. Although much of the labor of production is outsourced to service providers who are engaged for active projects, rather than retained on salary, studios nevertheless operate a high-overhead business, employing significant numbers of full-time executives and support staff. Studios finance or co-finance development expenses for a large volume of projects, only a small percentage of which are ever likely to make it to production of a pilot, let alone a series. This is, in part, because studios depend on networks to order projects to production, and the vast majority of development projects will never cross that hurdle (and therefore never see a return on the studio's investments). Even projects that make it to production may cause the studio millions or even tens of millions of dollars in losses if they fail to find an audience and are quickly canceled by the commissioning network. But with a major hit such as *Friends*, *Seinfeld*, or the *CSI* franchise, the studio's profits can easily reach hundreds of millions of dollars—and these major successes are necessary to subsidize the higher volume of projects that fail while the studio is in search of that next big hit.

Studios are an essentially "B2B" (or "business-to-business") business, engaging in numerous vital transactions with more visible players in the television industry (such as talent, on the one hand, and networks, on the other hand), while often operating more or less invisibly to the general public. For most television series, the only outward identification of the studio is a two- to five-second logo at the conclusion of the end credits. Few television viewers could likely identify the studios behind hits such as *House of Cards*, *Breaking Bad*, or *The Big Bang Theory* (Media Rights Capital, Sony Pictures Television, and Warner Bros. Television, respectively), yet it is the studios that, in the long-term, will likely reap the greatest economic rewards of their shows' successes. Because most studios have little branding relationship with the general public, they will often seek to develop and produce a wide variety of very diverse shows, across a variety of networks/platforms, without necessarily forming a "house brand."[9]

8 This comparison is perhaps the most strained in the "television series as smartphone" analogy because in general, factories/physical manufacturers do not own or control the intellectual property of the products they produce. In the television industry, studios are the IP owners.

9 It is important to note that, just because a studio may not have a "house brand" from the perspective of the viewing public, it probably has a reputation within the industry itself—generated by the studio's

The aforementioned Media Rights Capital, Sony Pictures Television, and Warner Bros. Television are representative of "independent" studios, i.e., television studios that have no corporate relationship, or only a highly attenuated corporate affiliation,[10] with a network. Other prominent examples of independent studios include Paramount Television[11] (*13 Reasons Why*), Legendary Television (*The Expanse*), and Skydance Television (*Grace and Frankie*). The market is largely dominated, however, by studios that are directly affiliated and operated in conjunction with sister networks, who have a corporate mandate to supply programming to their sister networks (and whose sister networks have a corporate mandate to purchase programming largely from their affiliated studios). Such studios exist in connection with all types of networks, including broadcast (e.g., ABC Studios for ABC, CBS Television Studios for CBS), basic cable (e.g., FX Productions for FX, AMC Studios for AMC), premium cable (e.g., Showtime and HBO's studio arms), and streaming (e.g., Amazon Studios for Amazon Prime Video). Although television studios that are directly affiliated with a network typically develop and produce content substantially exclusively for their sister networks, such studios do occasionally produce for third-party networks, particularly where they have developed a series that is incompatible with the brand or broadcast standards of their affiliate. For example, all four studios affiliated with the four major broadcast networks have produced at least one series for Netflix.

The precise elements of the contractual relationship between a studio and a network for a given television series will vary depending on a number of factors, including the type of network involved (e.g., broadcast vs. cable vs. digital), the type of show (e.g., thirty-minute comedy vs. sixty-minute drama), and the relationship between the studio and network (e.g., independent third-party studio vs. affiliated company). In general, however, the relationship between studio and network is based on a license agreement, by which the studio grants the network specified, limited rights in the series.

iii. Networks

Networks are the first players in the television industry's chain of rights transfers who tend to maintain a direct relationship with the consumer. They function as aggregators and distributors, collecting a variety of television series produced

own history of successes and failures in various formats and genres—as an effective/reliable or ineffective/unreliable producer of specific types of television programming.

10 For instance, Warner Bros. Television is part of a large corporate family that includes TNT, TBS, and a stake in The CW, but it is nevertheless generally managed within that conglomerate, and regarded by the broader television community, as an "independent."

11 Paramount Television is a division of Paramount Pictures, which is itself a subsidiary of Viacom. Viacom owns several cable networks (such as MTV), but the Paramount Television organization operates independently from the Viacom Media Networks.

by different studios but generally consistent with a network "brand," and then marketing—and, in some cases, directly delivering—that content to consumers. In the smartphone analogy, they are the consumer-facing brand and product wholesaler (e.g., Samsung, Apple, or Nokia).

Networks work hard (and spend heavily on marketing) to create a "brand" and to market that brand to viewers as a signifier of a certain style or quality of content, often embodied in a pithy advertising slogan, such as HBO's "It's not TV. It's HBO." Although consumers may not be able to put the perception into words, they generally associate networks with a specific type or style of series. A network's slate is, in the current television environment, generally a mix of content that it has acquired via license agreements with third-party studios/content owners, and content that it has generated in-house through a subsidiary studio or acquired via license from an affiliated studio entity.

The business models of networks have historically emphasized either the "direct pay" or the "ad-supported" revenue model, although modern trends have pushed networks to embrace a hybrid of the two. On one end of the spectrum are the broadcast networks (i.e., ABC, CBS, Fox, and NBC), which are freely accessible by customers across the country through their over-the-air broadcast signals. These networks primarily support themselves financially by selling advertising against their content, the value of which is tied to the volume and demographics of the network's viewership. Roughly speaking, the difference between the network's total advertising revenue, on the one hand, and the network's total content licensing costs, marketing expenses, and operational overhead, on the other hand, traditionally constituted the network's profits.[12] On the other end of the spectrum are "premium pay networks" such as Showtime and Starz, which generate 100% of their revenue from customer subscription fees, and promote their lack of advertising as a major attractive feature of their services. In between are conventional cable networks, such as FX and AMC, which generate revenue through a combination of advertising sold against their programming and carriage fees received from cable and satellite providers

12 Even broadcast networks, however, have begun to hybridize their business model. Broadcast networks generate ever increasing portions of their aggregate revenue through "retransmission consent fees" paid by cable and satellite providers (and financed by those providers through subscriber fees) in exchange for the right to carry and reproduce local broadcast stations' signals as part of the cable/satellite providers' subscription packages. In addition, all of the broadcast networks have either flirted with or actively launched Internet-based services, such as CBS's All Access, by which customers can access both local broadcast station streams and network library content over the Internet, through dedicated apps, by paying subscription fees directly to the network. In 2016, CBS made headlines when it announced that its new *Star Trek* television series (*Star Trek: Discovery*) would premiere on the CBS broadcast network, but thereafter be available exclusively through the CBS All Access subscription service. (However, CBS's focus on CBS All Access can be best understood not as a diversification of revenue streams, but a reaction to evolving consumer habits, which, in the twenty-first century, have moved away from traditional in-home, subscription-driven viewing experiences [a shift often referred to as "cord cutting"], and toward mobile and digital viewing experiences.)

(which are themselves driven by the overall level of viewership of and consumer demand for the network).

The particular revenue model of a network substantially affects how it evaluates its own return on investment and makes decisions about the shows it commissions and renews. For a traditional network that relies, at least in part, on advertising, the network's revenue is directly proportionate to the number of viewers that tune in to each show. This direct relationship between ratings and revenue makes viewership the essential measure of success for any given series. As a result, traditional broadcast networks, in particular, tend to commission "broad" programming that they hope will have wide, if potentially casual, appeal to viewers. On the other hand, for networks like HBO or Netflix, which eschew advertising and generate their revenue from monthly subscriptions, the goal of programming is not necessarily to attract as many viewers as possible, but rather, to attract new paying subscribers and to retain existing subscribers. As a result, such networks tend to prioritize exclusivity in their deals (in order to make their subscription services essential), and to look for a mix of larger series that achieve cultural ubiquity and must-see status (such as *Game of Thrones* or *House of Cards*) and smaller series that may not boast huge audiences but have dedicated followings (as when Netflix revived or rescued from cancellation series that had completed their runs on traditional networks, such as *Arrested Development* and *The Killing*). For these networks, show-by-show ratings may be less significant than overall brand-building across a portfolio, and there is greater reason to invest in arguably niche programs that command substantial loyalty from smaller groups of viewers. In any event, the performance that a network demands of one of its series is determined, in part, by the network's level of actual financial investment in that series. In other words, expensive shows may be required to demonstrate better and more immediate results than inexpensive series that the network can more easily afford time and opportunity to develop an audience.

New networks tend to follow a similar life cycle. They launch by offering a relatively low-cost mix of second-run content, filling their broadcast hours primarily with somewhat older theatrical motion pictures and/or reruns of preexisting television series from other networks. They eventually move into original series production but rely primarily on outside providers with established studio capabilities. Relying on outside studios reduces the need for costly overhead and infrastructure investments that come with building a studio, and gives the network superior access to the best show ideas, wherever they may come from. Once these networks have built an audience and a brand for their original content through their partnerships with outside studios, they tend to build their own studio operations, and shift toward ordering new shows primarily from their own in-house/affiliated studio arms. Two of the best known basic cable networks exemplify this process of evolution. In its early days, when "AMC" stood for "American Movie Classics," AMC was known for airing classic Hollywood films. It broke into original programming with shows like Sony Pictures

Television's *Breaking Bad* and Lionsgate Television's *Mad Men*. The more recent megafranchise *The Walking Dead* and its spinoff *Fear the Walking Dead* are produced by the affiliated AMC Studios (although, on balance, AMC Studios has struggled to generate other hits). Similarly, for years, FX's programming day was comprised primarily of reruns of broadcast network shows, such as *Dharma & Greg, Married . . . with Children*, and *Fear Factor*, and cable exhibition of major theatrical films (often those produced and distributed by the affiliated 20th Century Fox motion picture studio). It moved into original programming with shows like Sony Pictures Television's *The Shield* and Warner Bros. Television's *Nip/Tuck*. More recent hits like *American Crime Story* and *The League* have come from studio arm FX Productions, and the network has continued to lean heavily on studio affiliates 20th Century Fox Television (*American Horror Story*) and Fox 21 Studios (*Tyrant*), which also absorbed one-time sister studio Fox Television Studios.[13]

While all networks maintain a branding relationship with their customers, not all networks maintain a direct economic relationship with their customers. Just as Apple takes advantage of its status as a powerhouse consumer brand to operate its own Apple retail stores, certain networks maintain disintermediated subscription relationships directly with their customers. Netflix has done this since its creation. HBO began to do so only relatively recently, with the 2015 debut of HBO Now, a direct-to-consumer HBO subscription service that did not rely on cable or satellite television providers to offer customers access to the network.

However, operating its own stores makes Apple an outlier in the retail world. More often, brands market to consumers but do not sell to them directly; instead, they actually act as wholesalers, selling their products to retailers (who, in turn, sell those products through to the actual consumers). So, while Apple sells many of its smartphones at its Apple stores, its competitors like Samsung sell exclusively through third-party retailers like Best Buy.

The same concept holds true for most networks, which do not maintain one-on-one subscription relationships with their viewers. Instead, most networks enter into carriage agreements with multichannel video primary distributors, or MVPDs, such as cable and satellite television providers, who in turn bundle

13 It bears noting that, over the years, the broadcast networks have developed a similar preference for content that they (or their affiliated sister studios) own in whole or in part. In the case of the broadcast networks, however, this shift in business practice emerged as a result of significant regulatory change. In 1970, the FCC adopted a set of rules known as the "Financial Interest and Syndication Rules," or "fin-syn rules," which effectively prohibited the broadcast networks from owning the programming that they broadcast. These rules were somewhat relaxed during the 1980s, before being abolished entirely in 1993. The repeal of the fin-syn regulatory scheme precipitated a major shift by the broadcast networks toward ownership of their own programming, and with it, a substantial contraction in the marketplace of independent television studios (which found it increasingly difficult to compete with network-affiliated studios for scarce broadcast time, in light of the networks' significant financial incentives to favor their affiliated studios).

and actually deliver these networks into viewers' homes. Although the details of such carriage agreements are extremely complex and generally beyond the scope of this book, in general, these agreements provide for the MVPD to pay the network some portion of its collected subscriber fees in exchange for the MVPD's right to include the network as part of its channel offering to customers.

iv. Broadcast Stations

Broadcast stations occupy an unusual middle ground in the television industry landscape, one that does not neatly correspond to any analog in the world of physical goods.

Broadcast stations are usually closely affiliated with broadcast networks (i.e., ABC, CBS, Fox, and NBC) but are technically separate entities. Each broadcast station is an essentially local business, serving a defined geographic market that is usually based around a single major metropolitan area.[14] This distinguishes the individual stations from their affiliated networks, which are national in scope.

Every broadcast station in every geographic market—e.g., KABC7 in Los Angeles, CA, or WNBC4 in New York, NY—is a distinct business and a distinct corporate entity. In many major media markets, such as Los Angeles and New York, the broadcast networks actually own the local stations that carry their programming. Such stations are known as "owned and operated" or "O&O" stations. Other broadcast stations, particularly in smaller markets, may be owned and operated independently of the major networks and enter into "affiliation agreements" to gain access to such networks' programming. Many of these "independent" stations, however, are still parts of large "station groups" collectively owned by major media companies such as Tribune Broadcasting and Sinclair Communications (two companies which, as of early 2018, are seeking regulatory approval to merge).

Network-affiliated broadcast stations are generally provided with programming by their affiliated network for broadcast during morning and evening primetime hours. They fill the rest of the broadcast day (and unaffiliated stations fill the entire broadcast day) with a combination of original self-produced programming (most commonly local news); licensed reruns of television shows that were previously broadcast by a television network (so-called "second-run syndication licenses," usually for beloved half-hour comedies); licensed broadcasts of movies or other previously exploited programming; and licensed broadcasts of first-run original content produced by third-party studios or production companies ("first-run syndication," typically in connection with daytime talk shows such as *Ellen* [produced by Telepictures, a Warner Bros. Television affiliate] or

14 A few especially prominent stations, such as Atlanta's WTBS and Chicago's WGN, started out as traditional local broadcast stations but achieved "superstation" status by eschewing any affiliation with a major national broadcast network and securing nationwide distribution through cable and satellite services.

daytime game shows such as *Jeopardy!* and *Wheel of Fortune* [both produced by Sony Pictures Television]).[15]

Broadcast stations are also subject to an overlapping pair of regulatory structures, administered by the Federal Communications Commission (or FCC),[16] known as "must carry" and "retransmission consent."[17] By virtue of this regulatory framework, smaller broadcast stations (such as public television stations and other stations without a major network affiliation) generally exercise their "must carry rights" and compel MVPDs to offer their channels to local subscribers in their markets for no compensation (based on the premise that the public benefits from the broad availability of such broadcast stations). Larger broadcast stations (in particular, those affiliated with major networks), on the other hand, generally opt to negotiate "retransmission consent agreements," by which they receive significant fees from these MVPDs in exchange for allowing the MVPDs to include their stations in packages for local subscribers. These retransmission fees—which are technically unique to broadcast stations but essentially analogous to the "carriage fees" paid by MVPDs to networks—are typically split between the broadcast station and its affiliated network (an arrangement known as "reverse retransmission"), and represent an increasingly vital source of revenue for both broadcast stations and networks.[18]

v. MVPDs

Multichannel video primary distributors (MVPDs) such as Spectrum (formerly Time Warner Cable), Comcast, DirecTV, and Verizon FIOS are the television

15 The term "cable syndication" may be used to identify the licensing of library episodes of existing television series for reruns on a basic cable network (rather than on a broadcast station).

16 More broadly, broadcast stations are uniquely subject to regulation by the FCC, whose regulatory scheme is generally outside the scope of this book but dramatically impacts all aspects of the operation of these businesses.

17 Historically, prior to the advent of consumer satellite television services in the 1980s and telecommunications-based television services in the 1990s, a handful of cable providers maintained nearly monopolistic control over the market for multichannel television subscriptions, often engaging in minimal (if any) competition with one another on a geographic market-by-market basis. The prohibitively expensive cost of building cable wiring infrastructure posed a significant barrier to entry for would-be market challengers. The FCC's "must carry" and "retransmission consent" system was implemented as part of the 1992 United States Cable Television Consumer Protection and Competition Act, and offered broadcast networks and stations special protection in the face of the superior market power enjoyed by cable providers during this era. These rules are embodied in 7 U.S.C. Part II and were upheld by the U.S. Supreme Court in *Turner Broadcasting v. Federal Communications Commission*, 520 U.S. 180 (1997). In the intervening years, however, the pace of regulatory evolution has been slow, while the cable industry's market power has steadily eroded in the face of challenges from satellite and telecommunications-based television providers.

18 Between 2006 and 2014, aggregate broadcast station retransmission fees grew from $200 million per year to $4.6 billion per year, with analysts estimating that they could grow as high as $10 billion to $20 billion annually in the years ahead.

industry players that maintain the closest economic relationship with the customer, actually representing the point of sale where customers exchange their dollars for access to television programming. In short, they sell to consumers subscriptions for packages of various television networks. In the smartphone analogy, they are the retailer—the Best Buy or Verizon Wireless store that sells a wide array of different (and competing) brands in one convenient place.

Although the technical means they use vary from service to service (e.g., coaxial cable for cable providers; microwave transmissions for satellite providers; fiber-optic cable for telecommunications providers), MVPDs all provide essentially the same service to customers—a bundle of networks, delivered directly into the viewer's home. MVPDs maintain subscription relationships with customers, collecting monthly fees in exchange for access to the MVPDs' services. A substantial portion of these monthly fees are paid by the MVPDs to the networks on the MVPDs' services (in exchange for the MVPDs' right to offer such networks to their customers); in general, these carriage fees are denominated on a dollars-per-subscriber basis, with the most-watched and in-demand networks (led in recent years by ESPN, but also including prominent cable networks such as Comedy Central, MTV, FX, TNT, and AMC) commanding the highest carriage fees. Alongside the advertising revenue infused into the system at multiple levels, these carriage fees represent the essential economic fuel that flows through all of the other participants in the chain of television production and distribution.

Like brick-and-mortar retailers, who have to spend heavily on real estate or other physical overhead expenses, MVPDs invest significantly in the costly infrastructure needed to actually deliver access to television programming in viewers' homes. Like many retailers, they generally provide customers with access to very similar collections of products (i.e., networks) but compete with one another based on price, reliability, customer service, and overall customer experience. In marketing to consumers, they advertise both themselves and the products (i.e., networks) that they offer.

vi. Advertisers

a. Traditional Advertising

As described in Section A above, the television industry relies on a dual revenue model, which combines traditional "direct pay" (best exemplified by theatrical feature film exhibition) and "advertiser-supported" (best exemplified by terrestrial radio) business models. The "direct pay" revenue in this system originates with consumers, who pay subscription fees to MVPDs (such as Comcast, DirecTV, and Verizon FIOS) and direct-to-consumer "over-the-top" subscription services (such as Netflix, Amazon Prime Video, and Hulu, described in further detail in Section C below). These fees filter upward through the television ecosystem

through the series of intermediary contractual relationships described above (in the form of per-subscriber fees paid by MVPDs to the networks they carry and license fees paid by networks to the studios that provide their content).

Advertisers, on the other hand, channel money into the television ecosystem at virtually every stage of the process. On average, approximately 25% of broadcast time on advertiser-supported television networks—eight minutes of each half-hour program, or sixteen minutes of each one-hour program—is dedicated to advertising. Although national networks—which offer the broadest reach to the biggest advertisers—realize much of this revenue, the available advertising inventory (and associated advertising revenue) is allocated amongst all of the players in the system, with MVPDs, networks, and studios all acting as sellers of advertising time.

For instance, carriage agreements divide available advertising minutes between MVPDs (who often sell their available advertising minutes to local advertisers on a market-by-market basis) and networks (who sell their available advertising minutes primarily to national advertisers).[19] Similarly, affiliation agreements between local broadcast stations and national networks allocate available advertising minutes during the day to each of the parties, with the national network controlling most or all of the advertising inventory tied to the network's nationally distributed programming, while the station controls most or all of the advertising presented alongside the station's self-produced or licensed syndicated programming.[20] In the world of first-run syndication (which is dominated by daytime talk shows and daytime game shows), licensee stations typically compensate the studios with a mix of cash license fees and "barter" advertising time—in other words, allowing the studio that produces and distributes a show to sell, for its own benefit, some portion of the available advertising time during the program.

In general, creative and production service providers are effectively shut out of the television advertising sales market, with studios and networks expressly prohibiting writers, producers, and other providers from accepting compensation from advertisers without the studio and/or network's explicit consent or control over the transaction.[21] Often, these last transactions take the form of product integration deals.

19 This allocation of advertising inventory explains why viewers of national cable networks may still be presented with advertisements for local businesses.

20 For this reason, local news programming—for which broadcast stations control the entire available advertising inventory—is especially vital to the economic well-being of broadcast stations. Local stations also make a disproportionate amount of their revenue during election years, when political advertisers—who usually target specific, narrow geographic markets—buy advertising time in great quantities.

21 Federal regulations, particularly in the broadcast television world (which is subject to FCC oversight), also require that broadcasters disclose payments made by advertisers in exchange for having their products used, depicted, or mentioned on television.

b. Product Integrations

"Product integration" (or "product placement") is a broad term capturing the paid use, depiction, and/or mention of an advertiser's product within a television show (or other filmed entertainment). Product integration/placement differs from traditional advertising in that it is incorporated—or "integrated"—directly into the television program itself, as opposed to being presented through obvious, separately demarcated advertisements that are broadcast before, after, or during the creative program.[22]

Product integration can take many forms, and many levels of obviousness to the viewer. Some advertisers pay a relatively modest fee just to have their products and logos appear visibly but passively on screen during a program. This is sometimes referred to as a "passive integration." For a higher fee, an advertiser may purchase an "active integration," under which the characters on screen actively touch and use the advertiser's products, typically without any special mentions but with logos that are visible and reasonably conspicuous on screen. (Think of a camera shot of a car approaching the camera, swiftly pulling over, and parking, with the car's front grill and logo prominently coming into focus as the car nears the camera. That car manufacturer probably paid tens or even hundreds of thousands of dollars for that shot.) Other advertisers pay an extra premium for characters to mention their products aloud by name brand, though many networks and studios shy away from such intensive integrations because of their obviousness to the viewer. As a result, in scripted television, such extremely active integrations are seldom seen outside of the context of daytime soap operas.

A related concept is the "commercial tie-in," an arrangement between a show and a brand, by which the brand provides advertising for the show as part of advertising its own products. For example, in the theatrical world, Marvel Studios has a long-standing commercial tie-in relationship with Dr Pepper, by which the soda company has released special edition cans with Marvel characters on them to support the launches of various Marvel Cinematic Universe features. Such "commercial tie-ins" may resemble merchandising, which also involves the incorporation of series intellectual property into unrelated commercial goods or services. Unlike merchandising, however, commercial tie-ins tend to involve changes in packing and/or advertising for existing products rather than the creation of entirely new products and are primarily a marketing-based arrangement. A "commercial tie-in" deal may be made on its own, or as part of a broader product integration and/or advertising relationship.

Product integration represents a balance between art and commerce, and partnerships with brands can be a welcome source of cost savings for television production. Many studios actively solicit "tradeout" deals, by which an advertiser

22 The financial and control issues around such integrations are discussed in greater detail in Section A.xiii of Chapter 8.

provides the production with free products which can be used as wardrobe, set dressing, or props on screen (thereby saving the studio the expense of buying or renting such items), but does not provide any separate compensation to the studio, or receive any separate assurances about the nature and extent of the depiction of the brand's products. Where an advertiser does pay cash compensation for an integration, the more conspicuously a brand is featured, depicted, and/ or mentioned on screen, the more money the advertiser is willing to pay for the integration. But at some point, the obvious commerciality of such integrations can prove off-putting to viewers, as well as to writers (who typically don't want their creative work converted into an advertisement) and actors (who may feel that their participation in product integrations effectively converts them into indirect spokespeople for the brands).[23] As a result, most studios and networks seek integrations that are "organic" to the story being told, often favoring deals with everyday lifestyle products (such as cars, consumer electronics, and alcohol brands) that can be integrated seamlessly—and often solely visually—into the world of the television series.[24]

Product integration is often more conspicuous—and therefore more lucrative— in the world of unscripted programming. Because such programs are (ostensibly) "reality"-based and do not require a suspension of disbelief by the viewer, they are more amenable to intensive, conspicuous integrations. Sets can be designed specifically to highlight partner brands, as was the case on Fox's *American Idol*, which prominently featured Coca-Cola logos in set dressing and consistently depicted the series judges with large Coca-Cola logo cups in front of them at the judge's table. Individual segments or challenges of a competition program may be identified with a specific presenting sponsor, while major prizes may be expressly presented and funded by a specific brand. For instance, Glad Products, a company specializing in trash bags and plastic food storage containers, was for many years the presenting sponsor for the grand prize of Bravo's cooking competition series *Top Chef*; more recently, San Pellegrino Sparkling Natural Mineral Water replaced Glad as presenting sponsor for the grand prize.

Some networks have extremely particular policies about product integration, driven by other elements of the networks' business (or that of their parent companies). ABC holds itself to a higher standard of "family friendliness," including

23 Many higher-level actors—particularly those who have extensive branding or commercial endorsement relationships of their own to protect—seek to limit the extent to which a studio may compel them to use, mention, or otherwise participate in "active integrations."

24 An amusing counterexample is *Community* (originally broadcast on NBC and later on Yahoo! for its sixth season), which featured a prominent, multi-season integration program with sandwich chain Subway. Subway is integrated extensively throughout the scripted comedy, featuring prominently in major storylines, with one guest character even being named "Subway" and functioning as an explicit spokesman for the brand. The integration ended up serving as an amusing meta-commentary about product integration and television (while netting meaningful revenue for studio Sony Pictures Television).

with respect to its selection of integration partners, as a result of the network's status as part of the family-oriented Walt Disney Co. Amazon provides studios with a list of product categories that they can never integrate, because those products are competitive with Amazon's other consumer offerings. As a result, one can expect never to see an Amazon show that features an iPad (which competes with Amazon's Kindle tablets) or Google Home device (which competes with Amazon's Alexa-based line of products).

Product integration is particularly significant in digital series production outside of the premium, traditional television-like Netflix/Amazon/Hulu context, on platforms like YouTube, Verizon's Go90, and The CW's Seed. Although the license fees and advertising revenue shares on such platforms may not be sufficient to support larger-scale production, even in the short-form format more typical to such platforms, savvy digital producers have built partnerships with major brands, developing and producing entire series around products. Such arrangements go beyond both traditional advertising and even product integration, and the resulting productions are sometimes referred to as "branded content." In such deals, the brand sponsors can enjoy substantial creative input in exchange for covering most or even all of the branded series's production costs. For example, Funny or Die has produced original branded content in partnership with KFC, while AwesomenessTV has sold numerous brand-oriented or funded series to Go90, including *Royal Crush* (in partnership with Royal Caribbean cruise lines) and *Versus* (in partnership with Gatorade).

vii. Talent Representatives

The era of talent representation arguably began in 1898, when a German-Jewish immigrant named Zelman Moses, having adopted the anglicized name "William Morris," went into business as a "Vaudeville agent," starting the organization that would grow into the venerable William Morris Agency, regarded by many as the first great talent agency in show business. (The William Morris Agency merged with the Endeavor Talent Agency in 2009 to form William Morris Endeavor.) Talent representatives arose in the Wild West of the early twentieth century entertainment industry, when entertainers struggled to find work—and even more often, to get paid for the work they did—in America's emerging creative industries. Since then, agents, managers, and lawyers have played a crucial role throughout all areas of the entertainment industry, but arguably, nowhere is that role more visible—or more economically impactful—than in the television industry, where each of these players has carved out a specific and vital niche for themselves.

In considering the distinct roles played by agents, managers, and lawyers, as described below, it is important to remember that the distinctions among them may sometimes be more theoretical than practical. Every talent representative seeks to develop a trust relationship with his or her client and may be a creative

partner, a personal confidante, a business advisor, and a networking resource all at once. While many writers and actors choose to have one of each of these professionals on their teams, some more established and successful individuals are content to have only one or two of the three, and the selection of which one or two depends entirely on the needs and desires of the talent and the nature of their relationships with the members of their team.

a. Agents

The principal job of a talent agent (whether that individual represents a writer, director, producer, or actor) is to find work for his or her client. Agents nurture close relationships with creative executives at various studios and networks, and keep a close watch on the development activities (and hiring needs) of these organizations. Using these relationships and this business intelligence, agents find and create opportunities for their clients, often serving as the client's first line of communication with studios and networks (or "buyers"). In addition, depending on the style and preferences of the individual agent and client, as well as the presence or absence of a lawyer on the team, agents may serve as frontline deal negotiators on their clients' behalf.

In order to act as a talent agent in California, New York, or Tennessee (the three hub states of the American entertainment and media industries)—that is, in order to "procure employment" for an entertainer—an individual must be licensed in accordance with that state's requirements. At the same time, agencies that represent clients who are members of the major entertainment guilds—SAG/AFTRA (Screen Actors Guild/American Federation of Television and Radio Artists), WGA (Writers Guild of America), and DGA (Directors Guild of America)—are also subject to franchise agreements with the unions, which functionally further regulate the agencies' businesses. In California, the governing statute is the Talent Agencies Act, or "TAA," and licensing is administered by the California Labor Commissioner's office. Among other requirements, licensed talent agents must submit their representation agreements for the Labor Commissioner's review and approval, comply with statutorily defined bond requirements, and maintain client funds in dedicated trust accounts.

Agents may play a significant creative role in their clients' careers, counseling them on what jobs to take or decline, advising them on what types of projects to develop based on the appetites of the market, and providing a creative sounding board for their clients' ideas. However, because many agents maintain large stables of clients at any given time, the level of creative attention they provide may be limited (a limitation which creates further opportunity for managers). In addition, franchise agreements with the unions historically prohibited agents from acting as producers on their clients' projects. (In more recent years, however, the breakdown of these restrictions has opened the door to the largest agencies taking more active positions in the financing and production of their clients' projects.)

Most people understand agency economics to be based on percentage commissions—indeed, agencies are sometimes slangily referred to in industry trade publications as "tenpercenteries," referring to the standard 10% commission charged by talent agencies on all revenues earned by their clients.[25] In fact, however, the major Hollywood agencies—currently, William Morris Endeavor ("WME"), Creative Artists Agency ("CAA"), United Talent Agency ("UTA"), and International Creative Management ("ICM"), with a second tier of "minimajor" agencies in Paradigm Talent Agency and The Gersh Agency—make the majority of their money from so-called "agency package commissions" paid directly to the agencies by television studios.[26]

One of the ways the agencies can create opportunities for their clients is by connecting them to one another, putting together compelling groups of talented individuals who can more effectively attract the attention and interest of studios and networks than any one of the clients could alone. Although this type of "packaging" takes place in the feature film industry as well as the television industry, it is especially prominent (and critical) in television. Starting in the early 1990s, agencies began seeking payment from the studios for the services rendered by the agency in effectively doing, on the studio's behalf, the job of putting together (i.e., "packaging") the major creative elements of a project. In exchange for this fee, in addition to having brought together the initial key creative elements, the agency promises to continue servicing the project's future creative needs, providing from its client base a steady pipeline of staffing writers, actors, and other mid-level and lower-level contributors the show will need to thrive in the future. If two major agencies combine to provide the key elements for a series, they may agree with the studio and amongst themselves to split a packaging fee, with each agency receiving a "half package." (Splits in thirds are also sometimes negotiated but are less common.) The agency's entitlement to a package commission on a project, also known as its "package position," is typically negotiated at the time development deals are first entered into between the studio and the major creative elements. These days, nearly every major scripted

25 In California, there is no statutory limit on commissions, beyond the legal requirement that they be reasonable. New York law sets statutory maximums on commissions depending on the nature of the client's work. The 10% benchmark is an enshrined maximum in the agencies' franchise agreements with the guilds.

26 This may also be in the process of changing. In the short term, the rapid proliferation and historically high budgets of digital series for platforms like Netflix and Amazon have generated increasingly lucrative up-front packaging fees to the agencies. As described in Section A of Chapter 8, however, in the long run these shows have lower maximum profitability, which means that the agencies have less and less opportunity to reap extraordinary profits from their backend interests in such productions. The gradual erosion in the value of agency package commission backends also informs the major agencies' shifts toward more direct roles in financing and production. For example, in 2017, WME launched a new studio venture under the banner of Endeavor Content, developing and financing projects with both WME clients and talent represented by other agencies. CAA has been more quietly developing some type of television studio venture with former ABC chief Paul Lee since December 2016.

television series includes at least a partial package commission that has been committed to one or more agencies in connection with the project. Moreover, although the term "package" is universally used to refer to the fees paid to agencies in such circumstances, increasingly, agencies demand and receive partial or even full package positions on the basis of a single major agency-represented element (such as a writer/creator who is qualified to showrun his or her own series, or a particularly prolific and well-established non-writing producer; in either case referred to as a "packageable element").

The particulars of how agency package commissions are calculated and accounted for are described in Section F of Chapter 5. As a courtesy to its clients, and to avoid any appearance of "double dipping," an agency that receives any share of a package on a television project does not collect a 10% commission from any of its clients who are employed on that project. As a result of both the prevalence and the value of these package commissions, they are often the key economic drivers not just for the major agencies' television businesses, but for their entire operations.

b. Managers[27]

The precise role of a manager varies widely depending on the particular relationship he or she shares with his or her client, but in general, compared to agents, managers are distinguished by having fewer clients, more intimate personal relationships with their clients, a more pronounced creative influence on (and creative participation in) their clients' work, and a more significant role in their clients' personal as well as professional lives. Managers may serve as consiglieres, best friends, surrogate parents, or creative partners—sometimes all at once. Compared to agents, managers are much more likely to invest significant time and effort developing young, inexperienced clients who do not yet have significant, obvious, and immediate employment and revenue-generation prospects.

Unlike agents, managers are unlicensed and unregulated. As a technical matter, this means that they are legally precluded from procuring employment opportunities for their clients, an activity which is legally reserved exclusively to licensed agents. In theory, therefore, the role of manager is intended to comprise a mix of personal support and general career advice, without crossing the line into generating work. As a practical matter, few managers would be willing or able to explain to their clients that, in fact, they cannot help their clients find arguably the one thing the clients (especially the young, poor ones) want more than anything: a job. This puts managers at constant risk of running afoul of the

27 For all purposes here, this book refers to "personal managers" as opposed to "business managers," a term that refers to finance/accounting professionals, typically CPAs, who more narrowly help manage their clients' income, savings, investments, and other economic affairs.

agency licensure laws, particularly California's TAA, whose application is determined by conduct (i.e., the act of procuring employment), not titles (i.e., whether an individual refers to him or herself as an "agent" or a "manager"). Managers who cross the line into acting as unlicensed agents by procuring employment for their clients risk not only having their representation agreements prospectively voided, but may be required to disgorge past commissions they have already collected. Where clients and managers find themselves at odds—a fairly common occurrence, given the intense personal elements of the manager-client relationship—these powerful legal remedies almost always give clients a significant upper hand in the dispute.[28]

Like agents, managers are commonly understood to work primarily for a percentage-based commission on their clients' earnings—often 10%, although some managers (who, again, are not subject to state licensure laws or franchise agreements with the entertainment unions) may charge as much as 15%.[29] However, like agents, managers in the television industry actually rely primarily on a different primary source of income: producing fees.

Unlike agents, managers are in no way prohibited from serving as producers on their clients' projects; this freedom is one of the major reasons why some experienced talent representatives prefer to function as managers rather than agents, despite the risks posed by the TAA and its remedies for unlicensed procurement of employment. Many managers (particularly "literary managers," who represent writers and directors, as opposed to "talent managers," who represent actors) view themselves primarily, or at least equally, as producers. And for such managers/producers, their primary source of new projects to produce is their own clients—who are often happy to have their trusted confidantes enjoy formal ongoing creative roles on their projects, and even happier to have those

28 For this reason, although the TAA nominally regulates agents, many industry observers regard it as essentially a defensive tool of talent agencies, allowing them to maintain a legal monopoly over the critical service of helping clients find work, and making them effectively essential to clients in a way that managers may not be. This perception is bolstered by provisions of the TAA that allow an individual to procure entertainment employment without an agency license, *if* he or she works alongside a licensed agent. In short, the TAA—which is invoked in roughly thirty lawsuits per year between disgruntled clients and their former managers—is the bane of managers' collective existence and has survived numerous constitutionality challenges brought by spurned managers. See, e.g., *National Conference of Personal Managers, Inc. v. Brown*, Case No. CV 12–09620 (C.D. Cal. Aug. 13, 2015). In 2008, however, the California Supreme Court created some relief for spurned managers through its decision in *Marathon Entertainment, Inc. v. Blasi*, 174 P. 3d 741 (Cal. 2008). In that case, the California Supreme Court held that the legal doctrine of severability could allow terminated managers to retain the right to receive compensation for legally provided non-procurement management services.

29 The scope of this commission may vary between agents and managers as well. Agents generally commission clients only on revenues earned from deals specifically sourced and/or negotiated by the agent, leaving the client's other revenue sources, investments, and business endeavors outside of the scope of the agency's commission. On the other hand, because managers may play a more involved role in all aspects of a client's life, some managers insist on commissioning all of the client's earnings from all sources.

confidantes waive their commissions because they are being separately compensated by the studio with their own producing fees.[30]

As a result, the major literary management companies, such as Anonymous Content (*True Detective*), 3Arts (*It's Always Sunny in Philadelphia*), Principato-Young Entertainment (*Wet Hot American Summer: First Day of Camp*), and Brillstein Entertainment Partners (*The Sopranos*), are also among the most prolific non-writing producing entities in the television industry, although some studio executives tend to regard them (rightly or wrongly) as "baggage" that they must deal with in order to get access to the managers' clients.

c. Lawyers

Finally, many clients retain lawyers as part of their representation teams. As with the other types of representatives, the precise role played by the lawyer varies depending on the preferences of the client, the skills and capacities of the client's other representatives, and the relationship between the lawyer and those other representatives.

In the simplest terms, the lawyer's role on the team is as negotiator and (of course) legal advisor. In some cases, lawyers enter the dealmaking process only after the client's agents have already negotiated the substantive deal terms in full, with the lawyer focusing solely on negotiating the resulting paperwork. Other times, lawyers work side-by-side with agents to negotiate the substantive deal terms, with the lawyer taking over the paperwork on his or her own once that phase of the process is complete. And in other cases, an agent who has sourced an employment opportunity will immediately step aside and allow the lawyer to serve as primary negotiator for all phases of the dealmaking process (although the agent, in such instances, would almost certainly remain engaged with the process behind the scenes). Entertainment lawyers, of course, must be qualified and licensed to practice law in their state and are subject to the same professional responsibility rules and fiduciary duties (including duties of loyalty and confidentiality owed to their clients) as all attorneys.

Although lawyers may enjoy the same type of close personal relationship with their clients as agents and managers, for the most part, the role of the lawyer is narrower than that of the other representatives (and as a result, lawyers may be

30 One of the most acrimonious disputes between client and manager was between the late comedian Garry Shandling and his former manager Brad Grey (who eventually left the management company previously known as Brillstein-Grey Entertainment to become the chairman and CEO of Paramount Pictures). Shandling's primary complaint in the dispute was that Grey received substantial fees and backend as a producer of Shandling's successful *The Larry Sanders Show* on HBO, while simultaneously commissioning Shandling's fees and backend from the series in his capacity as Shandling's manager. Although Shandling and Grey confidentially settled the dispute on the eve of trial in 1999, as a result of this high-profile and nasty litigation, most managers have become extremely scrupulous about eschewing such "double dips."

able to simultaneously represent a larger number of clients). Compared to agents and managers, lawyers typically have a much less significant role in generating employment opportunities[31] or advising on creative matters, although again, it all depends on the specific client and the specific lawyer. For instance, actor Bill Murray famously chooses to operate without an agent or manager, and to conduct all of his business through his attorney.

Unlike agents and managers, entertainment lawyers generally maintain a basic, one-dimensional revenue model—commissioning their clients' earnings from deals negotiated by the attorney, typically at the rate of 5%.[32] Lawyers generally do not enjoy any alternative revenue streams (such as package commissions or producing fees) that they could accept in lieu of commissioning their clients. As a result, some individuals—particularly those represented by major agencies that employ their own lawyers as "business affairs" executives and make these lawyers available to assist the agency's clients as a further courtesy service—prefer to reduce their overall commission obligations by eschewing lawyers and allowing their agencies to handle all aspects of negotiating the clients' deals, without the participation of outside counsel.

C. Online Video Distribution

The emergence of online video distribution—the FCC's preferred regulatory term for the market most people refer to as "streaming" or "digital video"—over the last ten years has presented the television industry with its greatest market challenges and its greatest market opportunities of recent history. Online video distribution represents, all at once, the death of some classic markets (having

31 To the extent that lawyers engage in procurement activity on behalf of their clients, if they do not simultaneously maintain an agency license (which would be unusual), they face the same TAA-related risks as managers. In fact, one 2013 case before the California labor commissioner suggested even greater risks for entertainment lawyers, by ruling that "acts undertaken in the course of negotiating for the employment of an artist"—in other words, the very heart of the service particularly provided by entertainment lawyers to their clients—constitute "procurement" for purposes of the TAA. *Solis v. Blancarte*, TAC-27089 (Cal. Lab. Com. Sept. 30, 2013). This decision would effectively render virtually every practicing entertainment attorney an unlicensed agent, violating the TAA on a daily basis. However, at least thus far, this case has not generated the same wave of TAA-based disputes between disgruntled clients and attorneys as has historically been seen between disgruntled clients and managers.

32 This fee structure is unusual among attorneys, who most commonly work for hourly fees. When considering only the highest-earning clients, it may also seem overcompensatory, especially since lawyers may continue to commission backend payments from successful projects long after the lawyer's active representation of the client has ended, as long as the fee-generating deals were negotiated during the representation. In fact, some higher-earning clients eventually seek to move their attorneys to hourly rates, rather than commission-based fee arrangements. Most lawyers resist this fiercely, however, as the valuable 5% commissions from high-earning clients are necessary to sustain the lawyers' overall businesses, and allow them to invest time and effort in representing less-lucrative, lower-earning clients (who may someday grow into high earners).

largely cannibalized the physical home video business), the birth of a new one (providing a valuable new medium/window for downstream distribution of traditional television programming), and the exciting new frontier in original content (with the major players investing heavily in original programming and emerging as vital buyers for new television content).

The field of online video distribution also exemplifies the growing role of "big data" in entertainment and media business decision-making. Digital platforms can aggregate far more, and far more detailed, data about the viewing habits of their customers than was ever possible for traditional networks. The volume and nuance of data collected by services like Netflix and Amazon dwarfs the information historically gleaned from traditional data companies like Nielsen. The extent to which these companies actually rely on these data, versus on the more traditional human decision-making associated with studios and networks, is unclear to outsiders. At a minimum, however, they certainly have access to insights about their customers that allow them to make smarter and more targeted decisions about which projects they should develop and produce, which stars and creators will resonate with their audiences, and how much money they should dedicate to each project. Some of the major players like Netflix and Amazon tend to be extremely proprietary with their data, being cagey about exactly what data they have and what metrics they rely on. They also tend not to publish detailed information about the number of people who view any given project (which allows them to better control public relations narratives about what shows are a "success"). Others, like Facebook (which has also been deepening its focus on Facebook as a content platform as well as a social media service) and Google aggregate and package the data they glean about their customers, and directly monetize them through their relationships with advertisers.

As these emerging businesses have looked to find their footing in the broader entertainment industry, they have both been heavily influenced by, and heavily influenced, traditional television businesses and structures.

i. Types of Online Video Distribution

Online video distribution can generally be broken down into a series of acronyms, which differentiate among these various business models by their method of monetization. Content licenses often distinguish explicitly among these forms of distribution; services, on the other hand, may expressly rely on a combination of one or more of these means of monetization. Digital buyers of content consider the prior streaming history of a television series in determining that series's market value, and prior exhibition via the same streaming model (e.g., subscription-based, ad-supported, etc.) is generally considered to have a stronger downward impact on the licensing value of content, compared to prior exhibition via a different streaming model. Although ongoing technological change will inevitably force further

consideration of these labels in the future, for the time being, the world of online video distribution can be fairly reliably divided as follows:

a. SVOD

"SVOD" refers to "Subscription Video On Demand"—authenticated access for paying subscribers to a library of on-demand streaming content. The most recognizable providers of premium television content online, such as Netflix and Amazon Prime Video, generally follow a primarily SVOD-based model. SVOD constitutes a "direct pay" form of monetization, in that customers must pay for access to content, rather than receiving it for free in exchange for exposure to advertisements. However, it is an attenuated form of direct pay, in that customers pay for blanket access to a library of content, without regard to whether they are watching any specific piece, or any particularly quantity, of content (analogous to a customer paying for a subscription to a traditional pay television network like HBO, even if they may not watch every individual piece of content on that network).

b. AVOD

"AVOD" refers to "Advertising-Supported Video On Demand"—customer access to one or more pieces of on-demand streaming content, which is provided at no charge to the customer but is accompanied by advertisements (which may be "pre-roll" [i.e., before the content itself], "mid-roll" [i.e., in the middle of the content, like a commercial break], and/or "post-roll" [after the content is complete]). The Google-owned YouTube is currently the dominant market examples of a pure AVOD service, although more recently, the company has sought to diversify its business model by offering an SVOD variant called YouTube Red. Until 2016, Hulu also offered a subscription-less AVOD service, sometimes referred to as "Hulu Classic" (as distinguished from the company's subscription-based "Hulu Plus" service), although the company eventually merged its service tiers into a single SVOD/AVOD hybrid (i.e., a subscription-based service that also generates revenue by serving ads with its content).[33]

c. TVOD

"TVOD" refers to "Transactional Video On Demand"—paid access to content online, with purchase and/or rental fees paid on a specific product-by-product basis

33 More recently, in 2017, Hulu preliminarily launched a separate live TV streaming service essentially functions as, and competes with, traditional MVPDs. In putting together the service, Hulu notably reached an agreement with CBS—the only major broadcast network not counted among Hulu's owners—to include CBS-owned networks in its live TV streaming bundle.

(rather than for a blanket subscription to a library of content). TVOD can be further subdivided into "EST" (or "Electronic Sell-Through," referring to permanent downloads of episodes or series, akin to the purchase of a traditional physical DVD or Blu-ray that the customer gets to keep)[34] and "ERT" (or "Electronic Rental," referring to a temporary time-limited download/viewing right, akin to the rental of a traditional physical DVD or Blu-ray), although it bears noting that there is currently little or no active "ERT" market in connection with television (as opposed to theatrical feature film) distribution. Major TVOD services include digital marketplaces such as Apple's iTunes, Google Play, and Amazon Instant Video. TVOD is largely viewed as a successor to, and replacement for, the traditional home video market. Alongside traditional home video, it represents the purest expression of theatrical-style "direct pay" distribution/consumption in the television industry.

d. FVOD

"FVOD" refers to "Free Video On Demand"—access to digital content without a direct charge, subscription charge, or requirement of viewing ads. Because it is essentially a non-monetized business, FVOD has little practical role in the professionalized television industry, and typically appears, if at all, in the context of promotional exhibition of special feature-type secondary content (though even this type of content is often advertising-supported).

e. VOD

"VOD" just stands for "Video On Demand," and although the term is often used, it is essentially ambiguous and should be interpreted with care. VOD may act as a blanket term, which encompasses all of the above forms of Video On Demand exhibition. It may be used as a synonym for ERT, or may refer more narrowly to a free or ad-supported form of ERT that is offered through MVPD set-top boxes in connection with the customer's subscription to a television network included in his or her cable/satellite package. Of all of the acronyms involved in the alphabet soup of online video distribution, "VOD" can be the most ambiguous, particularly when used without a clear context.

f. Other Key Distinctions

In addition to identifying the method of monetization of digital content, licenses for digital exhibition generally must take into account a few other key factors

34 As a technical matter, some companies take the legal position that there is no such thing as a "sale" of digital content, and that even "EST" is merely a perpetual license to the consumer, not a "sale" as such. This fine legal parsing can have consequences for revenue accounting and piracy enforcement, but as a practical matter, is something of a legal fiction.

in defining the scope of such licenses (and therefore defining the scope of rights that are reserved and may be sold to another buyer).

First, streaming rights may be granted on a standalone basis, or solely a companion basis. "Standalone" rights are those granted to services that are inherently streaming-based, such as Netflix and Hulu. "Companion" rights are granted to traditional linear network licensees, who want to provide their customers (often subscribers, in the case of basic cable or premium pay television networks) with concurrent web-based access to the shows on their linear streams. These rights may be exploited through directly branded websites (such as ABC.com); directly branded mobile applications (such as HBO Go and FX Now); affiliated streaming services (such as Hulu, which is a joint venture of ABC, Fox, Comcast/NBCUniversal, and—most recently, as of late 2016—Time Warner);[35] or the MVPDs that carry a network (through set-top box on-demand offerings, which are tied to the customer's actual channel subscription package).[36]

Second, the status of "permanent downloads" is an important subject of current negotiation between content owners and digital content platforms. SVOD (as well as AVOD) services have generally been presumed to offer their content on a streaming basis—technically, this means that the customer never permanently downloads the content to the hard drive of one of their own devices, but accesses it through the Internet on a real-time basis (and therefore must be actively connected to the Internet in order to access the content). However, to manage bandwidth usage and improve customer experience, streaming services such as Netflix and Amazon have explored changing their technological model to allow subscribers to download content for permanent or semi-permanent access offline so long as customers maintain active subscriptions (akin to Spotify's strategy in the mobile music marketplace). This is sometimes called a "tethered download." Future generations of licenses will contain explicit terms governing this form of hybrid SVOD/TVOD exploitation. However, existing licenses that did not contemplate such exhibition must now be reinterpreted to account for such a practice, with licensees taking the position that subscription-authentication renders it subject to and included within their SVOD licenses, and licensors taking the position that the move toward downloading rather than streaming is outside the scope of the original licenses, requiring a renegotiation with (and further license fees from) the licensee.

Third, there exists a small marketplace—entirely separate from those introduced above—of linear digital services. "Linear" services are those that provide a continuous pre-programmed stream of content, via one or more channels, which

35 This ownership structure helps explain the availability of ABC, NBC, and Fox series—and the unavailability of CBS series—on Hulu in recent years. Instead, CBS has focused on using its CBS-owned and controlled series to develop and support its independent, proprietary CBS All Access platform.

36 These issues are also discussed in greater detail in Sections A.vi.b and c of Chapter 8.

is accessed by the customer by dipping into the stream at any given time. Such video services are digital and streaming, but are not "on demand," in the sense that the customer does not have on-demand control over what he or she watches and when. In other words, they resemble traditional free over-the-air television networks but are delivered over the Internet. To date, there has been limited activity in this space—which also occupies an arguably nebulous legal and regulatory position with respect to elements of copyright and communications law that governs linear broadcasts that are delivered to customers via more traditional technological means.[37] However, as the regulatory landscape clears up in the years ahead, it seems likely that linear (as opposed to on-demand) digital licensing will emerge as another market opportunity for owners of television content.

ii. The Roles of Digital Content Companies

In understanding the role of digital content platforms in the marketplace, it is helpful to refer back to our previous visualization of the television industry, at Chart 2 (repeated below). Most every major digital content company can be understood as occupying a specific position in that chart—and most every position in that chart has been taken up by at least one major digital content company.

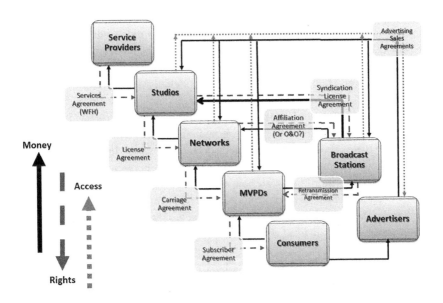

37 Litigation involving Aereo, a service that allowed subscribers to view live and time-shifted streams of over-the-air broadcast television stations on Internet-connected devices, reached the U.S. Supreme Court in 2014, challenging the boundaries of copyright and communications law. An adverse Supreme Court ruling led the company to suspend business operations in June 2014 and declare bankruptcy in November 2014. *See American Broadcasting Companies, Inc. v. Aereo*, 134 S.Ct. 2498 (2014).

Most well-known digital platforms function primarily as networks. Netflix, Amazon Prime Video, and Hulu all function essentially as pay television networks in the mold of HBO and Showtime, charging subscription fees for access to their entire range of services (albeit without the intermediation of an MVPD).[38] Streaming service Crackle is the leading fully advertising-supported streaming service, resembling a traditional broadcast network that makes its content available to users at no direct charge and derives its income primarily through advertising revenue.

At the same time, the evolution of Netflix, Amazon Prime Video, and Hulu looks a lot like the evolution, one to two decades before, of prominent basic cable networks such as AMC and FX, which evolved over time from offering only second-run content that had already appeared in theaters or on television, to original content produced by third-party studios, to a mix of content produced by third-party studios and content produced by their own in-house/affiliated studio arms.[39] All three services' streaming offerings began with a focus on second-run licensing of content that had previously appeared on other networks—essentially, cable syndication licenses in a digital context. Netflix and Amazon relied on arms-length licensing deals with outside studios, while Hulu enjoyed a pipeline of content from its owner-affiliates, broadcast networks ABC, Fox, and NBC. In response to increasing competition from one another and rising content licensing costs for second-run programming, all three services eventually expanded into original content. Netflix was first to market with its original content, debuting Norwegian series *Lilyhammer* in 2012 and breakout hit *House of Cards* in 2013, and initially relied entirely on outside studios to provide its content (*House of Cards* from Media Rights Capital; *Hemlock Grove* from Gaumont International Television; *Orange Is the New Black* from Lionsgate Television; *Arrested Development* from 20th Century Fox Television; etc.). More recently, Netflix has moved toward acting as a studio and producing its own content through its studio arm, allowing it to own and control all rights in its programming, such as its daily talk show *Chelsea* and hit dramas *Stranger Things* and *Mindhunter*.[40] Amazon trailed Netflix in entering the market for original content, debuting its series *Alpha House* and *Betas* in 2013; however, unlike Netflix, Amazon embraced a position as a studio as well as a network from inception, with both of its debut series being produced through Amazon Studios. Since then, Amazon's slate has represented a mix of in-house Amazon Studios shows (such as *Transparent* and *Man in the High Castle*) and shows licensed from outside studios (such as Fabrik Entertainment's *Bosch*, Sony Pictures Television's

38 The demands of this subscription-based model help contextualize and explain the strategic decisions of such SVOD services. Operating a subscription-based business means persuading customers to not only initiate a subscription, but just as importantly, to pay out-of-pocket fees, month after month, to maintain their access to the service. This requires the service to offer customers a sufficiently compelling value proposition to justify the monthly expense. One important way to create value for the customer is to offer a wide and diverse selection of content accessible via the subscription. Even more important, however, is offering the customer compelling content that they cannot find/access anywhere else. This premium on exclusivity helps explain the natural trajectory of subscription services toward increasing focuses on exclusive, premium, first-run content.

39 See Section B.iii above.

40 Economic factors driving this move are explored in greater detail in Section A.iv.a of Chapter 8.

Sneaky Pete, and Paramount Television's *Tom Clancy's Jack Ryan*). Among the three major streaming companies, only Hulu has, to date, continued to rely exclusively on original content from outside studios (such as Warner Bros. Television's *11.22.63*, Lionsgate Television's *Casual*, and Universal Television's *The Path*), although in many cases, Hulu's supplying studios (such as Universal Television) are themselves corporate affiliates of Hulu's parent companies. All three services also tend to take co-production positions in programming licensed from third-party studios.

In light of the foregoing, when it comes to original content produced for digital services, these platforms can be understood essentially not as *sui generis* players, but as a subset of networks, albeit with unique licensing requirements specific to the technological and economic models underlying their services.

The market also reflects a number of emerging "virtual" or "digital" MVPDs, such as DirecTV Now, Sony's PlayStation Vue, and Dish Network's Sling TV, all of which provide traditional-looking (if somewhat downsized) packages of linear channels, delivered via broadband Internet rather than through traditional coaxial, fiber-optic, or satellite equipment. These services effectively piggyback on existing Internet and "smart device" infrastructure, offering multi-channel television access through dedicated apps on users' smart televisions, set-top boxes (such as Apple TV or Roku), and/or mobile devices. The long-established YouTube service, in offering a variety of "channels" curated by third parties on its service, also arguably serves as a digital MVPD[41] (though it may alternatively be interpreted as an ad-supported network on its main service, and a subscription-supported network through its curated YouTube Red service). However, in February 2017, Google announced a new "YouTube TV" offering that would specifically serve as a more traditional-feeling virtual MVPD system, offering users access to approximately forty broadcast and cable TV networks (as well as Google's own YouTube Red offering) through users' computers or other Internet-connected devices, without a contract. In 2017, Hulu also launched a beta version of a digital MVPD offering, alongside its long-standing streaming service.

41 In this analogy, multichannel networks (or "MCNs") that have sprung up within the YouTube eco-system (and primarily target and serve YouTube's millennial audience), such as Fullscreen, Maker Studios, Machinima, and AwesomenessTV, can be understood as the "networks," while the producers and creators they work with function as the "service providers" and "studios," often retaining most or all of the rights in their content. These businesses, however, are undergoing a period of rapid transformation in their business models, looking to reduce their dependence on YouTube as a platform and expand their revenue streams. For instance, in 2015, AwesomenessTV struck a deal with Verizon to provide more than 200 hours of original programming for Verizon's upcoming Go90 streaming service; the next year, Verizon acquired a significant stake in AwesomenessTV, looking to use the company to further bolster its exclusive content offerings on Go90. Around the same time period, in 2014, competing MCN Fullscreen was acquired by a joint venture called Otter Media, which was funded in part by AT&T, and shortly thereafter announced that it would debut its own Fullscreen-branded SVOD service; that service launched in 2016, but by late 2017, Fullscreen announced that it would shutter its SVOD offering, which never attracted a substantial number of subscribers. This ecosystem of short-form content, which was largely born and nurtured on YouTube before expanding to a number of proprietary services with major investment from conglomerates like Verizon, AT&T, and Comcast, may warrant its own book—if it survives at all.

Finally, TVOD retailers, such as Apple's iTunes and Google Play, do not fit neatly into the above chart but occupy a spot traditional held by retailers and renters of physical home video products, such as Target, Best Buy, and now-defunct rental house Blockbuster Video.

D. The Power of Tax Incentives

The rapid growth of the television industry over the last ten years has created significant opportunity for all of the industry's stakeholders. But at the same time, the uniquely competitive marketplace has also put enormous cost pressures on all of the major players, with shows trying to achieve elusive "must watch" status by, among other strategies, courting costly top-tier on-camera talent, attracting and empowering wildly creatively ambitious directors and producers, and offering viewers production values on par with premium theatrical motion pictures.

The primary tool that studios have used to mitigate these ballooning costs is the tax credit. And in turn, the tax credit has turned nontraditional entertainment centers like Vancouver, Toronto, New Orleans, Pittsburgh, Atlanta, and Albuquerque into hotbeds of production, with Vancouver and Toronto even competing for the nickname "Hollywood North." Today, the availability and value of tax credits is arguably the single most impactful factor influencing the essential decisions behind a television production—not only where a show is produced, but how it is produced, for how much money it is produced, and in some cases, whether it makes sense to produce at all.

An ongoing television series production is a large business, which employs not only traditional "talents" such as writers, directors, actors, and producers, but also literally hundreds of tradesman and craftspeople, from carpenters to caterers, for months at a time. In addition, beyond the jobs created by the production itself, the cast and crew who descend upon a location to participate in the production of a television series spend significant dollars with local businesses. As a result, in order to incentivize studios to produce television shows (as well as other filmed productions) in their jurisdictions, government authorities at all levels—municipal, state/provincial, and national—employ a variety of incentive programs, usually in the form of tax credits or tax-based benefits, designed to lure producers with the promise of costs savings and economic efficiencies. In turn, such incentive programs dramatically impact studio decision-making with respect to where to produce a series and how much to spend on its production.

Production incentive programs take a variety of forms and vary widely from jurisdiction to jurisdiction (both within the U.S., and, increasingly, around the world). Common incentive programs include:

• **Production rebates**, by which a government authority directly reimburses a studio for some percentage of the studio's production expenditures within the jurisdiction;

- **Tax credits**, by which a government authority credits against a studio's local tax obligations some percentage of the studio's production expenditures within the jurisdiction. These tax credits may be transferrable (meaning that the studio can sell the tax credit to a third party who may be better able realize it) or non-transferrable (meaning that the studio cannot sell the tax credit, and therefore must have enough direct income tax liability in the jurisdiction in order to be able to realize the credit's benefits for itself);
- **Tax rebates**, by which a government authority refunds to a studio some portion of the studio's income, sales, value added, or other taxes, after such taxes have already been paid by the studio;
- **Tax exemptions**, by which a government authority exempts a studio, in advance, from paying taxes (typically sales or value added taxes), which would otherwise be due in connection with the studio's activities in the jurisdiction;
- **Direct government financing**, by which a government authority actually contributes funds toward the production of a series;
- **Subsidized production resources**, such as production stages and warehouses, owned by the government authority and leased to productions at favorable rates; and
- **Film commissions and film offices**, by which a government authority provides logistical support services to studios short of direct economic subsidies (such as assistance with obtaining film permits, scouting locations, and hiring local crew), in order to make it easier for the studios to do business within the jurisdictions.

Such programs are often subject to extremely specific conditions, including:

- Limitations on the types of eligible productions (e.g., theatrical feature films vs. television series; scripted vs. unscripted productions; dramas vs. comedies);
- Budget requirements (both floors and ceilings), which may be designed to appeal particularly to smaller or larger productions, according to the policy goals of the authority operating the program;
- Local expenditure requirements, which have the effect of requiring a production to spend a meaningful portion of its total budget within the local jurisdiction in order to access an incentive program (thereby limiting the value of such credits to productions that make only token investments in the local economy);
- Local content requirements (such as local story, character, and location elements), which are common in direct government financing programs operated at the national level and designed to promote the cultural goals of the authority operating the program;

- Local talent requirements, which require a production to make significant efforts to engage local cast and crew in production, rather than importing cast and crew from outside areas; and
- Local content ownership, in order to promote the further development of meaningful local film and television industries.

Government authorities may offer any one of the above programs, or a combination of multiple such programs, in order to lure studios to produce projects within their jurisdictions. Each program may be subject to specific and varying conditions. Depending on where it is produced, a production may concurrently enjoy access to multiple incentive programs offered at various levels of government—a municipal film commission office, a state or provincial tax credit, and a national production grant. For instance, a television production in Vancouver may simultaneously enjoy benefits from the Vancouver municipal government, the provincial British Columbia government, and the national Canadian government.

Perhaps the most prominent and impactful form of production incentives are tax credits, which are typically valued at between 20% and 35% of the studio's production expenditures within the jurisdiction. The studio is required to maintain exhaustive records of its expenses in order to support the claimed value of its tax credit, and the value of the credit may be capped based on the studio's ingoing production budget, as reflected in the studio's initial application for the credit. Where tax credits are transferable, secondary markets have emerged to facilitate the transfer of tax credits from the originating studios (who often have too little local tax liability to fully realize such credits) to local businesses or high net-worth individuals, who can save thousands or even millions of dollars by purchasing such credits at 85 to 95 cents on the dollar and pocketing the difference. Tax credit agents act as middlemen, connecting buyers and sellers in exchange for a percentage (usually 2%–3%) of the value of the credits. Some jurisdictions, such as Louisiana, offer direct buy-back programs, essentially allowing studios to more quickly and easily monetize their tax credits by selling them back to the state for 88 to 90 cents on the dollar (depending on market conditions). In any event, though, between the application, recordkeeping, and reporting processes, as well as the annualized tax cycle in each jurisdiction, studios must typically wait several months, or sometimes even years, to realize the benefit of these tax credits.[42]

Some jurisdictions offer tax incentives on an unlimited basis, to as many productions as are qualified and willing to avail themselves of the programs. Other programs—particularly those instituted in the states of New York and California

42 Larger producers can cover production expenses from available cash and withstand the wait for these credits to pay off in due course. Smaller producers with more immediate cash flow needs may obtain bank loans, secured against the tax credits (and with value carved out to cover the interest and fees on these loans), to monetize the credits immediately and apply the proceeds against the studio's cost of production in real time.

(traditional centers of entertainment production) in order to staunch the exodus of productions induced by the availability of favorable incentive programs elsewhere—are subject to annual caps that are insufficient to meet the total theoretical demand from producers, and are therefore allocated based on lotteries or other application processes used to distribute these scarce resources.

Successful tax incentive programs in states such as New Mexico, Georgia, Louisiana, Pennsylvania, and Virginia have had the effect of building up meaningful local production economies and resources in areas that were previously devoid of substantial production activity. In addition, significant government subsidies from countries such as Canada and France, in the form of both tax credits and direct government financing, have helped turn these countries into major centers of film and television production.

A key characteristic of these tax incentive programs, however, is their perishability. These programs are very much political questions. They usually come into existence with great fanfare, a substantial commitment of public funds, and promises of major economic stimulus. But the overall value of these programs to the sponsoring jurisdictions—weighing loss of tax revenues against the gains from local economic stimulus and job creation—is hotly debated. After a period of a few years, such programs often meet stiff political resistance from those opposed to "paying Hollywood millionaires with hard earned tax payers' dollars." When this occurs, governments may rescind existing incentive programs with little or no notice, and with few protections for studios that depended on those programs in deciding where to produce a series. (By this time, some other jurisdiction will have likely decided to jump into the game with a new incentive program of its own.) As a result, studios often skeptically consider the long-term stability of tax incentive programs in deciding where to produce their series.

In determining the economic risk and profit potential of a television production, major studios pay close attention to the availability, security, and value of tax credits and other incentive programs. Budgets are typically generated to reflect both "gross" and "net" spends, and these "net budgets" are often the basis of calculating license fees and modeling a series's economic prospects.[43] Based on its business projections, a studio may determine a maximum "net" spend it is willing to commit to a production, and the overall gross cost (and, accordingly, production value) of the series may therefore vary substantially depending on whether or not the studio can obtain a tax credit to offset its production costs. These calculations can prove determinative of not only where a series is physically produced, but also of the creative content of a series, as well as the threshold decision of whether it is produced at all.[44]

43 See Chapter 9.
44 For instance, AMC's *Breaking Bad* was, in its early development, set in California's Inland Empire, east of Los Angeles. When attractive tax incentives lured the production to New Mexico, the show was creatively reset in Albuquerque in order to preserve the verisimilitude of the setting.

2

THE LIFE CYCLE
OF A TELEVISION SERIES

A. From Idea to Production

The process of getting a television series from an idea (which may not even be committed to paper yet) to series production can be essentially divided into six stages. In the area of broadcast network television, which is organized around a principal "broadcast season" that runs from September of each year to June of the following year, the development process is so well established (and has remained so consistent over the decades) that it can be reliably mapped to the calendar. On other platforms (such as cable, premium cable, and digital platforms), the process is largely the same, but can start or end at any time of year due to such platforms' tendency to debut new programming year round, without reliance on the traditional broadcast calendar. These six stages are as follows:

i. Packaging and Studio Rights Acquisition

Every television series starts with an idea. This idea may be "original," i.e., a fresh invention from someone (usually a writer)'s mind, or based on some underlying piece of intellectual property (such as a book, article, film, foreign television format, or true-life story). The process begins as that idea is expanded and surrounded with additional key elements.[1]

The earliest stages of this process may take place solely among the development-stage "service providers" and their agencies. Independent writers, producers, and/or rightsholders may find one another, either directly or through their

1 This process goes on year round, but for broadcast network television projects, the studio dealmaking process is typically at its peak in late summer through early autumn.

agencies (which often represent multiple parties in a single creative "package"), and agree to jointly "pitch" (i.e., try to sell to) studios with a project. Parties may informally agree to work with each other without entering into an explicit agreement or may enter into a more formal "shopping agreement." In a shopping agreement, the parties agree to jointly develop and market a project and agree that neither party will enter into a further agreement with a studio in connection with the project unless the other party also successfully negotiates a deal. In such a case, in order to proceed with the project, the studio acquiring rights will usually have to enter into agreements with all of the principals who have come together during this pre-packaging process.[2]

The formal dealmaking process generally begins as a studio acquires rights to the idea, script, underlying property, or combination of these elements that will someday become a TV show. If the idea is original, the studio will enter into an agreement with the writer. If the writer is sufficiently senior and experienced, then the writer will usually sell a verbal pitch of his or her idea, without having committed it to paper. In addition, the presumption is typically that a senior, experienced writer will go on to "showrun" the eventual series, if it is produced. If the writer is more junior, he or she may have to write out a draft of their idea "on spec" (i.e., independently and without compensation) in order to convince a studio to develop the project. The junior writer/creator should also expect that, at some point, he or she will be paired with a more experienced writer who will serve in the showrunner role. If the project is also based on an underlying piece of intellectual property (e.g., book, life story, etc.), the studio will concurrently enter into an option-purchase agreement with the owner of this intellectual property.

The studio may, at this time, also make deals with multiple elements that have been pre-packaged (as described above) as a threshold to developing the project at all. Alternatively, the studio may make deals solely with a key writer or rights-holder, with the intention of independently choosing and hiring further elements down the line. Often, the studio will seek to incorporate a writer and/or producer with whom it has entered into an exclusive "overall deal" (which provides for that individual to render services exclusively for a single studio for a given period of time, in exchange for a significant guaranteed annual compensation that is recouped against fees as earned).[3]

Over the course of this process, the studio will work with the individuals involved to craft and improve the idea, and make strategic decisions about what key elements—underlying rights (essential, if applicable), writer/creator/producer (essential), showrunner (common but non-essential, if not the writer/creator), non-writing producer(s) (usually at least one, sometimes more), and perhaps pilot director (rarer) and/or one or at most two actor(s) (rarer still, but

2 Deals made at this stage of the process are described in further detail in Chapters 4 and 5.
3 See Chapter 7.

increasingly common)—it wants to attach to the project prior to the next phase: the network pitch.[4]

ii. Pitching and Set-Up

Once the pitch is ready and the studio has reached agreement on key terms with all of the necessary elements, the producers and studio executives collectively pitch one or more networks, seeking to "sell" the project to a network.[5] The studio, having already made deals with all of the elements and obtained control of the necessary rights, makes a deal with an interested network to continue the development and/or production of the project. Although the term "sale" refers to successfully making any deal with a network by which the development of the project is continued, the type of commitment actually obtained may vary widely, depending on the strength of the package and pitch, the interest level of the network, and the competitiveness of the bidding among multiple interested networks.

Most initial network deals are for development only, with the network agreeing to bear a portion of writing and other development expenses, in exchange for the studio granting the network the exclusive right, for some specified period of time, to order the production of a pilot and/or series. Some networks agree only to pay a portion of script writing fees, while others will consider paying or reimbursing a portion of other development expenses, such as option fees for underlying rights, or development or supervision fees paid to producers other than the principal writer. In determining the amount of cost coverage they will offer, networks consider the competitiveness of the situation, the amount of the script fee committed by the studio, and more broadly, the stature and development history of the writer. Some networks negotiate script coverage as a percentage of script fee—in such cases, 50% is a common benchmark, though coverage may be as high as 100% in a highly competitive situation involving a high stature writer. Other networks—particularly the broadcast networks—prefer to negotiate script coverage as pure dollar amounts, and many networks (broadcast and cable) strictly cap their script coverage (often at $75,000 per project) as a matter of rigidly enforced policy, allowing such networks to systematically limit their annual development expenses.

In addition to expense coverage, the studio and network may negotiate over, among other issues:

- The amount of expense covered by the network (typically in connection with the pilot script fee, but potentially covering option fees, supervision fees, or other development expenses);

4 In some cases, the service providers who initiate a project may elect to directly pitch one or more networks, without first approaching a studio. Where a network is pitched directly and is interested in proceeding, it typically refers the project and its elements to a studio of the network's choosing—usually a studio with which the network is affiliated—which will proceed with development of the project pursuant to a development agreement between the network and studio.
5 For broadcast network television projects, this typically takes place throughout autumn.

- The number of development steps committed to, or available at the option of, the network (e.g., "backup scripts" for further episodes after the pilot; series "bibles" or "formats" to summarize proposed long-term story or character arcs; etc.);
- The amount of time the network has to commit to production of a pilot or series; and
- Whether the network has the right to order production of a pilot, versus being forced to choose to produce a series or nothing at all.

The parties may also negotiate regarding what rights, economic or otherwise, the network retains with respect to the material in the event that it declines to order a pilot or series. Typically, rights revert to the studio, subject to a lien in favor of the network for its share of development expenses (potentially with interest) and possibly a modest passive participation (with both fixed and contingent compensation) payable to the network if the series is ultimately produced elsewhere.

At higher levels, particularly in competitive situations involving broadcast networks, the network may commit to pay a specified penalty to the studio—which may range in value from five figures to seven figures—in the event that the network elects not to proceed to production of a pilot and/or a further penalty if a pilot is produced but the network does not proceed to production of a series.[6] Networks may also rely on such penalties to nominally adhere to their own policies regarding script coverage (which, again, is often capped at $75,000 per project), while nevertheless making a more substantial development commitment.

Some networks require that, in order to proceed with development of a project, a license agreement be negotiated in full at this time, at least as to substantive principal terms.[7] Other networks will proceed with development on the basis of a mutual obligation to negotiate a license agreement in good faith at the time the network wishes to order production of a pilot and/or series, with a specified mechanism for what happens if the parties are unable to reach an agreement at that time—typically, a reversion to the studio, finite holdback against exploitation elsewhere, and lien for the network's costs if the project is produced elsewhere. In addition, a network with an affiliated studio may negotiate, at this time, for its sister studio to be granted a co-production position in the project.[8]

6 Curiously, the terminology of "penalties" is dominant, even in negotiation among experienced legal professionals in the television industry, despite the blackletter rule from contract law that contractual "penalties" are unenforceable. Presumably, the tight-knit, repeat-business nature of the entertainment industry is responsible for the fact that no network has ever mounted a full legal challenge to its obligation to pay such a penalty (and that no studio has ever mounted a full legal challenge against a network that quietly refused to pay a negotiated penalty).

7 Such license agreements are described in further detail in Section A of Chapter 8.

8 See Section B of Chapter 8.

For very strong packages, and/or in highly competitive situations, the studio may obtain a "pilot commitment" from the network, meaning a commitment by the network to order (and pay its applicable license fee/cost share for) the production of a pilot. This is also sometimes called a "put pilot," although that phrase may also refer more narrowly to a pilot commitment with a further penalty owed if the network declines to order a series. As a technical matter, the network is never actually committed to *do* anything, and can scrap production of the pilot at any time, or never proceed to production at all. However, this pilot commitment is typically expressed as a press release announcing the pilot order (which publicly commits the network to the project) and a pilot penalty equal to most or all of the full license fee that the network would have paid for a pilot (payable whether or not the pilot is actually produced).

Finally, at the highest, most competitive levels, the network may make a "straight-to-series" order—or even, in the rarest cases, a multiple-season order from inception.[9] While still very much the exception and not the rule, these straight-to-series orders are becoming increasingly common, for at least three reasons. First, speed to market: for companies looking to fill slates quickly (and sometimes take advantage of scheduling availabilities for big-name stars), the straight-to-series option allows for fast and opportunistic action. Second, actor demands: as studios and networks seek to lure ever bigger stars to television, they are finding that a certain level of star simply will not agree to participate in the pilot process but is willing to sign on to a show with a series commitment. Third, cost amortization: as television series have trended toward larger-scale "world-building" enterprises, costly and speculative pilots just seem like bad business, and it makes financial sense to amortize major set construction, production design, and visual effects costs over a full season order.[10]

Again, because a network is never actually contractually committed to *do* anything—only to pay as if it did—as a technical matter, this "series commitment" is expressed as a press release and a commitment to pay the minimum number of episodic license fees, based on the minimum episodic order negotiated as part of the applicable license agreement. However, in practice, it is

9 For instance, Netflix made headlines by initially ordering two thirteen-episode seasons of *House of Cards*, a major commitment that helped win the then-upstart service the series over interest from more traditional platforms that were unwilling to commit to more than a pilot. Such major up-front commitments, however, do not always result in great success. For instance, in 2015, Starz won a bidding war for Media Rights Capital's next major television series, *Blunt Talk* (starring Patrick Stewart, created by *Bored to Death*'s Jonathan Ames, and executive produced by *Family Guy*'s Seth MacFarlane), by committing up front to two ten-episode seasons. In December 2016, less than two weeks after the initial broadcast of the last of those twenty episodes, Starz announced the show's cancellation.

10 Where these factors are in play, but a network is not prepared to financially commit to a whole series based solely on the materials in existence at the time of set-up, it may agree to a "script-contingent" series order, i.e., a full series commitment (with no pilot step) that remains subject to the network's satisfaction with and approval of a pilot script and/or other development materials. This may also be referred to as a "script-to-series" deal (i.e., emphasizing the absence of a pilot step).

exceptionally unusual, and very costly, for a network to back away from a series commitment.

In recent years, the number of projects put into development by the major broadcast networks on an annual basis has declined substantially, from around seventy-five projects per network per year, to around forty to fifty projects per network per year. This decline is a result of several overlapping factors, including increased competition for projects from upstart cable networks and digital platforms, increased focus on producing (and extending the lives of) projects from affiliated studio partners, and a growing allocation of resources toward high-priced pilot and series commitments necessary to win competitive, in-demand projects from high-value creators.

iii. Script Development

During the script development stage, the studio, network, writer, and producers work together to further develop a project.[11] If the project was sold on the basis of a pitch alone, the writer prepares a complete draft of a pilot script and then writes subsequent drafts taking into account the notes of network and studio executives. If the project was based on a "spec script" already written by the writer, the writer goes straight to working on rewrites, again based on the notes of network and studio executives. Typically, these drafts are reviewed and commented on by other producers prior to formal submission to the studio and/or network.

For the most part, there is little dealmaking activity during this period. It is possible that the studio and network may jointly elect to attach further elements to the project at this stage or to engage a subsequent, independent writer or writing team to further revise the pilot script (although this would be somewhat unusual in television development). In addition, if necessary, the studio may negotiate for and commission additional writing steps from the writer, to the extent required by the network but not otherwise provided for in the writer's existing deal. For the most part, however, this period is dominated by creative development activity, which will determine which projects reach the next stage of the process—the pilot.

iv. Pilot

A television pilot is assembled over a period of intense creative, production, and dealmaking activity, during which the key team behind a project is solidified, and the words on a page are translated into a full audiovisual product. Networks typically order pilots in batches, so that they can choose among a group of pilots,

11 For broadcast network television projects, this phase generally takes place from mid-autumn through January of the following year.

side-by-side, in determining which projects will make it to series production.[12] Although it is difficult to make precise estimates, and figures will vary depending on the year, the network/platform, and the overall health of the marketplace, approximately 10% to 20% of developed projects may expect to earn a pilot order (although the percentage of scripts ordered to pilot has increased somewhat over time due to the declining volume of development projects per network, and the increasing volume of pilot commitments). Of these produced pilots, approximately 20% to 40% may expect to earn series orders.

For those projects that are not ordered to pilot production, the process may be dead, or it may reset to an earlier stage. In most cases, networks have "two bites" to order production of a pilot based on a developed script; meaning that if a network initially declines to order a pilot, it may continue to develop the project and reevaluate that decision during its next window for pilot orders. (In cable, where the development and production calendar is less consistent, the network's option window is typically defined in months rather than "bites.") During this development period, the network may commission further revisions of the pilot script or additional written materials (such as proposed scripts for episodes after the pilot, or a series format or bible that describes the proposed series) to assist the network in further evaluating the project. If the network's option has expired, or if it agrees to waive its rights and terminate its option early, the studio may seek a new network to take over development of the project, or perhaps proceed immediately to pilot production. For instance, AMC's *Breaking Bad* was originally developed for FX network; when FX declined to order a pilot, studio Sony Pictures Television made a new deal with AMC to keep the project alive, and the rest is history.

For those projects that are ordered to pilot production, the sprint is on. The first steps are typically to engage casting directors (who will assist in identifying and casting actors), line producers (who will assist in recruiting and engaging a production crew, and creating and managing a production budget), and a pilot director (who will help set the stylistic template of the proposed series, in the form of the pilot, and work with the producers to identify and hire key members of the cast and crew).[13] In addition, the studio and network will reengage in negotiating any major elements of the studio-network license agreement that had been left to future good faith negotiation (although even at this stage, they may elect to reserve finalization of the thorniest issues until after the pilot has been produced). Production executives and producers will work furiously to generate and refine a production budget, while the pilot script is continuously tweaked to respond to the demands of the budget (and vice versa).

The casting process for "series regular" actors (a classification explained in greater detail in Section E of Chapter 5, but which generally identifies the most

12 For broadcast network television projects, pilots are typically ordered in January and February, and produced between February and May.

13 Again, the key deals are described in further detail in Chapter 5.

significant principal actors in a series) involves a mix of so-called "straight offers" and "test options." "Straight offers" are firm offers to actors to be engaged on the pilot (with options to be hired for a series, if ordered) and are generally reserved for highly experienced actors with significant stature and/or name recognition, usually in lead roles. Such offers may be conditioned on a meeting with producers and/or a "reading" by the actor of lines from the pilot script (for further evaluation by producers and executives), though many high-level actors refuse to audition for parts in any way and will only consider and negotiate an offer with no creative contingencies attached.[14] Customarily, only one straight offer, to one desired actor, can be outstanding for a role at any given time.

Most major roles, however, are cast via a series of test option deals, by which the studio simultaneously enters into agreements with multiple actors who are competing for a single part. The candidates have been vetted by casting directors and producers but are typically precluded from formally auditioning for studio or network executives (whether in person or via taped audition) until they have not only closed a substantive deal, but signed paperwork that gives the studio the option to engage them for the pilot upon pre-negotiated terms. Usually, two to four actors at a time may compete for a role, although often none of the candidates are selected and a new batch is identified for a subsequent test. Consequently, for a single tricky role, ten or more separate deals could be made and negotiated to signature—often in windows of only 24 hours or less. Because of the volume and time pressures of this process, the negotiation of both deal terms and paperwork (generally carried out by business affairs executives on the studio side, and agents and lawyers on the talent side) often relies extensively on non-negotiable terms and pre-negotiated cut-through paperwork forms.

Particularly during broadcast network pilot season, when literally dozens of pilots are in concurrent preproduction and production across the country, the competition for the best talent in every role is high, which further contributes to the need for the dealmaking process to proceed swiftly and decisively. For any given pilot, this process may continue at a frenzied pace until the very eve of commencement of photography (and, for lesser roles/elements that are not needed until later, into the period of pilot production). Eventually, however, a pilot is completed and delivered to the network, and the studio and talent wait to see if the network elects to order a series based on the pilot.

v. Upfronts

The term "upfront" refers to an event thrown by a television network, attended by talent, press, and major advertisers, during which the network announces

14 The offer may nevertheless be subject to specified business contingencies, such as the studio concluding its license agreement negotiations with the network, if still outstanding.

its newest series for the upcoming season.[15] In some cases, the network has already committed to production of a series, and the upfront is merely the public announcement and celebration of that decision.

In other cases, however, a network may be on the fence about ordering (or "picking up") a series or may be deciding among various competing prospective series, and will use the upfront period to gauge advertiser interest before making a final decision. In this climate of uncertainty, with much at stake in the form of a series order, the upfront period may include a frenzy of eleventh-hour deal-making and renegotiation, during which networks and studios may revisit key terms of their agreements (or finally conclude negotiation on any issues that had been left unresolved up to that point) as they hash out at last which shows will make it to series production.

As at the pilot stage, a project that is not immediately ordered to series production may be dead, or it may be on hold or sent back a step. As with the pilot order, networks typically have "two bites" (or a negotiated period of months following delivery of the pilot) to order production of a series based on a pilot. An unsuccessful pilot may be subject to further development with the original commissioning network, which may include rewrites of the pilot script, recasting of the actors, and/or engagement of additional or replacement writers, producers, or pilot directors. In addition, if a network decisively passes on an unsuccessful pilot (sometimes referred to as a "broken pilot"), the studio—often in a race against the clock of expiring actor option dates—may look to entice a different network to take over the project. For instance, Amazon's *Sneaky Pete* was initially developed and produced as a pilot for CBS, before CBS passed on the project and Amazon elected to commission reshoots of the originally produced pilot, eventually committing to production of a series based on that revised pilot.

For those shows that are ordered to production, the process swiftly (and sometimes even semi-concurrently) moves into the final pre-production stage: staffing and writing.

vi. Staffing and Writing

Although a television pilot is almost always the product of the mind of a single writer (or writing team), a television series is inevitably a collaboration among a team of writers. The next stage of the process is to engage a "writer's room"[16]—a group of writers and writer/producers who, together, will not only determine the story and write the scripts for the coming season, but serve as key lieutenants to the showrunner and help creatively lead the production of the newborn

15 Broadcast television networks generally hold their annual upfronts in New York City in late May, in rapid succession to one another.

16 For broadcast network television projects, the staffing process typically begins in May or June, with writing commencing immediately in anticipation of series production beginning in late summer.

television series.[17] As with network pilot season, immediately during and after broadcast network upfronts, there are a significant number of new series launching at the same time, which creates significant competition for desirable talent in these roles and drives a hot pace of dealmaking.

In addition to writer/producers, studios may look to engage producer/directors (who will be expected to direct multiple episodes of the series and to work with other episodic directors to maintain a consistent look and feel for the series). At this time, the studio will also hire replacements for any key elements engaged for the pilot (e.g., actors, line producers, casting directors) who, for whatever reason (perhaps because they had been engaged for the pilot only or because the studio and/or network elected to replace them), are not returning for the production of the series.

Over this period, the principal creative and production team will be locked in. Meanwhile, the "writer's room" will come together to "break the season" (i.e., to determine the overarching narrative and character arcs for the season), before the individual writers and writing teams are assigned specific episodes to write. As the show takes creative shape, the line producer and his or her team will determine a series production plan that takes into account a studio-determined budget as well as the creative content of the scripts being generated by the writers. The episodic writing of a series will usually still be in progress (hopefully with a significant head start) when, at last, the show moves into its mature creative phase—series production.

B. Production

Television series production involves a coordinated effort to generate a significant amount of content within a relatively short period of time. A full season of a broadcast network television series is at least thirteen, usually twenty-two, and potentially up to twenty-six episodes. In cable (including premium digital services, such as Netflix, Hulu, and Amazon), a full season order is usually thirteen episodes, although some platforms tend toward shorter orders of ten or even eight episodes, while others (often in the final season of a successful series) may order a "super-sized" season of sixteen to twenty episodes.

In order to meet the exhibition calendars of traditional broadcast and cable television networks (particularly broadcast networks), series typically enter into production after only the first few episodes have been written. Writing of later episodes occurs concurrently with production of earlier episodes, and earlier episodes begin airing on television while later episodes are still in production. For premium digital providers, which have largely adopted a "binge viewing" release strategy (i.e., all episodes of a series are made available concurrently),

17 The relevant deals are described in further detail in Section B of Chapter 5.

production still typically begins while writing is ongoing, but exhibition must be delayed until all episodes have been fully produced and delivered.

The series production process generally relies on a rolling production schedule, with overlapping episodic production periods. For instance, episode #2 of a season enters pre-production as episode #1 is filming. When episode #1 completes filming, it immediately goes into post-production, while episode #2 begins filming. But at the same time, while episode #2 begins filming, episode #3 enters pre-production. In other words, at any given moment during the middle of a production season, three episodes are likely in some phase of production at the same time—one in pre-production, one in production, and one in post-production. (Meanwhile, at the same time, a fourth, later episode may be in the process of being written, and a fifth, earlier episode may be airing on television that week!)

This intense, overlapping production calendar involves very short production periods, particularly relative to theatrical feature film production, which typically takes at least several weeks, and often several months or even years for complex, effects-driven films, to yield a two-hour product. Multi-camera half-hour comedies typically involve two days of pre-production and five days of production (of which two days are dedicated to filming, and three days to rehearsal, blocking, and other preparatory work). Single-camera half-hour comedies also usually require two days of pre-production and five days of production, all of which are dedicated to filming.[18] One-hour dramas have traditionally allowed seven days of pre-production and eight days of photography. However, for premium digital platforms, which often feature longer episodic running times (due to lack of commercials) and binge viewing releases, the production calendar may be extended to nine or ten days of photography per episode, or even longer for the most complex shows. Because of the tight, overlapping production and exhibition calendars, going overschedule is seldom an acceptable option. The critical necessity of on-time, on-budget delivery drives the television industry's particularly strong preference for proven, experienced writers and producers leading every production.

The principal cast and crew of a television series are engaged at the outset of production for the season, and, for the most part, stay with the show through the

18 Multi-camera comedies (a category that includes classic series like *The Mary Tyler Moore Show* or *Friends*) are the traditional form of television comedy, have a more "old school" or "classic" feel to audiences than single-camera comedies, and are generally less expensive to produce. These shows are often filmed before a live studio audience (with multiple cameras simultaneously filming each take of each scene) and are recognizable by their use of a small number of stage-built sets and frequent reliance on laugh tracks. Single-camera comedies (such as *The Office* and *Modern Family*), however, are often perceived as more "premium" and have generally been more prominent and fashionable in recent years, particularly outside of the four major broadcast networks. These shows often involve more location (rather than stage) filming and eschew live audiences and laugh tracks. In more recent years, some producers have developed "hybrid" comedy series (like *How I Met Your Mother*) which combine and balance the creative elements and production methods of both multi-camera and single-camera comedies.

completion of production of that season. Shows often also attempt to maintain crew continuity from season to season, although only the highest-level "above the line" personnel (actors, writers, producers) are actually subject to contractual studio options for their services in subsequent seasons. While there may be further high-level dealmaking activity over the course of production of a season, most deals at this stage are negotiated by the high-level series staff who have already been hired by the studio, in accordance with the studio-approved budget. For instance, line producers negotiate most deals for crew department heads, who in turn negotiate deals for the members of their teams; production managers and coordinators engaged by the senior producers negotiate location and lease agreements; casting directors negotiate deals for guest and recurring actors; etc. Studio business affairs executives may be called upon throughout this process to assist the production team, coordinate necessary approvals from co-production partners and/or network licensees, and obtain additional financial contributions from network licensees to offset unusual major expenses designed to enhance the show (such as large acting fees for major guest performers, or additional production costs for large-scale, major event episodes).

High-level dealmaking activity may ramp up between seasons, as major new elements in various capacities are added (such as new actors), replaced (such as mid-level writer/producers or producers/directors), or have their contracts renewed prior to or upon expiration (particularly showrunners, whose initial agreements usually expire after two seasons have been produced). In addition, when a series is especially successful, studios will often entertain renegotiation of terms with actors who are still under contract, by which the actors may increase their episodic fees or acquire (or expand) a share of profits from the series—even if the actors are still technically under contract for years to come. For instance, in 2012, the adult cast of ABC's *Modern Family* famously banded together to renegotiate their agreements prior to production of the series's fourth season (a typical window for such renegotiations), going so far as to jointly sue studio 20th Century Fox Television to void their contracts when negotiations stalemated. (The parties settled, and the actors returned to the show with substantial raises.)[19] Backend participants may also seek to receive advances against their contingent compensation (also referred to more casually as "profit participation") if the show has proven successful enough that it seems certain to show profits under the defined formula. Key actors who did not originally participate in backend may seek to do so on a going-forward basis (and the studio may look to existing participants

19 To be clear, the *Modern Family* example notwithstanding, these renegotiations are not driven by the threat of actors voiding or opting out of their contracts. Instead, they are primarily a matter of industry custom and practice, and are justified by the need to "reward partners in success" and/or to "keep the talent happy," even where a multi-year contract remains firmly in place. Some studios rely on such early renegotiations to obtain long-term security, tying these early raises to extensions of the talent's deals beyond where those agreements are currently set to expire.

to reduce their allocated backends into order to "make room" for the new participants). In short, when a television series succeeds, the principal contributors to that success will seek to be rewarded for that success as the series matures, and the studio must balance the growing cost pressure created by those rewards.

C. Distribution

It is often said that a copyright is a "bundle of rights," whose divisibility is limited only by the availability of markets and the creativity of lawyers. This divisibility provides the foundation of the distribution and profit-making strategy of the television studio. For each project, the studio owns a single key asset—a television series, whose property value is embodied in the copyright of that series and each episode thereof. The business of a television studio is to sell that same product over and over, enough times to enough buyers, to recoup its investment in the cost of production and finally make a profit. In other words, a television studio makes money by using the divisibility of its copyrights to maximize revenue across media, territory, and time.

i. Media

The network on which a television series first airs is the show's first exhibition medium, but in success, it is never the show's last. As technology and business models evolve, new opportunities emerge.

The classic secondary medium for a television show is simply elsewhere in television—exploitation that is generally referred to as "off-network" or "syndication." Syndication licenses for content that has already appeared on a network can involve a variety of buyers and a variety of modes of exhibition. A license may provide for once-a-week exhibition of episodes by the licensee, or multiple-times-a-week (or "strip") exhibition. The licensee may be a cable network, or one or more broadcast stations. Conventional wisdom holds that the syndication market is most robust for: (1) half-hour shows (which are easier to schedule than one-hour shows); (2) episodic, non-serialized comedies (which are easier to watch and enjoy on a one-off basis than serialized shows with continuing plotlines); (3) shows that originally aired on broadcast television (which are both more familiar to viewers and would be all-new to the cable market, compared to cable series); and (4) shows with at least 100 episodes (which can fill a five-times-a-week exhibition schedule without dipping into repeats for at least twenty weeks).[20] Classic syndication success stories include multi-camera comedies such as *Seinfeld*, *Friends*, and *The Big Bang Theory*. However, procedural dramas (such

20 The historical minimum "magic number" for series to access syndication was three seasons of twenty-two episodes each—i.e., a total of sixty-six episodes—which enables thirteen weeks of reruns at the rate of five exhibitions per week, before episodes are repeated.

as CBS's *CSI* and *NCIS* franchises and NBC's *Law and Order* franchise) have also enjoyed successful cable syndication runs, as have some more serialized comedies with more limited runs, such as HBO's *Entourage* and *Sex and the City*. Due to a combination of contractual holdbacks in the initial network license and the need to stockpile a sufficient quantity of episodes, exploitation of a series in syndication typically begins three years (i.e., sixty-six episodes) to four years (i.e., eighty-eight episodes) after the series's premiere on its original network.

Although its overall importance in the industry has diminished in recent years, home video remains a significant downstream market for television distribution. Physical home video distribution (these days, in the form of DVDs or Blu-ray discs) typically occurs on a season-by-season basis, following the end of the broadcast season during which the featured episodes were initially exhibited, with the precise timing of the release often coordinated to coincide with and support the launch of the following season. In more recent years, permanent digital downloads of television episodes (so-called electronic sell-through, or "EST"), through online retailers such as iTunes (which launched its video download services for television series in 2005), Google Play, and Amazon, has largely supplanted the traditional home video market. In fact, EST licenses are often handled by the same distribution executives who manage traditional home video and are accounted for as home video transactions. Although EST exploitation may also be held back until the end of a given season's run on its home network, individual episodes are often made available for paid download only hours after their network premieres.

The most important new market to emerge in the television industry in recent years is digital streaming, exemplified by so-called "over-the-top"[21] services such as Netflix, Amazon Prime Video, and Hulu. These services offer customers the ability to stream episodes of a variety of television series that were originally exhibited on traditional television networks.[22] Competition among the three major streaming providers has led to a sharp increase, in recent years, in streaming license fees, particularly for valuable exclusive licenses. More recently, however, these services' growing focus on their own original content offerings[23] has caused the market for second-run streaming licenses to cool somewhat. In addition, variation among streaming providers in their specific business models (e.g., subscription-based vs. ad-supported) has, at least in the past, allowed licensors to narrowly define the scope of streaming licenses in hopes of facilitating multiple streaming sales. This,

21 The term "over-the-top" refers to these services' technological capacity to reach users through their general-purpose Internet subscriptions, without relying on a separate, service-specific technological system (such as the coaxial cables that underlie cable television or fiber-optic cables used by telecommunications-based television providers).

22 They have also all made significant pushes into commissioning their own original, exclusive first-run content. Issues related to such series are discussed in greater detail in Sections C.ii of Chapter 1, and Section A of Chapter 8.

23 See Section C.ii of Chapter 1.

too, has become less common in recent years, as the streaming companies have sought greater flexibility in their own business models, and as once purely ad-supported services have increasingly embraced subscription-based offerings.

Conventional wisdom holds that the streaming market is most robust for serialized, one-hour dramas—programming that is prone to "binge viewing" sessions in which customers consume several episodes in a single sitting in order to keep up with an engrossing ongoing story. Although, in the early days of the streaming market, the applicable holdbacks against streaming exhibition often mirrored the holdbacks against "off-network" or syndicated television exhibition, the more common recent practice is for each season of a television series to become available on a streaming service shortly before the debut of the subsequent season, a strategy that has proven valuable in attracting new audiences for the show (and its original network).[24]

ii. Territory

Although local entertainment industries have emerged throughout the world, the United States remains the number one producer and exporter of entertainment content worldwide, and the U.S.'s entertainment exports are a cornerstone of the country's cultural and economic power across the globe. A successful American television series will be licensed for exhibition in dozens of territories, both English-speaking and non-English-speaking (where shows may be distributed with subtitles or dubbed into the local language). Most networks operate specifically in a single country, especially in North America and Western Europe (although there are a number of regional networks that serve multiple countries in Latin America, Africa, and Southeast Asia), and most content licenses define a limited exhibition territory. Consequently, a single television series can be sold dozens of times to buyers across the world, and the pattern of multiple sales across media and time can, in success, be replicated on a country-by-country basis. U.S. networks are typically guaranteed worldwide premiere rights with respect to each episode of a television series, but international exhibition may otherwise be nearly concurrent with American exhibition.

24 The classic second-window streaming success story is AMC's *Breaking Bad*. Although it is now one of the most successful and celebrated television series of all time, for its first three seasons, the show was a critical darling with a very limited audience. The show narrowly avoided cancellation after its third season, and shortly before the fourth season's premiere, the first three seasons were made available for streaming on Netflix, where it was soon discovered—and hungrily consumed en masse—by a new, younger audience. That audience eventually followed the show to its home network, where ratings for the fourth and fifth seasons soared on the strength of the viewers who had discovered the show on Netflix (where audiences were able to immerse themselves in three seasons of backstory in time for the network premiere of the show's fourth season). This complementary relationship between the show's exhibitions on AMC and Netflix helped redefine the industry's prevailing assumptions about the impact of streaming services on traditional television markets, and the ultimate success of *Breaking Bad* was vital in defining and enhancing AMC's brand as a new destination for premium original content.

Conventional wisdom holds that the international market is most robust for one-hour dramas, especially action-oriented and procedural dramas, which are most universally appreciated across cultural and linguistic lines.[25] A smaller number of broad broadcast network-style comedies, such as *The Big Bang Theory* and *Two and a Half Men*, have also found success abroad.[26] The value of international licenses can vary dramatically depending on the population sizes, economic capacities, and interest levels of various territories, but in general, the most valuable international markets for American television series are the United Kingdom and Germany. Canada, France, Spain, and Australia may also be economically significant, and China continues to emerge as an increasingly important market (despite high levels of intellectual property piracy there). The financial prospects of a series in international markets are heavily influenced by the identity of the commissioning American network, with shows that are exhibited on U.S. broadcast networks generally commanding the highest international license fees.[27]

iii. Time

With few exceptions, every license is finite, providing for the licensee to enjoy rights for a limited number of runs on a particular media platform or platforms, for a specified period of time. In every territory, in every media, a successful television series may be licensed again and again over time, with multiple successive licenses over a span of years in the various exhibition media. This long tail for revenue generation creates significant asset value in successful library television series and contributes to the industry's structural reliance on a small number of mega-hits that, over time, subsidize the development and production of a large volume of unsuccessful or only marginally successful series.

iv. Ancillary/Merchandising

As the owner of the copyright in a television series, the studio controls a variety of "allied and ancillary" rights, such as soundtrack and music publishing rights. Perhaps the most lucrative of these rights, however, is licensing and merchandising,

25 The viability of dramas in the international market, combined with their success in the streaming market and the ability to access these markets without necessarily needing to produce a high volume of episodes, has made the one-hour drama a favorite of smaller, independent (and often more risk-averse) television studios.

26 In addition, while situation comedies (or "sitcoms") often "translate" badly into foreign languages and cultures, television "formats" may successfully traverse international borders, becoming the basis for local adaptations (reflecting local sensibilities) of successful comedies from the United States (or for American adaptations of successful comedies from other countries). Such international format licenses can prove highly lucrative for the producers of the original series. See Section C of Chapter 4.

27 More recently, the flow of television series between the U.S. and the international marketplace has become a two-way street, with British series such as BBC's *Sherlock*, Channel 4's *Black Mirror*, and ITV's *Downton Abbey* finding audiences on U.S. public broadcasting stations and on streaming services like Netflix.

by which the studio licenses manufacturers to incorporate elements of the studio's series (such as its logo, key art, or character likenesses) into consumer products, which may include T-shirts, mugs, posters, toys, physical board games, video games across all technological platforms, companion comic books, collectible figurines, Halloween costumes, branded apparel, lottery games, slot machines, theme park attractions, and special-edition beers and alcoholic spirits. While relatively few series ultimately yield meaningful licensing and merchandising programs, those that do can generate literally millions of dollars in ancillary revenue.

In general, studios enter into licensing relationships with product manufacturers, by which they grant such manufacturers the right to incorporate the studio's intellectual property into specified categories of products. These arrangements are generally structured as copyright and trademark licenses, with defined scope (i.e., licensed product categories), exclusivity, territory, and term. Like any trademark licensor, the studios retain significant creative and quality controls over the licensed products. Because most studios outsource the production and distribution of their licensed products, they also outsource the risk associated with these programs. Manufacturers bear substantial production and distribution expenses in full and are fully responsible for seeking retail distribution for their products. The studios are compensated with royalties, calculated as a percentage of the licensee's wholesale revenues from the distribution of licensed products—typically between 5% and 15% of the licensee's revenues, depending on the product category and the desirability of the intellectual property. Manufacturers may pay significant up-front guarantees (against these royalties) in order to obtain licenses, particularly when multiple manufacturers are competing for a single license.

In order to grant and monetize such merchandising rights, the studio must take care to ensure that it controls all of the underlying rights it seeks to exploit. Where a series is based on an underlying piece of intellectual property, such as a book or short story, the studio must explicitly obtain merchandising rights in that underlying work (and may negotiate fine distinctions between so-called "classic merchandise" that is based solely on the underlying work, versus "series merchandise" that is based on the derivative series).[28] In addition, in order to incorporate an actor's likeness in licensed products, the studio must expressly obtain this right from the actor him or herself.[29]

v. Portfolio Management and Diversification

From the perspective of a large independent studio, in particular, managing a slate of shows across a variety of networks is a bit like managing an investment portfolio: the key to long-term success is diversification.

28 See Section A.vii of Chapter 4.
29 See Section E.ix of Chapter 5.

As explained in Section A of Chapter 8, shows produced for different types of platforms tend to have different risk profiles. At one extreme, broadcast series carry major risk (high deficits) and major upside (lots of retained rights; huge international and second window revenue potential). They are the stocks in a studio's portfolio. Well-managed, they can make you rich; recklessly managed, they can bankrupt you. At the other extreme, series produced for major international digital platforms are very low risk (upfront license fees exceed production costs) but relatively low yield (off-network revenue opportunities are severely diminished, and initial profit is not high enough to cover major losses from unsuccessful projects). These shows are the high-yield bonds in a studio's portfolio. You may never go broke investing in high-yield bonds, but you probably will not retire to a private island either. In between are cable series, which offer a middle ground of risk (relatively lower deficits) and reward (substantial, but less valuable, reserved rights), with the occasional chance for a runaway smash success. These are the mutual funds in a studio's portfolio.

Smaller independent studios with good expertise and relationships but limited access to at-risk capital currently tend to focus primarily or exclusively on producing for major streaming platforms. For a small studio, the deficit-free (and therefore relatively risk-free) nature of such productions is appealing, and the capped returns can still be substantial enough for the company to operate a healthy and profitable business, as long as it avoids big losses and maintains very low overhead.[30]

For larger, better-capitalized studios, however, diversification across networks allows the studio to manage its level of risk, balancing steady cash flow from reliably low-risk series with riskier investments that can yield moonshot returns. At the same time, cultivating relationships with as many networks as possible reduces a studio's dependence upon (and therefore loss of leverage to) a single network partner. This also puts the studio in a better position to weather the natural tendency for networks to shift over time from ordering series primarily from third-party studios to relying more heavily on their in-house or affiliated studio arms.[31]

30 Such smaller studios may also have limited capacity to distribute reserved rights in any event, and so there is less institutional pressure to hold onto these rights (and less perceived loss from granting extensive rights to a streaming platform). On the other hand, large studios with well-staffed distribution operations face more institutional pressure to preserve a supply of reserved rights for their distribution teams to work with.

31 See Sections B.iii and C.ii of Chapter 1.

3

THE INTELLECTUAL PROPERTY CONTEXT OF TELEVISION (OR, WHEN DO YOU NEED TO ACQUIRE UNDERLYING RIGHTS?)

With the basic structural landscape of the television industry established, we can begin to turn our attention to the key deals in the life cycle of television development, production, and exhibition. The first category of such agreements goes to underlying rights—the acquisition of preexisting intellectual property for adaptation into a television series. In an increasingly crowded television landscape, buyers look more and more to preexisting intellectual property for a long-term creative plan—and a built-in audience. Major hits such as HBO's *Game of Thrones* (adapted from an ongoing series of fantasy novels by George R.R. Martin) and AMC's *The Walking Dead* (adapted from an ongoing series of comic books by Robert Kirkman) speak to the power of underlying rights in the marketplace. Before we tackle the details of the deals by which studios acquire rights to such properties, however, it is useful to first understand the basic framework of intellectual property and privacy law doctrines that govern these issues, and the essential question: when do you need to acquire underlying rights at all?

A. Copyrights

A copyright is the core intellectual property asset of the television industry, and indeed, of all content industries. In the language of the U.S. Copyright Act, copyrights protect "original works of authorship fixed in any tangible medium of expression."[1] In plain English, copyrights protect creative works that are tangibly recorded.

The Copyright Act identifies eight categories of works that are subject to copyright protection: (1) literary works; (2) musical works, including any

1 See 17 U.S.C. § 102.

accompanying words; (3) dramatic works, including any accompanying music; (4) pantomimes and choreographic works; (5) pictorial, graphic, and sculptural works; (6) motion pictures and other audiovisual works;[2] (7) sound recordings;[3] and (8) architectural works.

Modern American copyright law has substantially eliminated formalities that creators historically needed to comply with in order to secure and continue copyright protection for their works. For copyrightable works created on or after January 1, 1978 (the date on which the current 1976 Copyright Act became effective), copyright protection applies instantaneously and automatically from the moment a work comes into existence.[4] No formal registration or notice is required, although these may be necessary down the line in order to pursue certain types of legal claims and damages under the Copyright Act.[5]

Copyrights have long, but finite, terms. Under the 1976 Copyright Act, the term of copyright is the life of the author plus seventy years for works created by a known individual;[6] or, for works-for-hire, ninety-five years from the year of the work's first publication or 120 years from the year of its creation, whichever expires first. A work whose copyright has expired (or perhaps terminated for technical reasons applicable to older works) is said to be "in the public domain" and may be used freely by any member of the public without permission from or compensation to the original copyright owner.

In order to qualify for copyright protection, a work must be "creative" (although only a small amount of creativity is required) and "original" (meaning independently created and not the product of "slavish copying"). In general,

2 This category includes television programs, and the studio's ownership of the copyright in its productions is the legal basis of the studio's exclusive right to control the distribution of its series. The focus of this chapter, however, is how copyright principles apply to other works that may be adapted as the basis for a television series (and therefore how they impact studio decisions about whether to acquire rights), not on how studios can use copyright law to defend against others' infringement of their rights in their television series.

3 Prior to 1978, when the currently governing 1976 Copyright Act went into effect, sound recordings did not enjoy any copyright protection independent of the underlying musical compositions.

4 More precisely, copyright protection arises at the moment that the work is "fixed in a tangible medium of expression," i.e., when the work is written down. (Being typed into a computer file suffices.) For example, a poet may engage in the "creation" of a poem in his or her mind, and may even complete, memorize, and recite the poem to audiences, but copyright protection does not attach until the poet puts the poem on paper or has one of the poet's performances captured on video. Or, to use a more television-specific example, a writer/producer may develop a detailed and elaborate pitch for six seasons (and a movie!) of a proposed television series, but that pitch is technically unprotected by copyright until it is typed out.

5 The rules are all considerably more complex for works created before 1978, which are governed by the 1909 Copyright Act. The 1909 Copyright Act had substantially more rigorous formality requirements, which also evolved over the nearly seventy years the Act was in effect. Ascertaining the current copyright status of pre-1978 works can be a complicated process, requiring time-consuming research and analysis by copyright law specialists.

6 Where the work was created jointly by two individual authors, the seventy years run from the death of the last-surviving author.

courts look to avoid judging whether something is "art" or "worthy" of copyright protection. As long as the basic requirements of creativity and originality are satisfied, courts do not require novelty, non-commerciality, artisticness, or an intent to be original. In addition, there is no formal minimum length requirement for copyright protection, but courts do look for some nebulous minimum to be satisfied. For example, a single line of dialogue or poetry by itself, no matter how beautifully rendered or creative, probably would not suffice to give rise to copyright protection. Similarly, the title of a work does not, by itself, qualify for copyright protection (although, as explained in Section B below, in some circumstances titles may be protected as trademarks).

The owner of a copyright exclusively enjoys four basic rights (which include the exclusive right to authorize others to exploit these rights): (1) to copy or reproduce the copyrighted work; (2) to prepare derivative works based upon the copyrighted work; (3) to distribute the copyrighted work;[7] and (4) to publicly perform or display the copyrighted work.[8] It is these first two rights, the right of reproduction and the derivative works right, that are implicated when one considers adapting or otherwise drawing material from an existing work as the basis for a new one (such as a television series).[9]

Although qualifying a work for copyright protection is relatively easy, not every individual element of a copyrighted work is protectable. This becomes critical when courts consider claims for alleged infringement due to unlawful copying. In such cases, plaintiffs typically assert that defendants' work is substantially similar to theirs because it unlawfully incorporates many elements that were taken from the plaintiff's work without permission. The courts must then parse out in detail which allegedly copied elements of a plaintiff's work are copyrightable (and can therefore support an infringement claim) and which are not.

7 Lawyers often refer to copyrights as "a bundle of rights," which can be infinitely divided and subdivided. This is certainly true of the basic categories of copyright rights—for example, a copyright owner may grant a third party a license to reproduce the owner's work, but not to modify it (to create a derivative work) in any way. Critically, this type of subdivision is equally prevalent and important within each of the core copyright rights. A party may get the right to create a television adaptation of a copyrighted work, but still be prohibited from creating a theatrical feature film adaptation; this is a viable (and relatively common) subdivision of the derivative works right. Similarly, grants of distribution and public performance/display rights are typically specifically limited in territory, media, and time. This subdivision, in turn, creates the basic economic model for the television industry. See Section C of Chapter 2.

8 See 17 U.S.C. § 106.

9 The Copyright Act defines a "derivative work" as follows: "[A] work based upon one or more preexisting works, such as a translation, musical arrangement, dramatization, fictionalization, motion picture version, sound recording, art reproduction, abridgment, condensation, or any other form in which a work may be recast, transformed, or adapted. A work consisting of editorial revisions, annotations, elaborations, or other modifications which, as a whole, represent an original work of authorship, is a 'derivative work'." See 17 U.S.C. § 101. In plain English, a new copyrightable work that recasts, transforms, or adapts an existing copyrighted work, or which otherwise substantially incorporates protectable elements of an existing work into a new copyrighted work, is a "derivative work."

The first essential distinction made in copyright law is between ideas and expression: ideas are not protected by copyright, but the expressions of those ideas are. Practically, this means that the extent of copyright protection is partially a function of detail and abstraction. The concept of "six friends living in New York, dealing with life, love, and careers" is too vague and too abstract of an idea to be protectable under copyright. But if you name those six friends Ross, Rachel, Chandler, Joey, Monica, and Phoebe, give them distinct personalities and backstories, and pair them off with each other in specific dramatic ways, you have a show called *Friends* that is undoubtedly protectable under copyright law. The range of potential detail in between represents a wide range of judgment calls about where exactly "ideas" end and "expression" begins. However, the entertainment industry is rife with examples of dueling pairs of conspicuously similar projects that no one regarded as examples of copyright infringement—for example, asteroid disaster film *Armageddon*'s nearly concurrent release with comet disaster film *Deep Impact* in 1998, or the consecutive releases of shopping mall security guard hero comedies *Paul Blart: Mall Cop* and *Observe and Report* in 2009.

An extension of the idea/expression distinction is the *scenes a faire* doctrine, which provides that "stock scenes," archetypal characters, and other elements that are expected for a particular genre are not protectable under copyright. Such elements are necessary and predictable, in that they grow organically out of activities or circumstances common to a genre, like cowboys, horses, and gun fights in a Western. This doctrine was used by the estate of Alex Haley, the author of *Roots*, to successfully defend a claim brought by an author who claimed that *Roots* infringed on his copyright in *Jubilee*, a novel that also tracked an African American family though generations.[10] In finding for Haley's estate, the court noted that general elements of black folk culture were in the public domain, and that common scenes between the works of attempted escapes pursued by baying dogs, sorrowful or happy slave singing, and the buying and selling of humans were unprotectable as *scenes a faire*, because they were so closely connected to the common genre of the works that they were necessary to make the stories recognizable to a reader.

Another vital exclusion is facts, which are not subject to copyright protection. This is true even if the research to uncover those facts was long and arduous, and even if the facts are being published for the very first time.[11] (Or, as some lawyers like to put it: "facts are free.")[12] To be clear, non-fiction literary works

10 See *Alexander v. Haley*, 460 F. Supp. 40 (S.D.N.Y. 1978).

11 American courts have repeatedly rejected the so-called "sweat of the brow" theory of copyright, which would extend copyright protection to works and their elements primarily or solely on the basis of the effort that went into creating them.

12 In the *Roots* case, in holding for Haley, the court also expressly declined to give weight to commonalities between *Roots* and the plaintiff's novel that were elements of historical or contemporary fact.

are still protected by copyright, which protects the author's choices of language, narration, and presentation.[13] But the copying or use of pure facts collected or unearthed by an author, devoid from context or expression of presentation, would not constitute copyright infringement. This may be true even where the defendant uses a particular theory or interpretation of historical facts. So, for instance, a historian who had developed a theory, based on his own exhaustive research, that the 1937 crash of the Hindenburg was a result of sabotage could not sustain a copyright infringement claim against the producers of a film that was centered around that theory of the historical event.[14] Similarly, a playwright who wrote a play framing the death of Pope John Paul I as a murder by powerful Vatican insiders was found not to have infringed the copyright in a non-fiction book that first researched, developed, and espoused the same theory.[15] Ultimately, as with the idea/expression distinction, the line between unprotectable fact and protectable expression of fact may be difficult to draw in any given situation.

On the other hand, certain vital creative elements of a work may qualify for copyright protection on their own, even outside the context of the aggregate work. Most significantly, distinctive characters can qualify for separate copyright protection. The classic test used by courts is whether the character amounts to the "story being told." Applying this test, courts have denied copyright protection to the literary character of detective Sam Spade[16] and granted it to the theatrical version of the character of super-spy James Bond.[17] In the Bond case, the court actually noted that the fact that "many actors can play Bond is a testament to the fact that Bond is a unique character whose specific qualities remain constant despite the change in actors." More recently, instead of asking whether the character is the "story being told," courts have usually applied a "distinctive delineation" test. In this analysis, courts deny protection to "vague or stock characters" but grant it to those that are "distinctive," "finely-etched," and "unusual" in visual style, persona, and otherwise.[18] Practically, this "distinctive delineation"

13 Even highly literal and factual materials like maps, phone books, and compilations, or even collections of individually uncopyrightable elements (like databases), can enjoy "thin" copyright protection as to discretionary original elements of selection, color, coordination, or arrangement. See *Feist Publications, Inc. v. Rural Telephone Service Co.*, 499 U.S. 340 (1991). But these elements must still satisfy the basic requirements of creativity and originality to be protected. Thus, extremely obvious or functional choices like pagination and alphabetization would not qualify for copyright protection.

14 See *A.A. Hoehling v. Universal City Studios, Inc.*, 618 F.2d 972 (2d Cir. 1980).

15 See *Crane v. Poetic Productions Ltd.*, 593 F.Supp.2d 585 (S.D.N.Y. 2009).

16 See *Warner Bros. Pictures v. Columbia Broadcasting System*, 216 F. 2d 945 (9th Cir. 1954).

17 See *Metro-Goldwyn Mayer, Inc. v. American Honda Motor Co.*, 900 F. Supp. 1287 (C.D. Cal. 1995).

18 See *Titan Sports, Inc. v. Turner Broadcasting Systems, Inc.*, 981 F. Supp. 65 (D. Conn. 1997) (holding that the professional wrestling character of Diesel, as portrayed by Kevin Nash, may qualify for copyright protection); *Pokemon Company International, Inc. v. Jones*, 2016 WL 1643989 (W.D. Wash 2016) (applying copyright protections for Pokémon characters); *DC Comics v. Towle*, 989 F.Supp.2d 948 (C.D.

test is formulated in a way that makes it easier to obtain copyright protection for graphical/visually depicted characters than for purely written ones (although there is nothing explicitly in the doctrine that says a text-based character cannot be sufficiently "distinctively delineated" to qualify).

As noted above, the alleged unauthorized adaptation of a copyrighted work primarily implicates two core rights under copyright, the right of reproduction and the derivative works right. There are generally two key issues in play in a claim for copyright infringement based on these rights: (1) copying and (2) improper appropriation.

The requirement of "copying" means that, in order to be liable for copyright infringement, an alleged infringer must have actually seen and drawn upon the plaintiff's work. If a defendant can show that he or she created his or her work totally independently, and that the similarities between the defendant's and plaintiff's works are therefore purely coincidental, then there is no liability for copyright infringement, no matter how similar the works may be.[19] On the other hand, in litigation, the burden is on the plaintiff to prove copying, which the defendant can do in four basic ways:

- Direct evidence of copying, i.e., an admission by the defendant, or testimony by witnesses, of actual copying;
- Common errors, e.g., by showing that factual, grammatical, or typographical errors from a source work (which may have been placed there inadvertently, or intentionally as a trap for copiers) also appear in an allegedly copied work;
- Access and substantial similarity, i.e., a mixture of evidence that the defendant had access to the plaintiff's work, and that the works are similar enough to each other, that one can infer that the defendant copied the plaintiff's work; or
- "Striking similarity," i.e., the concept that, even in the complete absence of evidence that a defendant had access to the plaintiff's work, the disputed work is *so* similar to the plaintiff's work, and so unlike anything in the public domain, that the only reasonable conclusion is that copying occurred.[20]

Cal. 2013) (extending copyright protection to the Batmobile as a character); *Toho Co., Ltd. v. William Morrow and Co., Inc.*, 33 F. Supp. 2d 1206 (C.D. Cal. 1998) (extending copyright protection to the character of Godzilla).

19 This distinguishes copyright law from, for example, patent law, where "independent creation" (as this concept is usually called) is not a valid defense to a claim of infringement.

20 See *Ty, Inc. v. GMA Accessories, Inc.*, 132 F.3d 1167 (7th Cir. 1997) (affirming a finding of copyright infringement by a manufacturer that allegedly copied the design for Ty's highly distinctive "Squealer" stuffed pig Beanie Baby, even absent evidence of access; the court emphasized that the stuffed pig designs were unlike anything in the public domain, contrasting the situation against a hypothetical dispute over two nearly identical photos of Niagara Falls taken from the same place at the same time of the day and year and in identical weather, where the shared subject matter of the photos is simply the real-life, public-domain setting and vantage point).

Defendants typically deny any act of copying, and in a majority of cases, the dispute ends up focused on the third of these means of proving copying: access and similarity. Courts may infer a defendant's access to a plaintiff's work from the widespread dissemination of that work,[21] and even subconscious copying is actionable.[22] Access and similarity are on a sliding scale, relative to one another, in an analysis of copying; the more similarity between two works, the less compelling evidence need be presented of access, and vice versa. This is sometimes referred to as the "inverse ratio rule," and the "striking similarity" concept is its extreme manifestation.

Proof of copying alone, however, is not enough to establish copyright infringement. Rather, the *amount* and *nature* of what was copied, and how it was copied, must be great enough to amount to an improper appropriation of the plaintiff's work. The key question here is whether the defendant's work is "substantially similar" enough to the plaintiff's to amount to an act of infringement. In practice, courts take a variety of approaches to measuring substantial similarity, with the specific choice being influenced by the precedents of the courts in each jurisdiction and the particular nature of the works being analyzed.

While some courts consider and compare the totality of the disputed works in an infringement case, many courts first apply a "filtration" analysis, identifying and discarding from their consideration of each work all unprotectable elements (facts, ideas, *scenes a faire*, etc.), and then comparing only the "protectable expression" that remains in each work. The landmark case on filtration dates back to 1930, when a court determined that Universal Pictures' *The Cohens and the Kellys* did not infringe the copyright in playwright Anne Nichols's *Abie's Irish Rose*, a similar story about forbidden romance between the children of Jewish and Irish families in New York City.[23] In reaching this conclusion, the court found that all of the shared elements of the stories were non-protectable public domain concepts and that the remaining protectable elements of the stories were not substantially similar.

Beyond the filtration process, courts apply a variety of definitions and tests for "substantial similarity." New York courts primarily consider "whether an ordinary observer, unless he set out to detect the disparities, would be disposed

21 See *Three Boys Music Corp. v. Bolton*, 212 F.3d 477 (9th Cir. 2000) (upholding a jury's determination that Michael Bolton's "Love Is a Beautiful Thing" infringed the copyright in an Isley Brothers song by the same name, without any direct evidence of access, but based on evidence that the song was popular on radio when Bolton was growing up, and that he may have subconsciously copied the music, which was of a genre that he liked).

22 See *ABKCO Music, Inc. v. Harrisongs Music, Ltd.*, 722 F. 2d 988 (2d Cir. 1983) (upholding a copyright infringement verdict against George Harrison for his "subconscious copying" of the Chiffons' "He's So Fine" in Harrison's composition of "My Sweet Lord").

23 See *Nichols v. Universal Pictures Corp.*, 45 F.2d 119 (2d Cir. 1930). Technically, the word "filtration" does not appear in the case and was coined by later legal scholars to describe the court's "abstraction-filtration-comparison" method.

to overlook them, and regard [the] aesthetic appeal as the same." A New York court, applying this "ordinary observer" or "aesthetic appeal" test, held in 2011 that ABC's *Modern Family* did not infringe the copyright in an aspiring television writer's treatment and pilot script for a proposed project called *Loony Ben*.[24] When the analysis requires parsing out protectable elements from non-protectable public domain ones, these courts may also consider whether a "more discerning observer" would find "total concept and feel" of the contested works to be the same.[25]

In California, courts apply a two-part "extrinsic/intrinsic analysis" for determining substantial similarity. The "extrinsic text" examines objective articulable similarities between two competing works, including elements such as plot, themes, dialogue, mood, setting, pace, characters, and sequence of events, excluding non-copyrightable elements like facts, mere ideas (short of "expression"), and *scenes a faire*. Courts applying the extrinsic test may consider expert evidence about the alleged similarities, and judges can dispose of infringement claims without submitting them to a jury if they determine that the plaintiff's case fails the extrinsic test. The second step, the "intrinsic test," is a subjective consideration of whether an "ordinary reasonable person" would feel that the two works share a "total concept and feel." If a plaintiff can clear the "extrinsic test" with the judge, the "intrinsic test" question typically goes to the jury.

The federal courts in California first developed and applied the extrinsic/intrinsic test in 1977, holding that that McDonald's series of McDonaldland commercials infringed the copyright in the now iconic (and arguably psychedelic) 1969 *H.R. Pufnstuf* children's television series.[26] More recently, a California court applying the extrinsic/intrinsic test held that NBC's *My Name Is Earl* (a comedy about a thief and slacker who decides to become a better person by doing nice things for people he once wronged) did not infringe the copyright in an aspiring writer's feature screenplay called *Karma!* (a drama about a dirty cop making amends for past wrongs).[27] Another California court following the test concluded that a series of Fox network specials featuring a masked magician uncovering the secrets behind famous magic illusions did not infringe the copyright in a preexisting straight-to-video production with the same basic concept called *The Mystery Magician*.[28]

Again, as with many areas of this law, the applicable legal standards are broadly stated and highly flexible, and the lines between what is inappropriately

24 See *Alexander v. Murdoch*, 2011 WL 2802899 (S.D.N.Y. 2011). In this case, the defendants' access to the plaintiff's materials was actually undisputed.

25 See *Boisson v. Banian, Ltd.*, 273 F.3d 262 (2d Cir. 2001).

26 See *Sid & Marty Kroft Television Productions, Inc. v. McDonald's Corp.*, 562 F.2d 1157 (9th Cir. 1977).

27 See *Gable v. National Broadcasting Co.*, 727 F.Supp.2d 815 (C.D. Cal 2010).

28 See *Rice v. Fox Broadcasting Co.*, 330 F. 3d 1170 (9th Cir. 2003).

similar blurry enough, that the outcome of any given dispute can be difficult to predict, even for experienced observers.

B. Trademarks

Most people have an intuitive understanding of the concept of a trademark, even if they are unable to precisely define the term. A trademark is a limited property right in a particular word, phrase, or symbol that is used to identify an individual or company as the source of a given product or service. So, for example, "Pepsi," "Toyota," and "Microsoft" are all prominent examples of trademarks; all three words signify that a specific company is behind a given soft drink, automobile, or mediocre software product. Slogans can acquire trademark status, once they've developed enough notoriety and affiliation with a particular brand (e.g., "don't leave home without it" for American Express). Graphical logos are also commonly protectable as trademarks. Unlike copyrights, trademarks never expire, as long as they remain in use and the trademark owner makes appropriate efforts to enforce its exclusive trademark rights against infringers.

In special circumstances, a given image can be subject to both copyright and trademark protection at the same time (albeit on distinct legal grounds). For example, the character of Mickey Mouse is copyrighted and in many ways, is a classically copyrightable piece of intellectual property: an original character with a distinct voice and personality, as well as a unique and creative artistic form. At the same time, however, Mickey serves as the mascot for the entire Disney corporate empire, and in that regard, he is also a trademark: the image of Mickey signifies that the real Disney is involved with any given product or service. Mickey thus enjoys dual status, as a copyright and a trademark. But the thing that makes him copyrighted (i.e., the creativity in his character and image) is not the thing that makes him trademarked (i.e., his use as a representative of all of Disney), or vice versa. The copyright on Mickey Mouse will theoretically someday expire, but as long as Disney continues to use him as a mascot, he will enjoy trademark protection. Conversely, Disney could stop using Mickey in commerce altogether or stop policing other parties' use of Mickey, and thus lose trademark protection for the character, even as he remained protected by copyright.

Trademarks are protected under the federal Lanham Act, as well as a variety of state statutes and common law doctrines. Trademark law is an offshoot of consumer protection law; although trademarks are granted to and enforced by the companies that create and use them, the essential legal basis and purpose of trademark protection is not necessarily to protect the trademark *owners*, but rather, to protect *consumers* from being confused or misled by counterfeiters about what they are buying. For that reason, the central question in any trademark dispute is whether the defendant's actions (e.g., its use of a plaintiff's trademark or of something very similar to that trademark) are likely to cause

confusion among ordinary consumers as to the source, sponsorship, affiliation, or approval of the defendant's goods/services.[29]

Formal trademark registration is not a prerequisite for protection under the Lanham Act or comparable state laws. A trademark-type claim, styled as "false designation of origin" or "false endorsement," may be viable based on a defendant's alleged misuse of material (again, a product or corporate name, slogan, logo, or other text or visual identifiers) that is publicly identifiable with the plaintiff and its business but that is not actually registered as a trademark. For examples, celebrities litigating the unauthorized use of their name or likeness in commerce frequently assert Lanham Act claims for "false designation of origin" and/or "false endorsement." The essential theory underlying such claims is that, while the celebrity's likeness is not a registered trademark, its use in commerce implies endorsement, sponsorship, or some other form of authorization by the celebrity. These claims arise out of similar facts but exist alongside and in addition to traditional state law "right of publicity"-type claims (which are discussed in Section C.iii below).

Because a trademark, by itself, typically has relatively minimal creative content, it usually does not serve as the essential basis of a new television series.[30] To the extent that this occurs, it is more commonly in the context of unscripted series and is discussed in Section D of Chapter 4 and Section D.ii of Chapter 10.

On the other hand, studios frequently register the titles and logos of their series as trademarks. In general, the title of a single standalone book, film, or other such work does not qualify for trademark protection. But, if the title is attached to an ongoing series, and/or if the user of that title also builds a licensing and merchandising program around the property, trademark protection can apply.

Most commonly, trademarks come up in the course of "clearing" material (i.e., obtaining licenses or making a legal determination that a license is not needed) that appears on-camera, such as real-life company names featured in plot and/or dialogue, or logos on wardrobe, props, and/or set dressing. Such clearance activity is generally handled by lawyers and clearance specialists,

29 Although the precise legal test for consumer confusion varies slightly from jurisdiction to jurisdiction, the elements considered by the court in determining "likelihood of consumer confusion" generally track an eight-part test set out by the Second Circuit (the federal appellate court that covers New York, Connecticut, and Vermont) in a landmark case called *Polaroid Corp. v. Polarad Electronics, Corp.*, 287 F.2d 492 (2d Cir. 1961) (the so-called "Polaroid" factors): (1) the strength of the plaintiff's mark; (2) the similarity of the marks; (3) proximity of the products and their competitiveness with one another; (4) evidence that the plaintiff might "bridge the gap" by developing a product for sale in the defendant's market; (5) evidence of actual consumer confusion; (6) evidence that the defendant adopted or used a mark in bad faith; (7) the respective quality of the parties' products; and (8) sophistication of consumers in the relevant market.

30 That said, cautious lawyers will take care to address trademark rights in the course of selling or acquiring rights to adapt other intellectual property, such as a copyrighted book series with a preexisting merchandising program associated with it that might simultaneously be subject to trademark protection.

and does not generate significant up-front dealmaking activity at the business affairs level.[31]

C. Life Rights

Where a television series is inspired by or based on the life of a real, living human being, the studio will typically enter into a "life rights" agreement with one or more of the individuals at the heart of the story. However, the term "life right" is a bit of a misnomer. Unlike a copyright (which is a form of intellectual property created and protected under the federal Copyright Act, and a variety of corresponding laws in other countries) or a trademark (which is a form of intellectual property protected under both the federal Lanham Act and a patchwork of state statutes and legal doctrines, as well as a variety of corresponding laws in other countries), strictly speaking, there is no such thing as a "life right" under any form of property law in the United States.

Instead, a grant of "life rights" is actually a promise by the grantor not to sue the grantee under any of several legal theories that could potentially support a

31 This book does not seek to provide a comprehensive guide to legal clearance, but a few observations may still help illustrate how such intellectual property is treated in everyday practice.

Where trademarked material (such as the identity of a specific corporation) is central to the storyline or setting of a series, particularly one that is not specifically based on a true-life story, clearance attorneys may require that the studio obtain a license, or replace the real corporate name with a fictional one. Writers (on advice of counsel) may go so far as to establish the separate existence of the real company in the fictional universe, in order to defeat the implication that the fictional company is a thinly veiled stand-in for the real thing.

Where trademarked material appears or is referenced more incidentally, many lawyers take the position that, so long as an item is being used as generally intended, no clearance is necessary; but if the item is being abused in any way (either through excess use or improper use), then real-life logos must be obscured, avoided, or licensed. For instance: want to show your main character responsibly enjoying a single Heineken at a bar? Okay. Want to show your main character irresponsibly drinking twelve Heinekens and then breaking a Heineken bottle over another patron's head? Cover the logo or get a license.

Even where usage may be technically legally permissible, some studios prohibit the use of any recognizable trademarks without a specific agreement with the trademark holder, not for liability reasons but in order to protect and promote a robust market for product integration deals, by sending the clear message that no brand gets the free advertising of an on-screen mention or appearance without compensating the studio. (See Section B.vi.b of Chapter 1.)

Clever and creative attorneys can be valuable contributors to the creative process here. For example, USA's *Mr. Robot* is able to use an only slightly modified version of the logo for Enron (the real-life disgraced energy company whose 2001 collapse led to a nationwide recession and the passage of new corporate governance laws) as the logo for its fictional corporate antagonist "E Corp" (referred to by the main character as "Evil Corp") because Enron has been out of business and has not used its logo in commerce for more than a decade. The non-use of the still-recognizable logo offered practical comfort (no functioning company means no likely plaintiff) as well as legal comfort (even if the Enron Creditors Recovery Corporation formed to compensate Enron's creditors sued, the non-use of the mark in commerce may compel a finding that trademark protection in the logo had lapsed) to studio Universal Cable Productions in its decision to use the logo.

lawsuit arising out of the depiction of that person and his or her life.[32] Consequently, the hallmark feature of a "life rights" agreement is a broad waiver of claims, all of which arise within the general arena of privacy law.[33] Although the list of such claims is theoretically limited only by the creativity of the lawyer devising a complaint on behalf of an aggrieved plaintiff—and therefore the waiver of claims contained in a life rights agreement is written as broadly as possible[34]—the most common potential claims contemplated by a life rights agreement are summarized below.

i. Defamation and Related Claims

"Defamation" is the general term for a legal claim involving injury to an individual's reputation arising out of the publication of false statements about the individual. Although non-lawyers sometimes refer to "slander" (which refers to spoken defamation) or "libel" (which refers to written or otherwise fixed and recorded defamation), as a technical legal matter, both of these terms are merely plain language variations of the same thing: defamation. Under U.S. law, privacy-based torts such as defamation can only be pursued by living plaintiffs—a common legal adage is that "you can't defame the dead."

32 It bears noting that, unlike copyrights (which are governed exclusively by federal law) and trademarks (which are governed by a mixture of state and federal law, but which are most often interpreted by reference to federal law), the patchwork of claims that fall under the banner of "life rights" are all governed by state law. Consequently, the precise elements and contours of these causes of actions may vary, depending on the state in which a claim arises and/or a lawsuit is filed. However, these doctrines have long histories in common law and are therefore applied reasonably similarly from state to state. On the other hand, the applicable legal doctrines at issue under the heading of "life rights" may vary dramatically from country to country; consequently, in considering its potential liability under these various legal theories, a studio that does business worldwide and intends to distribute a project internationally may need to analyze its potential liability separately on a country-by-country basis.

33 It is the risk of these claims from someone who sees themselves as being depicted in a putative work of fiction that also motivates producers of even fictional original material to include in the credits a disclaimer to the effect of: "This is a work of fiction. Names, characters, businesses, places, events, locales, and incidents are either the products of the author's imagination or used in a fictitious manner. Any resemblance to actual persons, living or dead, or actual events is purely coincidental."

34 Some lawyers actually prefer drafting that is broad but more circumspect. Defamation is considered an "intentional tort," a category of torts that describes a civil wrong resulting from an intentional act on the part of the alleged wrongdoer. Courts are often skeptical of releases that purport to exculpate a party, in advance, from subsequent intentional torts, and may construe such releases very narrowly or treat them as altogether void. For example, at least one court in California has held that a reality television waiver used on *The Real Housewives of Orange County*, which specifically waived any defamation claims, could not be used as a license for people "to defame one another with impunity." *Rossi v. Photoglou*, No. G0482026 (Cal. Ct. App. Sept. 29, 2014). For this reason, some attorneys prefer to draft the waivers in life rights agreements to cover "all claims" generally, but without specifically identifying defamation or other intentional torts as being among the waived claims. Such cautiously drafted waivers may go on to state the studio's affirmative right to change, modify, add to, or subtract from the individual's life story in ways that may not conform to reality.

Although the legal elements of defamation were defined in an era long before the advent of television, they can be easily interpreted and applied in the television context (or that of other entertainment products, such as theatrical motion pictures). These elements—and a few key nuances of these elements as related to television production—are as follows:

- **The defendant published the statement.** For purposes of a defamation law, a television production (and any depiction of a real-life individual contained therein) constitutes a "statement" which could be the basis of a defamation claim. Notably, an individual or entity that has been accused of defamation cannot avoid liability by arguing that it was merely repeating someone else's statement; in practical terms, this means that a network may be liable if a show that it broadcasts proves to be defamatory, even if the show was actually produced by a third-party studio.[35]
- **The statement is about the plaintiff.** In order to give rise to liability for defamation, a statement or depiction need not identify a person by name. Rather, it is sufficient if the statement or depiction includes enough identifying information to make the person being depicted reasonably identifiable. For this reason, a studio could not avoid defamation liability from the depiction of real-life individuals simply by changing the characters' names. Individuals may be considered identifiable by virtue of their professional positions, their specific personal or familial relationships, or other information or context (even if unstated) that could reasonably cause a viewer to specifically identify the person being portrayed. In addition, a blanket statement about a reasonably small group of people—many courts use as a rough guideline statements directed at groups of twenty-five or fewer people—could be understood to refer to (and thus give rise to potential liability to) every member of that small group. An individual who seeks to file a so-called "libel in fiction" claim based on a fictionalized, unnamed portrayal of herself has a delicate tightrope to walk. To succeed, such a plaintiff must prove that she is similar enough to a fictional character that the audience will think the television program has portrayed her, but at the same time that she is different enough from the portrayal that her reputation is harmed by it. (As in, "everyone is going to think that alcoholic, unethical, promiscuous character is me, even though I'm not alcoholic, unethical, or promiscuous.") Lawyers also disagree about the liability-reducing (or increasing?) impact of composite characters (i.e., fictional characters that share attributes with, and stand in for, two or more real-life counterparts). On the one hand, combining two real-life

35 That said, the license agreement between studio and network will likely include representations, warranties, and indemnities, which would make the studio fully financially responsible for the network's damages, if the show delivered to the network by the studio proved to be defamatory and exposed the network to liability.

individuals into a single fictional character distances the fictional character from each of its individual real-life counterparts, which arguably reduces potential liability. On the other hand, the composite character may be considered to refer identifiably to *both* real-life counterparts, each of whom may feel they are defamed if the unsavory actions or characteristics of the other is ascribed to them in the public's perception.

- **The statement damaged the plaintiff's reputation.** In order to be defamatory, a statement must be damaging to the reputation of the person being depicted. For instance, a television production may depict a real-life individual as an unrepentant philatelist—that is, a dedicated stamp collector—without exposing the producer to liability (as the implication that one is a stamp collector is not damaging to one's reputation, even if it may suggest that one is a bit boring at dinner parties). Because the question of whether a statement is injurious to one's reputation depends on community standards, a statement that is defamatory in one era may not continue to be defamatory in an era when social norms have changed. For example, an untrue allegation that an individual was a homosexual would have undoubtedly constituted defamation in 1950; with changing social attitudes trending toward normalization of homosexuality, however, some courts no longer consider allegations of homosexuality to be injurious to one's reputation, which means such allegations would no longer sustain a defamation claim. In addition, the element of damage to one's reputation requires that the plaintiff have a good enough reputation in the first place that it could suffer damage. Individuals whose reputations are so tainted that they can no longer sustain claims for defamation are sometimes referred to as "libel-proof." For instance, the reputation of an individual who is known to have murdered five people may be so compromised that an allegation that the same individual murdered a sixth person, even if untrue, would not be deemed damaging to that person's reputation. On the other hand, an individual whose reputation has been compromised in one respect, however severely, may not be left without a remedy for further reputational harm of a different type. For example, that same convicted murderer may be able to bring a claim for defamation against an individual who falsely alleges that the murderer also sexually abused minors (an entirely different sort of allegation that goes to a different aspect of the murderer's reputation).
- **The statement is false.** No matter how damaging a statement may be to an individual's reputation, it cannot be defamatory if it is actually true. To put it another way, the depiction of demonstrably true facts about an individual can never be the basis of liability for defamation, regardless of how embarrassing those facts may be.[36] (Of course, the truth of a particular

36 It may, however, give rise to a claim for "public disclosure of private facts," discussed in greater detail in Section C.ii below.

allegation may be hotly disputed.) However, the fact that a work is explicitly presented as fictional (e.g., via a disclaimer) would not preclude a claim of defamation if a character being depicted so closely resembles a real person that the audience could reasonably understand that the character is intended to portray that real individual. The law generally requires only "substantial truth," meaning that a statement or depiction need not be perfectly accurate in every conceivable way in order to be immune from defamation liability. (For instance, if it was undisputed that an individual committed murder, a television production would not defame the murderer if it took creative license with incidental details in its depiction of how the murder was committed.) In addition, as a corollary to the requirement that a statement be literally false in order to be considered defamatory, statements of pure opinion are not defamatory. Rendering a value judgment about an individual, as by deeming them "stupid," a "jerk," or a "failure," constitutes a statement of opinion and therefore cannot be the basis of a defamation claim. A speaker cannot shield him or herself from liability just by couching a factual assertion in opinion based terms—e.g., by saying, "In my opinion, Frank murdered his wife." As a practical matter, a defamatory statement must generally go beyond a mere value judgment to state or imply that an individual said or did some particular thing. The line between "fact" and "opinion," however, can sometimes prove murky at best.

- **The defendant suffered damages.** In order to succeed on a defamation claim, a plaintiff must demonstrate that he or she was actually damaged by the defamation. This damage is typically demonstrated with evidence of the loss of a job or other economic opportunities, although many states allow a plaintiff to claim damages for mental anguish associated with the defamation. Several states also presume damages and recognize as defamation "per se" untrue statements that impugn an individual's professional character or standing; statements that allege serious sexual misconduct (such as extramarital affairs or allegedly "deviant" sexual behavior); allegations that a person has a sexually transmitted disease (amusingly and anachronistically referred to in many states as "loathsome diseases"); and allegations of immoral criminal conduct.

"False light" is a privacy-based claim closely related to "defamation"; in fact, not all states even recognize it as an independent claim. In states that recognize the claim, a statement generally gives rise to "false light" liability if it is published widely; identifies the plaintiff; places the plaintiff in a "false light" that would be highly offensive to a reasonable person; and the defendant was at fault in publishing the information. Many states understand "false light" claims to be based on implications, rather than outright factual statements. The classic example of a "false light" scenario is a true article about sex offenders, illustrated with a stock photograph of an individual who is not, in fact, a sex offender. The subject of that photograph could claim that the presentation of the photo implied (even

without any direct factual statement that would support a defamation claim) that the subject was also a sex offender.

Claims for defamation are also commonly accompanied by claims of "intentional infliction of emotional distress."[37] The elements of such a claim are (1) an intentional act by the defendant;[38] (2) the defendant's conduct was extreme and outrageous (beyond the standards of civilized decency); and (3) the plaintiff suffered severe emotional distress (as manifested by physical symptoms, a demonstrated lack of productivity, or a medically diagnosed mental disorder) that was caused by the plaintiff's act. The classic example of an "intentional infliction of emotional distress" is sending a letter to an individual falsely informing the person that a beloved friend or family member had died in an accident. Although such claims are often separately articulated alongside defamation claims, in the defamation context, any effective defenses to defamation liability would likely simultaneously preclude liability for intentional infliction of emotional distress.

ii. Public Disclosure of Private Facts

While a statement or depiction that is true can never give rise to liability for defamation, it may, under certain circumstances, lead to a claim for "public disclosure of private facts." Because "public disclosure of private facts" is another expression of the legal right to privacy, the claim can only be brought by living individuals; the estates and descendants of deceased individuals cannot assert such claims on behalf of the dead. The elements of such a claim are as follows:

- **The defendant's disclosure was public.** In order to give rise to liability for "public disclosure of private facts," a statement or depiction must be just that—public. A private communication to a single individual or small group would not suffice. However, the exhibition of a television series would undoubtedly satisfy this element.
- **The fact disclosed was private.** The facts disclosed must be private and intimate, and not generally known. Common examples of private facts include sexual orientation, medical conditions, and private financial information. Photos can be considered "facts," if taken in a private setting. In order to sustain a claim, however, the facts at issue must be broadly private, and not

37 A related claim of "negligent infliction of emotional distress" exists in situations where a defendant owed a plaintiff a legal "duty of care," and the defendant's negligent breach of that duty resulted in the plaintiff's severe emotional suffering. In general, no such special relationship is likely to exist between a television studio and an individual depicted in a television series, rendering this cause of action generally inapplicable.

38 This element refers to an intentional act, not necessarily intent to cause harm. A public statement, such as the depiction of an individual in a television program, would undoubtedly be considered an intentional act, whether or not the speaker (i.e., the producing studio) intended to cause emotional distress to an individual being portrayed within the series.

just unknown to a particular group. For example, publicizing an individual's homosexuality could give rise to a claim for a "public disclosure of private facts" if the subject had carefully protected his or her sexuality as a secret from the entire public and engaged in homosexual conduct only very discreetly; such a publication would not give rise to liability if the individual had been "out" and public about his or her sexuality throughout the gay community, even if the fact had otherwise been kept secret from certain friends or family members. Similarly, the publication of a photograph taken in public could almost never support a claim for "public disclosure of private facts" if the image was captured in public, even if few third parties were actually present when the photography was initially taken. Because liability requires that the fact at issue had been private prior to its publication, *republication* of a disclosure that has already been made by a third party cannot create liability for the speaker; only the initial disclosure is actionable. This is a key difference from the law of defamation, in which the repetition of defamatory statements initially made by others is still actionable.

- **The publication was offensive to a reasonable person of ordinary sensibilities.** A plaintiff bringing a claim for "public disclosure of private facts" must show that a reasonable person would have considered the disclosure to be highly offensive. The law does not protect individuals with "thin skins" from the publication of banal facts about their lives. For example, just as alleging that an individual is a notorious philatelist (again, a stamp collector), even if untrue, is not defamatory because it is not damaging to the subject's reputation, publicizing an individual's status as a philatelist, even if the individual jealously guarded the secrecy of his or her hobby, would not create liability for "public disclosure of private facts" because a reasonable person (without unusual sensitivities) would not consider the publication of that fact to be highly offensive.

- **The facts being published are not newsworthy.** The First Amendment protects the publication of facts that are "newsworthy" (sometimes stated as "matters of legitimate public concern"), even if all of the other foregoing elements are satisfied. Although the scope of this exception is difficult to define and predict, many courts apply it broadly, and in a fashion that arguably exceeds the scope of what might, in conventional journalistic terms, be considered newsworthy. Virtually any topic that concerns public affairs, crime, and recent events that occurred in a public setting, and nearly all details of the lives of prominent public figures (whether politicians or entertainment or athletic celebrities), may be treated as "newsworthy" for purposes of this element.

iii. Right of Publicity

The right of publicity is a commercial right that emerged out of the more general right of privacy. In many states, including California, it exists pursuant to both

statute and common law.[39] Whether the right of publicity survives death and is inherited by an individual's heirs (and if so, for how long after the individual's death the right survives) varies from state to state—for example, the right of publicity survives for seventy years after death in California, but is not inheritable at all in New York. While the details of the elements of a right of publicity claim also vary from state to state, the typical elements are as follows:

- **The defendant uses the plaintiff's identity.** The most obvious elements of a plaintiff's identity are his or her name and likeness, and the classic right of publicity claim involves the unauthorized use of an individual's name and/or likeness in commercial advertising. However, the right of publicity has been interpreted to protect against the use of numerous alternative indicia of identity, including the catchphrase "Here's Johnny" to refer to Johnny Carson,[40] and the distinctive appearance of race car driver Lothar Motschenbacher's racecar.[41] In addition, "use" does not require a literal depiction; courts have entertained claims based on look-alikes (of Woody Allen),[42] sound-alikes (of Bette Midler and Tom Waits),[43] and even a robot evoking the classic evening gowned look of game show co-host Vanna White.[44] There is no question that an actor's identifiable portrayal in a television series of a real-life individual, even under an alternative name, would constitute a "use" of the individual's "identity" for purposes of a right of publicity claim.

- **The defendant appropriated the plaintiff's identity to the defendant's advantage, commercially or otherwise.** Some state laws and statutes require "commercial use" of a plaintiff's identity in order to sustain a right of publicity claim; others, such as California's common law right of publicity, make actionable any use to the defendant's advantage, even if not specifically commercial. Without question, a studio's lucrative exploitation of a television series that incorporates an individual's identity would be "to the advantage" of the studio. Even applying the stricter requirement of "commercial use," a television series is both a work of art and a commercial product, and the incorporation of a real-life individual's identity into a series would generally be understood to qualify as a "commercial use."

39 The right of publicity works alongside the Lanham Act in protecting an individual's property rights in his or her identity, and most plaintiffs who assert right of publicity claims concurrently assert corresponding claims for false endorsement or false designation of origin under the Lanham Act. While the right of publicity itself is primarily concerned with harm to the plaintiff from misappropriation of his or her identity, however, the Lanham Act (as explained in Section B above) is primarily concerned with harm to the public from confusion.

40 *Carson v. Here's Johnny Portable Toilets, Inc.*, 698 F.2d 831 (6th Cir. 1983).

41 *Motschenbacher v. R.J. Reynolds Tobacco Co.*, 498 F.2d 821 (9th Cir. 1974).

42 *Allen v. National Video, Inc.*, 610 F. Supp. 612 (S.D.N.Y. 1985).

43 *Midler v. Ford Motor Co.*, 849 F.2d 460 (9th Cir. 1988); and *Waits v. Frito-Lay, Inc.*, 978 F.2d 1093 (9th Cir. 1992).

44 *White v. Samsung*, 971 F.2d 1395 (9th Cir. 1992).

- **The plaintiff did not consent to the use.** This element is self-explanatory (and can be reasonably assumed where there is no life rights agreement in place and a plaintiff has complained). However, this element may prove significant where an agreement between the plaintiff and defendant exists, but the defendant allegedly exceeded the scope of the rights and waivers granted pursuant to that agreement.
- **The plaintiff was injured.** A plaintiff's harm under a right of publicity claim may include the unrealized fair market commercial value of the defendant's use of the plaintiff's identity; injury to the plaintiff's future professional standing, goodwill, and publicity value; emotional distress; and, in some states (including under California's right of publicity statute), attorneys' fees.

On its face, the right of publicity would appear to pose a significant challenge to a studio's ability to produce a television series depicting, in a direct or fictionalized way, a real individual without a "life rights" agreement in place. However, as explained in Section D.iii.c below, the First Amendment provides a near-complete defense to such claims.

D. The First Amendment

The spectrum of potential claims under copyright law, trademark law, and the array of claims generally bundled together under the heading of "life rights," on its face, seems to present significant barriers against the incorporation of preexisting material or true-life elements into television productions (at least without the widespread negotiation of licenses authorizing the use of such material). There is, however, one significant legal concept that serves to substantially limit these rights, and to generate space for creators to draw upon the world around them in creating new works: the First Amendment.

The First Amendment famously forbids laws "abridging the freedom of speech," and courts have long interpreted creative works (including television series) as constituting "speech" that is subject to First Amendment protection. Where any creator (including, relevant to our purposes, a television studio) faces limitations on the content of its "speech" (for our purposes, a television series) on copyright, trademark, right of publicity, or other grounds, those limitations must be balanced against the protections and interests enshrined in the First Amendment. In practice, this balancing act manifests as a series of "affirmative defenses," which serve to create exceptions to copyright, trademark, and other legal property rights and theories of liability. The First Amendment therefore limits the rights of potential plaintiffs, and offers legal pathways for studios to draw on preexisting work and true-life material without necessarily obtaining a license.[45]

45 Courts have held, in a variety of legal contexts, that "commercial speech" enjoys less robust First Amendment protection than "non-commercial speech." Like other creative industries, television series

i. Copyright Claims

Because copyright law, by its nature, concerns original works of creative expression, it occupies a conceptual space directly adjacent to the First Amendment. Copyright protection and First Amendment principles are, in some sense, directly at odds with one another: copyright serves to limit the public's use of particular creative material, while the First Amendment protects creative speakers from restrictions on their speech. These two competing goals are balanced through one doctrine, which is so fundamental to the function of Copyright Law that Congress elected to draft it right into the text of the 1976 Copyright Act: fair use.

Section 107 of the 1976 Copyright Act provides:

> "[T]he fair use of a copyrighted work, including such use by reproduction in copies or phonorecords or by any other means specified by that section, for purposes such as criticism, comment, news reporting, teaching (including multiple copies for classroom use), scholarship, or research, is not an infringement of copyright. In determining whether the use made of a work in any particular case is a fair use the factors to be considered shall include—
>
> (1) the purpose and character of the use, including whether such use is of a commercial nature or is for nonprofit educational purposes;
> (2) the nature of the copyrighted work;
> (3) the amount and substantiality of the portion used in relation to the copyrighted work as a whole; and
> (4) the effect of the use upon the potential market for or value of the copyrighted work."

Where one party sues another for copyright infringement based on the defendant's unauthorized copying (violating the right of reproduction) or adaptation (violating the right to create derivative works) of the plaintiff's copyrighted material, the fair use doctrine offers an essential line of defense.

Courts have generally held that the first and fourth factors are the most impactful in a fair use analysis, and some courts have looked to that first factor—"the purpose and character of the use"—as being virtually dispositive in itself. Although the text of the Copyright Act refers to "criticism, comment, news reporting, teaching . . ., scholarship, or research," the fair use doctrine's

do represent a fusion of art and commerce, and their creation is unquestionably motivated by the opportunity to monetize the "speech" of the television series for millions of dollars. Many plaintiffs have therefore sought to characterize films, television series, and comparable works as "commercial speech" that enjoys limited First Amendment protection. While recognizing the commercial character of such works, however, courts have consistently differentiated between films, television series, and other creative works, on the one hand, and traditional advertising or other speech "proposing a commercial transaction," on the other hand. With this distinction, they have generally afforded such creative works robust First Amendment protection.

application is much broader than that, and can immunize the adaptation of existing copyrighted material into new commercially exploited creative work. As one court has articulated: "[W]hen a second author uses another's protected expression in a creative and inventive way, the result may be the advancement of learning rather than the exploitation of the first writer."[46]

In evaluating "the purpose and character" of a defendant's use of copyrighted material in a new commercially exploited creative work, the court's analysis generally turns on one key concept: transformation. In a 1994 decision concerning the rap group 2 Live Crew's adaptation of Roy Orbison's classic "Oh, Pretty Woman" into a profane new "Pretty Woman," the Supreme Court explained: "[T]he central purpose of this [factor] is to see . . . whether the new work merely 'supersede[s] the objects' of the original creation . . . or instead adds something new, with a further purpose or different character, altering the first with new expression, meaning, or message; it asks, in other words, whether and to what extent the new work is 'transformative.'"[47] The Court further held that, because "the goal of copyright, to promote science and the arts, is generally furthered by the creation of transformative works[,]" the "more transformative the new work, the less will be the significance of other factors, like commercialism, that may weigh against a finding of fair use." In that case, the Supreme Court ultimately held that 2 Live Crew's new song was a fair use because, with its unexpectedly shocking lyrics, it could reasonably be understood as commenting on and criticizing the blandness and banality of Orbison's original.

For some years, courts following the Supreme Court's decision in the 2 Live Crew case drew a distinction between parody (i.e., using a preexisting work to comment on that original work), which they found to be protected fair use, and satire (i.e., using a preexisting work to comment on something unrelated to the original work, such as a different work or on society generally), which they often held not to be protected fair use. So, for example, the Ninth Circuit (which covers California and much of the western United States) ruled in 1997 that a novelty book called *The Cat NOT in the Hat*, which appropriated the artistic style and rhyme scheme from Dr. Seuss's *The Cat in the Hat* to relate the saga of the O.J. Simpson trial, was not a fair use because it made no comment on the original work (and therefore was not protected as a parody), and made "no effort to create a transformative work with new expression, meaning, or message."[48] The Second Circuit (which covers New York, Connecticut, and Vermont) similarly found that artist Jeff Koons's sculptural appropriation of a copyrighted photo of a smiling husband and wife holding a litter of charming puppies was not a fair use because, although it may have been a commentary about modern society, it had nothing to say about the original photograph.[49]

46 See *Maxtone-Graham v. Burtchaell*, 803 F.2d 1253 (2d Cir. 1986).
47 *Campbell v. Acuff-Rose Music, Inc.*, 510 U.S. 569 (1994).
48 *Dr. Seuss Enters., L.P. v. Penguin Books USA, Inc.*, 109 F.3d 1394 (9th Cir. 1997).
49 *Rogers v. Koons*, 960 F.2d 301 (2d Cir. 1992).

More recently, however, courts in the Ninth and Second Circuits have taken a more expansive view of what constitutes "transformation" for purposes of a fair use analysis, essentially abandoning the requirement that a new use of copyrighted material comment on that original material, so long as there is a genuine creative rationale for the borrowing, and some further transformation in meaning, aesthetic, or otherwise as part of the new work.[50] With this updated style of analysis, fourteen years after its opinion against Koons in the *Rogers* case, the Second Circuit held on very similar facts that one of Koons's later works *was* a fair use in its appropriation and transformation of preexisting copyrighted material, even without directly commenting on that material.[51] In 2015, a trial court in New York allowed a playwright to put on a play that was an "upside-down, dark" take on *Three's Company* as a fair use.[52] And more recently, one trial court in California expressly found that "mash-ups" of creative elements from two unrelated copyrighted works—in that case, a Kickstarted kids' book hybrid of Dr. Seuss and Star Trek called *Oh, the Places You'll Boldly Go!*—were "transformative" for purposes of a fair use analysis.[53]

With respect to the fourth factor—"the effect of the use upon the potential market for or value of the copyrighted work"—courts examine not only the extent to which a defendant's use of copyrighted material directly impacts the market for the original, but also whether the defendant's use may harm the *potential* markets (whether or not actually exploited by the plaintiff) for other uses of the original (including authorized derivative works). Given the robust market for paid licenses to adapt copyrighted material for television series (and other audiovisual) production, this factor would frequently weigh against a defendant who tries to rely on fair use to adapt existing copyrighted material.

Ultimately, there are two key practical observations to make about the fair use doctrine, particularly as it relates to the decision to acquire underlying rights versus proceeding without a license with respect to the adaptation of preexisting copyrighted material in a new television project.

First, the fair use doctrine is extremely unpredictable in application. Its four factors are broadly stated, and because fair use is considered a "mixed question of fact and law," there is an extremely wide body of cases applying those factors in all sorts of ways. The practical effect is that judges who instinctively find a defendant's activity to be objectionable or unobjectionable can usually chart a course to finding that the fair use doctrine does or does not protect the defendant from liability, and two judges

50 See, e.g., *Seltzer v. Green Day, Inc.*, 725 F.3d 1170, 1177 (9th Cir. 2013) (the band Green Day's use of a photograph of copyrighted artwork, as part of a four-minute video backdrop for one of its songs in its stage show, was a fair use); *Cariou v. Prince*, 714 F.3d 694 (2d Cir. 2013) (finding that several works by an "appropriation artist" who painted over a series of published photographs in a wildly different artistic style were sufficiently "transformative" as to qualify as fair use).

51 *Blanch v. Koons*, 467 F.3d 244 (2d Cir. 2006).

52 *Adjmi v. DLT Entertainment Ltd.*, 97 F.Supp.3d 512 (S.D.N.Y. 2015).

53 *Dr. Seuss Enters., L.P. v. ComicMix LLC*, No. 16CV2779-JLS (BGS) (S.D. Cal. June 9, 2017).

looking at identical facts could easily reach opposing conclusions. As a result, when someone asks, "Is this fair use?" it is usually hard to offer a more definitive answer than "probably" or "probably not" (a response that offers only limited comfort to risk-averse industry attorneys looking to protect their employers).

Second, it is hard to imagine a studio relying on fair use alone to justify adapting preexisting material wholesale as the entire foundation of a new series. Certainly, fair use can justify the borrowing of specific elements, particularly where the effect is to parody a whole genre—consider, for example, Comedy Central's *The Colbert Report*'s adaptation of recognizable elements of Bill O'Reilly's *The O'Reilly Factor* as part of its comedic take on conservative cable news, or Fox's *The Orville*'s visual references to classic space series (and space spoofs) like *Star Trek* and *Galaxy Quest*. In addition, a studio might rely on fair use, rather than a license, to produce a single standalone episode of a series that clearly references and pays homage to existing work (such as, for example, theme episodes of ABC's *The Goldbergs* referencing classic '80s films like *Ferris Bueller's Day Off* and *Risky Business*). But where a proposed television series is based exclusively or substantially entirely on preexisting copyrighted material, even if its take is parodic or otherwise critical of the original, few studios would consider relying entirely on fair use rather than obtaining a license or release.

ii. Trademark Claims

The First Amendment also serves to limit the scope of trademark protection. Most significantly, courts recognize that it is virtually impossible to refer to particular products or services without using protected trademarks—for instance, how could a character reasonably refer to an Apple iPad in dialogue without using the words "Apple" or "iPad"? For this reason, the law allows the public to freely use a protected trademark nominatively, i.e., to describe the product or service underlying the mark, often in the only way that makes any sense. This is often referred to as "nominative fair use." The Ninth Circuit uses a three-part test for nominative fair use: (1) the product or service in question must be one not readily identifiable without use of the trademark; (2) only so much of the mark may be used as is reasonably necessary to identify the product or service; and (3) the user must do nothing that would, in conjunction with the mark, suggest sponsorship or endorsement by the trademark holder.[54] As a practical matter, "nominative fair use" probably

54 Legal history includes a number of interesting cases reflecting the notion that the law does not require one to go out of one's way to make some oblique reference to something that is principally readily identifiable only by its trademarked name. For example, former Playboy Playmate Terri Welles successfully fended off a lawsuit brought by Playboy, which sought to block her from referring to herself on her website as a former "Playboy Playmate of the Year" (two trademarks in that phrase). Why? Because she was a former Playboy Playmate of the Year, and the law did not require her to

wouldn't provide a defense toward altogether basing a series on a trademarked property, given the potential inference of sponsorship and affiliation that would be involved in such circumstances, but it does inform clearance decisions related to lesser references to and uses of trademarked names and logos on camera.

In addition, courts have permitted trademarks and indicia of identity to be incorporated into the titles of creative works where there is a legitimate creative basis for the use of the name, and the title does not explicitly denote authorship, sponsorship, or endorsement. In many cases involving creative enterprises that are clearly at the heart of First Amendment protections (such as films, musical compositions, and television series), courts apply a similar, but two-prong test: (1) whether the defendant's use of the plaintiff's trademark is relevant to the underlying work and (2) whether the use of the mark explicitly misleads as to the source or the content of the work. Under this test, the Second Circuit rejected a claim brought by noted actress and dancer Ginger Rogers, who objected to the title of Federico Fellini's 1986 film *Ginger and Fred* (which was about a pair of Italian cabaret performers whose routine impersonated the more famous pairing of Fred Astaire and Ginger Rogers).[55] The Ninth Circuit later applied the same test to determine that the Danish band Aqua's 1997 song "Barbie Girl" did not infringe Mattel's Barbie trademarks.[56]

iii. Life Rights Claims

The First Amendment also provides defenses to the various claims encompassed within the waiver associated with "life rights," seeking to protect both the public's right to be informed of matters of public concern, and the rights of artists and speakers to incorporate real-life elements in their creative works.

a. Defamation and Related Claims

Often, the individuals worth depicting in television series and other entertainment works are not merely private citizens, but rather, are people who are already well known to the public, either for their professional accomplishments or their well-publicized personal deeds (or misdeeds). For such individuals, the

refer to herself as "the Erstwhile Most Prominent Model for a Certain Well-Known Men's Publication Featuring Highly Airbrushed Disrobed Ladies." See *Playboy Enterprises, Inc. v. Welles*, 279 F.3d 796 (9th Cir. 2002). Similarly, boy band version 1.0 New Kids on the Block could not stop a group of newspapers from conducting surveys about which NKOTB member was the best and most popular, because the newspapers were using the NKOTB trademark to describe the band's services rather than their own, and because they could not even ask the question in any meaningful way without using the "New Kids on the Block" mark. See *New Kids On The Block v. New America Publishing, Inc.*, 971 F.2d 302 (9th Cir. 1992).

55 *Rogers v. Grimaldi*, 875 F.2d 994 (9th Cir. 1989).

56 *Mattel, Inc. v. MCA Records, Inc.*, 296 F. 3d 894 (9th Cir. 2002).

First Amendment may provide an additional bar to a successful claim for defamation (or other closely related privacy-based claims).

Where a would-be plaintiff is a public official or figure, in order to successfully bring a claim for defamation, the plaintiff must show that the defendant acted with "actual malice"—that is, that the speaker made a statement (which, again, can be in the form of a depiction in an audiovisual work) that the speaker knew was false, or that speaker acted with reckless disregard for the statement's truth or falsity. In making this determination, the court considers evidence of the speaker's actual, subjective state of mind when making an otherwise (allegedly) defamatory statement. The "actual malice" standard is so difficult to meet, it usually proves insurmountable for would-be plaintiffs who must prove it (and, as a result, often deters potential plaintiffs from filing claims in the first place). For instance, the availability of virtually any source for a factual allegation—even an anonymous or not particularly credible source—likely precludes a finding of actual malice. (This explains why tabloids such as the *National Enquirer* can publish sensational news stories about celebrities that are widely understood to be likely false. As long as they can point to any sources for their allegations, they can reasonably argue that they did not *know* their stories were false.) As a result, there have been only a handful of defamation claims over the years that have effectively overcome the "actual malice" requirement.

The "actual malice" requirement applies for any plaintiff that is a "public official," an "all-purpose public figure," or a "limited purpose public figure." The "public official" category encompasses politicians, high-ranking government officials, and even civil servants with substantial responsibilities. The "all-purpose public figure" category covers high-level celebrities, athletes, and titans of business; not all members of these professions necessarily rise to the level of "all-purpose public figure" (e.g., recognizable but not readily nameable character actors, or wealthy but little-known corporate executives, likely to do not qualify), but virtually any broadly known "name" would likely qualify. The "limited purpose public figure" category includes individuals who voluntarily become key figures in particular public controversies (such as outspoken experts or critics on specific issues), and individuals who have gained prominence in a particular, limited field, but whose celebrity has not reached an all-encompassing level (such as mid-level journeyman actors or athletes). The "actual malice" standard would govern defamation claims for statements involving virtually any aspect of the life of a public official or an all-purpose public figure; for a limited purpose public figure, however, the "actual malice" standard would apply only to subject matter related to the controversy or field in which the individual is prominent, but not to other aspects of the individual's private life.

b. Public Disclosure of Private Facts

The principles of the First Amendment are integrated into the very elements of a claim for "public disclosure of private facts," in the form of the requirement that

the published facts are not newsworthy. As discussed in Section C.ii above, to the extent that facts are newsworthy, the First Amendment recognizes a legitimate public interest in the discussion of these facts and precludes liability for "public disclosure of private facts."

c. Right of Publicity

Although, as set forth in Section C.iii above, the right of publicity would seem to provide a major risk to a studio that seeks to depict a real-life individual in a series without that individual's consent, in practice, the First Amendment provides a substantial defense against any such claims.

Most courts nationwide have followed the California Supreme Court in adopting a balancing test between the right of publicity and the First Amendment, known as the "transformative use" test. Under this test, a court determines whether a work that depicts a celebrity has sufficiently "transformed" that celebrity's identity, and is therefore immunized by the First Amendment from right of publicity liability, by considering five factors: (1) whether the celebrity likeness is one of the raw materials from which an original work is synthesized; (2) whether the work is primarily the defendant's own expression if the expression is something other than the likeness of the celebrity; (3) whether literal and imitative or creative elements predominate in the work; (4) whether the marketability and economic value of the challenged work derives primarily from the fame of the celebrity depicted; and (5) whether the artist's skill and talent has been manifestly subordinated to the overall goal of creating a conventional portrait of a celebrity so as to commercially exploit the celebrity's fame.[57]

This test is so general and subjective as to be highly unpredictable in application. But, although the test has never been applied in court to a television series based on or inspired by real individuals, courts applying it in the extremely similar context of theatrical motion pictures have consistently found that First Amendment protections trump the right of publicity. For instance, several years ago, the heirs of some of the fisherman who died aboard the Andrea Gail sued Time Warner, alleging that the portrayal of their family members in the 2000 Warner Bros. film *The Perfect Storm* violated the fishermen's rights of publicity. The Florida Supreme Court dismissed their claims, citing the First Amendment in concluding that the production and distribution of a motion picture was not a "commercial purpose" within the meaning of Florida's right of publicity statute.[58] Similarly, in 2016, a three-judge panel of the Ninth Circuit affirmed a lower court's dismissal of a long-pending lawsuit brought by U.S. Army Sgt. Jeffrey Sarver, who claimed that the character of Will James, portrayed by Jeremy

57 *Comedy III Productions, Inc. v. Gary Saderup, Inc.*, 25 Cal.4th 387 (2001).
58 *Tyne v. Time Warner Entertainment Co.*, 901 So.2d 802 (2005).

Renner in 2008's *The Hurt Locker*, was based on him and violated his right of publicity. The court's opinion, which held that the First Amendment "safeguards the storytellers and artists who take the raw materials of life—including the stories of real individuals, ordinary or extraordinary—and transform them into art, be it articles, books, movies, or plays," was perhaps the strongest ever legal endorsement of the First Amendment as a near-absolute defense to right of publicity claims arising out of the production and distribution of films, television series, and comparable creative works.[59]

E. Practical Considerations

Given the foregoing legal context—with limited legal protection against the depiction of true facts, lack of copyright protection for mere ideas or *scenes a faire*, harm to reputation as a requirement for liability for the depiction of untrue facts, non-existent defamation/privacy rights for deceased individuals, and extensive First Amendment defenses to potential claims—one might reasonably wonder why a television studio would seek to obtain rights outside of the narrow context of adapting fictional copyrighted works (for which permission to create a television adaptation is largely essential). Nevertheless, there are numerous practical reasons for making deals with rightsholders, even in situations where it may not be strictly necessary, as a matter of law, to do so.

The most obvious reason is risk mitigation. The author of a non-fiction work may feel wronged by the production of a television series that is based on his or her work, particularly if the author's work is the only major primary source for the facts discussed therein.[60] Similarly, an individual—whether or not that person is a public figure—may have legitimate personal objections to being depicted in a television series without his or her consent. The fact that such individuals' claims may be technically weak may do little to dissuade them from filing a lawsuit if they feel sufficiently aggrieved. The mere threat of a lawsuit may be sufficient to scare away licensees and other business partners from a project. Once a claim is filed, the defendants have no choice but to defend those claims, usually at great expense, no matter how unmeritorious the claims may be.[61] And once the claim has entered the system, judges and juries (many of whom may regard large, powerful entertainment companies as unsympathetic litigants) can prove extremely unpredictable, particularly given the vague and nebulous legal

59 *Sarver v. Chartier*, 813 F.3d 891 (9th Cir. 2016).

60 As an interesting aside, the author of a putatively non-fiction work could also suddenly reveal that the so-called "facts" he or she reported were actually made up, rendering the author's work a piece of fiction that would be entitled to substantial copyright protection. However, courts may treat with skepticism the claims of authors who initially present their work as factual, only to later say "just kidding" when expedient to support a legal claim.

61 In the majority of cases, successful defendants in such cases also have no basis for recovering their legal fees, even if they successfully litigate the claims to a judgment in their own favor.

standards for critical concepts like the idea/expression distinction, substantial similarity, and transformation.[62]

Relatedly, studios and networks routinely insist, as a condition of proceeding with the production or distribution of a television series, on obtaining a so-called "errors and omissions" insurance policy, which provides coverage against liability for claims of copyright and trademark infringement, defamation, violation of the rights of privacy and publicity, and comparable claims. Insurance carriers providing such policies may require that the insured exercise reasonable efforts to minimize prospective liability, including by obtaining releases from identifiable potential plaintiffs who may be likely to assert claims that would be covered by the policies. A carrier may treat such releases as a condition of offering coverage, or may insist on unfavorably high premiums or deductibles or significant coverage exclusions if such releases are not in place.

The risks of proceeding without acquiring rights are also greater where a studio has actually received a pitch for a proposed series. California and New York, where the entertainment and media industries are largely centered, have each developed bodies of "idea theft" law, a patchwork of state law actions available to plaintiffs who believe their ideas have been unjustly stolen. These disputes typically take the form of a claim of breach of express or implied contract.[63] In essence, the claim is that the studio heard an individual's pitch, and the individual agreed to disclose his or her idea, based on the explicit or implicit understanding that the studio would not use the individual's idea without entering into some kind of agreement with the individual for rights and/or services. Such idea submission claims have been asserted based on well-known projects like HBO's *The Sopranos*[64] and Fox's *So You Think You Can Dance*.[65]

The scope of potential liability for "idea theft" is potentially greater than that for copyright infringement, because idea theft claims can be based on material

62 For instance, in September 2017, a California judge surprised many observers by finding that 101-year-old Olivia De Havilland had a minimal probability of prevailing on a false light claim arising out of her arguably unflattering depiction as a "vulgar gossip," as portrayed by Catherine Zeta-Jones in FX's *Feud: Bette and Joan*. The claim itself probably came as a surprise to FX, given that De Havilland was an extremely minor supporting character in the series, which primarily concerned the true-life story of the rivalry between then-aging Hollywood starlets Bette Davis and Joan Crawford on the set of 1962's *Whatever Happened to Baby Jane*. The California Court of Appeal calmed the nerves of studio and network executives everywhere by reversing the lower court and dismissing De Havilland's lawsuit in March 2018. *De Havilland v. FX Networks*, No. B285629 (Cal. Ct. App. Mar. 26, 2018). The case nevertheless serves as a valuable reminder of the inherent unpredictability of litigation.

63 Plaintiffs in idea theft disputes also usually assert a variety of secondary state law claims, including misappropriation (a property/tort-based claim that is not recognized in the idea theft context in California, but that may be raised in New York), joint venture, unjust enrichment, false advertising, conversion, and unfair competition. These theories do not warrant detailed discussion, except to say that their legal basis is usually weak.

64 *Baer v. Chase*, 392 F.3d 609 (3d Cir. 2004).

65 *Cassese v. Fox Broadcasting Company*, No. B217655 (Cal. Ct. App. Aug. 10, 2010).

that does not qualify for copyright protection (e.g., because the "idea" in dispute is based on true facts that are in the public domain or is too general to qualify for copyright protection). This was the case in the classic California case on idea theft, *Desny v. Wilder*, in which the California Supreme Court allowed a plaintiff to maintain an implied contract claim based on director Billy Wilder's use of his idea for a movie about the life of Floyd Collins, a man who was trapped in a cave for two weeks in a widely publicized incident.[66]

Because idea theft claims are mostly based on breach of contract theories, the principal elements that a plaintiff must prove in an idea theft dispute are (1) mutual assent between the parties (i.e., an express or implied agreement by the studio to pay for the use of the plaintiff's idea, if used) and (2) the defendant's breach of the agreement (i.e., by actually using the idea).[67] In light of the industry custom and practices around rights acquisition, merely hearing a pitch may open up the door to idea theft claims if the studio runs with the idea without making a deal with the person who originated it. In evaluating the legal risk of proceeding with an idea that it has been pitched without making a deal, studio lawyers will consider whether the studio ever expressly disclaimed any express or implied agreement (such as in a published "submission policy" or in an explicit "submission agreement" disclaiming any such deal). The studio may also look to establish that it was separately aware of the disputed idea (or better yet, already developing it independently) prior to the plaintiff's submission.

Putting aside the potential liability from proceeding without rights, a studio may look to use a rights agreement as a sword as well as a shield. Making a rights deal may discourage a competing studio from pursuing a similar project at all or provide a basis for asserting a claim against a rival producer who elects to develop a competing project.

Another key benefit to making a rights deal is obtaining the cooperation of the individuals granting rights. The author of a non-fiction book or real-life

66 *Desny v. Wilder*, 299 P. 2d 257 (Cal. 1956).

67 In New York (but not California), courts have also historically required some showing that the idea that the defendant allegedly stole was "novel." On this basis, the Second Circuit once held that a plaintiff's idea for *Father's Day*, a television series about a middle-class black family starring Bill Cosby, was not sufficiently novel or original to sustain a claim against NBC for its alleged subsequent adaptation of the idea into *The Cosby Show*. The idea for *Father's Day*, the court reasoned, "merely combined two ideas which had been circulating in the industry for a number of years—namely, the family situation comedy, which was a standard formula, and the casting of black actors in non-stereotypical roles." The court rejected the plaintiff's contention that the "unique" and "revolutionary" portrayal of a non-stereotypical black family constituted legal novelty, holding that the show merely "represented an 'adaptation of existing knowledge' and of 'known ingredients' and therefore lacked 'genuine novelty and invention.'" Instead, to warrant protection, an idea had to be "truly innovative." See *Murray v. National Broadcasting Company, Inc.*, 844 F.2d 988 (2d Cir. 1988). In more recent years, however, the courts in New York have substantially weakened the novelty requirement for idea theft claims on express or implied contract theories, limiting the requirement to novelty to the buyer. See *Apfel v. Prudential-Bache Securities, Inc.*, 616 N.E.2d 1095 (N.Y. 1993); *Nadel v. Play-By-Play Toys & Novelties, Inc.*, 208 F.3d 368 (2d Cir. 2000).

subject of a series could be engaged to provide valuable consulting services, which would assist in both the development of a project and its ongoing production. Journalists and researchers can lend their expertise to the television writing team. Obtaining access to a real-life subject's personal records, letters, photos, and memorabilia can provide invaluable inspiration to the writing team, and lend impressive realism and verisimilitude to their work. Rightsholders may also be asked to participate in promotional and publicity efforts for a series. And all of this cooperation would be provided exclusively, meaning that the studio not only obtains the benefit of these efforts for itself; it also denies its competitors the opportunity to secure them.

This cooperation may be especially important to the studio as it attempts to navigate and mitigate less obvious liability risks. For example, the author of a non-fiction book or article may not be able to legally prevent a studio from producing a television series based on his or her work, but if that non-fiction work concerns one or more living individuals, it may be necessary to obtain the life rights of the individuals depicted in the work, whether or not a studio obtains the rights to the work itself. The author may be a valuable ally in obtaining the necessary rights and waivers from the subject(s) of his or her work. Similarly, although a studio may not fear a defamation claim from a deceased individual or an all-purpose public figure, it may be concerned about liability from depicting friends, colleagues, and family members of such individuals, who could be readily identifiable by their relationship to the primary subject (assuming that such friends, colleagues, and family members are alive and are not themselves public figures).[68] Making a deal with the primary subject of a series, even if legally unnecessary, may be extremely useful in obtaining the cooperation of (and releases from) such third parties. Indeed, a studio may reasonably choose to be so cautious as to obtain rights from a deceased individual's estate (even though defamation and privacy-based torts can only be pursued by living plaintiffs, and the First Amendment otherwise offers a strong defense against right of publicity claims), particularly if the studio may face problems with potential infringement of trademarks owned by the estate if it proceeds without the estate's consent.[69]

Finally, a studio's decision to obtain underlying rights may be motivated primarily by marketing-oriented concerns. A pithy and memorable title can be

68 This risk from seemingly tangential third parties makes open-ended series (as opposed to closed-ended television movies or mini-series) that are closely and recognizably based on true stories relatively uncommon. Such series, when they are produced, are usually subject to extensive legal vetting throughout the production process.

69 For example, Walt Disney was undoubtedly an all-purpose public figure, and both Disney and most members of his immediate circle have been deceased for decades. But the Walt Disney Co. nevertheless owns and rigorously enforces Disney's name as a trademark, rendering almost unthinkable the notion of any non-Disney-affiliated company attempting to produce a film or television series based on Disney's life. (Disney itself, on the other hand, dramatized the real-life Walt Disney's interactions with *Mary Poppins* author P. L. Travers in the 2013 film, *Saving Mr. Banks*, starring Tom Hanks.)

vital to a series's success, and securing the unquestioned right to use the specific title of a non-fiction work could easily justify the expense of a reasonably priced rights deal. A rightsholder and/or his or her work may bring with them a dedicated preexisting fan base, giving a new series a head start in finding an audience. Even absent a valuable title or substantial preexisting audience, many producers and executives believe that, in the modern competitive television marketplace, the mere existence of underlying intellectual property makes a project more attractive to network licensees and provides a writer with some much-needed inspiration to help him or her overcome the daunting blank page and undertake a new project. This line of thinking, perhaps more than any other, has generated an increasingly frothy, competitive market for underlying rights over the last five years.

In light of these factors, underlying rights deals for non-fiction works and life rights are surprisingly common, although the economics of such "legally unnecessary" deals tend to be somewhat more modest than those of deals for fictional copyrighted works.

On the other hand, in ambiguous legal or factual circumstances, a studio may reasonably determine that *not* seeking a release is the preferable course of action, particularly where the studio believes a rightsholder is unlikely to respond favorably or cooperatively to a request for a grant of rights or a waiver of claims. For instance, seeking a release may bring a project that might otherwise go unnoticed to the attention of would-be plaintiffs, or highlight to a potential plaintiff the availability of a marginal claim that the individual or entity would not have otherwise considered. The request for a rights grant or release may also signal to a potential plaintiff, rightly or wrongly, the studio's belief that the studio *needs* that rights grant or release, and could be construed as an implicit admission of liability if the studio were to proceed without it. In some cases, the active participation of rightsholders (in particular, when it comes with a desire to limit, dictate, or otherwise control the content or development of a new series based on their rights) may be considered a detriment rather than a benefit. Deciding when and from whom to obtain rights or waivers therefore requires a careful consideration of all of the relevant facts and circumstances.[70]

70 Actor, director, and producer Danny DeVito learned this lesson the hard way in connection with his planned feature film project *Crazy Eddie*, about Eddie Antar, the owner of the Brooklyn-based Crazy Eddie chain of consumer electronics stores (whose famous slogan was "His prices are insane!"). DeVito did the seemingly cautious thing and entered into a rights deal with Crazy Eddie. By 2010, however, DeVito had cut ties with Antar, after the actor-director was contacted by a lawyer representing several individuals who had been victimized by Antar's various fraud schemes (which had ultimately landed Antar $150 million in fines and six years in prison). The lawyer threatened to put liens on the movie to pay the victims of Antar's frauds and prevent Antar from benefitting from the film. Despite DeVito's severing of ties with Antar, the film never made it out of development. Antar himself died in 2016.

4

UNDERLYING RIGHTS AGREEMENTS

Having laid out the basic legal context for underlying rights agreements, we can now turn our attention to the agreements themselves. Although virtually any type of content can be acquired as the basis for a proposed television show—short-lived CBS sitcom *$h*! My Dad Says* was based on a popular Twitter feed of (almost) the same name—the most common properties on which television series are based, other than fully original series concepts, are published books and articles; life rights; and format rights. The mechanism by which a studio obtains these rights is an option/purchase agreement, an agreement by which a buyer (in this case, the studio) acquires the exclusive and irrevocable right, for a specified period of time, to purchase certain specified rights in the property, on pre-negotiated terms.[1] The decision to make that purchase is called "exercising the option" or "striking the option."[2]

1 For an option to be legally enforceable, there must be consideration for the option (which may be in the form of money or simply the option-holder's efforts to develop the project) and separately stated consideration for the purchase of the rights. The purchase price for the rights must be specifically negotiated and reflected in the deal; it cannot simply be left to future good faith negotiation.

2 Why an option rather than an outright purchase? The probability that any given project will make it to production is relatively low, and purchase prices can be quite expensive. Options allow studios to exclusively reserve rights at less up-front cost than it would take to buy those rights outright. And usually, as noted in Section A.i, the initial option fee is applicable against the purchase price, so if the studio does eventually purchase the optioned rights, its cost may not be any higher than if it had simply purchased the rights outright up-front. In an extremely competitive situation, however, a studio may prevail over other suitors for rights by agreeing to purchase the negotiated rights immediately, subject to "reversion" terms providing for the rights to eventually return to the seller if no show is ever produced. (See Section A.xi below.)

A. Rights Agreements for Books and Articles

i. Option Fees and Terms

The "option" is the buyer's right to purchase the negotiated rights, and the "option period" is the period of time for which that right is effective. When optioning a book or article, an initial option period of twelve months to eighteen months is typical, reflecting the window of time necessary to develop, write, and solicit an order of a television series based on the underlying property.[3] Initial option fees typically range between $2,500 and $10,000, and are applicable against the purchase price, though higher option fees can be found on highly desirable properties and/or in competitive dealmaking situations. Recent demand for expansive science fiction, fantasy, and other genre properties, in particular, has led to a significant spike in option fees for such works, with option fees almost routinely reaching $25,000 and even climbing as high as $100,000. An initial option fee in the range of 10% of the negotiated purchase price is typical.

Most option/purchase agreements also include a studio option to extend the option period by an additional nine to eighteen months, usually for the same price as the initial option fee (or proportionate to the size of the option period), but non-applicable against the purchase price.[4] In some cases, option extension periods may be shorter than initial option periods, or may be conditioned on "active development" or certain development milestones, such as a writer having been engaged to write a pilot teleplay or a network agreeing to develop the project (though such conditions are more common when the optioning party is an independent producer rather than a major studio, which usually resists such conditions).

ii. Purchase Price

The purchase price is the amount paid by the optioning party to acquire the rights under option. It is typically paid upon production of a pilot, though a

3 Some agreements provide for the option period to run from the "as of" date of the agreement, or from the date that the substantive deal terms were initially agreed. Other agreements set the clock as running for twelve or eighteen months from the date the option/purchase agreement is signed. This is because, under U.S. copyright law, an option must be reflected in a signed written agreement to be legally enforceable. While this practice effectively extends the duration of the studio's option, it may create problems down the line if the parties do not keep an unambiguous record of when the agreement was actually signed. In addition, the negotiation of written paperwork may take several months to complete, which could be regarded as unjustly inflating the initial option period. As a result, the parties to an option/purchase agreement may, in the course of negotiating paperwork, agree to start the option clock from a specific negotiated date, which may be sometime between when the initial deal terms were agreed and when the actual written contract was finalized.

4 In addition, the legal boilerplate for these agreements will typically provide that the option period is automatically extended in certain circumstances, such as the occurrence of a force majeure event (i.e., "acts of god" such as war, earthquakes and major weather events, union strikes, and other events beyond any party's reasonable prediction or control), or during the pendency of any adverse third-party claim that may undermine or encumber the optioned rights.

studio whose option is about to expire (and which does not hold any contractual option extensions) may elect to purchase the rights prior to the expiration of the studio's option in order to retain the rights.[5] On the other hand, in rare instances, the payment of the purchase price may be deferred to production of a series based on the rights.

A typical purchase price for a book or article may range between $30,000 and $100,000, though again, the prominence of the property (in terms of audience, sales, or other metrics), the scope of the property (e.g., a book series vs. a short story or short-form article), and the presence or absence of a competitive dealmaking situation may drive purchase prices as high as $500,000, a purchase price that was once reserved exclusively for theatrical productions. More recently, however, the hot market for underlying rights has seen purchase prices for mega-properties in the millions (though such extra-large purchase prices are often further applicable against subsequent payments, such as royalties, bonuses, or contingent compensation). If a project may be developed as either an ongoing episodic series, or a closed-ended television movie or mini-series, there may be different purchase prices negotiated for each form of initial production (with television movies and limited series coming with a higher price tag). If theatrical feature film rights are subject to the option, they will also often be subject to a separately negotiated purchase price—usually higher than the corresponding television purchase price, and often denominated as a percentage of the film's ingoing[6] production budget (2% to 3%) with a floor and a ceiling (with ranges that could span from $100,000 to as much as $2,000,000 for a bestselling blockbuster property).[7]

iii. Royalties

Where the applicable production is an ongoing episodic television series (as opposed to a television movie or mini-series), in addition to the purchase price, the deal will also include a negotiated episodic royalty, which is payable to the rightsholder for the life of the series's production. These royalties typically range from $1,500 per episode to $10,000 per episode (excluding the pilot) and may be tiered depending on the platform for which the series is produced.[8] They are

5 In general, all that is required to exercise an option is a timely written notice, accompanied or promptly followed by a check for the applicable purchase price.

6 The significance of this percentage being calculated on the "ingoing budget" is that if the film goes overbudget the purchase price customarily does not increase proportionately.

7 Often, a studio acquires rights for television and motion picture productions simultaneously, potentially without knowing what medium the studio will initially pursue for adaptation.

8 For instance, because budgets for broadcast television series tend to be higher than for cable television series, the deal may specify a higher episodic royalty if the applicable series is produced for broadcast than if it is produced for cable. Some studios may also allow this higher tier to include premium pay cable networks (such as HBO, Showtime, and Starz), while other studios may employ a three-tier system, with broadcast networks occupying the highest tier, premium pay cable networks occupying a

"passive," meaning that there is no requirement that ongoing services be rendered in order to receive these payments. In addition, rightsholders may negotiate to receive further royalties for reruns of each such episode, though this is not as commonly granted for underlying rightsholders as for pilot script writers,[9] and this right may be granted for broadcast network television series but not for cable series (where heavy reruns are more common) or digital series (where on-demand streaming renders the concept of a "rerun" a non sequitur).

iv. Backend

In addition to a purchase price and royalty, the seller of television rights will expect to receive a share of the "backend" or contingent compensation from the series. Depending on the stature and nature of the underlying property, this share tends to range between 1.5% and 5% of modified adjusted gross receipts ("MAGR") or the corresponding principal defined form of contingent compensation used by the applicable studio.[10] The majority of properties draw 2.5% of MAGR in backend.[11] Because it is based on the adaptation of existing intellectual property, as opposed to the ongoing rendering of services, the share of backend accorded in respect of the underlying source material is typically considered fully vested from inception.

v. Bonuses

Additional bonuses are a common, but not ubiquitous, economic element of underlying rights deals. The most common bonuses are for the ordering of a series (as opposed to merely a pilot) based on the underlying rights and are referred to simply as "Series Sales [or Sale] Bonuses" (or "SSBs"). These typically range from $10,000 to $50,000, with $25,000 being especially common. The bonus is typically subject to proration based on the number of episodes actually ordered and broadcast. Where a property is more valuable, or a rightsholder has essentially granted a discount on the initial purchase price, there may be additional bonuses (sometimes of comparable value; sometimes of escalating value) built into the deal for subsequent seasons of the series. If the initial option

middle tier, and basic cable networks occupying the bottom tier. Premium digital services such as Netflix and Amazon, whose budgets on their most prominent series frequently exceed those of broadcast network series, are usually included in these higher tiers. Precise categorization often varies according to the particular policies and practices of each studio. Henceforth, where this book refers to "tiering" of entitlements according to networks/platforms, the foregoing breakdown may be assumed to apply.

9 See Section A of Chapter 5.

10 The definition and accounting for contingent compensation is discussed in greater detail in Chapter 6.

11 A single percentage point of MAGR is sometimes referred to as a "point," so this might be referred to as "2.5 points."

is obtained by a small independent producer (especially if that initial option is granted for free), there may be "set-up" bonuses triggered by the development of the project with a major studio or a network. In addition, if an option/purchase agreement is entered into for a still unpublished book, the purchase price may be subject to certain "Best Seller Bonuses," meaning escalations to the purchase price (if the option is exercised) triggered by the book's appearances on the New York Times Best Sellers List.

vi. Granted Rights

Every option/purchase agreement must specify the rights that are being optioned, and are therefore subject to purchase, by the studio. Major studios typically define their rights acquisition as encompassing all rights in the underlying property, other than those that are expressly reserved (i.e., starting from 100% of rights and working their way down). Smaller producers and studios may settle for acquiring only specified rights (e.g., "all motion picture and television rights"), with all rights not expressly enumerated being reserved by the seller (i.e., starting from 0% of rights, and working their way up). Although television rights are the obvious rights subject to such deals, rights deals must also encompass so-called "allied and ancillary" or "subsidiary" rights, such as merchandising, music publishing, soundtrack, live stage, theme park, and subsequent/derivative productions. In addition, where the rightsholder claims trademark rights in any elements of those properties, it may be necessary to negotiate terms around the transfer, co-registration, or other coordination of such rights, particularly where the buyer wishes to integrate such trademarks into the title of the contemplated series and/or engage in merchandising and other licensing activity around the series.

vii. Reserved and Frozen Rights

"Reserved rights" refers to those rights in a piece of intellectual property that are excluded from the grant of rights under an option/purchase agreement and that are therefore "reserved to" the seller/grantor of rights (e.g., the author of a book). Because most major studios' rights deals operate on the (non-negotiable) model of acquiring all rights in the underlying property other than explicitly reserved rights, much of the negotiation of agreements focuses on reserved, rather than granted rights.

The author or rightsholder of a book or article is essentially always permitted to reserve the ongoing right to publish the original work, and to publish or authorize the publication of author-written prequel or sequel books (although there may be negotiated limitations on "enhanced books" that incorporate audiovisual elements, and/or negotiation about the pre-acquisition of corresponding motion picture and television rights in such author-written sequels). The status of comic books and graphic novel adaptations may also be subject to negotiation—rights

grantors seek to reserve these rights as a form of publishing, while grantees seek to acquire them as a form of merchandising.[12]

Other rights typically reserved by the author without controversy include radio rights (i.e., dramatic radio adaptations); live recital rights (i.e., public readings); and possibly live television rights (i.e., live telecast of a dramatic performance).

Authors often seek to reserve merchandising rights in their works, and in particular, rightsholders for science fiction, fantasy, and other genre titles tend to fight hard to reserve or at least freeze potentially lucrative video game rights. Studios strongly resist any such reservations of rights. There may be a distinction drawn between "classic merchandise" (i.e., merchandise based solely on the underlying work) reserved by the author and "series merchandise" (i.e., merchandise that recognizably incorporates logos, actor likenesses, or other unique elements of the television adaptation) controlled by the studio, though typically, this is only entertained by the acquiring studio where there is a meaningful preexisting merchandising program in place for the property.[13] Otherwise, most television studios have a strong expectation that they will control merchandising and, at best, may agree to a "separate pot" royalty granting the rightsholder a share of merchandising revenue that is not cross-collateralized with series production expenses and distribution revenues.

Major negotiation may take place around theatrical feature film rights and live stage rights, which may have significant value. The acquirer's ability to obtain such rights may depend on the relative bargaining power of the parties, and on the buyer's ability to make the case that it is positioned to effectively exploit such rights (e.g., through an affiliated motion picture production and distribution arm).

Rights reserved by the author, other than publishing rights for the initial work and author-written sequels and live recital rights, are typically subject to holdbacks that prevent the owner from exploiting such reserved rights for a defined period of time. Many television studios employ a framework from feature deals known as the "5/7 holdback"—reserved rights are held back until the earlier of five years following the initial exhibition of a production based on the property,

12 In some cases, the authors may have already granted such comic book/graphic novel rights to the publishers of their books, in which case the rights would not be available to grant to the studio in any event.

13 For instance, Robert Kirkman—the author of *The Walking Dead* comic book series on which the AMC series of the same name is based—had already sold licensed *Walking Dead* t-shirts, toys, and other merchandise directly to fans prior to making his deal with AMC for the TV rights and was able to retain those rights in his deal with AMC. *The Walking Dead* comics use a different logo than the TV series, and the characters, as drawn by Kirkman, are visually distinct from the real-life likenesses of the actors who portray them on TV. Kirkman has registered numerous trademarks and extensively licensed such "classic" *Walking Dead* merchandise across a variety of product categories, and Kirkman's *Walking Dead* merchandise lives alongside similar *Walking Dead* merchandise licensed by AMC, which "series merchandise" uses show-specific assets such as the TV series logo and actors' likenesses.

or seven years following the execution of the rights agreement. However, because of television's ongoing serialized production and distribution model, a more common holdback structure would be clocked to the initial exhibition of the last episode of a series or the expiration of a network's option to order more seasons of the series, with the actual length of the holdback (usually one to three years) potentially expanding as more seasons of the series are actually produced. These reserved rights may also be subject to a right of first negotiation and/or a right of first or last refusal in favor of the purchaser of the granted rights, as that party would have a natural interest in acquiring such reserved rights at some future time.[14] And again, each of these rights (particularly, e.g., theatrical motion picture rights) may have a separate purchase price and/or backend structure assigned to it.

Where parties cannot reach agreement on the granting or reservation of rights—again, most commonly with respect to theatrical feature film rights and/or live stage rights—they may agree to freeze these rights. "Frozen rights" are unexploitable by both the buyer and the seller unless the parties are able to reach some future agreement on the terms for the "unfreezing" and exploitation of these rights, or the "freeze" of the rights otherwise expires according to the terms of the contract and the rights revert to the sole control of one of the parties.

viii. Consulting Services

Rights agreements may include a services agreement element, by which the author of the underlying work agrees to render ongoing consulting services to assist the studio with developing and producing the series based on his or her work. For the seller, this is a way to draw more financial benefit from the deal; for the buyer, the author's perspective may be useful to the writers and producers of the series, particularly where the underlying work is autobiographical or heavily research-based. Consulting fees typically range between $1,500 and $10,000 per episode and may be committed for a single season, two or three seasons, or for the life of the series. Unlike a royalty, these fees are not passive and require

14 A "right of first negotiation" (sometimes also referred to as a "first opportunity," "first opp," "FN," or "ROFN") is a requirement that the seller of rights must undergo exclusive good faith negotiations with the holder of the ROFN before the seller may negotiate with other interested parties. This "first window" gives the ROFN holder the opportunity to take the rights off the market before others have an opportunity to bid. The terms "right of first refusal" ("FR" or "ROFR") and "right of last refusal" ("LR" or "ROLR") are often used imprecisely. Practically, a "first refusal" is a requirement that, if the seller of rights is prepared to accept terms less favorable to the seller than those last offered by the holder of the FR right (or, alternatively, less favorable than those last demanded by the seller), then, prior to accepting the deal, the seller must give the FR holder an opportunity to purchase the rights on those same terms. A "last refusal right" differs from a "first refusal right" in that the seller must give the LR holder a final opportunity to accept the deal, even if a third party has offered the seller more favorable terms than were ever offered by the LR holder. Last refusal rights are especially burdensome and are quite rare.

the author to be available to render a reasonable amount of services when called for, though in practice, the level of commitment is often very low, and authors often relish the opportunity to have an ongoing impact on the television series based on their work. At higher levels, particularly where the author has some personal experience in television, such consulting deals may escalate to full-fledged non-writing producing deals.[15]

ix. Credit

Source credit is typically accorded to the underlying work from which a series is adapted. A typical form would be "Based on the novel by [AUTHOR]" if the series has the same title as the underlying work, or "Based on the novel [TITLE] by [AUTHOR]" if the series has a different title. For non-fiction works, "Inspired by" credit is more common than "Based on," typically for risk management reasons—television series based in whole or in part on true-life events must often emphasize their fictionalization in order to reduce the risk of right of publicity and/or defamation claims from the individuals connected to the works.[16] Rightsholders typically seek to negotiate for these source credits to appear in the main or opening titles,[17] rather than the end credits, of a series. In addition, rightsholders may push for such credits to appear in paid advertising for the series (with placement often tied to credits accorded to writers and creators).

If the rightsholder's name is a meaningful marketing tool (e.g., Stephen King), then the agreement may include a much more detailed description of how the studio may or may not use the rightsholder's name, likeness, and biographical information to promote the series, both on screen and in advertising. If the rightsholder is a household name, the deal may go so far as to allow (or, alternatively, require) the studio to title the series using a possessory credit with the

15 See Section C of Chapter 5.

16 See Section C of Chapter 3.

17 Although these terms are used somewhat inconsistently and interchangeably, to be precise, "main titles" refers to an opening title sequence that precedes the actual action of the episode (and may be elaborately animated or produced, as in the case for well-known, Emmy-winning main title sequences for HBO's *True Detective* and *Game of Thrones*), while "opening titles" refers to credits that appear at the beginning of the episode, with text superimposed over the actual filmed action of the episode. There is significant flexibility (and inconsistency) in which credits appear in the main titles vs. the opening titles, and not every series necessarily includes both main and opening titles. In general, main titles contain, at a minimum, the name of the series and often the series's "Created By" credit (which is described in greater detail in Section A.x of Chapter 5). Some main title sequences also incorporate the credits for series regular actors (whose deals are described in greater detail in Section E of Chapter 5). Longer main title sequences may also include credits for producers, episodic directors, and episodic writers, though these are more often included in the opening titles. In general, credits for individuals of like functions (e.g., all series regulars, all producers above a given seniority level, etc.) are grouped together within one of these two title sequences. But creative variations abound; for instance, some shows include neither main titles nor opening titles, and credit even senior cast and crew at the end of the episode (a format sometimes referred to as "main-on-end").

rightsholder's name, such as *Stephen King's Storm of the Century* (ABC) or *Philip K. Dick's Electric Dreams* (Amazon).

In addition, if there is a consulting services component to the rights deal, there is usually a separate credit granted to the author for such services. "Executive Consultant" is a standard lower-level credit, usually granted in the end titles; "Consulting Producer" would be considered a higher-level credit and may be granted in the main or opening titles (where other major producers are credited). If more substantial credits are accorded (such as "Co-Executive Producer" or "Executive Producer"), these services agreements have typically been expanded into full-fledged producing deals, as noted in Section A.viii above.[18]

x. Subsequent Productions

Because the rights granted in these agreements typically include the right to produce future productions (whether remakes, sequels, prequels, or spinoffs of the original series), there are usually negotiated economic terms that relate to such subsequent productions (also sometimes referred to as "derivative productions").

Payments for subsequent series may include additional purchase prices, royalties, bonuses, and backend; the buyer will typically seek to limit the variety of repeated payments (e.g., royalties and backend only), while the seller will seek to have all of the various forms of payment obligation revived for subsequent series.

A low-level rights agreement might provide for 50% of the applicable negotiated payments for the initial series to be made for any generic spinoffs (definitions vary, but typically meaning a spinoff that includes as a principal character one or more principal characters who appear in the original series or the underlying work) or sequels/prequels, 33% of the applicable negotiated payments to be made for any remakes, and 25% for any planted spinoffs (spinoffs that follow a character introduced anew into the original series in order to set such characters up for their own series, e.g., the character of Mork from Ork, played by Robin Williams, who appeared in a single episode of *Happy Days* before being spun off into the series *Mork & Mindy*). At higher levels, generic spinoffs, sequels/prequels, and remakes may be subject to rights payments up to 100% of the payments owed for the original series, and planted spinoffs paid at up to 50%.

xi. Reversion

Rightsholders will often negotiate for the rights granted in an option/purchase agreement to automatically return to the grantor after a specified period of time, depending on whether, or the extent to which, programming has actually been

18 The WGA discourages crediting individuals as "Creative Consultants," and requires studios to obtain a special waiver from the guild in order to accord credit to an individual in this particular form.

produced based on the granted rights. This concept of "reversion" is a subtle but often hotly contested deal issue.[19]

Reversion is typically allowed without objection when rights are purchased but no pilot is ever produced, or if a pilot is produced but no series episodes are produced. (A typical reversion may kick in if no pilot is produced within a year of rights purchase or no series is produced within a year of completion of the pilot.) However, the issue is more contested where the rightsholder looks to reclaim rights even after a series is produced. Buyers will want their purchase of rights to vest permanently if any series episodes are produced; sellers will want rights to eventually return to them no matter how many series episodes are produced, once continuous production of a series has ended. Typical compromises involve rights that vest permanently with the buyer if a threshold number of episodes or seasons of the series are produced (often two to three seasons or seasons' worth of episodes), but that are subject to reversion if those thresholds are not met. The reversion typically occurs one to three years after the last episode of a series is exhibited (or after the network's option to order more seasons expires), and, as with the holdback on reserved rights, this time period may increase or decrease depending on how many episodes/seasons have actually been produced before cancellation. For the most part, unless the property under option is extremely well known or valuable, the studio will insist that, at some point, its rights vest permanently.

Reversion is typically subject to a lien for the buyer's purchase price and its unreimbursed development expenses (if no pilot or series was ever produced), or at least for its purchase price (if a pilot or series was produced). The buyer may also seek a passive participation in any new productions based on the rights it had previously acquired, the right to and size of which may also be tied to how many episodes/seasons had actually been produced (if any) prior to reversion, and which typically range from $2,500 to $5,000 per episode in royalties and 2.5% to 5% of MAGR in backend. The buyer may also seek certain additional protections in a reversion scenario, such as a further holdback on the exploitation of reverted rights, or first negotiation and/or first refusal rights to reacquire reverted rights.

19 Reversions are somewhat rarer in the theatrical feature film world, where studios typically exercise their options as close as possible to the commencement of principal photography, and a single produced film is usually considered good enough to permanently vest the studio with the acquired rights. In the theatrical context, reversions may come up if a very aggressive studio in a highly competitive bidding situation agrees to purchase the rights outright, rather than pay for a mere option. In addition, where a rightsholder has great leverage, the studio may agree that sequel or remake rights revert if a certain number of years (typically five to ten) pass following the release of the first produced film, in which no sequel, prequel, or remake is produced. Some observers have attributed Columbia Pictures' repeated and narrowly spaced reboots of its Spider-Man franchise (in 2012 and again in 2017) to the studio's need to continue producing new Spider-Man films, lest the rights to the character revert to Marvel (which, after selling the Spider-Man film and television rights to Columbia, began producing its own superhero movies before selling itself to Disney in 2009 for $4 billion).

B. Life Rights Agreements

As described in Chapter 3 (which delves more deeply into the question of what "life rights" are and why a studio would need to acquire them), a "life rights agreement" is not, strictly speaking, a "grant of rights," but rather, a waiver of claims that may otherwise be brought by an individual who is depicted without his or her consent in a television series. The overall structure of such an agreement is nevertheless generally identical to that of an option/purchase agreement for rights in a book, article, or other published work, although these deals tend toward the lower end of the economic range described in Section A above.

The buyer of "life rights" generally demands that the rights and waivers it receives under the deal are granted exclusively (so as to prevent any competing "authorized" projects about the same individual), and that the subject cooperates (again, exclusively) with the buyer going forward (for example, by providing access to personal notes and memorabilia, or assisting in obtaining releases from friends and family members). Specific negotiation may take place concerning the scope of the rights granted (e.g., for a television series only vs. for other entertainment products such as films and stage plays, carveouts for news or documentary programming, etc.); limitations on the portions of an individual's life that are subject to the rights grant/ claim waiver (e.g., limiting the grant to a certain time period in the individual's life); specific objective restrictions on how the individual may be portrayed (e.g., prohibiting the individual from being portrayed as committing a crime or engaging in an extramarital affair); and rules governing whether the real names of the subject (or the subject's family members) may be used in the actual series.

C. Format Rights Agreements

Another increasingly rich source of television inspiration is, simply, television: formats of television series from foreign countries. The term "format" refers generally to the overall concept and branding of a copyrighted television program, independent of the specific scripts and shot episodes of the series itself.[20] Unscripted series formats, such as singing competitions *American Idol* and *The Voice*, have long been exported across national boundaries and adapted into local versions. More recently, scripted series have become subject to the same process of international exportation, with general story, setting, and characterization (but not necessarily specific scripts, dialogue, and filmed production assets) being packaged and adapted across territories. NBC's long-running hit *The Office* was based on a British television

20 The level of copyright protection for series formats (which do not include expressive elements such as specific dialogue and individual storylines) is debatable in light of legal concepts like the idea/expression distinction and *scenes a faire* doctrine. (See Section A of Chapter 3.) Trademark law would, at best, prohibit the recycling of the name of a television series, but not the substance of its format. (See Section B of Chapter 3.) The robust market for television formats seems to represent an unspoken détente among studios around the world. In other words, each studio subscribes to a worldwide industry custom and practice of paying for format licenses in part to ensure that other studios accord them the same courtesy.

series of the same name; Showtime's *Homeland* is based on an Israeli series called *Prisoners of War*; NBC's short-lived *Game of Silence* was based on Turkish series *Suskunlar*. Formats also travel in the opposite direction, out of the United States: Fox's first major comedy hit, *Married . . . with Children*, has been adapted to local versions in at least a dozen countries, while AMC's hit *Breaking Bad* was recently recreated for the Latin American market as *Metastasis*.

Format rights agreements also largely track the structure and economic parameters of option/purchase agreements for print publications—option fees and periods, purchase price, royalties, bonuses, backend, subsequent productions, reversion. However, such agreements often require negotiation around a few more particular aspects of the granted and reserved rights. A format owner may wish to subdivide territorial rights, so as to enter into numerous deals for local productions, across a variety of countries, based on the original series. A U.S. buyer probably only needs to obtain English-language U.S. adaptation rights but must take care to preserve its right to distribute its U.S. version worldwide. Format licensees in the U.S. also typically seek restrictions on the distribution of the original series or other versions in the U.S., as American networks generally will want to limit the availability of other versions, particularly other English-language versions, of a format they have taken to market locally. Format licensees also generally seek the right, to the greatest extent possible, to use other specific elements of the original series (such as music or specific episodic stories or teleplays) in their local version.

In addition, because international format rights are generally held by the individual producers of those foreign formats,[21] and because these individuals are usually experienced television professionals, format rights deals are almost always accompanied by non-writing executive producer deals for the individuals (or principals of the company) who control the format.

D. Other Forms of Underlying Rights

As studios have gone in search of inspiration for their writers (and dedicated built-in audiences for their potential series), they have experimented with an increasingly diverse universe of source material as the bases for their projects. When AMC's *The Walking Dead* premiered in 2010, it may have been considered unconventional for drawing on a long-running independent comic book series by Robert Kirkman. Recent years have rendered the idea of a comic book adaptation mundane in light of subsequent series based on Twitter feeds (CBS's *$h*! My Dad Says* in 2010), web series (Comedy Central's *Broad City* in 2014), podcasts (ABC's *Alex Inc.* in 2018 and Amazon's recently announced *Homecoming*), and even defunct corporate trademarks (ABC's *Pan Am* in 2011).[22]

21 This is at odds with norms in the United States, where studios (rather than individual producers) generally own and control the format rights for the series they produce.

22 *Pan Am* is perhaps the only scripted television series essentially "based on" a mere trademark, without any further underlying narrative material. However, the notion of "adapting" a trademark into series form is more common in the context of unscripted television. See Section D.ii of Chapter 10.

In general, these deals follow the basic template of underlying rights deals for books and articles (although underlying material with minimal narrative content or which is subject to very thin intellectual property protection will tend toward the less lucrative end of the pricing spectrum). To the extent the material is also autobiographical or otherwise non-fiction in nature, the deal would also need to be structured and drafted to include "life rights"-style waivers, as applicable. To the extent the material's title (which the studio may wish to use in connection with its own series) is also subject to trademark protection (which books and articles conventionally are not, unless they have already given rise to a merchandising and consumer products program), the deal would need to account for these rights. In general, however, this is a matter of careful thought and drafting, and these rights extensions are meant to anticipate potential legal issues without necessarily requiring any further compensation to the rightsholder.

If the underlying material continues to exist and grow outside of the television series (e.g., an ongoing serialized podcast, web series, comic book, or Twitter feed), a well-structured deal will also address whether the studio also acquires rights to subsequently created material (and whether any additional compensation is due in connection with the studio's use of such subsequently created material); whether the rightsholder has any right to use studio-owned or created intellectual property in its own series; potential limitations on the rightsholder's right to continue its project if a television series is produced (particularly in the case of web series or other audiovisual materials); and ongoing coordination efforts between the rightsholder and studio to maximize value and avoid interference in the marketplace.

E. Quick Reference Guide

TABLE 4.1 Underlying Rights Agreements

Deal Term	Main Issues/Ranges	Other Issues
1. Option Fees and Terms	• Initial option periods between 12 and 18 months • Initial option fees usually $2.5K to $10K (or 10% of purchase price) • Options to extend option fee for additional fees	• Initial option fees usually applicable vs. purchase price • Option extension fees usually non-applicable • Possible extension conditions (e.g., "active development," setup, etc.)
2. Purchase Price	• Usually $30K to $100K • At high levels, up to $250K, but mega-properties may be in the millions	• Usually paid on pilot production (or first episode if no pilot); may be deferred in part to series

(Continued)

TABLE 4.1 (Continued)

Deal Term	Main Issues/Ranges	Other Issues
		• May have separate prices for limited series vs. ongoing series
		• May have separately stated theatrical feature purchase price (2% to 3% of budget, with floor and ceiling)
3. Royalties	• Usually $1.5K to $7.5K per episode (excluding pilot)	• Possible rerun royalties
		• Possible tiering based on network/budget level
4. Backend	• 1.5% to 5% of MAGR	• Miscellaneous backend definition issues (see Chapter 6)
	• Most commonly 2.5% of MAGR	
5. Bonuses	• Usually $10K to $50K (one-time) for series pickup	• May be prorated based on the number of episodes produced
	• Most commonly $25K	• Possible set-up bonuses
		• Possible subsequent season pickup bonuses
6. Granted Rights	• Usually "all rights," other than reserved rights	• May need to address scope of waivers in "life rights" agreements
	• Must address "all television [and motion picture] rights," including allied/ancillary or subsidiary rights	• For format rights, may need to address right to use specific elements of preexisting series
	• For life rights, must obtain necessary waivers of claims	• For format rights, may need to address exploitation of preexisting series in the U.S.
	• For format rights, must address language and territory restrictions	
7. Reserved and Frozen Rights	• Standard to reserve publication rights (including author-written sequels)	• May need to address grant of equivalent rights in author-written sequels (or exclusivity of elements)
	• Also normal to reserve radio rights, live recital rights, and live TV rights	• Freezing rights may provide a compromise between granting and reserving
	• Comic books and graphic novels?	• Possible to distinguish between "classic merchandise" and "series merchandise"
	• Merchandising?	
	• Stage rights?	
	• Theatrical feature film rights?	• Separate pot royalties for merchandise?
		• Negotiated holdbacks on exploitation of reserved rights other than publishing (e.g., 5/7 holdback)

Deal Term	Main Issues/Ranges	Other Issues
8. Consulting Services	• Usually $1.5K to $10K per episode • Locks between 1 year and life	• At higher levels, may be styled as Producer or Executive Producer deal
9. Credit	• Customary source credit ("based on") • "Executive Consultant" or "Consulting Producer" credit for services	• May prefer "inspired by" for true-life stories • Services credit may be at higher levels ("Producer" or "Executive Producer")
10. Subsequent Productions	• 50% to 100% for generic spinoffs/sequels • 33% to 100% for remakes • 25% to 50% for planted spinoffs	• Typically paid based on royalties and backend only • May apply to purchase prices, bonuses, royalties, etc. as well
11. Reversion	• Rights revert 1 to 3 years after last produced pilot/episode • Reversion window may extend based on number of episodes/seasons produced • Rights may vest permanently if a specified number of episodes/seasons are produced	• Must determine whether episode counts or season counts control reversion terms • Reversion may be subject to liens, royalties ($2.5K to $5K), and passive backend (2.5% to 5% MAGR) • Possible post-reversion holdbacks and FN/FR

5

TALENT AGREEMENTS

A. Writing/Writer-Producer Agreements

Because television is a writer-driven medium, the writer-producer agreement is often the most significant deal in the development process. At the development/pilot stage, there is seldom any such thing as a writing deal by itself—nearly every agreement for the writing or acquisition of a pilot script will include negotiated terms for the writer's ongoing participation in the production of the series as a producer (usually an "Executive Producer," the highest-level credit in television).[1] An experienced creator[2] will be expected to serve as the "showrunner" of the series, the lead creative manager of the production process.[3] This job requires a complete television production skill set consisting not only of the ability to write great scripts, but also to generate story arcs, lead large teams of writers and other production personnel, understand and manage budgets and schedules, and otherwise coordinate with studio and network executives. Less-experienced writers will still usually be engaged as senior-level producers, and

1 In theatrical feature films, the equivalent, senior-most credit is simply "Producer."

2 This book consistently refers to a "writer," "creator," "producer," or comparable individual in the singular. In reality, while many writers work as individuals, many others choose to partner with a co-writer as a "bona fide writing team." Such teams enter into agreements as a pair, and divide all compensation between them (usually on a 50/50 basis). The scale minimum payments applicable to writing teams are the same as those applicable to individual writers, and usually, compensation for a writing team is comparable to whatever would be paid to an individual writer of similar stature. In other words, writing teams don't get paid more than individual writers just because they have two mouths to feed instead of one. Three-person teams are rare, and largely frowned upon by the WGA. Where three individuals render services as a bona fide team, each applicable WGA minimum is increased by 50%.

3 Not all executive producers are showrunners, but all showrunners are executive producers.

will enjoy a meaningful and central creative role in the series going forward but will be paired with (and ultimately subordinate to) more experienced producers who are brought on to run the show, if produced (and who may actually join at a very early stage and help supervise the pilot writing process).[4]

Regardless of the experience level of the writer/creator, the critical factor in these deals is creation credit. As explained in detail in the following sections, writing credit for the pilot screenplay generally determines "creation" credit for the series, and "creation" credit, in turn, dramatically impacts nearly all of the writer/producer's entitlements, from locks to royalties to backend to attachments to derivative productions.[5] Ultimately, in the television world, writers are much more likely than any other creative contributors to be viewed as the creators and auteurs of their series (even if their lack of experience requires that they eventually be paired with a more experienced writer/producer who will "run" the show on a day-to-day basis). And it is that status as creator, as reflected in the formal credits for the series, that serves as the lynchpin to nearly all other components of the writer's deal.

i. Writing and Spec Acquisition

When a writer "sells" a show to a studio, he or she may be approaching the studio with a verbalized idea for a new series (a "pitch"), or with a previously written pilot script embodying that idea (a "spec script"). Less experienced writers must generally write out their ideas, independently and without initial compensation, into a "spec script" in order to attract attention and interest; more experienced writers seldom put pen to paper until they have a firm deal in place based on their pitch.

A "pitch" may be purchased on one of three basic structures—if/come, firm, or blind. An "if/come" deal relates to a specific idea that the writer has pitched to a studio. The studio negotiates writing and producing terms for the writer to develop the idea, but the entire agreement (and all financial commitments) are contingent on the studio, in turn, selling that idea to a third-party network licensee (which will contribute to the development costs of the project). A "firm" deal is reserved for higher-level writers and involves a commitment to pay for the writer to write the project, whether or not a network deal can be put

4 Often, these originating but initially subordinate writers will find their producer status elevated in later seasons, as showrunners move on to other projects and other key creative personnel for the series move up the producing ladder. See Section A.x below.

5 Television writers are much less likely than their counterparts in the feature film world to see their work rewritten by another writer. Compared to feature films, television series are more frequently the product of a single writer/creator. If the original writer cannot figure out how to develop the project into something that the studio and network want to produce and exhibit, the parties are more likely to scrap the project altogether and start from scratch than to bring in a new writer to rework the original writer's efforts.

into place. A "blind" deal is sometimes used synonymously with a firm deal, but more precisely refers to a firm deal that is not tied to a specific predetermined show idea; it may commit the studio to pay for a script from the writer but require the writer to pitch multiple concepts before the studio approves one of them to proceed to writing. Sometimes, these deal structures can be combined; for instance, a studio may make an "if/come" deal with a writer for a specific concept, with the understanding that if that idea does not sell to a network and the if/come deal is therefore never triggered, the deal automatically converts to a blind script deal.

Where a writer walks in with a pre-written spec script, the deal is based on an option/purchase structure (but, again, with a negotiated producing deal as part of the agreement). A writer may grant a free "if/come" option to the studio to immediately shop the spec script to network buyers; a network's commitment to develop the project could then trigger either a paid option fee (and specified option window), or the payment of the whole purchase price. Alternatively, particularly if the studio does not intend to pitch the spec script to networks in its current form, the studio may immediately pay for an option on the script (which, again, usually costs about 10% of the purchase price, and in any event must be no less than 10% of the WGA scale minimum price for the pilot script). Again, the parties may negotiate as to whether payment of the purchase price is triggered merely by a network's agreement to develop the project, or only when the studio elects to purchase the rights (or, at latest, upon commencement of production of a pilot based upon the script). Larger studios are apt to pay the purchase price based on earlier triggers, in order to attract writers with more immediate paydays and maintain tighter control of rights; smaller studios may seek to defer large payment obligations as long as possible (ideally until a major studio or network brings its checkbook to the table), which also allows writers to avoid divesting themselves of ownership of their scripts without a more certain network development opportunity in play.

A script deal typically buys out five writing steps—a story (or outline), first draft, two sets of revisions, and a polish[6] (although creative executives and non-writing producers will often informally manage the writing process and, in practice, obtain more drafts from writers than are formally reflected in this structure). Where a spec script is acquired, the purchase price typically buys out the initial story and draft reflected in the existing script, and pre-pays for the two sets of revisions and the polish by the writer.

As of 2018, WGA scale minimum for a network primetime thirty-minute pilot script (story and teleplay) is approximately $40,000, and for a network primetime sixty-minute pilot script (story and teleplay) is approximately $59,000. For non-network primetime (e.g., cable), the applicable scale numbers are approximately

6 A "polish" is a term of art for a less labor-intensive revision to a screenplay, in which changes are made to dialogue, narration, or action, but without altering the basic storyline or interrelationship of characters in the script.

$23,000 for a thirty-minute script, and approximately $42,000 for a sixty-minute script.[7] Larger studios, as a matter of policy, tend to pay at least the "upset price" for a pilot script. The "upset price" is a WGA-determined minimum—as of 2018, approximately $55,000 for thirty-minute pilot scripts and approximately $81,000 for sixty-minute scripts—which allows the studio to buy out certain "separated rights" (including stage, theatrical, publication, and merchandising rights), which are otherwise automatically reserved to the writer/creator of an original television series under the WGA Basic Agreement.[8] Independent studios may negotiate separate writing fees or purchase prices, depending on whether the project sells to a broadcast network (or other high-budget platform, such as Netflix or HBO) or a cable network. Where a deal is based on WGA scale minimum fees, the parties may sometimes negotiate to add a 10% premium on applicable WGA scale amounts in order to cover the agency commissions payable by the writer on his or her fees.

The actual writing fee/purchase price negotiated may vary wildly depending on the "quotes"[9] (i.e., past deals) of the writer; the contemplated budget of the project; the nature of the contemplated distribution platform; the policies of the studios and networks involved; and applicable WGA scale. For major broadcast, cable, and premium digital television production, writing fees/script purchase

7 These pilot minimums are each 150% of the corresponding scale minimum payments for non-pilot scripts. These minimums, as well as all other WGA scale minimum amounts, generally increase by 2.5% to 3% annually.

8 Although the WGA Basic Agreement technically requires a "separate negotiation" in a "separate document" and for a "separate consideration" for the studio to acquire such separated rights, studios generally manage this via a small separate form included with the writer agreement and a nominal separate fee (e.g., $100), both of which are effectively non-negotiable.

9 This text will refer frequently to such quotes as impacting the negotiations for various individuals' services, and for many years, the "quote system"—in which studios request an individual's "quote" as the first step in commencing a deal negotiation and largely seek to anchor deal terms to match or only narrowly better the terms to which the individual previously agreed—has largely defined the negotiation context of the television industry. This, however, may not be true for much longer. In January 2018, a new California state law went into effect prohibiting employers from inquiring about a candidate's salary history in the course of negotiating terms of employment. A similar New York City ordinance went into effect in November 2017. These laws (which applied across all sectors, without specifically targeting the entertainment industry) were intended to close the gender pay gap, as the systematically lower wages earned by female workers across all sectors were frequently justified by the fact that employers typically anchored salary negotiations to candidates' actual salary histories, thereby making it difficult or impossible for female workers to ever catch up and "close the gap" between them and their male counterparts. Under the new laws, employers (which would include studios negotiating deals with writers, producers, actors, and other service providers) cannot ask about an individual's past fees and cannot justify wage disparity between the sexes solely on the basis of earning history, although individuals remain free to volunteer information about their salary histories in the course of negotiations. By essentially illegalizing a request for an individual's "quote," these laws promise to reshape negotiation dynamics in the television industry (and indeed, throughout the entertainment industry). The market for actor fees appears likely to be most affected by the change in law. As the ultimate effect of these laws is still unclear, however, this book will continue to refer to "quotes" as relevant factors in deal term negotiation.

prices tend to range between approximately $75,000 and $250,000, with most scripts costing between $100,000 and $200,000, and some outliers on either end (particularly for successful feature writers, who are accustomed to drawing larger writing fees for theatrical projects). WGA scale minimums may or may not be applicable to productions written for new media (digital) exhibition, depending on the budgets of the productions and the number of subscribers to the service; on smaller platforms and for short-form productions, prices are freely negotiated, and are typically significantly lower than for traditional television development (e.g., approximately $10,000).

ii. Producing Fees

Producing fees for writer/producers who create a series are a function of a number of factors, including the quotes of the writer; the contemplated budget of the project; the nature of the contemplated distribution platform; the policies of the studios and networks involved; and whether or not the writer/producer is expected to serve as the showrunner. It is generally understood that broadcast networks, premium pay television networks, and premium digital platforms support higher overall budgets—and therefore higher fees to executive producers. When the eventual platform is unknown at the time a project is initially put into development, the deal may provide for tiered executive producer fees depending on the identity of the network buyers. In addition, many studios require that total ingoing executive producer fees on any given project be capped; consequently, a writer/producer who is working as part of a large team of collaborating producers may be expected to work for lower fees than if that same writer/producer was involved in a package with fewer high-level collaborators.

Executive producer fees for writer/creators generally range from $15,000 per episode to $60,000 per episode, depending on the various factors set forth above—though again, there are outliers on either end. The applicable fees for smaller digital studios and digital productions, especially short-form, are usually significantly lower. On the other hand, experienced creator-showrunners on high-budget projects can see fees closer to $100,000 per episode. Pilot fees may be identical to the negotiated episodic fee for the first season, or slightly elevated. Cumulative annual bumps of 5% in episodic fees are typical, but variations abound; some studios insist on lower (e.g., 4% bumps), while others may be willing to offer larger, round increases between the first and second season's episodic rates (e.g., an increase of $2,500 or $5,000 per episode), particularly where the executive producer is perceived to have allowed some form of "discount" on the initial fee.

iii. Years/Locks

Most deals for producing services by a writer/creator cover a pilot and two seasons of production (although inexperienced, lower-level writers may sometimes

be forced to accept three-year deals). Because of the central role that writers (as creators, showrunners, or both) play in the creative process, writers generally prefer such short-term deals for at least two reasons: first, because of the expectation that, in success, they will be able to negotiate a more favorable deal to return to a show in its third season (or thereafter); and second, to allow themselves greater freedom/opportunity to move on to their next creative endeavor at that time.

While a two-year deal may often be presumed for a writer/producer creator, the "lock" under the deal may be more heavily negotiated. In television, the presumption in every deal is that a studio never actually has to *use* the services of an individual it has engaged, but it may have to pay for those services even if they are unused. This is the concept of "pay-or-play"—a guarantee that an artist will be paid some specified amount, whether or not the artist's services are actually required by the hiring party. "Pay-or-play" protects artists by providing for some amount of their fees to be guaranteed, but it also protects studios by preserving the studio's unfettered right to terminate anyone, at any time, with or without cause, as long as it is willing to deal with the financial consequences (if any) of that decision.

The "lock" under a writer/producer deal refers to the period of time for which the writer/producer's fees are guaranteed, if the series is actually produced for that long, whether or not the writer's services are actually used. A "one-year lock" would guarantee the payment of episodic fees for the pilot and all episodes produced for the first season of the series. A "two-year lock" would guarantee the payment of episodic fees for the pilot and all episodes produced for the first two seasons of the series. A "modified two-year lock," also known as a "two-year Warner lock," is effectively an initial one-year lock, which automatically expands to cover the second season of the series if the studio fails to exercise its "pay-or-play" right (i.e., termination without cause) prior to the completion of the individual's services on the first season.[10] In any event, the guarantee provided by the "lock" only applies to the extent that series episodes are actually produced; a "two-year lock" would not entitle a writer to two years' worth of episodic fees if only one season of the series is ever actually produced.

The vast majority of deals for writer/producers who function as series creators provide for two-year Warner locks. Higher level deals for more experienced writers may provide for a firm two-year lock. At the very highest levels, a creator with major bargaining power may negotiate for a "life lock"—i.e., to be guaranteed the payment of the artist's episodic fees for all episodes produced for the entire run of the series—with an option (held by the individual) to "drop down" to a lower level

10 To put it another way, if a studio fires a writer under a "two-year Warner lock" any time prior to the completion of the first season, it only has to pay the writer his or her full applicable first season fees, but not any fees for the next season. However, if a studio fires a writer under a "two-year Warner lock" any time after the completion of the first season, the studio will still have to pay the writer his or her full applicable second season fees as well.

of services[11] at some point during the term of the deal. This provides the writer/producer with a maximum amount of protection and flexibility—he or she cannot be divested of his or her fees for the life of the series without cause, but can still force a subsequent renegotiation (in his or her own favor) by threatening to exercise the "drop down" right and effectively walk away from the obligation to continue to work on the show in a full-time showrunning capacity.

Locks for writer/producers are generally credit-contingent. Because the WGA credit determination process[12] has not taken place at the time a pilot is order to production, the writer/producer's lock for pilot services is usually contingent on the individual having been the sole writer of the pilot script, as produced (perhaps excluding production polishes). If the individual was not the sole writer, his or her services are usually at the studio's option. Similarly, a writer/producer's series lock is usually contingent upon the writer obtaining sole "created by" credit on the series according to the WGA's determination; if the writer does not obtain sole "created by" credit, again, his or her services are usually at the studio's option. However, if writers are assigned to work together, or for writers who are brought in to rewrite a preexisting script, it is typically agreed that shared "created by" with concurrent or preexisting writer(s) will suffice to satisfy such a condition.

iv. Services and Exclusivity

When rendering services as executive producers, writer/producers generally work on a full-time basis on a single series and provide services to their studio on an exclusive basis during production periods of that series. In addition, studios often require writer/producers to agree to render services exclusively in the medium of television for the life of the agreement, even outside of active series writing and production periods. However, there are several nuances and exceptions to these general presumptions.

Writers at all levels often want the right to continue to develop projects for third parties and/or to write for feature films, even while one of their series is ongoing. This is generally agreed as a matter of course for hiatus periods (i.e., when the individual's ongoing series is not in active production), and the right to develop (but not produce) for third parties is often permitted (on a part-time, "second position," non-interfering basis) even during production periods (though sometimes such third-party development is not allowed during production of the critical first season of a series).

Extremely experienced and prolific writer/producers may insist on the right to render even production services on more than one series at the same time (often with the benefit of a strong "number two" writer/producer working beneath them).[13] Typically, if this is agreed, it is in a context where all of those

11 See Section A.vi below.
12 See Section A.x below.
13 See Section B below.

series are being produced by a single studio, which can coordinate closely with the writer/producer to manage his or her schedule across various commitments. For instance, during 2013, showrunner Chuck Lorre worked on four different broadcast network comedies—*Two and a Half Men, Mike & Molly,* and *The Big Bang Theory* (all of which Lorre created), and *Mom* (which was created by another writer)—for studio Warner Bros. Television and network CBS at the same time. Similarly, during 2016, showrunner Shonda Rhimes worked on four broadcast network dramas—*Grey's Anatomy* and *Scandal* (both of which she created), and *How to Get Away with Murder* and *The Catch* (both of which were created by other writers)—for ABC Studios and the ABC network at the same time.

v. Preexisting Commitments

Because of the large and steep funnel of television development (many development projects, which yield few pilots, which yield even fewer series), successful writers often have multiple projects in development at any given time. These concurrent deals, which may be made with separate studios for projects that are developed at separate networks, require managing the "priority" or "position" of the writer's various commitments.

In general, the television industry subscribes to a presumption of "first in time, first in line"—services on any project are usually subject to any preexisting contractual commitments, and individuals and their representatives have a generally understood obligation to disclose extant preexisting obligations prior to finalizing any new deals (so that their new employer can make an informed decision to proceed with the deal despite that preexisting obligation). If a writer's higher-priority project goes into production, he or she is usually rendered unavailable to render ongoing services on a lower-priority project. If a lower-priority project goes into production while a higher-priority project is still in development, the studio behind the lower-priority project faces a risk that the writer may be forced to walk away in order to work on the higher-priority project if it is subsequently ordered to production as well. For this reason, studios will often consider a writer who is subject to a higher-priority preexisting commitment to a third party to be effectively unavailable unless that writer obtains a waiver from the other employer of its right to pull that writer away.

If a writer/producer is subject to higher-priority preexisting commitments at the time a script deal is entered into, the negotiated script price is usually discounted somewhat (e.g., by around 15% to 25% compared to what the writer would command for a first-position deal) to account for the risk of the writer's unavailability at the time a pilot or series may be produced. If the writing services themselves are interfered with by a preexisting commitment, the studio usually has the right to "roll" the deal (i.e., to postpone writing by up to twelve months, into the next development season), or to terminate the agreement. If the writer/producer cannot render executive producer services on the pilot due to a prior commitment, series services are usually then at the studio's option.

Usually, if a preexisting commitment goes away (because the project dies in development without ever being produced), subsequent existing commitments automatically move up in "position" or "priority." In some instances, however, aggressive representatives with prolific, in-demand clients (or whose clients are accepting substantially lower-than-market script fees) may seek to make "no position" deals (i.e., deals that do not enjoy priority over subsequent development projects until a production is actually ordered), or to otherwise reserve the right to book additional projects in higher priority than a current deal.

Finally, higher-level writers who are stacking multiple concurrent development projects may make two-tier deals, such that, if the writer/producer is unavailable to render services at a full, "Tier 1" exclusive executive producer level (as described in Section A.iv above), they may still be locked to render services (and collect fees) at a less-demanding (and lower-paid) non-exclusive "Tier 2" level of services (though often still with an executive producer credit).

vi. Consulting

Most writer/producer agreements provide that, at the end of the individual's initial two-year term as an executive producer (assuming that the term of executive producer services is not extended), the individual is locked for an additional two years to render services as a consultant. This is referred to as a "consulting one-for-one," as in one year of consulting services for each year of executive producer services rendered. This may be abbreviated as "consulting 1:1." Consultant-level services are non-exclusive, only occasionally (if ever) in-person, and typically non-writing. Although the studio may require active services to be rendered in exchange for the consulting fees ascribed to such services, as a matter of practice, a former executive producer's stint as a consultant is often nearly or entirely passive, allowing the original creator/executive producer some form of ongoing fee and credit while leaving room for that individual's successor as showrunner to establish and preserve his or her own creative stewardship of the series going forward.[14]

A consulting lock is typically conditioned on the writer/producer having received sole "created by" credit on the series, having rendered two years of executive producer services without being "pay-or-played" (i.e., terminated without cause), and otherwise not being in breach of his or her agreement. The applicable fee is usually $7,500 or $10,000 per episode produced during the two

14 For example, *Community* creator Dan Harmon was fired from the series after its third season and received executive consultant credit (and, presumably, fees) for all of the episodes of the show's fourth season. After Harmon was rehired to return to the show as showrunning executive producer for its fifth season, however, he revealed (via his own podcast) that he had not even watched the fourth season until his rehiring, and publicly criticized the quality of the show as it had been produced without his participation.

years of the consulting lock (non-escalating), though it may be as low as $5,000 per episode, as high as $15,000 per episode, or stated as a fraction (e.g., one-third or, rarely, one-half) of the individual's last-earned executive producer fee. At very high levels, the consulting lock that follows the period of executive producer services may be for the life of the series, rather than on a "one-for-one" basis, though this is rare.

vii. Royalties

In addition to any applicable executive producing and/or consulting fees, the creator of a television series is almost always entitled to a passive episodic royalty for the life of the series, excluding only the pilot (which royalty is cumulative with any services fees or other bonuses payable to the individual). These royalties typically range from $2,500 per episode to $6,000 per episode for a writer who receives sole "created by" credit (as always, with outliers on either side) and are reducible if the writer receives shared "created by" credit to an amount between 50% and 75% of the applicable royalty for sole "created by" credit. The reduction for shared "created by" credit may be automatic to the reduced level indicated above, or on a dollar-for-dollar basis (to the negotiated floor) based on royalties payable to other credited writer(s). And, as with other economic terms, the applicable royalty may be tiered, depending on the platform for which the series is produced. Finally, on broadcast network shows, it is typical for the writer to receive an additional "100/5" royalty—that is, a further royalty payment equal to 20% of the initial royalty amount, payable for each of the first five reruns of the applicable episode.[15]

viii. Bonuses

Virtually every writer/producer deal for a series creator also provides for a series sales bonus, payable to the writer if the project makes it past the pilot stage and a series is actually produced. The vast majority of such bonuses are for $25,000 for a writer who receives sole "created by" credit, reducible (either automatically or on a dollar-for-dollar basis by bonuses paid to other writers) if the writer receives shared "created by" credit to $12,500. However, the applicable "sole credit" bonus may, in some instances, be reduced to $20,000 (e.g., if the series is produced for lower-budget cable, or for very low-stature writers) or increased to as high as $50,000 (for very prominent creators). On rare occasions, series sales bonuses may also be payable for one or more subsequent seasons of a series,

15 For cable programming, some (but not all) studios agree to a "100/12" royalty—that is, a further royalty payment equal to 8.33% of the initial royalty amount, payable for each of the first twelve reruns of the applicable episode by the program's cable licensee. For first-run programming on streaming services, for which the concept of a "rerun" is a non sequitur, no such rerun royalties are generally due.

but such an agreement is unusual and typically a negotiated response to unique circumstances.

Usually, such series sales bonuses are subject to proration based on the number of series episodes actually produced. For broadcast network series, the standard is for the full bonus to be payable based on the production of twelve series episodes (excluding the pilot), with proration downward for smaller production runs, and no bonus payable for fewer than six episodes produced. In cable, the negotiated proration may be more favorable (e.g., 100% payable based on ten episodes produced, inclusive of pilot), less favorable (e.g., 100% payable based on twenty episodes produced, inclusive of pilot), or identical to the standard "12/6 proration" for broadcast network deals, depending on the identities, policies, and order patterns of the studios and networks involved.

In rarer cases, particularly where a writer has agreed to a lower-than-market pilot script writing fee, the deal may also provide for a pilot production bonus (which often serves to get the writer to where they wanted to be economically for the script alone, in the successful scenario of a pilot being produced).

ix. Backend[16]

As with other entitlements under writer/producer deals, the amount of backend accorded to a writer under his or her deal is typically tied to the share of "creation by" credit received by the writer, with a base entitlement that is laid out if the writer receives sole "created by" credit, and various applicable reductions from that base entitlement. Backend entitlements are, like other deal terms, heavily driven by the stature and quotes of the writer and, in particular, whether it is contemplated that the writer will render showrunning services in series, or whether a third-party showrunner will have to be engaged to help produce the series, once ordered. However, because most studios have rigid policies capping the total contingent compensation granted in connection with any given series (for most studios, 35% of the MAGR or the corresponding form of contingent compensation used by the applicable studio), backend reductions are commonly negotiated for heavily packaged projects that involve many prominent elements who are entitled to contingent compensation.

It is common for a writer/producer's backend entitlement to be stated as involving an artificially high ceiling (again, conditioned on the writer receiving sole "created by" credit on the series). This ceiling is usually reducible, to some extent, by participations granted by the studio to third parties (i.e., other producers, writers, actors, and other participants) in connection with the same series,[17]

16 Again, to best understand these terms, it may be best to first consult the more detailed discussion of contingent compensation contained in Chapter 6.

17 It is essentially inevitable that some third-party participations will be granted in connection with the series, and therefore, that this initial reduction will be triggered. Consequently, the initial "ceiling"

and may be further reducible if total backend entitlements on the series, for all participants, exceed a maximum threshold (usually 35% or 30% in the aggregate, without regard for differences in definition). The writer's backend will be further reducible (if not automatically reduced) if the writer receives shared "created by" credit on the series, with, in most cases, no backend actually due for a writer who does not receive even a share of "created by" credit (though such a circumstance is rare, and, when it arises, usually specifically negotiated around). In some cases, where a writer's status as a potential showrunner is uncertain at the time the deal is made, the backend terms may reflect tiering or further reducibility if the writer is not the sole showrunner, and the studio is forced to provide backend to a third-party showrunner.

To illustrate, a substantial writer/producer deal for a writer who is expected to showrun his or her series may provide that the writer receives 17.5% of MAGR if he or she receives sole "created by" credit, reducible on a dollar-for-dollar basis[18] by all participations granted to third parties to 15% of MAGR, further reducible on a dollar-for-dollar basis to the extent that aggregate participations granted on the series exceed 35% of MAGR to a floor for the writer of 12.5% of MAGR, further reducible if the writer receives shared "created by" credit to a floor of 7.5% of MAGR. (This may be stated, in shorthand, as "17.5% → 15% → >35% to 12.5% → for shared to 7.5%.")

At the lowest entry level, floors of 5% to 7.5% for sole "created by" credit, and 2.5% to 5% for shared "created by" credit, are common. At middle levels, floors of 10% to 12.5% for sole credit, and 7.5% for shared credit, are typical. At high levels, one might expect floors of 15% to 17.5% for sole credit, and up to 12.5% for shared credit. The applicable ceilings under such deals may range from 10% (at low levels) to 20% (at high levels) to as high as 35% (at the highest, rarest of levels, 35% representing the full pool of backend most studios will allow on any given project); again, however, the structure of reducibility built into these terms, and the practical necessity of granting participations to parties other than the writer/producer, render such ceilings largely symbolic and cosmetic.

For writer/creators, contingent compensation virtually always vests in quarters—one-quarter upon completion of the writer's pilot writing services, one-quarter upon completion of pilot producing services, one-quarter upon completion of series producing services for the first season, and one-quarter upon completion of series producing services for the second season. Some studios may allow (particularly for higher level writers) for *pro rata* vesting of the final

figure in a backend deal term is often essentially cosmetic and virtually impossible for the participant to achieve, and the floors more relevant in determining the writer's practical, real-life entitlement.

18 Some studios seek to apply such reductions on a point-for-point, rather than dollar-for-dollar basis. If the various participants have substantively different backend definitions that make one party's points more or less valuable than another's, this point-for-point reduction may allow the studio to bank additional savings by essentially pocketing the difference in value between the parties' differently defined points.

two quarters—in other words, if a writer is terminated after half of the episodes of the second season have been produced, he or she will vest for one-half of the final one-quarter of the writer's backend, i.e., for a total of 87.5% of the writer's total backend entitlement. Sometimes, such *pro rata* vesting may require that the writer complete services on at least half the episodes of the season in order to receive any share of vesting for that season.

x. Credit

There are three main credit issues in play in writer/producer deals for show creators: producing credit, logo or company credit, and creation credit.[19]

Pilot writers are virtually always accorded Co-Executive Producer or Executive Producer credit.[20] Some studios offer Executive Producer credit to all creators, regardless of stature; others restrict lower-level creators to Co-Executive Producer credit, or, at worst, Supervising Producer credit, though this is rare. If a junior writer starts with Co-Executive Producer credit for the pilot and first season of the series, it is common for the deal to provide for the writer to graduate to Executive Producer credit in the second season of the series. Such credits are virtually always granted on separate cards (or, for bona fide writing teams, on cards shared only between the members of the team), in the main or opening titles of the series.

Higher-level writers, particularly those with showrunning experience, may also be accorded a "logo credit" or "company credit," in the form of a logo that appears after the end credits at the end of each episode. This logo card typically bears the name of the writer's "production company," though for the vast majority of writers, this is essentially a vanity company name that serves as a calling card for the writer him or herself, and does not signify a meaningful full-fledged production company operation.[21] Negotiated issues around such logo credits include conditions (e.g., requiring that the writer receive sole "created by" credit and/or that he or she be rendering sole or co-showrunning services); whether such logo must be static or may be animated; and whether such logo must appear on a separate card or may be on a shared card with another logo (which is a function of both the writer's stature and the availability of such

19 In television, all credits for all roles are customarily made subject to the approval of the applicable network, including the negotiated credits for writer/producers, other than guild-determined and mandated credits.

20 The hierarchy of television producing credits is discussed in further detail in Section B.ii below.

21 Some of these logo cards can prove iconic with time. Ubu Productions, the independent production company of non-writing producer Gary David Goldberg, gained recognition in the 1980s and '90s for its logo card, which featured an audio cue of Goldberg's voice saying "Sit Ubu Sit! [Dog barks.] Good Dog." Writer/producer Chuck Lorre openly refers to his production company logo as a "vanity card," and customizes that card, on an episode-by-episode basis, with lengthy comedic texts, directed specifically at the audience, discussing (in text far too long for two seconds of screen time) topics as varied as Lorre's show's stars, network executives, atomic bomb drills, and veganism.

logo cards, which are limited in number by virtually all networks to no more than three or four cards per episode).

Finally, deals must address "created by" credit (which, as discussed throughout this section, is a condition for most of the entitlements under a writer/ producer deal). This usually actually requires little negotiation because most major scripted television production is subject to the jurisdiction of the WGA, which has exclusive control over the determination of writing and series creation credits for WGA-covered series. As a general rule, whatever writer(s) receive(s) "written by" credit on the pilot episode of the series also receive(s) "created by" credit on that series.[22] This credit determination (which is made by the WGA) then becomes the basis of satisfying various conditions on the writer's benefits under his or her deal. However, where the pilot script is based on underlying material (such as a book, article, movie, or preexisting television format), "written by" and "created by" credits are generally unavailable under the WGA's credit determination standards. In such circumstances, it is common to negotiate for "created by" and "written by"-based credit conditions (for purposes of writer benefits) to be deemed satisfied if the writer receives "developed by" and "teleplay by" credit, respectively. Studios also usually agree to submit any writer who solely wrote a pilot script for "developed by" credit from the WGA, if the WGA determines that "created by" credit is unavailable.[23]

Other aspects of writing credit (including the determination of episodic writing credits in series and the placement of such credits) are also generally determined and governed by the WGA, and therefore not expressly negotiated. In many respects, credits are so fleeting and non-obvious to viewers as to be largely meaningless. Nevertheless, such credits can be extremely significant for the professional resumes of the parties and provide valuable precedents that substantially influence the parties' entitlements in subsequently negotiated deals.

22 In the WGA's system, "story by" credit is accorded to the writer(s) who establish the essential plot and characterization for a script, while "teleplay by" credit is accorded to the writer(s) who execute that basic narrative and characterization with specific scenes and dialogue. The "story by" and "teleplay by" credits may each be accorded to a single individual or writing team, or to up to two individuals or writing teams. (For all purposes, the WGA considers a bona fide writing team to be a team functioning as an "individual" in all respects. Bona fide writing teams are readily identifiable in credits because their names are separated by an ampersand. When the written-out word "and" separates two writers or writing teams, it signifies that the writers on either side of the word "and" operated independently of one another, and not as a bona fide team.) When the "story by" and "teleplay by" credits are to be accorded to the same individual or writing team, the credits are combined into a single, unified "written by" credit. When a pilot script results in story and teleplay credits for separate writers or writing teams, all of those writers or writing teams share "created by" credit for the series. Pilot writing credit also generally determines the awarding of "separated rights" in a series, if applicable and if not already bought out by the studio.

23 The WGA technically allows for studios to contractually accord "created by" credit, outside of the WGA credit determination process, where a pilot/series is based on underlying material. Some studios use creative alternatives, such as "Created for television by." However, such contractual entitlements are extremely rare.

xi. Perks

There are a small number of "perks" that may be negotiated as part of a writer/producer deal. Most writer/producers are accorded a right to an office, assistant, and parking during production periods of a series; for showrunners, the office and assistant must usually be exclusive (rather than shared with other series staffers). Showrunners are typically entitled to meaningful consultation with respect to key creative issues on the show, befitting their role as the primary creative stewards of the series, but full-blown contractual approval rights over any creative or business elements are extremely rare to the point of being virtually nonexistent. If a writer is required to travel as part of his or her services (e.g., to a distant location to supervise physical production of an episode the writer has written), the writer is typically provided with business class travel, first-class hotel accommodations, ground transportation, and a per diem (minimum terms for which are prescribed by the WGA Basic Agreement, where applicable).[24]

xii. Subsequent Productions

Finally, a writer/producer deal will typically provide the writer with the first opportunity to negotiate to render pilot writing and pilot/series executive producing services on certain subsequent productions based on the original television series. This right is often limited to television spinoffs, although for higher-level writers and writers with bona fide theatrical writing experience, it may extend to cover theatrical derivatives as well.

This first opportunity is subject to various customary conditions, including some or all of the following: the writer receiving sole "created by" credit on the original series; the writer rendering at least two years of executive producing services on the original series without being "pay-or-played"; the writer not being in breach of his or her original deal; the writer being professionally available when required by the studio; approval of any applicable network (which the studio must generally use good faith efforts to obtain); the writer then being active in the industry; and time limits (e.g., the derivative being produced within five or seven years, measured from the production of the pilot, the production or exhibition of the last episode of the series on which the individual actually rendered executive producer services, or the production or exhibition of the last episode of the original series). The first opportunity right may initially be limited to the first spinoff of the original series, but automatically "roll" for (i.e.,

24 In some cases (particularly when a series films in Los Angeles, though sometimes for New York, as well), the writing team (led by the showrunner) lives and works in the same city where production takes place. However, for series that shoot outside of Los Angeles and New York, it is common for the writers (including the showrunner) to be based in Los Angeles, while other producers and series staffers manage day-to-day affairs at the production location, subject to periodic set visits by the showrunner and/or by the writers of specific episodes as they are actually produced.

apply to) subsequent spinoffs, if the same conditions continue to be satisfied for each successive spinoff.

Often, the first opportunity clause will provide that, for comparable productions (e.g., television spinoffs to a television series), the writer's deal for the original series serves as a floor for the negotiation of a new deal for the spinoff. Commonly, such clauses will further provide that, if no deal is reached or if certain conditions of the first opportunity right are not satisfied (such as availability or network approval), the creator of the original series is entitled to a passive participation on the spinoff. This usually amounts to 50% of the royalty and backend (but, usually, not the executive producer fees) of the original series for any generic spinoffs or sequels/prequels/remakes, or 25% to 33% of the royalty and backend (but, usually, not the executive producer fees) of the original series for any planted spinoffs.

xiii. Quick Reference Guide

TABLE 5.1 Writing/Writer-Producer Agreements

Deal Term	Main Issues/Ranges	Other Issues
1. Writing/Spec Acquisition	• If/come (contingent on network sale) vs. firm (guaranteed on specific concept) vs. blind (guaranteed on TBD concept) • May be based on pitch (unwritten concept) or option/purchase of "spec" (pre-written) script • Network scale: $59K one-hour/$40K half-hour • Cable scale: $42K one-hour/$23K half-hour • Upset price: $81K one-hour/$55K half-hour • Usually $75K to $250K	• Usually 5 writing steps bought out; may have to address additional steps • For spec scripts, must negotiation option and purchase terms, plus additional writing steps for further revisions • Possible tiering based on network/budget level
2. Producing Fees	• Usually $15K to $60K per episode • Possible tiering for multiple classes of services (especially if preexisting commitments)	• 5% annual bumps are typical, but may be higher (e.g., $2.5K or $5K) • Possible tiering based on network/budget level
3. Locks	• Usually a "modified 2-year lock" or "2-year Warner lock" • At higher levels, may have firm 2-year lock	• At highest levels, may agree to "life lock" with drop down rights • Usually subject to sole "created by" credit, with studio options if writer receives shared "created by" credit

(Continued)

TABLE 5.1 (Continued)

Deal Term	Main Issues/Ranges	Other Issues
4. Services and Exclusivity	• By default, fully exclusive during writing and production periods, and exclusive in television at all times	• Usually may develop for third parties and render limited other services during hiatuses, in "second position" • May have right to develop in "second position" during production periods • At very high levels, may allow for juggling of multiple concurrent projects
5. Preexisting Commitments	• Must address "position" if writer is under active preexisting deals • 15% to 25% discount on script fee, compared to first position	• May provide for drop-down to non-exclusive services, if unavailable for exclusive services due to preexisting commitment • May make "no position" deal (i.e., "position" does not lock until production is ordered)
6. Consulting	• Usually agree to consulting 1-for-1 • Usually $7.5K to $15K per episode	• Usually requires 2 years of services • Possible tiering based on network/budget level
7. Royalties	• Usually $2.5K to $6K per episode for sole "created by" credit • Usually reduced by 25% to 50% for shared "created by" credit	• Possible rerun royalties • Possible tiering based on network/budget level
8. Bonuses	• Usually $25K for series pickup, if writer receives sole "created by" credit • Usually $12.5K for series pickup, if writer receives shared "created by" credit	• May be prorated based on the number of episodes produced • Possible set-up or pilot production bonuses • Possible subsequent season pickup bonuses
9. Backend	• Often negotiate ceilings and floors, with participations reducible by third parties (perhaps over a 35% aggregate participation threshold) • Ceilings usually between 10% and 20% of MAGR for sole credit • Floors usually between 5% and 17.5% of MAGR for sole credit • Usually between 2.5% and 12.5% of MAGR for shared credit	• Vests ¼ for pilot writing, ¼ for pilot producing, ¼ for season 1 producing, and ¼ for season 2 producing • Possible *pro rata* vesting • Miscellaneous backend definition issues (see Chapter 6)

Deal Term	Main Issues/Ranges	Other Issues
10. Credit	• Usually Executive Producer credit, except for extremely junior creators, who may start at Co-Executive Producer • Logo credit at higher levels (e.g., showrunners) • "Created by" credit per WGA • "Executive Consultant" credit for consulting 1:1, as applicable	• Generally main or opening title credit, separate card, with ties to other Executive Producers • May provide for "Developed by" credit where source material makes "created by" unavailable
11. Perks	• Contractual consultation rights for key creative matters • Business-class travel, first-class accommodations, per diem • Ground transportation or rental car • Parking, office, and assistant	• Negotiate exclusivity of office and assistant • Engagement of personal assistants
12. Subsequent Productions	• First opportunity to write and executive produce spinoffs, if writer receives sole "created by" credit • Passives on subsequent productions (still subject to writer receiving sole "created by" credit) if no new deal is made (e.g., 50% of royalty and backend for generic spinoffs; 25% to 33% of royalty and backend for planted spinoffs)	• Subject to other customary conditions (e.g., time limits, network approval, etc.) • May "roll" for further subsequent productions • Current deal may be floor for future negotiation

B. Staffing Writer Agreements

"Staffing writer agreements" (or "staffing agreements") are those for the writers and writer/producers (other than the creator) who will populate the "writer's room" for the series. Depending on the creative needs of the series, the nature of the distribution platform, and the number of episodes being produced, a series will typically employ between four and eight "staffing" writers per season. Writers are generally selected by consensus among the showrunning executive producer, studio executives, and network executives. These individuals may contribute generally to episodic ideas (e.g., dialogue, scenes, or entire storylines), write full original teleplays for the series, or punch up or rewrite episodic teleplays prepared initially or primarily by other writers. Often, writers are identified based on the preexisting relationships and preferences of senior writers and executives, although on ongoing existing series, a new junior writer may earn a spot on the writing staff by submitting a "spec script" that demonstrates the

individual's creative command of the series's characters and tone. If the show-runner of a series is not the writer/creator of the pilot, the showrunner's agreement is essentially a variation of a staffing agreement (the particulars of which are discussed in Section B.vii below).

i. Term/Options

The vast majority of staffing agreements are three-year deals, covering the immediately upcoming production season of a series, with studio options to engage the writer, season-by-season, for up to two additional seasons thereafter. This default may be discarded in favor of a one- or two-year deal for particularly high-level writers, or writers who are engaged to work on a part-time or consulting basis.

ii. Credit

The majority of producer-type credits on any given television series belong to writer/producers (whose primary responsibility is in the writer's room), and there is a well-established hierarchy of credits for writers (which, like other credits, are subject to network approval).[25] The most junior and inexperienced writers begin as Staff Writers (who may or may not be accorded on-screen credit for their series), with a promotion track that goes to Story Editor (the first position that consistently receives on-screen credit), then Executive Story Editor, then Co-Producer (the first position that tends to receive credits in the main or opening titles of a series), then Producer, then Supervising Producer, then Co-Executive Producer, and finally Executive Producer.[26] In addition, writers who are working part-time or otherwise below their usual rank or pay may be accorded Consulting Producer credit, which occupies a less obvious position within the above hierarchy. As writers grow to higher and higher ranks, they are generally expected to assume more duties in connection with the production, as well as writing, of series episodes. Lower-ranked writers may be released from their services once writing of a season has been completed, while higher-ranked writers may be expected to work until the completion of photography for the season (which may be several weeks after writing is completed).

25 As discussed in Section C below, most shows also employ one or more non-writing Executive Producers, who often played a key role in the packaging and development of a project, and may employ a producer/director who is also credited as an Executive Producer (or, if less experienced, perhaps Co-Executive Producer). "Produced by" (as opposed to "Producer") credit is generally accorded to line producers (discussed in Section G below), although higher-level line producers may instead receive credit as Co-Executive Producer or even Executive Producer as well. "Co-Producer," "Associate Producer," or "Producer" credit may also be accorded to lower-level non-writing producers (such as the development executives who serve credited Executive Producers).

26 Executive Producer credit for writers who are neither creators nor showrunners is relatively rare and usually accorded only for strong "second-in-command" types with close personal relationships with the showrunner.

Writers must generally work for one to two complete seasons (of ten to twenty-two episodes each) at any given title level before being promoted to the next title, with the promotion track moving more slowly between more senior ranks. In early seasons, a writer's room will typically feature writers of widely varied titles and experience levels. In later seasons of a series, staff titles tend to be more top-heavy, as staffers who have remained with a show for many seasons have crawled up the ranks and escalating production budgets on a successful series can support more expensive staff.

iii. Fees

Writers who are engaged as Staff Writers are almost always paid the WGA-mandated scale minimum for term writers, which varies depending on the number of weeks guaranteed to the writer under his or her deal. As of 2018, this amount ranges between approximately $3,800 per week and $4,900 per week, with the most common minimum guarantee, of twenty weeks, requiring a minimum rate of approximately $4,200 per week. Writers who are working for a second season as Staff Writers may expect to make 110% of WGA scale.

Writers who are engaged as Story Editors are almost always paid the so-called "Article 14" scale minimum (referring to the WGA Basic Agreement section governing "Writers Employed in Additional Capacities"). As with Staff Writers, the applicable scale minimum depends on the number of weeks guaranteed to the writer under his or her deal, and as of 2018, the rate for a twenty-week guarantee is approximately $6,800 per week. Executive Story Editors usually receive between Article 14 scale and 110% of Article 14 scale. The practical responsibilities of such Story Editors and Executive Story Editors are often very similar to those of Staff Writers, and such positions are still considered quite junior within the ladder of writer/producer ranks; however, the titles offer a symbolic reflection of greater stature, experience, and prestige for those who have already "put in their time" at the Staff Writer level.

Starting at the Co-Producer level, writers are generally engaged on the basis of episodic, rather than weekly, fees. Expected fees climb with titles, and range from $12,000 to $15,000 per episode for Co-Producers, to $16,000 to $19,000 per episode for Supervising Producers. In each subsequent year of a multi-year deal, the writer may expect to see a fee bump between $500 and $2,500 per episode, even if he or she is not being promoted in title (though title escalations often involve more substantial fee bumps). At the Co-Executive Producer and Executive Producer levels, episodic fees can climb substantially higher (according to experience and quotes), though the showrunner always remains the highest-paid writer/producer on a series.

Although fees for Co-Producers and more senior writer/producers are typically denominated episodically, the engagement of such writers remains subject to applicable WGA requirements, which have grown increasingly complex in the face of the industry trend toward shorter episodic orders and longer production

periods.[27] As of May 2018, in most cases,[28] the episodic fee paid to a writer buys out 2.4 weeks of services; in other words, the episodic fees paid to a writer on a ten-episode order covers only twenty-four weeks of services. For work in excess of such 2.4 weeks/episode period, the writer receives overage compensation at the rate of one episodic fee per 2.4 additional weeks worked (prorated for extension periods less than 2.4 weeks).[29] This concept, of a limited number of actual work weeks bought out by a writer's episodic fee, is often referred to as "span." As a result of these WGA-negotiated protections (the negotiation of which was so contentious that it nearly led to a writers' strike in 2017), many writers working on shorter-order cable and digital shows can routinely expect to earn more than the apparent negotiated salary in their employment agreements.[30]

iv. Guarantees

Weekly engagements (i.e., for Staff Writers, Story Editors, and Executive Story Editors) usually guarantee a minimum number of weeks, depending on the needs of the production schedule and the studio's desire to qualify for more favorable scale minimum weekly rates. As discussed in Section B.iii above, twenty-week guarantees are common, with the studios retaining options to extend the writer's

27 This trend is itself driven by the increasing popularity of highly cinematic, premium, serialized content on television, particularly on cable and digital platforms. These types of shows are generally not amenable to production on the tighter production schedules historically favored by the television industry.

28 In particular, these rules apply to writers earning less than $350,000 (excluding script fees) per contract year and to productions for which the full season order (including the pilot) is fourteen or fewer episodes for non-broadcast series, or twelve or fewer episodes for broadcast series. Based on prevailing norms as of 2018, the salary threshold functionally captures most "staffing writers" but does not capture most showrunner-level executive producers; and the episodic threshold functionally captures most cable and digital series (which are typically ordered in seasons of eight to thirteen episodes) and excludes most broadcast series (which are typically ordered in seasons of thirteen to twenty-two episodes).

29 To illustrate: if a writer/producer is employed on ten episodes at a rate of $25,000 per episode (i.e., a total guarantee of $250,000), but works a total of thirty-six weeks, he or she will receive $250,000 for the initial twenty-four weeks of work (i.e., $25,000/episode times 10 episodes), plus $125,000 for the remaining twelve weeks of work (i.e., 12 excess work weeks, divided by 2.4 weeks, times the $25,000 episodic rate), for a total of $375,000.

30 Prior to 2018, the episodic fees for staffing writers simply remained subject to the applicable WGA Article 14 weekly scale minimum rate. In other words, regardless of their negotiated episodic fees, writers could not be paid less than this scale amount, once their fee was amortized over the number of weeks they actually worked. Although this backstop protected writers by preventing their effective weekly rate from being diluted below the floor of scale, it also resulted in writers at disparate levels, with disparate episodic fees, earning the same effective weekly salary for their services over the course of any given production period. By limiting the number of services weeks bought out by a writer's negotiated episodic fee, and calculating overages based on that negotiated episodic fee rather than WGA scale, the new system results in more senior writers more consistently earning higher effective wages than their less experienced colleagues.

services for as many additional weeks as are necessary for the writer to complete his or her duties for the season.

Episodic engagements for the first season of a series typically cover the initial network order, with the studio retaining a further option to extend the writer's engagement for any backorder of additional episodes by the network. Even in later seasons of a series (particularly for broadcast network series), for a writer's first year on staff, the applicable guarantee will usually cover only an initial chunk of episodes (e.g., thirteen out of twenty-two), as a hedge for the studio is in its new relationship with the writer, with the studio holding an option to extend the writer's guarantee and services for the balance of episodes produced. In subsequent years of a writer's deal, the applicable guarantee will cover all episodes produced for the applicable season. Unlike in series regular actor deals, there is typically no episodic minimum attached to the "all episodes produced" guarantee (as the WGA Basic Agreement, unlike the SAG Basic Agreement, does not require any such minimum guarantee in order for a studio to retain its exclusive options on a writer's services), although writers nevertheless at all times enjoy the backstop of the applicable WGA Article 14 scale minimum for weeks actually worked by the writer, and any applicable "span" requirements (as described in Section B.iii above).

v. Episodic Scripts

The showrunner generally assigns each episode of a series to a specific writer, subject to studio and network approval. Such episodic scripts are always paid at the applicable WGA scale minimum rate—as of 2018, approximately $39,000 for a sixty-minute broadcast network episode; approximately $27,000 for a thirty-minute broadcast network episode; approximately $28,000 for a sixty-minute cable episode; and approximately $15,000 for a thirty-minute cable episode. As with other WGA and DGA scale minimum amounts, the applicable minimums (if any) for digital productions depends on the subscriber base of the digital platform and the budget of the series, and, depending on these variables, may be pegged to the corresponding broadcast network minimum, the corresponding cable minimum, or freely negotiable.[31] For Staff Writers—and sometimes, though not usually, for Story Editors and Executive Story Editors—episodic script fees are applicable against the writer's weekly fees. For most Story Editors and Executive Story Editors, and all writers more senior than that, episodic script fees are paid on top of the writer's negotiated weekly or episodic fees.

31 Most series produced for Amazon and Netflix, and some series produced for Hulu, are sufficiently high-budget to qualify for broadcast network minimums. Some smaller series on these platforms are subject to cable minimums.

vi. Exclusivity

Most staffing writers render services on a fully exclusive basis—or, at a minimum, on an exclusive basis with respect to television services, with no other services to materially interfere—during production periods. Writers will seek the right to develop (i.e., write and develop pilot or theatrical feature scripts) for third parties during the term of this engagement. Studios typically allow this during hiatus periods of a writer's primary series and on a second-priority/non-interfering basis during production periods of the second and third seasons, but most studios prohibit staffed writers from developing, especially in television, during their first production season on a show (particularly if that is also the show's first season). Some studios limit the right to develop in second position only to more senior, experienced writers. Showrunning executive producers may have strong opinions about whether or not the writers on their teams should be permitted to engage in development on the side.

Writers will also often negotiate for the right to opt out of their staffing deals in the event that a project they have created and developed is ordered to production of a pilot or series. Usually, this request is accommodated with respect to development projects that predate the staffing deal itself, although typically, the studio only permits the writer to opt out between seasons (or to decline an engagement for an upcoming season) and not to leave a production season midstream. However, even though studios seldom grant a contractual right to opt out mid-season (and, when they do, usually require significant notice and coordination to avoid disruption to the series), when a writer's development project is ordered to production, many studios will, as a courtesy, agree to release the writer from his or her obligations, so as not to deprive the writer the opportunity to work on his or her own series.

Finally, particularly at junior and mid-range levels, many studios will require writers who have staffed onto one of their shows to accord the studio a "first look" at any proposed development projects during the term of the writer's staffing deal, giving the studio the opportunity to negotiate with the writer to develop any such project before the writer is permitted to present it to third-party studios.[32]

vii. Showrunners

Deals for showrunners who did not create a series (but were attached later, perhaps because the writer/creator of the pilot was too junior to lead the series through production) largely resemble other staffing deals. Such agreements usually have two-year (rather than three-year) terms, and the applicable credit is always "Executive Producer." If a showrunner joins a series prior to its third season, he or she

32 First look agreements outside of the context of staffing deals are discussed in greater detail in Section B of Chapter 7.

will typically demand a share of backend from the series, the size of which will depend on the showrunner's stature and quotes, as well as the timing of the show-runner's attachment (with showrunners who are attached at earlier stages, such as during development or pilot production, usually commanding more substantial contingent compensation than those attached after one or more seasons have been produced). Typical backend allotments for such showrunners range from 1% of MAGR to 5% of MAGR (and, in rare cases, up to 7.5% or even 10% of MAGR, especially for showrunners who are attached at the development stage of the proj-ect and supervise the more junior writer/creator's work on the pilot script). The showrunner's backend allocation is expected to "fit" within the studio's maxi-mum permitted aggregate pot (again, most often 35% of MAGR).

viii. Quick Reference Guide

TABLE 5.2 Staffing Writer Agreements

Deal Term	Main Issues/Ranges	Other Issues
1. Term/Options	• By default, usually 3-year terms • May negotiate for 2-year or 1-year deals	
2. Credit	• Credit hierarchy: o Staff Writer o Story Editor o Executive Story Editor o Co-Producer o Producer o Supervising Producer o Co-Executive Producer o Executive Producer	• Main or opening title credit at producer levels (possible ties) • Consulting Producer credit for part-time or below-usual-level work • May escalate between years of a deal
3. Fees	• Staff writer scale based on guarantee, usually $4.2K/week with 20-week guarantee • Article 14 scale based on guarantee, usually $6.8K/week with 20-week guarantee • Mid-level producers paid $12K to $19K per episode • Senior producers paid $20K to $50K per episode (or more)	• Raises between season, often $500 to $2.5K per episode • Larger raises may accompany credit bumps • Span limitations (2.4 weeks per episodic fee, with overages at one episodic fee per 2.4 additional weeks)
4. Guarantees	• May guarantee minimum week counts on weekly engagements (most commonly 20 weeks) • Episodic deals usually guarantee "all episodes produced"	• In any event subject to scale weekly minimums and span requirements

(Continued)

TABLE 5.2 (Continued)

Deal Term	Main Issues/Ranges	Other Issues
5. Episodic Scripts	• Usually paid at applicable scale on top of weekly or episodic fees • Network: $39K one-hour/$27K half-hour • Cable: $28K one-hour/$15K half-hour	• May be applicable against weekly fees for Staff Writers
6. Exclusivity	• By default, services are exclusive in television throughout term, and fully exclusive during active services periods • Studio may require first look on new development	• May negotiate to develop in second position during hiatus periods (and potentially during production periods after the first year) • May negotiate for opt-out if writer's own development project is produced
7. Showrunners	• Executive Producer credit standard • May provide for backend (usually 1% to 5% of MAGR, or more at higher levels), especially if engaged at pilot or first season	• Usually 2-year terms (rather than 3)

C. Non-Writing Producer Agreements

Non-writing producers serve a variety of roles on television series. Many effectively serve as an outsourced labor force for a studio's development activities, scouting the marketplace for interesting pitches from writers and underlying properties to adapt and bringing them to the attention of studios. Many non-writing producers enjoy close relationships with writers, actors, or other key talent, and can play a vital role in the packaging of a product; others focus on close relationships with studio and network executives and decision-makers, which can be vital to getting traction for a project. Some play an active role in casting, crafting the visual look and feel of a series, or other key creative tasks that are not directly related to writing, while others actively engage directly with writers (albeit without ever putting pen to paper themselves). Many series have an executive producer who serves as producer/director, personally directing multiple episodes of the series while working closely with the line producer and other episodic directors to manage physical production and maintain a consistent look and feel to the series.[33] And some non-writing producers are

33 Unless the producer/director is actively involved in setting up a project with a studio and developing it before the pilot stage, however, such deals usually bear more resemblance to staffing deals (described in Section B above) than to other non-writing producer deals. Similarly, high-level line

the managers and close confidantes and creative supporters of writers, rightsholders, star actors, or other elements of the creative process, who manage to insinuate themselves as producers of their friends' or clients' projects. Bigname non-writing producers active in television today include well-known theatrical producers like Steven Spielberg (*Bull*, *Extant*, and *Under the Dome*, all on CBS) and Jerry Bruckheimer (CBS's *CSI* franchise and Fox's *Lucifer*) and successful manager-producers like Steve Golin (Netflix's *13 Reasons Why* and USA's *Mr. Robot*) and Peter Principato (ABC's *Black-ish* and Netflix's *Wet Hot American Summer: First Day of Camp*).

In general, non-writing producer deals are subject to the same basic structure as writer/producer deals (with the obvious exception of pilot-writing services, which are non-applicable to such deals). Consequently, the summary set forth in Section A above can generally be understood to apply to non-writing producers, as well, with the following caveats and modifications.

i. Development Fees

Although non-writing producers do not personally write the pilot screenplay, they are often actively engaged in that process, working closely with the writer to craft the initial story, and providing notes on the writer's drafts. For the most part, such services are rendered by the non-executive producer for no initial charge, in exchange for the promise of episodic fees and backend if a pilot or series is ever actually produced. But in some rare instances, a non-writing producer may be able to extract from the studio a development fee (which may be an advance against future fees owed to that producer for services on the pilot/series). Where applicable, such fees typically range between $10,000 and $50,000, with $25,000 being most common (but again, all such development fees are relatively uncommon and usually reserved for high-level producers in unique circumstances). Producers who independently spent money on the development of a project prior to setting it up with a studio (e.g., by commissioning a script or paying option fees to lock up an underlying property) may also seek reimbursement for their historical development expenses, which could come immediately, be deferred until the production of a pilot and/or series, or be divided between the two.

ii. Producing Fees

The range of producing fees for non-writing producers, and the structure of fee bumps in subsequent seasons, is typically comparable for non-writing producers

producers may be accorded Co-Executive Producer or Executive Producer credit, but also render exclusive full-time services that are structured more like staffing writer deals than other non-writing producer deals. Indeed, although the term "non-writing producer" is a technically correct description of an EP-credited producer/director or line producer, the term would not generally be used in reference to such roles.

as for writing producers (i.e., between $15,000 and $60,000 per episode), though for non-writing producers, fees near the top of this range or beyond are rarer than for high-level writing producers. Non-writing producers who definitively control desirable underlying rights, or who engage in significant packaging activity prior to stepping up a project with a third-party studio or network, may be able to command more substantial fees, up to $100,000 per episode or even higher. These higher fees are more common where the "non-writing producer" is a bona fide company operation (such as Amblin Entertainment, Plan B Entertainment, or Anonymous Content), rather than an individual or pair of individual independent producers.

Where a studio employs hard caps on aggregate executive producer fees on any given series, non-writing producers are more likely than writer/producers to reduce their fees to accommodate a package of many high-level collaborators. In addition, unlike writer/producers, non-writing producers are typically not in a position to substantially renegotiate their fees upward in future seasons, even on a successful series.

iii. Locks

Although the variety of locks applicable to non-writing producers is identical to those applicable to writer/producers, the norms for such locks are different. Non-writing producer deals may be based on two-year Warner locks at lower levels or life locks at higher levels; however, the majority of non-writing producer deals feature firm two-year locks. In addition, because non-writing producers do not receive story, teleplay, writing, or series creation credit, the credit-based conditions for locks under writer/producer deals are not applicable to writer-producer deals. Instead, series locks are typically conditioned only on the individual not being in breach and completing pilot producer services without being "pay-or-played." Finally, because non-writing producers typically play a more vital role in the development and pilot stages of a television series, and a less vital role in its ongoing production, they have less leverage than writer/producers to negotiate more favorable terms to stay with a successful series in later seasons. Consequently, unlike writer/producers (who generally favor two-year deals), non-writing producers virtually always seek to be locked for the life of a series (particularly since, as explained below, their exclusivity is rarely if ever a condition of their attachment).

iv. Services and Exclusivity

Unlike writer/producers, whose services for a series are usually substantially exclusive and full-time, the services obligation of non-writing producers is usually non-exclusive, with services for third parties not to materially interfere. Some studios may insist that particularly key non-writing producers render

services on a non-exclusive, first-priority basis[34] (or require that at least one of the members of a two-person producing team be designated to do so), but this is relatively rare, and, with the exception of producer/directors, requiring full-time exclusive services from non-writing producers is virtually unheard of. This comparatively low standard of services allows non-writing producers to concurrently work on multiple projects at any given time, and the most successful and prolific such producers routinely render services on multiple series simultaneously.

v. Royalties

Non-writing producing deals generally do not provide for the producer to receive any form of passive royalty (as distinguished from "backend" participations, as described in Section C.viii below) under any circumstances. Fees for non-writing producers essentially always require some level of services to be rendered (though the actual level of services required by the studio or provided by the producer may vary widely from person to person and from project to project).

vi. Bonuses

Series sales bonuses for non-writing producers may be given from time to time (and are certainly more common than royalties), but are substantially rarer than for writer/producers (for whom they are essentially ubiquitous). When provided for a non-writing producer, the parameters are generally the same as for writer/producers, although again, credit conditions are not applicable.

vii. Consulting

Non-writing producers who are not locked for the life of a series may also be entitled to a "consulting one-for-one." As with some of the other terms for non-writing producers, this entitlement is not necessarily as automatic and ubiquitous as it is for writer/producers, but it is relatively common. In addition, a life lock as a consultant (which commences after the initial lock as an executive producer has expired) is a more common accommodation to non-writing producers, as a step short of the desired life lock as executive producer.[35]

34 If the studio has "first priority," it has the general right to require the individual to render services when and where required by the studio, and the individual's services for third parties would need to be subject to the individual's commitment to satisfy his or her obligations to the first-priority employer.
35 Significantly, a studio may elect to continue to engage a non-writing producer as an executive producer (rather than as a consultant), even after the individual's "lock" as executive producer has expired. In fact, this is fairly common where the relationship between the non-writing producer and the studio and other members of the creative team is positive. However, studios naturally prefer preserving their flexibility to make this decision to contractually committing themselves from inception to paying executive producer fees for the life of a series.

viii. Backend

In general, the backend entitlements for non-writing producers are comparable to those applicable to writer/producers, with a few key distinctions. First, again, credit contingencies do not apply, so the backend entitlement simply vests over the period of the producer's services without regard for credit. Second, rather than vesting in quarters, the backend for a non-writing producer typically vests in thirds—one-third upon completion of pilot producing services, one-third upon completion of series producing services for the first season, and one-third upon completion of series producing services for the second season (with similar variations around *pro rata* vesting). (Again, this is because the first quarter vest for writer/producers, based on the completion of pilot script writing services, is not applicable to the non-writing producer context.) Third, the range of backend granted to non-writing producers varies more widely depending on stature than for writer/producers, with backend floors that may range from 2.5% of MAGR to 17.5% of MAGR.

ix. Credit

The vast majority of negotiated credits for non-writing producers are as Executive Producer, though high-level non-writing producers may also negotiate for lesser credits (such as Co-Executive Producer or Producer) for their own development executives. High-level non-writing producers also seek and receive logo/company credits, subject to the same variations and parameters described for writer/producers (but again, absent any credit or showrunning-based conditions). But again, issues related to pilot teleplay and series creation credit do not apply to non-writing producers.

x. Perks

The perks accorded to non-writing producers are comparable to those provided for writer/producers, although exclusive offices and exclusive assistants are rarer, given the comparatively part-time, non-exclusive nature of the role. Some non-writing producers may also negotiate for a guarantee that the studio will pay for their travel to the production location of the pilot and/or series at least once (or once per season), in order to assure their ongoing creative involvement with the production, though studios generally reserve such decisions about the necessity and propriety of in-person on-set services to their own judgment, rather than making contractual commitments.

xi. Subsequent Productions

Like writer/producers, non-writing producers typically seek to be attached to subsequent productions based on the original television series they have

developed. First opportunities for subsequent productions, comparable to those accorded to writer/producers (but again, excluding credit conditions that are not applicable to non-writing producers), are sometimes accorded to non-writing producers as well. Some studios grant such entitlements freely, while others tend to reserve them only for higher-level producers or those who have some special articulable history with a property or project. This is in contrast to writer/producers, for whom first opportunity rights, at least for subsequent television series, are generally granted freely (albeit subject to the sole "created by" credit condition). In addition, while writer/producers may expect to receive some form of passive participation if no deal is reached on the subsequent production, passives for non-writing producers are relatively rare (and, where granted, typically limited to a share of backend; again, 50% of the share from the original series for generic spinoffs, sequels, prequels, and remakes, and 25% to 33% for planted spinoffs).

xii. Quick Reference Guide

TABLE 5.3 Non-Writing Producer Agreements

Deal Term	Main Issues/Ranges	Other Issues
1. Development Fees	• Usually no development fees • If development fee is paid, usually $10K to $50K, most often $25K • Independent producer's historical out-of-pocket costs may be reimbursed	• Development fees may be applicable against subsequent fees • Cost reimbursements may be deferred, in whole or in part, to pilot and/or series production steps
2. Producing Fees	• Usually $15K to $60K per episode • Highest-level fees are generally slightly lower than highest-level fees for writer/EPs	• 5% annual bumps are typical, but may be higher (e.g., $2.5K or $5K) • Possible tiering based on network/budget level • May be higher where producer controls important rights or has done significant packaging
3. Locks	• Usually a firm 2-year lock • At higher levels, may have a "life lock"	• No applicable credit contingencies (unlike writer/EP deals)
4. Services and Exclusivity	• Usually non-exclusive, no-material-interference services (producer is expected to concurrently work on multiple projects)	• May request first priority for key individuals

(Continued)

TABLE 5.3 (Continued)

Deal Term	Main Issues/Ranges	Other Issues
5. Royalties	• Generally not applicable (unlike writer/EP deals)	
6. Bonuses	• May agree to series pickup bonus, but less common/ automatic than for writer/ EPs • Usually $25K, if granted	• May be prorated based on the number of episodes produced • Possible set-up or pilot production bonuses • Possible subsequent season pickup bonuses • No applicable credit contingencies (unlike writer/EP deals)
7. Consulting	• May agree to consulting 1-for-1, but less automatic than for writer/EPs • Usually $7.5K to $15K per episode	• Usually requires 2 years of services • May lock for life as consultant after 2 years of EP services • Possible tiering based on network/budget level
8. Backend	• Often negotiate ceilings and floors, with participations reducible by third parties (perhaps over a 35% aggregate participation threshold) • Floors usually between 2.5% and 17.5% of MAGR, depending on stature • At highest levels, 35% of MAGR, reducible by all third parties to a negotiated floor	• Vests 1/3 for pilot producing, 1/3 for season 1 producing, and 1/3 for season 2 producing • Possible *pro rata* vesting • Miscellaneous backend definition issues (see Chapter 6) • No applicable credit contingencies (unlike writer/EP deals)
9. Credit	• Usually Executive Producer credit • May provide additional credit for key executives/ employees (usually lower level, e.g., Producer or Co-Executive Producer) • Logo credit at higher levels • "Executive Consultant" credit for consulting 1:1, as applicable	• Generally main or opening title credit, separate card, with ties to other Executive Producers
10. Perks	• Business-class travel, first-class accommodations, per diem • Ground transportation or rental car • Parking, office, and assistant	• Exclusivity of office, assistant, etc. less common where services are non-exclusive/part-time • May negotiate guaranteed travel to production

Deal Term	Main Issues/Ranges	Other Issues
11. Subsequent Productions	• May receive first opportunity to produce spinoffs, but less common than for writer/EPs	• Applicable conditions similar to writer/EPs, excluding credit contingencies

D. Pilot Director Agreements[36]

Although the role of the director is comparatively diminished in television relative to the significance of the director in the theatrical motion picture industry, the pilot director still has a very important role to play in setting the stylistic, tonal, and visual template of the series to come. He or she also usually coordinates closely with the executive producers and creative executives of the project in connection with the casting process. Even where a series is ordered directly to production without a pilot, the director of the first episode is chosen with particular care and has a comparable creative impact on the series.

Pilot directors are usually engaged after a pilot has been ordered to production, in close coordination with the network, although the current trend in television development favors packaging of multiple elements early in the process, and it is not uncommon for pilot directors to be attached to a project during the development phase (although the director's ultimate right to actually direct the pilot is then typically subject to network approval, which the studio will use good faith efforts to obtain). In addition, as the television medium has continued to grow in prestige and attract more and more theatrical talent, major directors such as McG (Fox's *Lethal Weapon*; NBC's *The Mysteries of Laura*; the CW's *Nikita*) and Justin Lin (CBS's *Scorpion* and *SWAT*) have taken an increasingly active role in sourcing and developing new television projects.

Pilot directors enjoy an unusual place in the entertainment industry. While some successful theatrical directors also direct television pilots, for the most part, even the most successful full-time pilot directors do not enjoy the fame of their theatrical counterparts. Yet despite their relatively low profiles, the most prolific and successful pilot directors are also among the best-compensated and most sought-after professionals in Hollywood. Hardworking, in-demand pilot directors like James Burroughs (*Friends*) and Pamela Fryman (*How I Met Your Mother*) may direct anywhere from two to five pilots per year. As described in the sections that follow, for each such pilot, the director will receive not only six-figure fees for a few weeks of work, but more critically, potentially lucrative contingent compensation stakes in the series they help launch. Pilot directors enjoy these benefits without rendering any ongoing services for the series after the pilot; but if they do agree to render further services, they may receive even greater long-term benefits. Burroughs alone

36 This section focuses specifically on pilot directing engagements. Episodic directing engagements, which are far simpler in nature, are discussed in Section G below.

directed the pilots for, and therefore has lucrative backend positions in, *Taxi, Cheers, Night Court, Frasier, Friends, 3rd Rock from the Sun, Will & Grace, Two and a Half Men, 2 Broke Girls,* and *The Big Bang Theory,* among other shows. Not bad for someone whose name is barely known outside of Hollywood.

i. Services

The services of a pilot director are typically rendered on an exclusive basis during formal pre-production (a period of about six to eight weeks) and production (about two to four weeks) of the pilot and on a non-exclusive but first-priority basis during post-production of the pilot, until delivery of the director's cut. Between the delivery of the director's cut and final delivery, the director's services may be fully non-exclusive and subject to such individual's professional availability. The actual level of activity by the director during this late post-production stage varies widely in actual practice, with directors who are also engaged and credited as executive producers tending to play a more active role during these late stages.

If the pilot director is attached at the development stage, when the actual production period for the pilot is totally unknown (and totally speculative), the director's obligations are usually subject to his or her professional availability at the time the pilot is ordered. If the director is unavailable at that time, he or she may be entirely divested from the project without any further obligations owed, or, more commonly, entitled to some more limited (and less lucrative) ongoing attachment as a non-exclusive, non-writing executive producer. In addition, because networks retain approval rights over pilot directing engagements, the director's engagement may be made expressly subject to network approval (which the studio would typically agree to use good faith efforts to obtain).

ii. Directing Fees

The fees paid to pilot directors vary widely depending on the length of the pilot (i.e., thirty-minute vs. sixty-minute) and the identities and policies of the applicable studios and networks. Some smaller cable networks and their affiliated studios never pay more than applicable DGA scale minimums for pilot directors[37]—as of 2018, approximately $77,000 for thirty-minute broadcast network pilots; approximately $102,000 for sixty-minute broadcast network pilots; approximately $46,000 for thirty-minute basic cable pilots; and approximately $61,000 for sixty-minute basic cable pilots.[38] At most studios,

37 Virtually all director engagements in the United States, at least with respect to scripted television, are subject to DGA jurisdiction, irrespective of network/platform and budget.
38 Like WGA-governed script fees, applicable DGA minimums for directors of projects on digital platforms may be tied to the corresponding broadcast network or basic cable minimums, or may be freely negotiable without any minimum, depending on the budget of the production and the number

pilot directing fees range from approximately $100,000 to $250,000, depending on the nature of the production, the platform, and the director's quotes and stature, although highly sought-after feature directors and a handful of A+++ pilot directing specialists may, on rare occasions, command even higher fees. The DGA Basic Agreement also permits any portions of the pilot directing fee in excess of 200% of applicable scale for the days worked to be credited against residuals,[39] if explicitly agreed by the studio and director; consequently, deals featuring high directing fees often include a residual crediting component.

iii. Executive Producing

Directors who participated in the development of the project are usually also attached as executive producers for the resulting series. In general, the terms of this attachment follow the structure described in Section C above for non-exclusive non-writing producers, though in some rare cases, the pilot director may stay with the series as a full-time, exclusive producer/director.

Where a director has not participated in the development of the project and was only engaged after the pilot was ordered to production, he or she may be still credited as an executive producer—although in such circumstances, usually only for the pilot, without being attached to the series on an ongoing basis. The function of a pilot-only executive producer role may vary. The credit may signify a heightened level of creative leadership and responsibility, particularly if other executive producers on the pilot are relatively inexperienced. It may be a mere vanity gift to satisfy the director's desire to be credited more prominently. It may serve as cover for the studio on the financials of the deal, allowing the studio to pay the director a relatively lower pilot directing fee, but supplement it with a separately-stated executive producer fee (which may range from $10,000 to $50,000, and which fee the studio may or may not elect to treat as part of the budgeted fee pool for all executive producers).

iv. Royalties

The director of a pilot is usually entitled to a passive royalty for the life of the resulting series, if it is ordered, without any obligation to direct future episodes or otherwise render active services on the series in any way. This royalty generally ranges from approximately $3,000 per episode to $6,000 per episode (with, as always, outliers on either side), usually falling somewhere in that range in

of subscribers of the relevant digital platform. And, like WGA minimums, they generally increase by 2.5% to 3% per year.

39 The term "residuals" refers to payments payable to talent, as a percentage of revenues received by a studio from international and other secondary exploitation of a series, pursuant to applicable union collective bargaining agreements. All three of the principal talent collective bargaining agreements—with SAG/AFTRA, WGA, and DGA—provide for residual payments to union-covered service providers.

proportion to the level of the other terms of the deal. Tiering, rerun royalties, and other structural elements of this entitlement are generally akin to those applicable under writer/producer deals (with the condition of being the sole pilot director replacing any applicable writing-credit based conditions).

v. Bonuses

Independent of the ongoing episodic royalty, the director of a pilot that is ordered to series is also typically entitled to a series sales bonus. In every respect, these bonuses are generally identical to the corresponding entitlement for writer/producers—$25,000 being considered standard (with lower or higher amounts possible according to stature), proration according to the number of episodes actually produced, and potential tiering or other differentiation depending on the network for which the series is ultimately produced.

vi. Backend

The majority of pilot directors receive 2.5% of MAGR in backend from series that are produced based on their pilots, which contingent compensation vests 100% based on the director's pilot services. Inexperienced pilot directors may receive somewhat less backend (e.g., 2% of MAGR, or, in very rare cases, as low as 1.5% of MAGR), while highly successful and experienced pilot directors may command 3% to 4% of MAGR, and A-list theatrical directors and the most prolific pilot directors may, in rare instances, receive up to 5% of MAGR for pilot directing services alone.

In addition, if the director is engaged as a non-writing executive producer in series, there may be additional points allocated to those services, which would vest consistently with how such points may vest for any non-writing executive producer (e.g., in thirds, across the pilot and first two seasons of series services; although sometimes, the executive producing backend will vest in halves, across the first two seasons of services, because the director has already vested for a share of contingent compensation based on his or her pilot directing services alone).

vii. Credit

Credit for pilot directors is generally governed by the DGA Agreement (including matters of determination, form, and placement) and therefore not expressly negotiated. However, executive producer credit, where applicable, must be negotiated and is subject to the same issues applicable to other non-writing executive producers. (Additionally, as noted in Section D.iii above, the director's engagement and crediting as an executive producer may be limited to the pilot only or may extend into series.)

viii. Perks

The "perks" accorded to a pilot director are generally comparable to those accorded to a showrunning executive producer—travel (business class transportation, first-class hotel accommodations, ground transportation or rental car, and per diem, with certain minimums for these perquisites prescribed by the DGA Basic Agreement), parking, and office and assistant (usually exclusive to the director). Many directors look to have their own personal assistants put on the payroll of the production for the duration of their services, a request that is usually accommodated, though this may become more expensive (and therefore more problematic) if the director (and therefore the assistant) needs to travel for the pilot production.

ix. Subsequent Productions

Many pilot directors seek a first opportunity to be engaged to direct the pilot of any spinoffs of the series for which they are currently engaged. Where granted, the conditions applicable to such a first opportunity are generally equivalent to those applicable to a writer/producer's first opportunity to write and executive produce the spinoff. However, first opportunities for pilot directors are exceedingly rare and generally reserved for the highest-level directors (unlike first opportunities for writer/producers, which are usually given as a matter of course).

x. Quick Reference Guide

TABLE 5.4 Pilot Director Agreements

Deal Term	Main Issues/Ranges	Other Issues
1. Services	• Exclusive during formal pre-production and production; non-exclusive, first-priority until delivery of director's cut • If attached at development stage, may be subject to director's professional availability and/or to network approval	• May be non-exclusive during post-production
2. Directing Fees	• Network scale: $102K one-hour/$77K half-hour • Cable scale: $61K one-hour/$46K half-hour • Usually $100K to $250K	• High-stature feature directors may command even higher fees • DGA permits amounts in excess of 200% of scale to be applied against residuals

(Continued)

TABLE 5.4 (Continued)

Deal Term	Main Issues/Ranges	Other Issues
3. Executive Producing	• May negotiate for additional Executive Producer fee (up to $50K) and credit	• May include full-scale series non-writing executive producer deal (especially if director participated in development of series)
4. Royalties	• Usually $3K to $6K per episode	• Possible rerun royalties • Possible tiering based on network/budget level
5. Bonuses	• Usually $25K for series pickup	• May be prorated based on the number of episodes produced
6. Backend	• 1.5% to 5% of MAGR • Most commonly 2.5% of MAGR	• Miscellaneous backend definition issues (see Chapter 6)
7. Credit	• Directing credit per DGA • Executive Producer credit, as applicable	• Further Executive Producer credit issues as negotiated in Executive Producer deals
8. Perks	• Business-class travel, first-class accommodations, per diem • Ground transportation or rental car • Parking, office, and assistant	• Negotiate exclusivity of office and assistant • Engagement of personal assistants
9. Subsequent Productions	• May receive first opportunity to direct spinoff pilots	

E. Actor Agreements

If writer/producer agreements most potently illustrate television's status as a writer-driven medium, then actor agreements reflect television's status as a serialized medium.[40]

Unlike a motion picture—which, in even the most extreme circumstances, seldom requires more than a year of the actors' time to produce, and usually significantly less (i.e., months or even weeks)—a successful television series will be in production for five to eight months a year, every year, for five, seven, ten, or even more years. And for viewers, actors are the (literal) faces of these series. Actor agreements must therefore strike a balance between, on the one hand, the actors' desires to preserve the opportunity to develop their careers and accept

40 See Section A of Chapter 1.

work outside of their primary television series, and, on the other hand, the needs of the studio and network to protect series continuity over a period of years.

The terms below relate to agreements for "series regulars"—the six to ten lead actors (although the list tends to grow in later seasons of a series) who are most central to the show's creative content. These actors enter into complex, multi-year deals that firmly establish the television series as their primary employment and their primary obligation, for as long as the studio and network wish to continue to employ them. Such deals are distinguishable from "recurring guest" deals—deals that contemplate the actor appearing in multiple episodes of a series, often over long story arcs, but without binding the actor to the series long-term to the same extent.[41]

To the viewer, it may be difficult to distinguish which cast members of a series are series regulars and which are recurring guests. Typically, series regulars are credited in a series's main or opening titles, while guests are credited elsewhere under the heading "Guest Starring" or "Special Guest," but in some cases, guests may successfully negotiate to be credited among series regulars. In any given episode, the role of a guest star may be of equal or greater prominence to that of any given series regular. Usually, recurring guest stars appear on a series sporadically or for specific finite runs, but this, too, is not always the case—actors Grizzwald "Grizz" Chapman and Kevin "Dot Com" Brown appeared on over eighty episodes of NBC's hit series *30 Rock* as recurring guests, rather than series regulars. Actors who start out as recurring guests may eventually be promoted to series regulars, as was the case for Jim Rash, who played Dean Craig Pelton on NBC's *Community*, or Michael Emerson, whose performance as Benjamin Linus on ABC's *Lost* persuaded the show's writers and producers to expand his character's role from that of a short-term bit player to the series's principal antagonist for several seasons. Other actors may turn down the opportunity to move from a recurring to a regular role, as was reportedly the case with Alison Brie, who played Trudy Campbell on AMC's *Mad Men* (and elected to instead accept a series regular role as Annie Edison on *Community*).

Rather, the major difference between series regulars and recurring guests is not discernible on-screen, but off-screen, in the actors' contracts. The primary distinguishing features of a series regular agreement, compared to a recurring guest agreement, are threefold—term, priority, and exclusivity. With respect to term, series regulars make an open-ended commitment for multiple seasons, as may be required in the future by the studio and network; recurring guest stars contract for a specified, committed number of episodes at any given time, and only after the studio and network have resolved to actually produce those

41 In addition, one may consider a "guest actor" deal—a deal for an actor to appear in only one or two episodes of a series—as a third category of television acting agreement. A "day player" agreement—a deal for a short period of work in a very minor role, which may or may not be named or have spoken dialogue—is the fourth principal form of television acting deal.

episodes (although studios and actors often subsequently agree to extend creatively successful runs beyond the number of episodes initially committed). With respect to priority, series regulars generally must preserve their availability to work as, when, and where required by the studio and network as the series proceeds; recurring guest stars can fill their schedules freely with other work unless and until they are firmly engaged, with guaranteed compensation and specified dates, to work on their episodes. With respect to exclusivity, series regulars generally agree (for the benefit of the network that airs the series) to severely curtail their right to take outside work in television; recurring guest stars generally do not submit to any such exclusivity.

As a result of the foregoing differences, the same actor may work for vastly different episodic rates, depending on whether he or she is engaged as a series regular or a recurring guest star. Indeed, while the willingness of actors to take discounts on their highest-negotiated fees varies from actor to actor, it is not unusual for an actor to charge anywhere from two to ten times as much per episode to appear as a series regular, versus being engaged as a guest star or recurring guest. Many shows seek to limit all guests to no more than "top-of-show," a SAG/AFTRA-defined flat rate for "major role performers" that buys out all services required from the actor for a single episode's work. As of 2018, the SAG-AFTRA top-of-show rate is about $8,400/episode for a sixty-minute episode or $5,300 for a thirty-minute episode. Guests who have recurred for an extended period of time on a mature series may receive, as a standard, double top-of-show.

In effect, a significant portion of the episodic fee payable to actors under series regular deals compensates them not only for working for the studio, but also for *not* working for third parties. Consequently, where a studio chooses to employ an actor on a recurring guest, rather than series regular, basis, the studio's significant cost savings come with a risk that the actor, having no long-term commitment to his or her series, takes a competing job that prevents him or her from continuing to portray his or her role in future seasons.[42]

42 For example, actor Ed Skrein portrayed the role of Daario Naharis in season 3 of HBO's *Game of Thrones*. When season 4 debuted after a long hiatus, the character remained, but was portrayed by actor Michael Huisman rather than Skrein. Why? Because Skrein had reportedly taken a job portraying a younger Jason Statham in a reboot of the successful *Transporter* franchise, and that theatrical engagement rendered Skrein unavailable to reprise his role as Daario Naharis in the subsequent season of *Game of Thrones*.

More recently, however, studios have become increasingly inventive with deal structures to turn actors into "shadow series regulars." This is especially common on cable or streaming series with shorter order patterns, where roles that may have traditionally been treated as fractional guaranteed series regulars (see Section E.v below) have been re-structured as studios look to secure series regular-like availability at recurring guest star-like prices. Such deals may provide for multi-episode guarantees, block out specified calendar periods during which the actor is contractually exclusive or first-priority to the studio, provide for the studio's option to bring the guest star back to the show the following season as a series regular, and/or grant the studio preemption rights in the event the guest star is prepared to accept an outside offer that would render him or her unavailable to continue recurring for the studio.

i. Test Options

For actors who must test for a role, as opposed to receiving a straight offer, the studio must negotiate specific terms for its initial option.[43] There are actually typically two "tests" for actors who are going through the casting process—a studio test where the studio's executives consider options that have been curated by a show's producers and casting directors, and a network test where the network's executives consider options that have been deemed acceptable by the studio's executives to show to the network. For the most part, in the modern industry, the actor's "test performance" is actually pre-recorded by the casting directors and shown to studio and/or network executives at the appointed date and time. Studio executives generally will not consider, and in no event will present to a network, an actor whose deal is not fully negotiated and executed by the actor prior to the date and time of the test. This policy contributes to the "fire drill" pace of dealmaking for test options, especially during broadcast network pilot season, when there is an extensive amount of simultaneous casting activity going on within the television community. Casting decisions are usually made by consensus among network, studio, producers, and casting directors, although network approval is mandatory—and, in the event of a disagreement, the network's will tends to prevail. Although most studios and networks prefer to make creative decisions on purely creative grounds, financial considerations often inform which actors are approached and considered for a role in the first place (depending on the amount of money in the pilot/series budget allocated to the role, and the amount of the aggregate cast budget that has already been affirmatively committed to actors engaged for other roles).

The studio takes an option to engage the actor for pilot (or, if there is no pilot, first season) services, which is exercisable within a specified period following the test—usually five business days, often reducible to three business days if the actor receives a bona fide outside offer for another engagement.[44] During the height of pilot season, and in highly competitive situations, the option period may be shorter. If there are separate tests scheduled at the studio and network levels, the deal must specify which test triggers the option period, and whether the option period automatically shifts or extends if the test date and time changes.

The actor's engagement may be subject to further conditions, such as the conclusion of negotiations between the studio and network of a license agreement,

The net effect is that studios are managing the availability of actors who are not technically exclusive to the studio (and are not getting paid in the way that true exclusivity would usually require), but for all intents and purposes are functionally exclusive to the studio, at least for specified periods of time.

43 The "test option" process is explained in Section A.iv of Chapter 2.

44 Such "engagement" entails guaranteeing the actor's full pilot services fee, even in the by-then unlikely event that the pilot is not actually produced; however, the studio at all times retains the right to replace the actor, as the agreement requires only that the studio pay the actor as if he or she had been used, and not necessarily that the studio actually use the actor.

or the satisfaction of other conditions imposed by the studio or network on the unconditional greenlight of the pilot production. Outstanding conditions that are outside of the actor's control may cause some actors to hesitate to commit to a test option agreement, and often, deals will provide that all conditions must be waived or acknowledged satisfied within a specified time, or the actor is free to walk away from the deal.[45]

ii. Pilot Services

The pilot component of a series regular deal typically "buys out," or provides compensation in full for, a specified number of days of services for pre-production (e.g., rehearsal, wardrobe fittings, etc.), production, and post-production (including retakes, added scenes, and audio dubbing/looping work). That number is usually specifically tailored to the pilot production schedule, with a few buffer days. This buyout will usually cover some small number (e.g., two to four) of post-production days that may be non-consecutive with the principal period of pilot production, although non-consecutive services days are usually subject to the actor's professional availability. Services in excess of the pre-bought days may be paid at the applicable SAG/AFTRA scale minimum rate, though, where an actor's initial compensation exceeds the applicable SAG/AFTRA scale rate (as is typical for series regular engagements), it is more common for overage days to be paid at a *pro rata* daily rate, based on the negotiated pilot fee divided by the number of bought-out work days under the actor's pilot deal.

iii. Pilot and Series Fees

The fees paid to a series regular actor are a function of many factors, including the stature and quotes of the actor;[46] the prominence of the role in the series; the overall budget of the series and the cast budget in particular; and the amount of budget available for the studio to spend following commitments of the balance of the cast budget to previously engaged actors. Actors and their representatives will generally expect to make no less than the amount negotiated for their most recent deal, and will seek to improve upon such quotes to the greatest extent

45 Because acting engagements are often contingent in this fashion, an actor (and his or her representatives) may pursue multiple series opportunities during a single casting cycle, by arranging the various offers in precise contractual "priority" relative to one another. Of course, the studio/network may consequently elect to pass on an actor whose availability is uncertain when time is of the essence for a casting decision.

46 As noted in Section A.i above, recent changes in California and New York law designed to promote gender pay equity, prohibiting employers from inquiring about a candidate's salary history, are likely to dramatically impact the negotiation market for actor fees in the years ahead. The effect will be felt most strongly among non-marquee actors, whose fees have historically been set primarily by reference to their most recent quotes.

possible, especially where the quote was "earned" (i.e., the actor was actually cast in the role, and performed in a pilot and/or series). However, some actors and their representatives will accept slightly lower fees for "straight offers" than for "test options," because they are freed from having to further compete to win the role.

Typically, the actor's episodic rate for the first season of a series will be the same as his or her pilot fee, though pilot fees may sometimes be slightly above or below the applicable first season fee, depending on negotiating needs and policies. The majority of studios and networks recognize 5% cumulative annual bumps in this episodic rate (i.e., on a season-by-season basis), though some studios, as a matter of policy, limit such increases to 4%. Some studios will consider granting actors an unusually high fee bump between the first and second seasons, particularly if the actor's negotiated fee for the pilot and/or first season are below the actor's quote or otherwise unusually low; however, most major studios tend to avoid this. Fees may be tied to program length (i.e., thirty-minute episodes, sixty-minute episodes, etc., taking into consideration that shorter episodes generally have smaller budgets and take less time to produce), with negotiated increases (which may or may not be on a *pro rata* basis) for episodes whose running times exceed the presumed program length under the deal.

Finally, the parties may negotiate to deem some portion of the actor's negotiated pilot and episodic fee—which portion may be denominated as a specific dollar amount or a percentage, often 10% to 20%, of the actor's fee—to be an advance against residuals that may be due to the actor, pursuant to the requirements of the SAG Basic Agreement, for the studio's foreign or off-network exploitation of the series.

In kids programming, child stars typically make about $7,500 to $12,500 per episode for the pilot and first season, with escalations thereafter. Child actors on adult primetime programs usually start at between $10,000 and $20,000 per episode.[47] Inexperienced adult actors with no preexisting quotes as a series regular usually earn between $17,500 and $22,500 per episode to start. The vast majority of steadily working television actors make between $25,000 and $75,000 per episode, with major stars who have appeared in numerous series or who have significant film experience commanding between $75,000 and $125,000 per episode.

These longstanding traditional fee ranges, however, are quickly being abandoned in the new, wildly competitive television marketplace. One of the major

47 Deals with minors have several unique elements. For example, California law requires that a portion of every child actor's compensation be placed in a trust account, known as a "Coogan account," until the child turns 18. (These accounts are named after Jackie Coogan, a 1920s child star who later sued his mother and stepfather for squandering his film earnings.) In addition, because the law may permit a minor to cancel a prior contract upon turning 18, many studios protect themselves by requiring the child's parents to essentially co-sign the agreement, and submitting those co-signed contracts to the local state courts for judicial "confirmation" that prevents the minor from later disavowing the deal.

ways that shows have sought to distinguish themselves in an era of unprecedented small screen options is with marquee on-camera talent. As premium cable and digital platforms, in particular, have sought to lure A-list movie stars to the small screen (and marquee actors have allowed themselves to be courted), the economic market for on-camera talent has exploded.[48]

Arguably, the trend began with 2014's *True Detective* on HBO, which lured stars Woody Harrelson and Matthew McConaughey (the latter of which won an Oscar that year for his performance in *Dallas Buyers Club*) with reported paychecks of $300,000 per episode each for a single eight-episode season, with additional executive producer fees for each paid on top.[49]

In the years since *True Detective*, however, the trend of exploding actor paychecks has only deepened and widened, with mega paychecks luring top-tier talent to ongoing episodic series as well as mini-series or anthology series with single-season commitments. HBO itself has been a consistent force in courting major stars, and paying them well to make the jump to the small screen. Dwayne "The Rock" Johnson reportedly receives $450,000 per episode to star in and executive produce HBO's *Ballers*. HBO also reportedly paid Nicole Kidman and Reese Witherspoon $350,000 per episode each, over seven episodes, to star in mini-series *Big Little Lies*, and then increased those fees to around $1 million per episode each to lure the stars back for a second season. (Industry observers credited the salary spike in part to the influence of Apple's entry into the marketplace, including its decision to pay Witherspoon and Jennifer Aniston a rumored $1.25 million per episode each, over two guaranteed ten-episode seasons, for an upcoming morning-news drama based on Brian Stelter's non-fiction book *Top of the Morning: Inside the Cutthroat World of Morning TV.*)

The trend has been even more pronounced on digital services such as Netflix and Amazon, which have demonstrated a willingness to pay top dollar to lure talent to their platforms (and to compensate that talent for the diminished value, at least in popular perception, of backends and residuals from shows on these digital platforms). Jason Bateman and Laura Linney each reportedly commanded $300,000 per episode (over ten episodes) for Netflix's *Ozark*, produced

48 One consequence of the explosion of series regular fees, however, has been a squeeze on the fees of recurring and non-recurring guest stars, whose salaries have been compressed in order to help the studios absorb their growing costs for series regulars. Actors whose roles may have been previously treated as fractional series regulars (see Section E.v below) are now being engaged as recurring guest stars. Actors who may have commanded huge guest star fees in the late 1990s or early 2000s are being forced to work for top-of-show, or perhaps double top-of-show. Lower-level actors who may have been engaged as top-of-show "major performers" have been forced into the less lucrative "day player" category.

49 It is still somewhat rare for actors to receive executive producer credit on a series, particular in a show's first season. However, as more and more prominent actors attach themselves to proposed television series at the development stage, they also increasingly expect to receive executive producer fees and credit in exchange for their efforts to develop and sell the series, and help shepherd it to production.

by Media Rights Capital. Billy Bob Thornton reportedly received $350,000 per episode (over eight episodes) to star in Amazon's self-produced *Goliath*, while industry publications reported that Kevin Costner declined an offer of $500,000 per episode to star in another Amazon series. Reported price tags have proven even higher for multiple-Oscar winners such as Robert De Niro ($750,000 per episode over twenty episodes for a David O. Russell-produced Amazon series)[50] and Meryl Streep ($825,000 per episode for the J.J. Abrams-produced *The Nix*, from Warner Bros. Television; although, as of this writing, the studio is still seeking a network buyer for the show).

This explosion in acting fees has, in turn, reverberated in the broadcast network world, where the major networks must now work harder than ever to lure major stars away from the premium and digital platforms. In 2016, the traditional $125,000 per episode ceiling was shattered by former *NCIS* star Michael Weatherly (on CBS's *Bull*, produced by CBS Studios) and former *24* star Kiefer Sutherland (on ABC's *Designated Survivor*, produced by ABC Studios), each of whom reportedly commanded $300,000 per episode during their new series's first seasons, before lucrative executive producing fees and backend.[51] And for these network stars, success will mean twenty-two to twenty-six, rather than eight to ten, of these enormous episodic fees per year.

To be clear, as noted in Section B of Chapter 2, actors on highly successful series have long had the opportunity to renegotiate their way to massive paydays. In 2002, the six principal stars of NBC's *Friends* (produced by Warner Bros. Television)—Jennifer Aniston, Courteney Cox Arquette, Lisa Kudrow, Matt LeBlanc, Matthew Perry, and David Schwimmer—famously banded together, following a recent ratings renaissance for the iconic series, to negotiate fees of $1 million per episode *each* to return for the show's ninth and tenth seasons. Jerry Seinfeld reportedly turned down $5 million per episode to return for a tenth season of *Seinfeld*. Among more recent television series, the three top stars of CBS's *The Big Bang Theory* (Jim Parsons, Johnny Galecki, and Kaley Cuoco) also command $1 million per episode, while even their co-stars reportedly receive approximately $800,000 per episode. On cable, *The Walking Dead*'s Andrew Lincoln and Norman Reedus reportedly renegotiated their deals to each make $550,000 and $650,000 per episode for the show's seventh and eighth seasons, respectively. Meanwhile, conflicting reports have the five top-tier stars of HBO's *Game of Thrones*—Peter Dinklage, Kit Harington, Emilia Clarke, Lena Headey,

50 This series was ultimately canceled prior to going into production in the wake of sexual harassment scandals that engulfed Hollywood throughout late 2017 and early 2018. The show was to have been produced by The Weinstein Company. Amazon quickly dropped the series, despite its substantial financial commitments on the project, after allegations of a long history of serious sexual abuses by producer Harvey Weinstein came to light in October 2017.

51 Backend for actors remains rare, particularly in the first season of a series, and is largely reserved for the highest-level stars.

and Nikolaj Coster-Waldau—earning salaries of anywhere from $500,000 per episode to $1.1 million per episode each for the final thirteen episodes over the series's closing seventh and eighth seasons. In early 2018, *Grey's Anatomy*'s Ellen Pompeo made headlines as TV's "new $20 million woman," negotiating a deal covering the show's fourteenth through seventeenth seasons that reportedly provided for a seven-figure signing bonus, $575,000 per episode (with twenty-two episodes per year), and two full backend points estimated in value at $6 million to $7 million per season.

Nevertheless, the explosion of acting fees for actors in the *first seasons* of new television series, whose long-term economic prospects are highly unproven, represents an unprecedented economic opportunity for these stars—and unprecedented economic risk for the studios behind their shows. In addition, some commentators have argued that the explosion of salaries for top tier talent has depressed the available compensation for mid-level supporting actors, and that the industry's accommodation of movie stars' preference for fewer episodes and shorter commitments has reduced earning opportunities for lower-paid (on an episodic basis) actors who would prefer (and in many instances, need) to work as much as possible.

iv. Series Options

An actor's pilot fee buys out an initial option to engage the actor to render services on a series (if ordered). During this option period, the actor is precluded from accepting any third-party engagements that would prevent him or her from rendering series services as required by the studio.[52] The initial series option date may be set based on a concrete calendar date (which is typical for broadcast network pilots, which are produced in early spring with initial series option dates set to June 30 of that year), or a specified amount of time following the delivery of the pilot (which is typical for cable pilots that produce year-round, and is usually set to three to six months following the pilot delivery).

Studios also typically build in contractual extensions for such initial options (often to accommodate the right of a network licensee to place a later series order in anticipation of a mid-season launch). The historical standard for such extensions is six months (on a broadcast network pilot, to December 31 of that year), subject to payment to the actor of an additional pilot fee. More recently, studios and networks have experimented with variations such as breaking up the six-month extension into two three-month extensions for a half-pilot fee each, and/or making extension fees applicable in whole or in part against subsequent series fees. Extensions may prove particularly controversial or difficult to negotiate

52 To be clear, the studio is virtually never obligated to engage an actor to render services, even if the series is ordered; CBS chief Les Moonves famously demanded that *Big Bang Theory* pilot actress Amanda Walsh be replaced for the series, leading to the subsequent casting of star Kaley Cuoco.

if they have the effect of keeping an actor off the market for a subsequent pilot season (as may be the case for cable pilots that are initially produced later in the year). For the most part, all series regulars engaged for a given pilot are accorded equivalent treatment (with extension fees scaled according to their respective pilot fees) in the option structures under their deals.

In addition, the series regular deal must specify option periods for the studio to exercise its option to engage the actor for subsequent seasons of the series. Again, these subsequent season option dates may be defined based on calendar dates (again typical for broadcast network pilots; usually June 30 annually), or a specified amount of time following the delivery or exhibition of the last episode of the prior season (again typical for cable; commonly set to the earlier of six to seven months following the initial exhibition, or nine to ten months following the final delivery, of the last episode of the prior season). Subsequent season option dates may also be annualized to the calendar date of the initial series option deadline. In any event, the subsequent season options must be set with sufficient spacing to allow the studio and network adequate time to produce and exhibit enough of the prior season for them to be prepared to make decisions about whether a show will be renewed, and whether any given actor will be required to return. Some studios and networks also negotiate for the ability to pay for one-time extensions and/or re-annualizations of subsequent season option dates, in order to account for potential delays or exigencies of production or exhibition (such as "binge" releasing of all episodes) that may make it difficult for them to be ready to render decisions within the default option period. Again, all series regulars engaged for a given series are generally accorded equivalent treatment in such option structures.

The vast majority of series regular deals bind the actor to the studio for six years.[53] This practice derives from California law, under which the so-called "seven years rule"[54] renders personal services contracts with terms longer than seven calendar years unenforceable.[55] In very rare instances—in particular, deals

53 Deals for broadcast network series are often for "six and a half years," with the "half year" allowing for six full seasons that follow a shortened (e.g., eight to thirteen episodes) first season that is ordered to production for a "mid-season start"—i.e., premiering during January to April, rather than September or October, of the applicable broadcast year. For reference, "broadcast years" are typically understood to run from September of any given calendar year until August of the following year.

54 This is also sometimes referred to as the "De Havilland Law," named after actress Olivia De Havilland, who, in 1943, successfully challenged her long-term exclusive agreement with film studio Warner Bros. This legal decision helped contribute to the collapse of the so-called "studio system" of the 1920s through 1940s (an era during which film production and distribution was dominated by a small number of dominant, vertically integrated studios, who exercised significant control over the labor of talent via long-term exclusive contracts).

55 During the contentious *Modern Family* cast renegotiation, also discussed in Section B of Chapter 2, the actors' lawyers sought leverage in their negotiation by suing for a declaration that the actors' contracts were altogether void, due to an alleged error in the dating and structuring of the actors' deals, which had the effect of extending their terms to more than seven years (and therefore caused the contracts to violate California's "seven years rule").

with extremely high-level and active film actors (who are reluctant to sign extremely long-term deals), and deals for closed-ended limited or anthology series (which do not require season-to-season continuity of characters)—studios may agree to accept shorter-term deals (e.g., three to four years). These shorter term deals have become increasingly common with the inflow of prominent feature actors on television productions. Nicole Kidman and Reese Witherspoon were able to negotiate their extraordinary paydays for season 2 of *Big Little Lies* in part because their original deals had only covered one year of services, and HBO was forced to negotiate new deals from scratch at a moment when the actresses enjoyed significant leverage in the negotiation. However, deviations from six-year deals are still quite unusual, and even where a character is specifically contemplated to require only a one- or two-year story arc before being written out of the series, the preferred studio practice is to obtain a six-year deal on a blanket, non-negotiable basis.[56]

In addition, studios behind successful series often, as a matter of courtesy and custom, entertain renegotiations of actors' deals before those deals actually expire. Traditionally, this renegotiation usually took place following the fourth season of a series, as described in Section B of Chapter 2. More recently, the general climate of rapidly growing actor fees and the decreasing frequency of series surviving for five or more seasons have emboldened representatives to force these renegotiations sooner, after the third or even second season of a successful series. Such renegotiations may be conditioned on the actor's agreement to extend the deal by adding further series options.

v. Series Guarantees

A series regular deal will also specify a guaranteed number of episodes-per-year for the actor. The majority of series regulars are guaranteed to receive their episodic fees for all episodes produced during any season for which they are engaged (whether or not they actually appear in every episode). Actors in smaller roles may receive "fractional guarantees"—the usual variations for broadcast network series are 7/13 (i.e., a guarantee that the actor will appear in seven thirteenths

56 Such conservatism in dealmaking can often prove extremely important in hindsight. For instance, it has been widely reported that the character of Jesse Pinkman (played by Aaron Paul) was initially intended to die before the end of the first season of *Breaking Bad*, but series creator Vince Gilligan was so impressed with Paul's performance in the series that he decided to change his creative plan, making the character of Jesse Pinkman central to the show's full five-season run. Had studio Sony Pictures Television made a one-year deal with Paul from the outset because of Gilligan's initial creative plan, it would have been forced to negotiate a new (and potentially significantly more expensive) deal to extend Paul's run on the show after the first season. In any event, studios always retain the right not to exercise their option for another season of an actor's services (and actors are only paid for the seasons for which they are actually engaged to render services), which makes obtaining the greatest number of options/years possible in the deal a no-brainer for the studio.

of episodes produced) or 10/13 (i.e., a guarantee that the actor will appear in ten thirteenths of episodes produced),[57] and for cable series is 7/10 (i.e., a guarantee that the actor will appear in seven tenths of episodes produced).[58] Such guarantees are generally driven by the creative needs and expectations of the series creator and producers, but sometimes, the decision-making may flow in the opposite direction: a major actor who is negotiating to play a character that is contemplated for a fractional guarantee may insist on being guaranteed all episodes produced, effectively forcing the studio and creative team to alter their ingoing creative plan and enhance the character's significance, or to take on dead-weight financial obligations (paying an actor for all episodes produced, whether or not the actor is actually used in all such episodes), in order to successfully close the deal with the desired actor. In addition, it is not uncommon for a role with a fractional guarantee in the first season of a series to escalate to "all episodes produced" by the second or third year of the deal.

In addition to stating a series guarantee as a percentage (7/10, 7/13, 10/13, or all) of episodes produced, a series regular deal will also typically provide for a per-season numerical number of guaranteed episodic fees.[59] The majority of deals, whether for broadcast or cable, guarantee actors a minimum of seven episodic fees for the first season of the series, reducible to a minimum of six episodic fees if the initial order is for six or fewer episodes. In subsequent years, the annual guarantee will increase somewhat, usually to thirteen episodes for broadcast network series, and to anywhere from ten to thirteen episodes in cable (but in any event no more than the expected actual number of episodes per season).

In some instances, actors' representatives may seek to negotiate maximums as well as minimums on their clients' episodic services. This issue typically arises when a high-level film actor is tentative about committing to long annual television production periods, or when a show is being produced for a newer platform

57 This reflects the fact that, until recently, most broadcast series were ordered in increments of no less than thirteen episodes, and a full season usually consisted of twenty-six episodes. In recent years, a "full order" for a broadcast network is usually twenty-two episodes rather than twenty-six (though particularly successful series may still be ordered for twenty-three to twenty-six episodes in a given season). The move toward shorter seasons has been driven by a variety of factors, including the more rigorous demands of producing higher production value "premium" television content, the great expense of such series, the preferences of talent and creators, and the emergence of (and need to leave room for) broadcast network "summer seasons" with distinct programming slates.

58 With such guarantees, the relationship between the creative content of the show and the business deal with the actor is bidirectional: the deal with a series regular may be made on a 7/13 or 10/13 basis because the series creator and producers have deemed it creatively unnecessary for the character to appear in every episode, but once the deal is struck, the studio may pressure the writers and producers to ensure that the character is not used more frequently than the actor's guarantee requires (so as to preserve the financial template for the series, which reflects that fractional guarantee).

59 This is driven by the SAG Basic Agreement, which requires that an actor be guaranteed no less than seven episodic fees per season in order for the studio to maintain its exclusive option on the actor's services.

with a relatively unestablished order pattern (making it difficult for the actors and their representatives to measure and predict the level of commitment they are undertaking). Studios and networks are both typically extremely resistant to such maximums—for studios, more episodes generally corresponds to more revenue, while networks naturally want to maximize the available number of episodes of their most successful series. Consequently, studios generally resist making any accommodations with respect to series maximums, though they may sometimes agree that production of more than a specified number of episodes per season automatically triggers an annual fee bump. In addition, in the rare instance where a studio actually agrees to limit the number of episodes for which an actor may be required to render services in any given season (as was reportedly the case for Kevin Bacon on Fox's *The Following* and Viola Davis on ABC's *How to Get Away With Murder*), that studio will nevertheless reserve the right to produce as many episodes per season as the studio (and/or its commissioning network) desires (albeit without paying the actor for unworked episodes in excess of the negotiated maximum).

vi. Credit/Billing

Series regulars are generally guaranteed that their screen credits will appear in the series's main or opening titles, grouped with other series regulars, and in a size and style that is the same as—or, as the folks who draft these contracts often prefer to say, "no less favorable than"—the credit accorded to any other series regular actors.[60] Duration ties (referring to the amount of time a credit actually appears on screen) are also common, but less universal. Series regulars' credits typically appear on every episode of the series, whether or not the actor actually appears, although some studios and networks revise the credits for each episode to reflect only actors who actually appear in that episode.[61]

Higher-level actors, or actors who know that they are negotiating for a particularly prominent role, will negotiate for guaranteed credit position (in other words, a requirement that their credit will appear first [or in some other numerical position] among all credited series regulars). Credit position is usually a creative decision, combining considerations of the prominence of the actor and the prominence of the role in the series. Position guarantees are generally styled as "no less than ___ position," to allow the studio to accord even more favorable credit position in its own discretion. Prominent actors in smaller supporting roles often negotiate to receive the final credit among series regulars, with the word "and" before their names (called "last/and" credit). If this credit has already been committed to an actor, a subsequent actor in a similar position may negotiate for credit

60 By contrast, "Guest Star" credits almost always appear in the end titles of each episode.
61 For instance, this is the case on HBO's *Game of Thrones*, which sports a particularly massive cast of series regulars, none of whom consistently appear in every single episode of the series.

in penultimate position, with the word "with" preceding his or her name.[62] Early in the casting process, a studio negotiating with a prominent actor may negotiate for credit position options that it may choose among in its discretion (e.g., a credit that will appear in no less than second position, or in penultimate/"with" position, or in last/"and" position, at the studio's discretion). Alternatively, a studio may preserve its right to credit all series regular actors in alphabetical order, or to accord so-called "Laverne & Shirley" credit (a form of joint first-position credit granted to two co-leads, in which both credits appear on a single card, with one name positioned to the bottom-left and the other to the upper-right).

Finally, higher level actors may seek to require that the studio credit them in all paid advertising for the series (e.g., billboards, magazine and newspaper advertising, etc.).[63] Such prominent mentions of the actor's name in advertising bolster the individual's stature in the industry and notoriety with the public. Although the studio may consider the actor's name valuable in marketing and may intend to mention the actor's name in any event, in general, the studio also wants to reserve as much discretion as possible to craft advertising as it sees fit. As a result, studios tend to resist these requirements; or, if they agree to any paid advertising provisions at all, agree to "ties" rather than absolute entitlements. In other words, the studio may not guarantee that the actor's name will be used in paid advertising, but agree that, if the studio elects to use any *other* actor's name in a piece of advertising, it will *also* use the name of the actor who has the "paid ad tie."[64] This retains flexibility for the studio, while reducing the risk of embarrassment for the actor should the studio try to promote the series solely around one or more of his or her co-stars.

62 CBS's long-running sitcom, *How I Met Your Mother* (which premiered in 2005) offers a helpful example of how such credits are allocated. Over its nine seasons, the show maintained a cast of five series regulars: Josh Radnor (playing Ted Mosby), Jason Segel (playing Marshall Eriksen), Cobie Smulders (playing Robin Scherbatsky), Neil Patrick Harris (playing Barney Stinson), and Alyson Hannigan (playing Lily Aldrin). Although Radnor was perhaps the least experienced actor of the group, he received first billing by virtue of his character, Ted Mosby, being the principal protagonist of the series. Segel, one of the stars of the critically acclaimed series *Freaks and Geeks*, received second billing. Smulders, another relative unknown at the time *How I Met Your Mother* debuted, received third billing. Harris, who had found fame as a child star in 1980s sitcom *Doogie Howser, M.D.* and parodied himself in the 2004 film *Harold & Kumar Go to White Castle*, received the penultimate "with" credit. Hannigan, who had concluded a successful run on *Buffy the Vampire Slayer* in 2003, received the last "and" credit.
63 Like photo/likeness/biography approval rights, discussed in Section E.viii below, such a requirement would typically bind only the studio, *not* the network (even though the network controls most series advertising). The studio would ordinarily at least advise the network of the existence of such negotiated terms.
64 "Paid advertising" is often a contractually defined term and is subject to a variety of exclusions that fall under the heading of "excluded advertising." The effect of "excluded ads" is that, even where an actor receives an entitlement to paid ad credit or a paid ad tie, those rights do not constrain the studio's actions for excluded ads. The "excluded advertising" category often includes such obvious and important types of advertising as television and radio commercials. As a result, actors may also seek an "excluded ad" tie, separate from their "paid ad" tie.

vii. Dressing Room

The type of dressing room accorded to an actor during production of the series is generally considered a material substantive term of the actor's deal, as actors will spend a considerable part of each shooting day prepping (or waiting) for their calls off-set. When a show is filmed on a studio stage location (as is common for multi-camera comedies), actors are generally provided with private dressing rooms within the studio facility. However, when a show is filming on location, actors will be provided with spaces in dressing room trailers and may negotiate fiercely for favorable accommodations. Single "star" trailers (which have a single compartment, for a single actor) are fairly uncommon in television production, and, because of cost considerations, many studios have strict policies against providing such dressing rooms. Many of the theatrical stars entering the television industry, however, are bringing their customary demands for single "star" trailers with them.

Most series regulars (as well as high-level guest stars) are accorded one compartment in a so-called "double banger" (i.e., a 40+ foot trailer with two separate side-by-side private compartments). Lower-level series regulars (and most guest stars) may be accorded one compartment in a so-called "triple banger" (i.e., a trailer with three smaller side-by-side-by-side private compartments). Triple bangers are especially common for shows that film on location in New York City, where space constraints are a major production consideration. Nearly every actor will seek (though not every actor will receive) contractual assurances that his or her dressing facility will be no less favorable in any material respect than that accorded to any other actor on the series.[65]

viii. Photo/Likeness/Biography Approvals

Most series regulars will negotiate for approval rights over still images, non-photographic likenesses,[66] and biographical information depicting or concerning the actor that are used in publicity for the series. Studios have widely disparate policies with respect to the granting of such rights; some studios accord them to series regulars as a matter of course, while others steadfastly reserve such rights only for higher-level actors (sometimes by requiring, as a matter of policy, that an actor must receive higher than a threshold fee in order to qualify to receive such approval rights).

65 It is difficult to overstate how important dressing room issues can become for some actors, and therefore, for the negotiation of some actor deals. For instance, many actors negotiate for extremely specific dressing room furnishings and amenities. Moreover, while such details are never negotiated contractually, the most particular actors may insist on being assigned whatever trailer (or trailer compartment) is physically nearest to the actual filming area, as a way of reflecting that actor's superior importance to the production.

66 Think of the stylized artistic rendering of Harrison Ford as Indiana Jones on the poster art for *Raiders of the Lost Ark*.

When an approval over still photographs is granted, it may be granted solely as to photographs in which the actor appears alone, or extended to photographs in which the actor appears with others (or with others possessing comparable approval rights). Actors must typically approve no less than 50% of photographs in which they appear alone, and, if applicable, no less than 75% of photographs in which they appear with others, and must exercise such approvals (typically through their representatives) within short time windows or those approvals are deemed granted. For non-photographic likenesses, the actor negotiates for how many rounds of comments (or "passes") he or she is permitted to make on a proposed rendering before it is deemed approved—usually one pass, and almost never more than two passes, being the standard.

Vitally, while a studio may agree to accord such approval rights to an actor, networks—which are the entities that actually control the majority of advertising activity around a series—virtually never agree to assume the corresponding obligation and honor such approval rights. Consequently, such restrictions are almost always limited to advertising materials that are created by or under the direct control of the studio (and therefore may have somewhat limited practical effect, as such advertising materials are considerably less common than those produced and distributed by the network).

ix. Merchandising Rights

Series regular deals typically expressly provide for the studio's right to use an actor's name, voice, and likeness in merchandising and commercial tie-ins. Actors, in turn, often seek a right of approval over such merchandising and/or commercial tie-ins using their names, voices, or likenesses. Such approvals are seldom granted to series regulars (whose significant guaranteed compensation is generally understood to include compensation for exclusivity, likeness rights, and the like), as opposed to high-level guests (who may appear in as little as one episode, for what may be a modest fee, and therefore have greater basis to resist granting such rights).

More commonly, actors are granted a limited right of approval over the use of their names or likenesses in specified restricted categories (e.g., firearms, alcohol, tobacco, pharmaceuticals, personal hygiene products, etc., as well as product categories that directly compete with the actor's preexisting branding and endorsement obligations for third-party brands).[67]

In addition, a studio will generally agree to pay actors a percentage of the studio's revenues from merchandising featuring that actor's likeness. The

[67] One contested but highly valuable category is gambling. Although some actors may be sensitive about the use of their names or likenesses in lottery games, slot machines, and comparable contexts, these rights can be extremely valuable to the studio (and, by extension, to the actor who receives a royalty for the use of his or her likeness).

standard royalty rate is 5% of the studio's "net merchandising receipts" (the studio's merchandising receipts, less distribution fees for the studio or its subdistributors, and out-of-pocket expenses), reducible by royalties granted to other actors featured on the same piece of merchandise to a floor of 2.5% of the studio's "net merchandising receipts" from each such product (a 5/2.5 royalty formula).[68]

x. Other Approvals/Consultations

Generally speaking, actors are only able to negotiate fairly limited approval and consultation rights. Actual contractual approval rights are exceedingly rare, and, when such requests are accommodated, it is almost always in the form of a contractual consultation (rather than approval) right. In addition, as for many of the deal points discussed throughout this section, the according of such rights depends on the stature and bargaining power of the actor.

Very high-level actors who are attached at the development stage of a project, when the details of the creative team and content are not yet certain, may seek and receive consultation rights over the pilot screenplay, the pilot writer, the pilot director, principal filming location, and/or the showrunner, to the extent that such elements have not already been determined as of the time the actor makes his or her deal. Many such top-level actors also seek approval over networks to which the project may be pitched or sold (which often results in the negotiation of a list of pre-approved buyers). Any such rights would be considered exceptional.

More commonly, series regulars have a contractual right to consult with producers with respect to the look and feel of their hair, makeup, and wardrobe for the series. Higher level actors may also receive contractual consultation or approval rights over the actual personnel engaged to render hair, makeup, and wardrobe services. Approval over the distribution of bloopers featuring the actor is relatively common, though approval of non-blooper behind-the-scenes or deleted scenes footage is often sought but seldom granted.

xi. Travel/Relocation

If an actor is to render services on a pilot that is produced more than 50 or 75 miles from his or her principal residence, as a matter of course, the actor will be provided with a standard travel package—business class transportation, first-class hotel accommodations, ground transportation, and a per diem (minimum terms for which are prescribed by the SAG Basic Agreement, where applicable).[69] High-level actors often negotiate for first-class transportation and/or companion

[68] In some instances, however, studios may seek further reducibility of their royalty obligations from products that feature a large number of (royalty-earning) cast members from an ensemble cast.

[69] This basic travel package is also the norm for guest stars who must travel for filming.

tickets, though these are seldom provided in television (as opposed to feature films, where they are more common accommodations).[70]

For series, however, studios generally presume that an actor will actually relocate permanently (or at least for the life of the series) to the filming location of the series.[71] Consequently, in lieu of providing transportation and accommodations, the deal will typically provide for a flat relocation package for the actor—usually comprised of one or two business-class tickets, and a non-accountable allowance of around $7,500 to $10,000. At higher levels, an actor may be provided with as many as four business class tickets (which the actor may use to travel back and forth to his or her permanent home, or to provide transportation for friends or family members), and a relocation fee as high as $25,000, though such enhanced packages are reserved only for very high-level, hotly negotiated deals.

In the past, studios often sought to limit these relocation packages to the first season only (on the logic that the actor would permanently relocate him- or herself, and thus no relocation expenses would be incurred in future seasons). In practice, most actors actually declined to relocate to their shows' production locations on a permanent, full-time basis, and starting in 2017, SAG/AFTRA successfully negotiated in collective bargaining to require studios to pay such relocation packages on a season-by-season, rather than one-time, basis.

Because many actors are sensitive to where they live and work—and the pursuit of cost-saving tax incentives has attracted production away from traditional entertainment industry centers like Los Angeles and New York (and toward places such as Vancouver, Toronto, New Orleans, Pittsburgh, Atlanta, and Albuquerque)[72]— high-level actors will often negotiate for the right to opt out of their obligations altogether if the studio moves principal production of the series away from one of a negotiated list of production locations that the actor deems acceptable. Unusually lucrative relocation packages are often a product of a studio's efforts to persuade an actor to entertain alternative production locations.

xii. Exclusivity

As noted in the preface to this section, exclusivity is one of the key elements that distinguish a series regular deal from a guest star deal. Most networks have a somewhat proprietary attitude toward talent that appear on their shows;[73] con-

70 For many years, the SAG Basic Agreement actually required that all actors on SAG productions be flown first-class, a costly perk that was pared back to a business class guarantee during the collective bargaining that led to the 2011 amendment and extension of the SAG Basic Agreement.

71 This presumption may hold less water for shorter-order cable series, which produce ten to thirteen episodes over five- to six-month production periods per year, compared to broadcast network series, which usually produce twenty-two episodes over an eight-month production period per year. Nevertheless, even if fictional, this assumption is a hallmark of most series regular deals.

72 See Section D of Chapter 1.

73 This attitude—which was born in an era with three broadcast networks and no cable networks—is arguably anachronistic in the modern marketplace, which features literally dozens of competing television networks and digital platforms, and actors who jump regularly between feature film and television

sequently, networks usually require that studios obtain significant exclusivity (within television) over actors' services as a condition of engaging such actors as series regulars. Deviations from such exclusivity requirements are extremely rare, and require the network's approval in every instance.

Series regulars' services are generally fully exclusive (in all media) during production periods, exclusive in television (subject to limited carveouts) at all times, and always first-priority with respect to production services (which means that the studio has first call on the actor's time, and can call on the actor to render production services whenever necessary, unless the studio has specifically agreed to waive such priority for specified dates on which the actor wishes to take other work).[74] The exclusivity in television typically includes carveouts for non-recurring/non-regular guest appearances for third parties (which are often limited to no more than three appearances every thirteen weeks), and unlimited appearances in talk, news, radio, game, panel, or variety-type programs. Guest appearances for third parties may also be subject to "time period" protection— i.e., the actor may not agree to make a guest appearance for a series that is likely to be broadcast on the same day and time of the week as the actor's primary series. Some studios also prohibit actors from rendering behind-camera (e.g., writing, directing, or producing) services for outside television series (though this is more commonly a studio, rather than network, prerogative).

Series regulars typically must obtain the approval of the studio and network that employ them before entering into commercial endorsement agreements during the term of their agreements for a series (and, in general, series regulars are altogether prohibited from entering into commercial endorsement agreements with competitors of the series's major sponsors). Actors with preexisting endorsement relationships must typically disclose these up-front and obtain specific contractual carveouts to allow these relationships to continue.

Where actors sign on for limited series or otherwise make only one-year commitments, rather than entering into long-term multi-season deals, the foregoing exclusivity requirements (other than full exclusivity during production periods) may be substantially limited or eliminated entirely.

xiii. Publicity/Promotion

For a series to succeed, it is vital that it be promoted aggressively, and actors have a unique and critical role to play in the publicity and promotion of a television series. Consequently, series regular deals usually include explicit terms setting

work. But it is nevertheless ubiquitous, particularly among broadcast networks, which often work hard to create a brand association in viewers' minds between a given star and their own network.

74 Depending on the network, genre, and level of compensation, lesser exclusivity may be considered—for instance, performers on unscripted series are generally subject to far more limited exclusivity requirements, such as exclusivity solely in unscripted programming, or in programming of a comparable genre or theme. However, again, such compromise is rare for actors on scripted series, who generally submit to full exclusivity in television (subject to the carveouts described here).

forth the actor's obligation to render publicity services, as directed by the studio and/or the network, to support the series.

Generally, publicity services may be freely required of the actor during series production periods, while publicity services that are to be rendered outside of production periods are subject to the actor's professional availability, and to the studio or network's obligation to provide transportation, accommodations, and expenses if the actor must travel in connection with such promotional services. However, studios and networks generally require that the actor remain available to render publicity services, on a first-priority basis, in connection with key annual promotional events, whether or not these events fall during production periods. Such lists of first-priority promotional obligations are hotly negotiated, particularly for feature actors who want to preserve their ability to work freely outside of series production periods. At a minimum, studios and networks require their actors to remain available to appear at the network's annual Upfronts event, and at the network's presentation at annual Television Critics Association events (or "TCAs"), which are a key part of the network's promotional cycle. In addition, studios and networks may seek to guarantee the actor's availability for other key events (such as major national and international sales and distribution conferences [e.g., MIPCOM in Cannes], Comic-Con, or series or season premiere events), or time periods (such as the one or two weeks immediately preceding the scheduled premiere of a series or season).

More recently, some networks have recognized the impact that actors with strong social media presences can have in mobilizing their followers and have begun making aggressive demands for cooperation or even control of the social media accounts of their stars in promoting their series. While some actors have been eager to use their social media platforms to support their shows, others view the networks' efforts to contractually mandate such cooperation as a burdensome expansion of the actors' publicity obligations, and an undue intrusion on a space that the actors may view as personal to themselves and their relationships with their fans. This is a developing area of controversy in dealmaking with actors.

xiv. Quick Reference Guide

TABLE 5.5 Actor Agreements

Deal Term	Main Issues/Ranges	Other Issues
1. Test Options	• 3 to 5 business days from "test" to elect to engage actor for pilot (or, if no pilot, series) on pre-negotiated terms	• Option period may be reducible for bona fide third-party offers • May agree to shorter options in competitive situations
2. Pilot Services	• Buy-out of specified production period, including some post-production days	• Non-consecutive services usually subject to professional availability • Overages usually paid *pro rata* based on negotiated fee and ingoing bought-out period

(*Continued*)

TABLE 5.5 (Continued)

Deal Term	Main Issues/Ranges	Other Issues
3. Pilot and Series Fees	• For entry-level actors, usually $17.5K to $22.5K per episode • For most working actors, usually $25K to $75K per episode • For high-level, experienced working actors, usually $75K to $125K per episode • Major theatrical actors may now command $300K to $1M per episode • For children on primetime shows, usually $10K to $20K per episode • On children's shows, usually $7.5K to $12.5K per episode	• Fees may be renegotiated during an active contract on a successful series • Fees may be negotiated even higher when an initial contract for a successful series is set to expire • A portion of fees may be deemed an advance against SAG/AFTRA-mandated residuals.
4. Series Options	• Almost always 6-year (or 6-season) deals • Option periods covering engagement for series (after pilot) and engagement for subsequent seasons (after each season ends)	• For high-level theatrical talent, may negotiate significantly shorter-term deals • For closed-ended limited or anthology series, may negotiate 1-year deals
5. Series Guarantees	• Fees guaranteed for "all episodes produced" or for specified fractions (e.g., 7/13, 10/13, 7/10) • Typically guarantee at least 6 episodes for first seasons, and at least 7 to 13 episodes for subsequent seasons (depending on broadcast vs. cable order patterns)	• Roles may start with fractional guarantees and escalate to higher fractions or "all episodes produced" in subsequent seasons • High-level actors may negotiate for maximum episodes per year
6. Credit/Billing	• Usually main or opening titles for series regulars • Credit position negotiated based on stature of actor and prominence of role • Last/"and" or penultimate/"with" credit for higher-level actors in smaller (non-leading) roles	• Often include size/style/duration ties to other series regulars • Series regular acting credits generally appear on every episode, whether or not the individual actor appears in that episode
7. Dressing Room	• Single "star" trailers are uncommon, but may be granted to high-level theatrical stars • Most series regulars have one compartment in a "double banger"	• Lower-level series regulars may get one compartment in a "triple banger" • May negotiate for "no less favorable" ties to other actors

Deal Term	Main Issues/Ranges	Other Issues
8. Photo/Likeness/ Biography Approvals	• Approval of publicity stills (at least 50% of stills alone and, if applicable, 75% of stills with others) • Usually one or two "passes" on non-photographic likenesses in publicity • Approval or consultation on biography in publicity	• Approval/consultation rights generally bind studio but not network (which controls most publicity)
9. Merchandising Rights	• Standard royalty for merchandise including the actor's name or likeness • Usually 5% of net merchandising receipts if actor appears alone, reducible to 2.5% if actor appears with others	• Typically restrict use of name/likeness in sensitive merchandising categories (e.g., firearms, alcohol, hygiene, etc.) • In rare cases, may grant actor approval over other use of name/likeness in merchandising
10. Other Approvals/ Consultations	• Actors usually may consult on look and feel of hair, makeup, and wardrobe • High-level actors may consult on or approve hair/ makeup/wardrobe personnel • Actors frequently may approve bloopers	• Approvals on non-blooper behind-the-scenes is less common • High-level actors attached at development stage may receive formal or informal approvals or consultations over pilot screenplay, pilot writer, pilot director, showrunner, and/or buyer network
11. Travel/ Relocation	• Usually flat annual relocation packages (e.g., 2 business class tickets and $10,000 per season) • High-level actors may receive the right to opt out if show is to be produced outside of pre-approved locations	• At higher levels, actors may receive more tickets, higher relocation fees, etc. • Highest-level actors may seek first-class or private travel (SAG/AFTRA requires at least business class in most instances)
12. Exclusivity	• Services are usually fully exclusive during production periods • By default, actor is exclusive in television for life of deal, subject to standard exceptions and specially negotiated carve-outs • Network generally has sponsor protection and right to approve new sponsorship or endorsement deals	• Exclusivity usually allows for non-recurring guest appearances • Permitted guest appearances may be subject to "premiere week" or "time period" protections • Exclusivity may also limit television producing, directing, etc.

(*Continued*)

TABLE 5.5 (Continued)

Deal Term	Main Issues/Ranges	Other Issues
13. Publicity/ Promotion	• Actor must render publicity services, subject to professional availability if outside production periods • Major publicity events (e.g., Upfronts, TCAs) are firmly required and not subject to availability	

F. Agency Package Commissions

As noted in Section B.vii.a of Chapter 1, in many instances, as a condition of acquiring valuable rights or engaging a prominent piece of talent in connection with a proposed television project, the television studio agrees to pay the agency (or agencies) that represent(s) these key elements a "package commission." The most common agency package commission in scripted television is known as a "3/3/10 package"—a studio that agrees to pay a "full package" pays the agency (1) an up-front fee equal to 3% of the license fee received from the initial domestic network licensee;[75] (2) an additional fee, equal to the first 3% fee, which is deferred and payable (if ever) out of the "Net Proceeds" of the series;[76] and (3) a backend equal to 10% of MAGR (generally on the same definition as the most favorable definition accorded by the studio to any of the agency's clients on the project, but with no third-party participations of any kind taken off-the-top).[77] Most studios and networks impose an episodic cap on the value of the 3%-of-license-fee upfront fee, usually between $15,000 and $75,000 (depending on show length, total budget level, applicable network, etc.), with episodic package fees in the $40,000 to $50,000 range being especially common.[78] This total package may be divided amongst up to three

75 This up-front fee is accounted for as a production cost of the show and is reflected in its production budget.

76 A series's "Net Proceeds" are calculated very similarly to its "Modified Adjusted Gross Receipts," using essentially the same formula, but with the studio deducting higher distribution fees and overhead charges. Because of the extremely high deductions taken by the studio, even the most successful television series are extremely unlikely to ever "break even" under a "Net Proceeds" definition. Again, these backend formulae are more fully addressed in Chapter 6.

77 This concept is addressed in Section G of Chapter 6.

78 There is a Hollywood legend told about the emergence of the package fee cap. Creative Artists Agency packaged the major creative elements behind *ER*, one of the most significant megahits of the 1990s, produced by Warner Bros. Television for NBC. The initial license agreement between the studio and the network provided the network with the right to only order up to four seasons of the series. By the time the series was wrapping up its fourth season, it was one of the most-watched shows on television, which gave Warner Bros. significant leverage in negotiating with NBC for an extension of its license agreement that would allow the network to retain future seasons of the series. The resulting

agencies, in one-half or one-third shares, depending on the number of high-level elements involved in the project and the number of different agencies representing such elements.[79]

deal provided Warner Bros. with a massive increase in its episodic license fee, which paid the studio well in excess of its cost of production of the series for years to come, and CAA's percentage-based package fee on the series skyrocketed accordingly. The agency is reputed to have made several tens of millions of dollars on the show—and the industry's realization of how much money CAA made caused every studio and network to adopt caps on their agency package fees. (Interestingly, NBC's traumatic experience in having to pay so much to hold onto *ER* has also driven the broadcast networks to negotiate harder to obtain extended term license agreements with pre-negotiated ratings-based bonuses and license fee increases in later seasons, as described in Section A.iii of Chapter 8.)

79 Agency package commissions are increasingly controversial. Arguably, the package commission represents the agency's effort to extract a fee from studios for simply doing the agency's job for its clients—finding and creating job opportunities for its clients. (Agencies would counter that packaging goes beyond the job of finding work and amounts to an outsourcing of the studio's job of putting together projects, for which the studio should pay appropriately.) The agency's episodic package fee on a project may be higher than the fee received by any one of its clients on the show. (Agencies would note that, in many cases, the agency's package fee is nevertheless lower than the agency would have collected had it charged a 10% commission on every client working on that project.)

Moreover, the economic impact of agency packages on clients is disputed. Agencies generally argue that package fees substantially benefit their clients, by allowing their clients to retain more of their income from their work (because, as noted in Section B.vii.a of Chapter 1, an agency that receives a package from the studio waives its right to a commission on its clients' earnings from the project). However, the agency package fee is accounted for as a production cost of the show, and therefore must be recouped by the studio—after the deduction of distribution fees, interest, and overhead charges—before the agency's clients will see any backend payments from the series. (See Section F of Chapter 6.) The clients' contingent compensation is even further diluted by the contingent compensation paid to the agency as part of the package commission, a 10% share that is deducted off-the-top in the calculation of the clients' MAGR. (See Section G of Chapter 6.) As with the upfront fee, the agency's 10% share of MAGR may exceed the backend entitlements of any of the agency's individual clients on the series. And because no third-party participations are typically deducted off-the-top in the agency's backend definition (while, at a minimum, the agency's participation is deducted off-the-top in the client's definition), every "point" of backend controlled by the agency may be worth substantially more than every "point" of backend controlled by the client on the same project. On a successful series, the studio's backend obligations to the packaging agency may cost the agency's clients far more in diluted contingent compensation than the clients would have otherwise paid in commissions. As a result, some of the savviest individuals—only those with the most leverage—sometimes negotiate with their own agencies with respect to whether the agency will receive a package commission on the client's projects.

Agency package commissions raise ethical concerns as well, as they cause potential conflicts of interest between agency and client. As noted above, the agency typically negotiates its package position on a project concurrently with negotiating its clients' deals on that project. If a studio resists granting the agency its desired package, the agency may hold up closing the client's deal, even if the client's deal terms have otherwise been negotiated and agreed in full. The perceived unavailability of packages from a certain buyer may cause an agency to steer its clients away from that buyer, even if the buyer may otherwise offer the clients good opportunities. Conversely, the availability of favorable package terms from another buyer may create an incentive for the agency to steer its clients toward that buyer. Some upstart studios offer especially generous package terms (with episodic caps as high as $75,000 to $100,000 per episode) as a way to curry favor with agencies and gain access to projects, while networks may offer similarly generous package terms in order to encourage agencies to deliver projects directly to the networks rather than going through third-party studios.

G. Other Key Agreements

While there are a number of other key contributors to the creative success and smooth physical production of a television series, the deals for such individuals tend to be simpler, and warrant only more general discussion here.

Every show needs a line producer (whose role is explained in greater detail in Section A.iv of Chapter 2), and usually, line producers engaged for the pilot are subject to options for the studio to continue to engage the line producer for the series (with the deals usually covering up to three seasons of services). Line producer pilot fees typically range from $50,000 to $70,000, while episodic fees range from $20,000 to $35,000 for the first season, with negotiated bumps (usually 4% to 5%) for subsequent seasons. More recently, however, for complex premium cable and streaming series (which tend to have long production periods but few episodes per season), the most in-demand line producers have begun commanding fees in the range of $65,000 to $75,000 per episode. The base credit accorded to such line producers is "Produced by," though more experienced line producers may command Co-Executive Producer or (at the highest levels and/or in later years of a series) Executive Producer credit. Some producers also work as unit production managers (or UPMs), a DGA-covered class of services (which enables the individuals to access DGA health, welfare, and pension plans), and a portion of the line producer's fees may be allocated to such additional services (without increasing his or her aggregate compensation). Line producers may also negotiate for reimbursement of expenses (particularly if they loan the production key equipment they own). In addition, unlike many other producers (including showrunners), line producers must generally work from the production location and will therefore negotiate more extensive travel and relocation expense packages (often on the basis of flat monthly allowances, where appropriate).

Casting directors are another essential part of the team, mandatory at the pilot, and usually continuing with the series if ordered. The initial engagement of a

Finally, all of the above concerns are compounded by the sheer prevalence of agency packages in the modern television market, and the shifting standards and expectations around them. The term "package" itself is now largely a misnomer, as most agencies routinely demand (and receive) a full package position based on a single major client, such as a writer/creator who can showrun his or her own series or a particularly powerful non-writing producer (known as a "packageable element"). The majority of overall deals provide for a full package to automatically attach to any project created or developed by that individual. Even where a writer/creator is too junior to showrun his or her own project, agencies commonly demand and receive a half-package, which may automatically escalate to a full package if the agency subsequently attaches another major element, such as a pilot director, showrunner, or high-level lead star. (In other cases, this may be styled as a full package, which the studio may reduce to a half in the event it needs to grant another half package to a different agency for later-attached elements.) In the modern marketplace, nearly all scripted television projects include a package commission committed to one or more major agencies.

In March 2018, citing several of these concerns, the WGA announced its intention to renegotiate its franchise agreement with the Association of Talent Agencies, seeking new restrictions of the agencies' right to receive packages. The WGA also expressed concern about the growing trend of major agencies (such as WME and CAA) adopting studio positions on their own clients' projects, and the potential conflicts of interest inherent in such situations.

casting director (or team of casting directors) for a pilot will usually cover ten weeks of services, at a fee between $45,000 and $70,000, with additional weeks paid at a *pro rata* weekly rate. The studio will agree to cover the cost of a junior casting associate or casting assistant (or, on particularly expansive or challenging pilots, both), and to provide or reimburse the casting directors for office and other business expenses. As with line producers, studios typically retain options to engage the casting directors, season-by-season, for up to three seasons, at an episodic rate that closely corresponds to the weekly rate from the pilot. In other words, a casting director who works for ten weeks on a pilot for $50,000 will often render series casting services (which are less intensive than pilot casting services) for $5,000 per episode during the first season, with negotiated bumps—again, usually 4% to 5%—for subsequent seasons. High-level casting directors may seek credit in the main or opening titles, though such credit may depend on network and studio policies. Casting directors who work on a pilot may also receive a modest bonus (e.g., $5,000) if the pilot is picked up to series and receive additional fees (again, usually $5,000) for any additional series regular roles that the casting directors cast (or recast) during production of the series.

Episodic directors are generally hired on an episode-by-episode basis, for a finite number of days corresponding to the actual production periods for each episode. Compensation is almost always set to the applicable DGA scale minimum rate—as of 2018, approximately $46,000 for a sixty-minute broadcast network episode; approximately $27,000 for a thirty-minute broadcast network episode; between approximately $24,000 and approximately $34,000 for a sixty-minute cable episode (depending on the episodic budget and which season the series is in); and between approximately $12,000 and approximately $17,000 for a thirty-minute cable episode (depending on the same conditions), although the fees may grow based on a daily rate if production requires more than the DGA-specified number of days covered by these scale amounts. Pre-production and photography services are rendered exclusively on location, and post-production services are rendered on a non–exclusive basis, often in the city where the writer's room is based (e.g., Los Angeles or New York) rather than at the principal production location. In later seasons of successful series, lead actors may be rewarded with episodic directing assignments.

As noted in Section E above, non-series regular acting deals are typically very simple, and require negotiating only episodes, dates, role, trailer, and fee (although complications may arise if a studio wishes to extend an actor's story arc, and representatives may seek escalating fees as an actor appears in more and more episodes). Nearly every other crew member—including vital department heads such as the editor, director of photography, production designer, and costume designer—is engaged on a weekly basis, with deals often negotiated directly by the line producer or UPM in accordance with the budget, with or without the direct involvement and participation of the studio (other than to approve the identities of the individuals engaged).

6

BACKEND

As discussed throughout Chapters 4 and 5 above, contingent compensation (often referred to as "profit participation" or "backend") is a key component of numerous agreements with the key creative talent and underlying rightsholders behind a television series. Backend represents the talent's opportunity to share in the upside of a truly successful television series. When a series succeeds in a big way, the value of even a modest share of backend will easily prove far more valuable to the profit participant than whatever upfront fees he or she may have collected from the budget of the series over the course of the production.

As referenced in various sections above, to control the total amount of participations granted for any given series, most studios employ a rigid and non-negotiable policy of limiting the contingent compensation granted on any given series to no more than 35% of MAGR. (Some studios attempt to employ caps as low as 30% of MAGR, or as high as 40% of MAGR, but both would be considered somewhat exceptional, particularly the higher cap.) Although differences in backend definitions can make one participant's 1% of MAGR worth substantially more or less than another's, for purposes of ease and rough justice, this 35% cap is generally applied without regard to differences in definition. The rigidity of this policy has proven especially important in the modern era of television development, which emphasizes the packaging of numerous high-level elements (i.e., prominent writers, actors, directors, producers, and/or underlying intellectual property) as a way to help projects break through the noise of a crowded marketplace. The hard 35% cap requires participants in series with many profit participants to accept lower backend floors than they may otherwise be inclined to accept, or to renegotiate their existing entitlements in order to make points available for the studio to allocate to a newly added element on the series (such as an actor or showrunner attached late in the development and production process).

A typical 35% aggregate backend pool may be allocated as follows: 2.5% to underlying intellectual property; 2.5% to the pilot director; 15% to the writer(s)/creator(s), and 15% to non-writing producers. If an actor requires one or more backend points as a condition of joining a project, these points will typically be borne by reductions from the writing and/or non-writing producers.

Profit participants receive regular statements (typically quarterly or semi-annually) and enjoy audit rights, which allow them to review the studio's records of revenues and expenses in order to scrutinize the studio's calculations and accountings to the participant. Such audit rights are subject to incontestability provisions, which require that a participant commence an audit (or a lawsuit based upon an audit) within a specified period of time following his or her receipt of accounting statements (usually two to three years). If he or she fails to do so, those accounting statements are deemed final and binding upon the participant. However, most studios freely agree to toll such deadlines at the participant's request, which allows a participant's audit to cover more accounting periods at once (making the audit process more efficient for studio and participant alike). In addition, some studios require that any disputes arising out of an audit or accounting issue be submitted to binding arbitration, rather than being litigated in open court. This helps the studio avoid unfavorable publicity arising out of an audit dispute with a profit participant, while also minimizing the risk that an adverse judgment opens up the floodgates for other claims.[1] For those studios that prefer arbitration to litigation, such arbitration clauses are usually non-negotiable in concept and scarcely negotiable in detail.

The details of contingent compensation can vary in numerous ways between studios. Different studios employ different terminology; this book universally uses the term "Modified Adjusted Gross Receipts" (or "MAGR"), which is common, but some studios refer to their defined form of contingent compensation as "Modified Adjusted Gross" ("MAG"), "Modified Gross Receipts" ("MGR"), "Adjusted Defined Receipts" ("ADR"), "Contingent Proceeds" ("CP"), or by other terms still. Some studios use relatively plain-language backend definitions that are as few as three pages long, while others rely on complex and detailed definitions that can run for literally dozens of pages. And different studios have different policies as to various key aspects of these definitions, with each studio prioritizing the issues important to it, and no one studio systematically offering participants the most or least favorable available definition in every respect.

Despite such variation, however, at the end of the day, every television contingent compensation definition is a mostly similar formula, whose main variables are simply the dollars earned by the studio from all forms of exploitation of a series, and the expenses incurred by the studio in all aspects of production,

1 Such studios may also require that non-accounting disputes arising out of their agreements with talent be submitted to arbitration, though even studios that do not require arbitration of non-accounting disputes may demand it for accounting disputes in particular.

marketing, and distribution. As a series goes through its life cycle of ongoing production and development, this formula is regularly calculated and recalculated to account for revenues and expenses as they each mount; although over time and in success, it is fair to expect revenues to accrue faster (and for a longer period of time) than expenses.

The basic television contingent compensation formula (sometimes referred to as a "waterfall") can be articulated as follows:

- Gross Receipts
- Distribution Fees
- Distribution Expenses
- Overhead
- Interest
- Cost of Production
- Third-Party Participations
- Modified Adjusted Gross Receipts

What follows is a deeper examination of each of the elements of this formula.

A. Gross Receipts

"Gross receipts" refers to all revenue received by (or credited to) a studio from its exploitation of a television series and all rights therein, from all sources. For the most part, this is a straightforward concept. There are, however, some important nuances.

First, it may be necessary to clarify at what level (or, to put it another way, from the receipts of which entity) gross receipts are determined. For instance, if a studio intends to use a subdistributor to distribute any of its rights in a series, the gross receipts should generally be measured as those collected by the subdistributor (as opposed to those remitted to the studio after the subdistributor retains its fees and expenses).[2] If the studio enters into contracts through a special purpose production entity, gross receipts should be defined as those received by that special purpose entity *or any of its affiliates*, to ensure that the studio's real receipts are properly accounted for.[3] On the other hand, if a studio is part of a major conglomerate (such as ABC Studios, a Disney company, or Universal Television, a

2 The proper treatment of this issue also depends on how distribution fees are assessed on such revenues. For example, if gross receipts are defined at the subdistributor level, then it is appropriate for the studio to assess distribution fees on them; if gross receipts are defined as net of the subdistributor's withholdings, then a distribution fee should not be charged.

3 Studios may favor such one-off companies, sometimes called "special purpose vehicles" (or "SPVs"), for reasons of liability management, union obligation management, and/or tax and accounting preferences, among other considerations.

Comcast/NBCUniversal company), and the studio's affiliates engage in distribution activities that are customarily performed by third-party licensees, then the definition may need to identify the appropriate revenues *of the studio, as a studio,* and to wall off revenues from affiliates who are acting in the capacity of bona fide third-party distribution partners. This issue commonly arises with respect to revenues from the exploitation of ancillary rights, such as music publishing, soundtracks, and merchandising.[4]

Second, "gross receipts" often exclude revenues from certain specified sources, even when they seemingly refer to "all revenue from all sources." For instance, although derivative rights—e.g., the right to produce spinoffs, sequels, theatrical feature adaptations, etc.—are among the "all rights therein" for a television series, most backend definitions expressly exclude revenues (and expenses) from these separate productions. The one exception may be license fees received from third parties for the right to create local language adaptations of a series, which may be accountable as gross receipts. Some studios may seek to exclude ratings and other bonuses received from their licensees, or revenues received in connection with product placements or integrations.[5] Such exclusions, where sought at all, are often negotiable.

Third, nearly all backend definitions include special accounting provisions related to home video revenues. "Gross receipts" are typically defined to include an amount equal to 20% of the receipts actually received by the studio or its affiliated company from home video distribution.[6] This unusual royalty-based accounting is a function of the history of home video distribution in the film and television industry. In the 1980s, when the home video market was first emerging for feature films (and was altogether nonexistent for television series), most film studios relied on small outside companies to exploit these rights, which were not perceived as particularly valuable. The film studios entered into deals with these outside home video subdistributors by which the studios received a 20% royalty from the subdistributors (who absorbed all duplication and manufacturing expenses from their 80% shares). These royalties, in turn, became the

4 To illustrate, imagine a television series produced by ABC Studios (a Disney company), which spawns a toy that is produced by a Disney-owned consumer products company, which is in turn sold to a customer at a Disney retail store. Although the Disney retail store is owned by an affiliate of ABC Studios, the studio would not account to a profit participant for the money collected at the point of sale by the Disney Store as "gross receipts." Rather, it would rely on a formula to translate the Disney Store's retail revenues into the Disney-owned consumer products company's wholesale revenues, and in turn translate those into ABC Studios' licensing revenues (which would then be deemed ABC Studios' "gross receipts" from that merchandising transaction). This mathematical process essentially simulates the revenues ABC Studios would have realized if it were an independent company that operated solely in the business of television production and distribution, and had licensed merchandising rights to a third-party licensee, which in turn placed its merchandise on the shelves of a third-party retailer.

5 See B.vi.b of Chapter 1.

6 At higher levels, this royalty rate may be negotiated up to approximately 35% or 40%, but this is rare for all studios, and seldom if ever granted by major studios.

gross receipts that were accounted to profit participants in the films. Eventually, however, the major studios (such as Fox, Disney, Paramount, Universal, Columbia, and Warner Bros.) realized two crucial facts: first, that home video was quickly developing into a huge business;[7] and second, that the home video subdistributors' costs only amounted to approximately 40% of their revenues, allowing those subdistributors a huge profit margin even after accounting to the studios for their 20% royalties. The studios quickly developed in-house home video distribution arms, effectively increasing their share of wholesale revenue from home video sales from 20% to 60% (while forcing many smaller, independent home video subdistributors out of the business). When the studios did so, however, they decided to retain for themselves the full benefit of that additional 40% margin, by redefining their theatrical contingent compensation definitions to continue to account for home video revenues at a 20% royalty rate (as if the studios were still receiving 20% royalties from real third-party home video distributors). By the time profit participants and their representatives realized the economic impact of this move, the practice was firmly established, and the studios were able to maintain it through sheer stubbornness and superior bargaining power. The 20% royalty rates for home video revenues were eventually imported into the backend definitions of television studios, and by the 2000s, a robust home video/DVD market for television programming had emerged as well. This 20% royalty accounting for home video revenues remains the standard to this day.

Fourth, the historical quirk of royalty accounting for home video receipts has impacted the accounting (and negotiation) around receipts received from digital licensees of television (and other) content, such as Netflix, Amazon, and Hulu. When these digital platforms first emerged and began pouring license fees into the studios, backend definitions that had been drafted years before were silent as to the treatment of revenues from such sources. Citing the precipitous collapse of the home video market that coincided with the emergence of these new digital platforms (which had begun rendering physical home video effectively obsolete), the studios initially reasoned that the new digital platforms were effectively successors to the home video market, and therefore that revenues received from digital platforms should be treated as home video revenue—at a 20% royalty rate. They took this position despite the fact that the actual physical manufacturing and distribution costs associated with traditional home video distribution (which had been absorbed within the 80% of home video revenues withheld from the profit participant) were virtually nonexistent when it came to the distribution of digital content, in 1s and 0s, to the new platforms. Profit participants and their representatives (including the talent

7 Indeed, home video receipts (initially based on VHS tapes, and later DVDs and Blu-rays) were critical in economically buoying the entire film industry through the 1990s and early 2000s.

guilds) across the film and television industries revolted against this reasoning, and currently, the majority of studios account for revenues received from SVOD and AVOD-type licensees as television revenue (which is accounted for based on 100% of revenues received). Most studios, however, continue to treat revenue from TVOD/EST-type licensees (which more closely resemble traditional home video distribution) as home video (and therefore account for it at a 20% royalty rate).

Finally, where a studio licenses a television series to its affiliated network (e.g., AMC Studios producing a show for AMC network, or CBS Studios producing a show for the CBS broadcast network), the studio's backend definition will include an "imputed license fee." The "imputed license fee" is a contractually defined amount that represents the revenues received by the studio from its sister network. This is because sister studios and networks generally do not engage in arms-length negotiations to determine the precise scope of rights granted to, and license fees paid by, the broadcasting network, nor is real money necessarily transferred from the account of the network to the studio. In lieu of such a negotiation and payment, the studio's backend definition will identify an amount that the studio is deemed to have received from its sister network for its license (and the studio will continue to account to the participant for revenues received from third-party sources, as actually received).

As with arms-length negotiated license fees,[8] the applicable imputed license fee may be denominated as a flat dollar amount (or series of flat dollar amounts) or as a percentage of the production budget (with or without caps), according to the preferences and policies of the entities involved. In order to induce participants to accept these definitions, the applicable imputed license fees are generally structured and valued to resemble license fees that may have been obtained in a real arms-length negotiation, and the license fee generally buys out a specified scope of exploitation by the network.[9] Often, the applicable imputed license fee is non-negotiable by the participant or negotiable only within a narrow range and only for high-level participants. In general, however, participants can expect that such imputed license fees will be somewhat less substantial than the license fees that the studio would extract from an unaffiliated network licensee in a bona fide arms-length negotiation.[10] For licensing transactions with affiliated entities other than the initial network license, participants may negotiate for

8 See Section A.iv of Chapter 8.

9 Notably, because it is widely known that international streaming platforms like Netflix and Amazon pay license fees to their studio partners in excess of 100% of the cost of production, when these companies are in a studio position and negotiating backends with participants directly, they may be forced to agree to imputed license fees equal to or exceeding the full cost of production of their series.

10 Writer/director/producer Frank Darabont, who adapted Robert Kirkman's *The Walking Dead* comic book series for AMC, has been engaged in heated litigation with AMC for several years, primarily over the calculation of Darabont's backend from the show. One of Darabont's major contentions in the lawsuit is that AMC used an imputed license fee that critically undervalued the show and

an express contractual requirement that such transactions be conducted on an arms-length basis.[11]

B. Distribution Fees

In calculating MAGR, the studio first deducts its distribution fee. The distribution fee is a defined percentage of revenues received from nearly all sources, which the studio retains as compensation for its investment of time, effort, overhead, and other resources in the distribution process.

The distribution fees charged by a studio are one of the most critical, and most hotly negotiated, elements of a backend definition. They generally range from 10% to 25%, with some variation among studios regarding the lowest fees they will agree to, and the circumstances under which they will agree to their most favorable available distribution fees. A 15% distribution fee is relatively common, with 10% being considered "A-level." Some studios distinguish among various revenue sources in defining the applicable distribution fee—for instance, charging a higher distribution fee on revenues from foreign distribution than from domestic, or on revenues received from the exploitation of ancillary rights rather than traditional linear licensing of series episodes (based on the argument that such sales require more effort to generate substantial revenue). Other studios charge a flat distribution fee, as negotiated, on revenues from all sources. Some studios will agree not to charge a distribution fee on home video receipts (because those receipts are already being accounted for on a 20% royalty basis, rather than based on 100% of revenues actually received).

Across the board, studios will generally agree to forego charging distribution fees on revenues received in respect of the initial domestic license for a television series (including extensions, amendments, and renewals thereof). The rationale for this exclusion is that a television series is never produced in the first place without the deal from the original U.S. network, and therefore no distribution

made it functionally impossible for the wildly successful series to ever show a "profit" according to the studio's backend definition.

11 Affiliate transactions are viewed skeptically by participants and may be closely scrutinized, especially if the parties wind up in litigation. Celador International, a British company that licensed the rights to the UK-created *Who Wants to Be a Millionaire?* game show format, won a $269 million jury verdict against ABC and the Walt Disney Co. when it sued for its share of profits from the historically successful game show. See *Celador International v. Walt Disney Co.*, 347 F.Supp.2d 846 (C.D. Cal. 2004); *Celador International, Inc. v. ABC*, No. 11–55104 (9th Cir. Dec. 3, 2012). One of the critical legal issues on which the case turned was whether, in calculating Celador's backend interest, Disney/ABC's revenues and profits should be measured at the level of the Disney-owned production entities (Buena Vista Television and Valleycrest Productions) or the Disney-owned broadcast network (ABC). During the trial, the plaintiff presented evidence that the on-paper deal between the production entities and network essentially guaranteed that the series would never show significant profits in which Celador could share, if they were measured at the production company level alone. This fact certainly influenced the jury's determination that Celador should share in profits at the network level instead.

resources or separate efforts were actually expended to obtain these revenues. However, where the initial licensee takes rights in multiple territories (as is typical for licenses to global streaming services such as Netflix and Amazon, where the applicable license fee also typically exceeds the cost of production), the parties may also need to negotiate with respect to how much of the license fee is allocated to domestic rights, for purposes of not charging a distribution fee. It is currently common to allocate an amount equal to 75% of the series budget to domestic rights for this purpose, though high-level participants may negotiate aggressively for distribution fees to be eschewed on up to 100% of the series budget (with fees therefore charged only on the "premium" of the license fee over and above the series budget).[12]

Most studios freely agree that, to the extent they rely on subdistributors to exploit rights in certain media or territories, the applicable distribution fees charged by the studio are inclusive of any distribution fees charged and retained by the subdistributor. If the fee charged by the subdistributor is less than the fee charged by the studio, the studio retains the difference as its own fee (with studios justifying this margin by reference to the amount of effort and resources it takes to engage, manage, and generally police subdistributors). Where the distribution fee charged by a subdistributor is greater than the distribution fee that would otherwise be charged by the studio, the backend definition may expressly provide that the higher distribution fee applies (so that the studio is not forced to economically absorb the difference between the distribution fee charged by the subdistributor and that otherwise applicable to the participant in the backend accounting). Where the distribution fee charged by a subdistributor is equal to or greater than that charged by the studio, the studio may provide for its own right to take an "override" on such distribution fee, meaning a distribution fee charged on the subdistributor's receipts, over and above that charged by the subdistributor (again, citing the effort and expense of managing and monitoring the subdistributor). Such overrides have become rare in more recent years and generally do not exceed 5% of gross receipts.[13]

12 The mechanics of these "cost plus" deals, and a more detailed explanation of the "premium" concept, is contained in Section A.iv.a of Chapter 8. As that section explains in greater detail, deals between studios and international streaming services typically provide for license fees that exceed the cost of production, but the further revenue potential of the series beyond this initial profit is speculative and likely minimal. As a result, from the perspective of the backend participant, the allocation of revenue from these network deals to domestic (no distribution fee charged) vs. international (distribution fee charged) is hugely impactful on the ultimate value of the participant's contingent compensation from the series.

13 A few illustrative examples may be helpful here. If a studio charges a 15% distribution fee, inclusive of subdistributors and without any override, and then engages a subdistributor that charges a 15% distribution fee, the studio will not retain any distribution fees for itself (because all the full 15% of receipts charged as distribution fee will be retained by the subdistributor). If the same studio employs a subdistributor that charges a 10% distribution fee, the subdistributor will retain 10% of receipts collected by that subdistributor as the subdistributor's fee, and the studio will retain for itself 5% of

C. Distribution Expenses

After retaining distribution fees, studios will next reimburse themselves, off-the-top, for all actual expenses incurred in the process of distribution. Such expenses may include, without limitation, advertising and marketing expenses; costs for subtitling or dubbing of foreign versions; the expense of duplicating and transporting physical materials to licensees; clearance fees that have not otherwise been accounted for as production costs; residuals and reuse fees payable to talent pursuant to applicable union collective bargaining agreements; costs of enforcement (including intellectual property and audit litigation); and other so-called "off-the-tops" (referring to checking, collection, currency conversion, and certain tax [but not income tax] expenses). If negotiated, many studios will agree not to deduct some or all distribution expenses attributable directly to home video distribution, because they are already accounting for the resulting revenues on a 20% royalty basis. While participants sometimes may attempt to negotiate for a cap on deductible distribution expenses (e.g., that they may not exceed 5% of gross receipts), studios seldom agree to such caps for profit participants (due to the risk that legitimate out-of-pocket expenses may, in fact, exceed such limits).

In general, studios recoup their actual, third-party, out-of-pocket distribution expenses. However, larger studios that maintain (whether directly or through an affiliated entity) certain in-house creative services facilities (e.g., to assist in advertising and marketing) may assess fair-market charges for such services, as though they had been obtained and paid for from third parties. Some studios may also attempt, particularly in definitions for low-level profit participants, to charge "advertising overhead" (i.e., a 5% to 15% surcharge on advertising expenses). However, this is rare, and often waived in negotiation, as the rationale for such a surcharge is essentially duplicative with the rationale for the studio's distribution fees. In addition, some studios may seek to assess and recoup interest on their distribution expenses, but this is also relatively uncommon. Many studios will agree to clarify, for the benefit of participants, that expenses that are charged as production costs may not also be recouped as distribution expenses, and vice versa.[14]

receipts collected by the subdistributor. If the same studio engages a subdistributor that charges a 20% distribution fee, depending on the nature of the backend definition, the studio will either absorb the subdistributor's incremental 5% distribution fee out of its own profits, or functionally increase its distribution fee to 20% in order to pass on the full expense of the subdistributor to the participant. If, however, the studio charges a 15% distribution fee subject to a 5% override on subdistributors, and then engages a subdistributor that charges a 15% distribution fee, then the subdistributor will retain a fee equal to 15% of the subdistributor's receipts, and the studio will simultaneously retain a distribution fee equal to 5% of the subdistributor's receipts, resulting in a functional distribution fee (to the participant) of 20%. If that same studio reserves for itself a 5% override and engages a subdistributor that charges a 20% fee, the functional fee to the participant will be 25% of receipts collected by the subdistributor.

14 In general, where an expense may be reasonably justified as a production charge or a distribution expense, the studio will opt to treat it as the former, to take advantage of applicable overhead and interest charges (which, as noted here, apply to production expenses but not to distribution expenses).

D. Overhead

After deducting distribution fees and distribution expenses, the studio will next recoup an overhead charge. This overhead charge is calculated as a percentage of the actual cost of production of the series, and generally ranges between 10% and 15%. It is meant to compensate the studio for the in-house salaries, offices, and other overhead expenses used in the studio's production business. Implicit in this practice is the assumption that, in general, the size and scale of a production (as reflected in its cost) is roughly proportionate to the demands that production places on the studio to manage that production.

Like distribution fees, the percentage amount of the overhead charge is heavily negotiated and has a significant impact on the value of an individual's contingent compensation—a participant in revenues from a hit series who is entitled to 10% of MAGR with a 10% distribution fee and 10% overhead charge may earn literally millions more dollars than another participant in the same series who is entitled to 10% of MAGR with a 15% distribution fee and 15% overhead charge.

In scripted television (which is based on a deficit financing model, in which the studio's costs of production exceed license fees paid by an initial commissioning network),[15] studios generally do not assess production fees (or other fees for in-house executives or staff) within the budget of the show itself.[16] Consequently, many studios will freely agree not to charge participants for any production company or supervisory fees, other than the negotiated percentage-based overhead charge. In addition, studios will generally agree not to calculate an overhead charge on interest assessed against the production cost,[17] or on contingent compensation paid to third-party participants.

E. Interest

The studio will next charge and recoup interest on the actual expenses it incurred in producing a television series. This interest is generally recouped from gross receipts after the studio has deducted its distribution fees, distribution expenses, and overhead, but before revenue is applied against the cost of production (effectively increasing the amount of time that interest runs on the underlying production costs). Such interest is assessed whether or not the studio actually relies on

15 See Section A.iv.a of Chapter 8.

16 This is not the case in unscripted television, in which the license fee paid by the network is generally equal to the full cost of production, and the studio or production company typically receives a fee within the budget of the series equal to 10% of the hard production costs of the series (perhaps subject to a cap). For such programs, studios usually also assess profit participants an overhead charge as part of their backend definitions, but may agree to not calculate such overhead charges on the production company fees retained by the studio from the budget of the series, or even (at higher levels) to reduce such overhead charges in the backend definition on a dollar-for-dollar basis by the production company fees retained by the studio from the budget of the series.

17 See Section E below.

outside financing to cover its costs of production, as compensation to the studio for its loss of use of the funds (which could have been applied to other production or corporate purposes).

If the studio does rely on outside financing, the applicable interest deduction is likely equal to the studio's actual cost of financing; if the studio relies on its own cash reserves to finance production, interest is usually assessed at a rate between 1% and 2% above the then-current prime interest rate. Studios will generally agree not to charge interest on the overhead charge assessed by the studio, or on contingent compensation paid to third-party participants, or on the interest itself (in other words, the interest rate is simple, not compound).

F. Cost of Production

Next, the studio will recoup its actual cost of production of the series. As with distribution expenses, these are generally actual, out-of-pocket, third-party costs that had been paid out by the studio. However, to the extent the studio relied on some of its own facilities (or those of an affiliated entity) in connection with the production, it may also record and assess charges for such resources at fair-market rates. Some profit participants are wary of definitions that may allow for the assessment of "overbudget penalties" (e.g., a term that provides that, if a show goes $1,000 overbudget, the backend calculation reflects a $1,500 charge for the extra $1,000 spent, with the $500 difference being a penalty for the show's failure to come in on budget). However, such penalties are very rare in television contingent compensation definitions (as distinct from feature film profit participation definitions, where they are common, particularly for participations granted to producers and directors, who have a direct responsibility for controlling budgets).

G. Third-Party Participations

Finally, after recouping the cost of production, some studios also deduct contingent compensation paid by the studio to some or all profit participants on the same show off-the-top from other profit participants. In other words, if Participant A is entitled to receive 10% of MAGR, but the studio retains the right to deduct third-party participants off-the-top and has granted 25% of MAGR to Participant B, then Participant A's 10% is effectively 10% of 75% of MAGR, or 7.5% of 100%. At the same time, Participant B has Participant A's participation deducted off-the-top of Participant B's definition, so Participant B really receives 25% of 90% of MAGR, or 22.5% of 100% of MAGR. When third parties are prohibited from being deducted off-the-top in calculating MAGR, a participant's backend entitlement is usually explicitly styled as being "of 100% of MAGR"—in other words, "10% of 100% of MAGR," rather than "10% of MAGR."

Some studios grant "of 100%" participations to all participants, regardless of stature. Some grant "of 100%" participations on a discretionary basis, depending on the stature and negotiating leverage of the participant. Some studios will

grant "of 100%" participations only to those receiving relatively low participations, such as 5% or under, because denying this accommodation would cause such a massive dilution of that individual's backend as a result of the large volume of participations granted to third parties. Studios that reserve the right to deduct third-party participations off-the-top will generally not deduct third-party participations both "off-the-top" *and* "off-the-bottom." In other words, if Participant A is entitled to receive 15% of MAGR, reducible on a dollar-for-dollar basis by all participations granted to third parties to a floor of 10% of MAGR, the studio will usually at least agree that those third-party participations that have the effect of reducing Participant A from 15% to 10% of MAGR may not also be deducted off-the-top in calculating the value of each percentage point of MAGR.

Even those studios that expressly agree not to deduct third-party participations off-the-top in calculating MAGR universally reserve the right to deduct, off-the-top, contingent compensation paid to talent agencies in respect of their "packages" on the show.[18] Such agency packages are actually usually recouped as distribution expenses, immediately after the studio retains its distribution fees from gross receipts. In addition, even studios that generally agree not to deduct third-party participations off-the-top may also reserve the right to treat advances on participations granted to third parties as production costs (with or without the right to assess interest and/or overhead on such advances) until such advances have actually been earned, thereby delaying the "break point" at which other participants will begin to see fresh cash from their contingent compensation formula. Finally, some studios retain the right to deduct participations granted to network licensees,[19] if any, off-the-top. Those studios that agree not to deduct network/licensee participations off-the-top generally require that such participations fit within their standard 35% cap on aggregate third-party participations.

Whether and to what extent third-party participations may be deducted off-the-top in calculating MAGR is, together with the percentage values of distribution fees and overhead, one of the most impactful negotiated variables determining the value of a participant's contingent compensation.

H. Treatment of Tax Incentives

Although tax incentives are not expressly addressed in the waterfall described above, how a studio accounts for them (if at all) is arguably the fourth major driver of the value of a contingent compensation definition. As described in Section D of Chapter 1, tax incentives significantly impact not only whether and where a television series is produced, but how much the studio is willing to invest (in gross dollars) in the show's production. The significant financial impact of tax incentives affects not only a studio's economic situation, but that of profit participants as well.

18 See Section B.vii.a of Chapter 1, and Section F of Chapter 5.
19 See Section A.xiv of Chapter 8.

As was the case with the emergence, in the 2000s, of digital platforms as a source of television licensing revenue, when state production incentives rose to prominence in the 1990s, most studio backend definitions were silent as to their impact on the calculation of MAGR. In this vacuum, many studios initially declined to account for tax incentives at all when calculating contingent compensation for talent participants. Enjoying the subsidy provided by these tax incentives, the studios increased their gross spending on production. This increased spending, combined with the non-acknowledgment of tax incentives, had the effect of diminishing the value of participants' contingent compensation by making it more difficult for the show to achieve breakeven or profit, according to the applicable MAGR definitions. When this practice was eventually discovered by participants and their representatives, a wave of contentious audit disputes ensued.

These days, studios almost always account somehow for tax incentives in their backend calculations. Talent representatives prefer for tax incentives to be treated as a reduction in the production cost of the series. This approach is simple and intuitive. However, studios generally reject this approach because, as a practical matter, treating tax incentives this way both reduces the amount of production costs that must be recouped for the MAGR definition to first show profit (or "break"), and reduces the principal base on which overhead and interest charges are calculated. This substantially accelerates the point at which profit participants would expect to see their backends pay off.

Instead, most studios treat tax incentives (net of any actual third-party costs of obtaining, accessing, or otherwise monetizing such incentives) as gross receipts. Studios argue that this approach is fair in part because, while a tax credit can be fairly reliably estimated, it may take months or even years to actually receive the financial benefits from such programs, during which time the studio is actually out-of-pocket on the full gross production spend for the series. At the same time, however, this approach preserves a higher principal base for production cost, which generates a higher overhead charge and interest charge that must be recouped from revenues before participants first see payments under their backend definitions.[20] In addition, the classification of tax incentive monies as gross receipts, rather than reductions in production costs, may allow the studio to charge a distribution fee on the tax incentive amounts (although talent representatives may specifically negotiate to eliminate such distribution fees on tax incentive amounts).[21]

20 According to the studio argument, although a television production that enjoys a tax incentive may ultimately cost the studio less out-of-pocket expense than an identical production without a tax incentive, the scale of the production (and resulting complexity and labor demands in managing that production) is identical to that of the incentive-free counterpart, justifying the studio's practice of charging its overhead fee on the gross (rather than net) production cost.

21 Studios justify this practice by reference to the amount of time and effort required for the studio to get the benefit of these tax incentive programs. As described in Section D of Chapter 1, these programs are complex and vary widely from state to state, requiring considerable expertise from studio production and tax executives in order to maximize them. Obtaining a tax credit is far from automatic; it requires meticulous, sometimes burdensome recordkeeping, reporting, and filing with state authorities.

I. Quick Reference Guide

TABLE 6.1 Backend

Deal Term	Issues and Negotiated Concessions
1. Gross Receipts	• Gross receipts at source vs. post deductions • Typically 20% royalty on home video receipts (including TVOD, but excluding SVOD or AVOD streaming, which is treated like television) • Excluding revenues from format fees or subsequent productions • Imputed license fees for affiliate transactions • May require studio to conduct affiliate transactions on an arms-length basis
2. Distribution Fees	• 10% to 25% of gross receipts off-the-top; 15% is common, and 10% A-level • May not be charged on home video receipts (if calculated on royalty basis) • May be inclusive of sub-distribution fees (or subject to 5% override) • Typically no fee on initial domestic license (including extensions, amendments, and renewals thereof) • For multi-territory initial licenses, no distribution fee charged on amount allocated to domestic (typically 75%, potentially up to 100%, of budget)
3. Distribution Expenses	• May be subject to cap (e.g., no more than 5% of gross receipts), with exclusions from cap • Often no interest or overhead on distribution expenses • Costs charged as distribution expenses not deducted as production costs and vice versa
4. Overhead	• 10% to 15% of production costs • May prohibit production fees in budget on top of overhead charges • No overhead on interest? • No overhead on advances/third-party participations?
5. Interest	• Usually prime plus 1% or 2% • No interest on overhead? • No interest on advances/third-party participations? • No interest on interest (i.e., no compounding)?
6. Cost of Production	• Actual out-of-pocket production costs • Overbudget penalties rare

(Continued)

TABLE 6.1 (Continued)

Deal Term	Issues and Negotiated Concessions
7. Third-Party Participations	• Agency package participations always come off-the-top • Advances and/or network licensee participations may come off-the-top • Studio policies vary as to whether third-party participations come off-the-top against other participations • "Of 100%" signifies a limitation on third-parties coming off-the-top • No deducting the same third-party off-the-top and off-the-bottom
8. Treatment of Tax Incentives	• May be treated as gross receipts, or as a reduction in cost of production • If treated as gross receipts, may or may not be subject to distribution fees • If treated as reduction in cost of production, may still need to address calculation of overhead and interest charges

7

EXCLUSIVE STUDIO-TALENT RELATIONSHIPS

In today's highly competitive environment, the lifeblood of a studio is the talent who wants to work there. Studio creative executives develop and nurture relationships with talent and their representatives, and each studio seeks to make a case for why writers, directors, and producers should want to work with it, rather than with another studio. Network-affiliated studios advertise their shortened pipeline to motivated network buyers, the clarity of their creative mandates, and the absence of multiple layers of executive interference with the talent's creative desires. Independent studios advertise their ability to shop projects freely and find the best (and most lucrative) home for every show, their unconflicted motivation to maximize their economic returns (and therefore profit participants' economic returns) on every project, and the role they can play in protecting and supporting talent against unreasonable network demands. Virtually every studio claims to offer the best creative environment, the most creative freedom, and the most talent-friendly attitude.

In terms of economics, most studios structure deals in roughly the same way, and pay roughly the same amounts for similarly situated individuals on a show-by-show basis. Where economic competition really comes into play alongside the aforementioned noneconomic factors, however, is in the context of overall term deals (or "overall deals" or "overalls") and first look deals. Under these agreements, studios offer highly desirable writers, producers, and directors significant, long-term guaranteed compensation, in exchange for the talent's exclusive services during the life of the agreement. Overall term deals and first look deals are a vital element of how studios compete to stay relevant, by offering the marketplace of network buyers something that no one else can—the specific creative talent they want to work with.

A. Overall Term Deals

An overall deal is an agreement by which a studio obtains the fully exclusive[1] services of an individual for the term of the agreement. Studios retain ultimate discretion as to whether or not to proceed with development or production of any given project, but even if the studio declines to proceed with a given project proposed by the talent, the talent cannot shop the project to third-party studios during the term of the overall. Studios may enter into overall deals with writer/producers, non-writing producers, or directors, although overall deals with writer/producers are most common. Prolific writer/producers such as Chuck Lorre and Shonda Rhimes (whose expansive slates of projects are discussed in Section A.iv of Chapter 5) are able to balance numerous projects simultaneously in part because of their carefully managed long-term relationships, via overall deals, with their home studios.[2]

Overall deals are most prominently offered to highly successful and desirable show creators, and most highly successful and desirable show creators choose to work under overall deals at any given time rather than operating as free agents (although they may leave one studio for another when their deals expire). The majority of overalls contemplate that the individual will dedicate a significant amount of their time and energy to developing and launching new projects. However, in the latter seasons of a successful television series, even mid-level writers without significant intentions or prospects for development may demand the security of a more modest overall deal as an inducement to stay with (and therefore maintain the creative continuity of) a long-running television show.[3]

When granted to non-writing producers, overall deals are often referred to as "pod deals." A non-writing producer (including his or her production company

1 In this context, "fully exclusive" refers to fully exclusive in television. An individual may be fully exclusive to a studio in television, while retaining the right to write, direct, and/or produce feature films for third parties. However, if a television studio is affiliated with a theatrical motion picture studio, the individual may enter into a comparable deal to be fully exclusive in features with the sister studio. And, to the extent that an individual's non-television services (whether for an affiliated or unaffiliated third party) render that individual unavailable to render television industry services, the television studio may suspend and extend the term of the artist's overall term deal for the duration of such unavailability.

2 Sometimes, upon the end of the term of a prominent writer's overall deal with a given studio, the writer elects to enter into a new deal with a competing studio, rather than renewing his or her agreement with the writer's prior studio. In such cases, the original studio retains ownership and control of all series created by the writer while working for that studio. In addition, all of the parties may need to negotiate further with respect to the amount of time/level of services the writer may continue to render for his or her ongoing series with the prior studio, while that writer is now on the payroll of the new studio.

3 Where such overall deals are entered into solely or primarily to retain the services of the writer for the benefit of a specific ongoing series, they are sometimes referred to colloquially as "showveralls," and most or all of the cost of such agreements is accounted for as a production cost of the applicable series.

team) in a pod deal offers a sort of semi-independent, outsourced team of creative executives and talent scouts. Studios effectively bolster their own creative ranks, without directly taking on all of the associated overhead. Because their standard of services for any given project is non-exclusive/no-material-interference (rather than exclusive and first-priority, like writer/producers), and because the day-to-day demands on their time from any given show are lower than those of writer/producers, non-writing producers tend to work on many more projects (both in development and production) at any given time than do writer/producers. For this reason, some studios actually focus much of their investment in overall deals on "pods," rather than writers.

The key negotiables of an overall term deal are as follows:

i. Term

The first issue to negotiate is the duration of the agreement. Most overall deals are for a term of between one year and three years, with two years being particularly common. One-year deals may be favored for uncertain new relationships, while three-year deals may be favored for parties that already have a long history with each other (and are perhaps entering into a second or third consecutive overall relationship). The years under an overall deal may be fully guaranteed, or in part at the studio's option. For instance, a "2 + 1 deal" refers to an overall with a two-year guarantee and a third-year extension at the studio's option. Sometimes, such options can be triggered (i.e., automatically deemed exercised) if the talent achieves certain benchmarks of success, such as having a specified number of pilots or series ordered to production, or getting one or more ongoing series renewed for additional seasons. In success, studios often seek to negotiate extensions to overall deals well before they are set to expire, in order to reduce the risk of poaching of talent by other studios.

ii. Guarantee

The economic value of an overall deal can be summarized briefly: how much money, for how many years? This, however, is perhaps too much of an oversimplification. In fact, the nuances of the structure of the overall deal guarantee can have a significant impact both on how much the talent may expect to earn over the life of the deal and how much the deal will actually cost the studio out of its own pocket.

a. Financial Guarantee

The first aspect of the guarantee to negotiate is that essential question: how much money, for how many years? The "how many years" part of that question is discussed in Section A.i above. As for "how much money," that may mean

anywhere from $300,000 per year for a mid-level writer whose only job will be to continue working as a staffed writer on an ongoing series, to $4,000,000 per year for a well-known show creator with a proven track record. At the most extreme level, the most prolific and successful creators, like Shonda Rhimes and Ryan Murphy, may now expect to command eight-figure annual guarantees.

Non-writing producers (i.e., pod deals) and directors may expect to earn annual guarantees toward the lower end of that range, between $300,000 and $1,000,000 per year, although major film directors entering into television over-alls may command north of $2,000,000 per year.

The financial guarantee is typically flat for every year of a deal, although where a studio makes one or more years of the deal at its option rather than fully guaranteed, it may agree to a slightly higher guarantee (e.g., an uptick of 5% to 10%) for the optional year(s).

b. Recoupability

The guaranteed compensation under an overall deal is always, in whole or in part, an advance against fees that may be actually earned by the talent for services rendered during the term of the overall deal. In other words, during the term of the deal, the talent will not see any new money (or "fresh cash") for services for which the applicable fees are deemed to be recoupable against the overall guar-antee (at least until the total aggregate value of such fees exceeds the guarantee against which they are recouped).

From the talent's perspective, recoupability is important because it defines the extent to which the talent may expect to earn any fees on top of the guaranteed annual compensation under the overall during the term of the agreement. From the studio's perspective, recoupability is critical not only because of its effect on the aggregate payout to the talent, but also because it impacts how the expense of the overall is accounted for on the studio's books: in general, as fees are earned and recouped under an overall deal, they are accounted for as expenses of the applicable project (as opposed to general development expenses), which makes it possible to share the allocated cost burden with third parties (e.g., in the form of network development expense coverage,[4] percentage-based license fees,[5] or cost/deficit contributions from co-production partners).[6]

For most writer/producer and non-writing producer (pod) deals, the vast majority of fees are recoupable, including (as applicable) script writing fees, supervision fees, and pilot and series producing fees, but solely to the extent such fees are actually earned during the term of the agreement. Post-term fees (i.e., fees earned for work done after the term of the agreement, even if the project

4 See Section A.ii of Chapter 2.
5 See Section A.iv.a of Chapter 8.
6 See Section B.iii.d of Chapter 8.

was initially developed during the term) are usually not recoupable, absent very specific circumstances informing the negotiation. Studios will consistently agree not to recoup against an overall guarantee the talent's contingent compensation from any series, or any WGA-mandated and defined payments (such as residuals, which may be substantial, and so-called "program fees" and "character fees," which are usually relatively minor). Royalties and pilot production or series sales bonuses may be up for grabs in the recoupability negotiation, with royalties usually being non-recoupable (i.e., "paid on top"), and series sales bonuses potentially being recoupable, non-recoupable, or, as a compromise, paid on top of the guarantee but as a recoupable enhancement to the guarantee rather than as pure fresh cash (which gives the studio the opportunity to potentially recoup that amount, as well, out of future recoupable fees).

For directors, the recoupability is sometimes quite similar to that for writer/ producers, with all directing and pilot/series producing fees being recoupable; contingent compensation, residuals and other DGA-mandated payments being non-recoupable; and royalties and series sales bonuses being negotiable as described above. However, because (for schedule reasons) most pilot directors cannot direct more than two or, at most, three, pilots in a year, it is more common in directing overalls for fees to be recoupable against the guarantee only in part—for instance, only the director's first pilot directing fee may be deemed recoupable, or each directing fee may only be 50% recoupable, with the other 50% paid as fresh cash (i.e., not recouped against the artist's guarantee).

Although the above parameters are generally standard, recoupability can be a highly negotiated, and a highly peculiar, deal term on a deal-by-deal basis. This is because the recoupability structure of the overall deal—and the studio's projections for likely actual recoupment levels—is a critical consideration when negotiating the annual guarantee. The difference between an individual's overall guarantee and the amount recouped during the term of the deal is referred to colloquially as the "vig." The studio wants to offer a guarantee it believes will be "earned out" (i.e., covered by actual recouped fees) to the greatest extent possible, thereby minimizing the vig.[7] On the other hand, the talent wants to both maximize their opportunity for payments beyond the guarantee (again, "fresh cash") *and* minimize the recoupment/maximize the vig under the deal (with the vig representing the premium paid to the talent for his or her exclusivity during the term of the deal). Because of this dynamic, some particularly complex and high-level deals may provide for recoupability to slow down (e.g., from 100% to 50%) as the guarantee approaches being fully earned out, in order to ensure that the talent continues to enjoy a vig under the deal. An independent studio, on the other hand, would be only too happy

7 For so-called "showveralls" in particular, the guarantee may be precisely calculated to cover the writer's anticipated earned episodic fees during the term, plus a specified number of development scripts (e.g., one or two fresh scripts per year), with little or no premium on top.

to see fresh cash paid if it means that its overall guarantee had been earned out and recouped in full.[8]

This deal term may also affect the treatment of the talent's revenue streams from third parties which preexist the overall deal. In general, talent retain for themselves, outside of their overall deal, 100% of fees from their preexisting projects (and are permitted to continue rendering non-exclusive services on these projects, outside of the exclusivity of their deal). However, the studio may be willing to substantially increase the annual guarantee offered to the talent if the talent essentially assigns to the studio his or her right to compensation from the preexisting projects, making such fees recoupable against the guarantee. Even if the enhanced guarantee paid by the studio is essentially equal to the expected third-party fees, this may be desirable to the talent as a way to smooth out the timing of payments, as series producing fees are generally received in irregular bursts as production occurs, while overall guarantees are paid in consistent, equal weekly installments over the term.

c. Cross-Collateralization

Finally, the parties to an overall deal must determine the extent of cross-collateralization under the deal—that is, the extent to which the guarantees paid and fees recouped in separate years of the deal are aggregated with one another for purposes of determining the vig and the availability of fresh cash. In general, all of the years of the deal are "crossed," which reflects the reality of the likely work process; during the first year of a deal, when the relationship between the parties is ramping up and settling in, and the talent is beginning to develop new projects for his or her new home studio, it is rare for the studio to recoup significant fees. The pace of development and production dictates that, most likely, projects that are developed during the first year of the deal will not bear fruit (in the form of produced pilots and series, and therefore recouped fees) until later years of the deal; without cross-collateralization, it would be too difficult for the studio to recoup fairly against the first year guarantee, and too easy for the talent to see fresh cash in later years of the deal.

However, when the parties to an overall deal renew or extend their relationship, it is not uncommon for the extension/renewal term to be walled off from the initial term, with the guarantees and earned fees from the latter term *not* being cross-collateralized with those from the former. Alternatively, fees from prior terms may be cross-collateralized with subsequent terms, but deemed only

8 In order to reduce the financial impact of the vig, studios generally reserve the right to charge the unrecouped portion of an overall guarantee as a production expense on the show (or allocated amongst multiple shows) worked on by the talent during the term. (See Section F of Chapter 6.) This has the effect of allowing the studio to effectively recoup the vig from the revenues of these series, while pushing back the (non-recoupable) backend earned by the individual (as well as all other profit participants) on the show(s).

partially recoupable rather than fully recoupable. This is a concession to the competitive nature of the marketplace for desirable talent. If a writer/producer or pod were to leave its home studio when its overall expired and enter into a new overall relationship with a different studio, most likely, it would retain its ongoing fees from preexisting projects without recoupment against its new studio deal. Consequently, in order to avoid losing talent to competing studios, many studios must show flexibility in the recoupment and cross-collateralization structure between terms, by structuring the new deal so as not to leave the talent in a materially worse economic position than they would enjoy by leaving for an otherwise identical deal from a different studio.

iii. Overhead

Many writers, directors, and producers of sufficient stature to warrant an overall deal are interested in building their own production companies.[9] Doing so requires an investment in expenses such as an office, an assistant, and one or more development executives. In substantial overall deals, studios commonly assume or reimburse some or all of these overhead expenses on behalf of the primary individual engaged under the overall. Ultimately, the studio must consider the cost of these expenses (which is generally non-recoupable), as well as the cost of the recoupable guarantee, in assessing the total financial burden of the overall deal to the studio.

There are many logistical variations that the parties may agree upon in connection with overhead-type expenses. A studio with available resources may provide office space and/or an assistant to the talent. The studio may directly pay for third-party overhead expenses (e.g., by directly renting and paying rent on an office space, and/or engaging an assistant or executive designated by the talent on the studio's own payroll), or reimbursing the talent for verified expenses that the talent incurs directly. In some cases, some portion of the annual guarantee may be deemed a non-accountable, non-recoupable overhead allowance; this approach also effectively reduces the amount of fees that must be earned under the deal in order for the talent to fully recoup the guarantee and see fresh cash.

iv. Assignability

In many cases, it may be clear, at the time an overall is entered into, what role the studio and the talent collectively envision that the talent will play over the life

9 Building a production company allows an individual to increase the volume of development and production projects he or she can handle at any given time; affords the individual greater effective control over the projects on which he or she works; enables the individual to develop a broader portfolio of projects on which he or she can draw fees for part time, non-exclusive services; and generally represents enhanced stature and prestige for the principal(s) of the production company.

of the deal. However, the parties may not always see eye-to-eye on such matters, and even if they do, opinions can change over time. Consequently, assignability—that is, whether and to what extent the studio may assign the talent to work on projects other than those originated by the talent themselves—is a key aspect of overall deals.

Many high-stature writers, directors, and producers strongly prefer to work only on projects that they have developed from inception; or, at a minimum, that they joined willingly at an early stage in the process. On the other hand, a studio that has made a substantial financial commitment to an individual may not want to rely entirely on that individual's ability to generate and sell new projects to be able to recoup that investment through earned fees. As a result, the parties must hash out the studio's rights with respect to project assignability. The studio prefers the unfettered right to assign the talent to work on any of the studio's projects during the term, while the talent looks for the deal to be non-assignable, or, alternatively, assignable solely with the talent's consent.

Many studios retain the right, at least on paper, to assign talent into any project of the studio's choosing. As a practical matter, however, most studios preserve good long-term relationships with individuals under overalls by consulting meaningfully with talent prior to any such assignments and generally avoiding assigning talent into any project against their will. The nature of the assignment may also vary substantially depending on the needs of the applicable project and the role the parties envision for the individual being assigned in; a writer/producer with sufficient stature and experience to create and showrun his or her own projects may supervise a more junior writer/creator with the intention of showrunning the series should it be produced. He or she may even be assigned as a senior staffing writer (perhaps on a part-time basis) to support another show that is in need while the writer/producer's own projects are not in active development or production. In order to protect the talent's interest in working on their own projects, representatives may seek more favorable recoupment terms to apply (for example, allowing a portion of fees to be paid as fresh cash rather than recouped, or to enhance the overall guarantee) on assigned, rather than artist-originated, projects.

v. Inside Terms

The "inside terms" of an overall deal refer to the specific terms—fees, bonuses, royalties, contingent compensation, etc.—applicable for every project on which an individual renders services during the term of the overall deal. The relevant terms are those that are negotiated on a project-by-project basis for individuals who are not under overall deals,[10] but pre-negotiated and applied on a blanket

10 See Sections A, B, C, and D of Chapter 5.

basis for all projects during the term. These "inside terms" are the subject of the negotiation as to recoupability under the overall deal, as described in Section A.ii.b above. Typically, when an overall deal is extended or otherwise renegotiated, the talent will seek improvements on the inside terms, as well as the annual guarantees payable under the deal (so as to improve their own quotes for future deals, and expedite the recoupment of their guarantee).

Although the overall deal sets out pre-negotiated inside terms, often these terms represent only the beginning, rather than the end, of the negotiation of the talent's entitlements for any given project. For instance, if an individual under an overall deal is packaged with many other high-level elements that render the individual's default inside terms impractical for the project (e.g., because the aggregate executive producer fees and/or aggregate backend payable to all elements for the project would be too high), the studio and the individual will routinely negotiate project-specific reductions to those inside terms. In addition, particularly for writer/producer deals, the inside terms that are initially negotiated may not cover the full range of services that the individual might ultimately render under the deal. For instance, it is not unusual, when entering into an overall deal with an experienced writer/producer who can function as a showrunner, to negotiate inside terms solely in connection with projects that are created and actually showrun by that individual. However, if that individual supervises a junior writer/creator during development, joins a preexisting third-party series as showrunner, or renders part-time consulting services on an ongoing project, the studio and the writer/producer will typically need to determine revised terms, so as to budget and charge off appropriate fees and accord the writer/producer an appropriate amount of backend (if any) for the services actually being rendered. Similarly, if an overall deal contemplates that an individual works exclusively in scripted episodic television, the parties may need to negotiate revised inside terms if that individual subsequently finds him or herself working on a television movie, mini-series, or unscripted project.

B. First Look Deals

A first look deal is an agreement by which a writer/producer, producer/director, or, most often, non-writing producer grants a studio an exclusive first opportunity to develop and produce projects that are created, owned, or controlled by that individual/company, before the individual/company may present any such projects to another studio or network for consideration.[11] First look deals operate similarly to overall term deals—they are characterized by a close and preferential relationship between studio and producer, upfront guaranteed compensation in

11 First look clauses, in the context of staffing writer agreements, are discussed in Section B.vi of Chapter 5.

exchange for the exclusive first look, potential overhead cost coverage by the studio on behalf of the producer, and pre-negotiated inside terms that are automatically applicable in the event the studio elects to proceed with a project. However, they also differ from overall deals in a few key respects.

First, most importantly, unlike an overall deal, a first look agreement is not a fully exclusive relationship. If a producer under an overall deal pitches a project to his or her home studio, and the studio is not interested in proceeding, then the producer is effectively precluded from working on the project until his or her overall expires and he or she has the opportunity to pitch it to another studio that may be more receptive. On the other hand, if a studio passes on a project pitched by a producer under a first look deal, then that producer is immediately free to bring it to third parties, and to actually proceed with the development and production of the project with one of those third parties, so long as that work does not interfere with the producer's ongoing obligations under the first look agreement.

Second, because a studio entering into a first look deal is buying merely a first opportunity rather than a fully exclusive relationship, the applicable guarantee under a first look is typically substantially smaller than would be commanded by the same producer for an overall deal. Similarly, the studio's appetite to support the producer's company via overhead cost coverage may be diminished in a first look context, compared to an overall context. On the other hand, particularly with non-writing producers, the studio may seek to negotiate for a first look payment that is only sufficient to cover the producer's overhead expenses, without providing any substantial profit center on the basis of the first look payment alone.

Third, in light of the first two primary differences described above, it is much more common for first look guarantees to be non-recoupable, in whole or in part (meaning that the producer will see fresh cash for all fees [or a higher percentage of fees] earned from projects developed and/or produced under the first look). This is a significant deviation from overall deals, for which the applicable guarantees are typically fully or substantially fully recoupable against fees earned by the producer during the term of the deal.

Finally, the scope of the studio's first look rights must be more carefully defined under a first look deal than under an overall deal (under which there is a simple presumption of total exclusivity during the term). A first look deal must specify whether the first look applies to all television projects, as opposed to solely all scripted or all unscripted projects. It must provide for the parties' rights and obligations in the event the producer is approached to render services on a project the producer does not personally control—may the producer render services for third parties if the producer is unable to deliver the project to the studio's control, or must the producer make at least a good faith effort to accomplish this? And it may require the producer, under certain circumstances, to resubmit to the studio projects for which the studio initially declined to proceed with development.

8

NETWORK AND STREAMING LICENSES AND STUDIO CO-PRODUCTION AGREEMENTS

Chapters 4 through 7 of this book have focused on the relationships between studios and various categories of rightsholders and service providers that sit up the chain from studios in the visual framework we've previously used to describe the television industry:

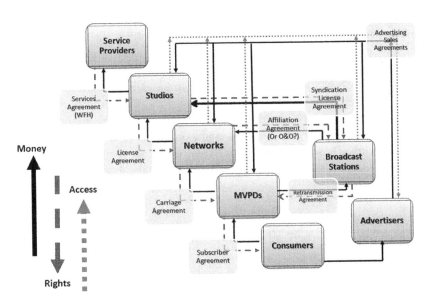

We now turn our attention to the next linkage in the chain, between studios and networks, as well as a further relationship not directly reflected in the visualization above: co-production agreements between two studios—one of which

is often affiliated with the commissioning network—to jointly own, finance, and produce a series. In so doing, we pay particular attention to the unique issues affecting the new generation of digital streaming platforms, such as Netflix, Amazon, and Hulu, and the way that traditional license deal structures have adapted to address these issues.

A. Network and Streaming License Agreements

No single agreement has a greater effect on the ultimate profitability of a television series to its studio than the initial network license agreement, the deal under which a television series is first commissioned and exhibited by an American licensee.[1] If, as described in Section C of Chapter 2, "a television studio makes money by using the divisibility of its copyrights to maximize revenue across media, territory, and time," then the goal of a studio in negotiating a network license agreement is to grant the network as few rights, in as few territories, for as brief a term, and for as much money as possible, retaining for itself as much freedom as possible to further license the same series to additional licensees across various platforms, countries, and time windows. The particulars of these agreements vary widely depending on whether the network at issue is a broadcast network, a basic cable network, a premium pay cable network (e.g., HBO or Showtime), or a digital platform (e.g., Netflix or Amazon)—and this book will endeavor to summarize some key differences that emerge in license deals across various types of networks—but the essential issues being negotiated remain essentially the same regardless of the nature of the licensee.

Significantly, the type of network involved dramatically impacts the level of risk and reward. Broadcast networks require supplier studios to put significant capital at risk, but leave open numerous high-value rights and windows that, in success, can generate wildly profitable returns. Relative to broadcast networks, cable networks tend to demand less at-risk capital from their studio partners, but shows created for cable platforms tend to generate lower revenues from off-network exploitation. Rights-hungry digital platforms virtually eliminate the studio's economic risk from any given project, but take so many rights off the

1 Interestingly, despite the critical role these agreements play in the television business, they are frequently heavily negotiated as to substantive terms, but never actually reduced to a fully executed long-form agreement. Many networks condition license fee payments on the execution of a short-form term sheet and/or an "indemnity agreement" addressing some basic legal liability issues between the studio and network, but never insist on the full execution of their long-form agreements. In many cases, the network issues a long-form agreement, the studio replies with a set of comments, and the parties reserve their positions in perpetuity while otherwise carrying on business as usual. The willingness of both parties to make huge multimillion dollar investments with such an essential document unresolved further reflects the relatively small, tight-knit, repeat-business nature of the television industry. Streaming services, which are rooted in a technology industry mindset (rather than or in addition to a traditional entertainment industry mindset) are more likely to rigorously insist on signed long-form agreements.

table, for such a long period of time, that the studio is left with little opportunity to make further profit from other sources.

i. Development Contributions

At the time a series is first set up with a network for development, the studio and network negotiate for the network to cover some portion of the development expenses incurred by the studio in connection with the project. The key parameters of this negotiation are discussed in Section A.ii of Chapter 2.

ii. Pilot and Series Options

When a studio sets up a project with a network for development, it grants that network the exclusive option to order a pilot and/or series episodes of the project.

Broadcast networks generally insist on "two bites," meaning two opportunities to order a pilot or series to production. At the pilot phase, the "bites" refer to the network's customary annual "pilot seasons," with pilot production orders placed by February 28 of the applicable year; at the series phase, broadcast networks must generally order production of a series for a fall start no later than May 31 of the applicable year, or for a mid-season start no later than December 15 of the applicable year. However, when a project is set up with a broadcast network in a competitive situation, the studio will often negotiate for the network to have only "one bite" for pilot and/or series, making it easier (and faster) for the studio to solicit interest from a competing network if the original network declines to proceed with the project.

For licensees other than broadcast networks, who often order pilots and series without regard for the traditional, rigid annual calendar employed by the broadcast networks, pilot option periods are defined based on a certain number of months (usually three to six) following the delivery of the final pilot script writing step commissioned by the network. For such licensees, the initial series option period is also based on a certain number of months (again, usually three to six) following the studio's delivery of the completed pilot. Streaming services, which often commission higher-budget series and eschew economically inefficient pilots, are more likely to insist on receiving additional written materials (e.g., a series format and/or backup script[s]) prior to starting their option clock.

In addition, the parties must negotiate the timing of the network's options to order subsequent seasons of the series. For broadcast networks, the applicable option must generally be exercised by May 31 annually. For other networks, the season-to-season option date may be annualized based on the option exercise date or option exercise deadline for the initial series option (in other words, if the initial series option was exercisable by October 31 of a given year, the option for subsequent seasons must be exercised by October 31 each year); fixed to a

certain number of weeks prior to the expiration of the annual cast option dates;[2] or set based on a certain number of months following the final delivery and/or initial exhibition of the final episode of the prior season (typically, the earlier of six months following initial exhibition, or nine months following final delivery, of the last episode of the prior season).

iii. Series Term

The "series term" of a network license agreement identifies the number of consecutive, dependent options held by the network to order additional seasons.

Traditionally, most broadcast network license agreements had four-year (or four-and-a-half-year)[3] terms, meaning that the network had the ability to order a pilot and up to four seasons under its original license agreement before the network would be forced to negotiate a new license agreement with the studio covering additional seasons. In success, a network would be highly motivated to retain the ability to continue ordering and exhibiting new seasons of the series, and the studio would be able to extract a substantial improvement in its license terms commencing with the fifth season of the series. From the studio's perspective, a traditional 4/4.5-year term license agreement is preferable and remains achievable for especially desirable projects, particularly when networks are competing with one another for the opportunity to develop such projects.

However, for less competitive projects, broadcast networks have increasingly begun to insist on so-called "extended term" license agreements, which provide for seven-year (or seven-and-a-half-year) terms, thereby delaying the point at which the network may face a costly renegotiation with the studio to a point that few series have the longevity to achieve. Although these extended term license agreements include pre-negotiated improvements in the license fee structure that kick in with the fifth season of the series,[4] and may include a premium even on the license fees for the first four years that the network pays in respect of receiving the extended term, these negotiated improvements are often less substantial than those the studio would expect to negotiate for a successful series entering its fifth season following the expiration of a traditional 4/4.5-year term deal.

Outside of the broadcast network context, most networks insist on even longer, "perpetual term" license agreements, which grant the network unlimited successive, consecutive, dependent options to continue ordering new seasons of the series, for as long as they wish to do so. Like extended term deals, perpetual

2 See Section E.iv of Chapter 5.

3 Again, the half-year refers to a first season of a series with a mid-season start, which will entail fewer episodes (typically, thirteen) than a full season with a fall start (which is usually comprised of twenty-two episodes). This same "half-year" concept is incorporated into the term of series regular actor agreements for broadcast network series. See Section E.iv of Chapter 5.

4 See Sections A.iv.c and d below.

term license agreements provide for studio-friendly escalations in the economic terms that are pre-negotiated at the inception of the deal, when the studio has less leverage than it would enjoy if the network faced the prospect of losing a successful series to a competing network due to an expiring license agreement.

iv. Pilot and Series License Fees

The fundamental economic term of a license agreement is the license fee paid by the network in exchange for the rights granted to it under the deal. The size of the license fee commanded by the studio is a function of numerous factors, including the desirability of the project and its elements and the competitiveness of bidding amongst multiple networks; the budget of the series; the scope of the rights (in terms of media, territory, and time) obtained by the network licensee; the series term of the license agreement; and the extent of the network-imposed holdbacks on the studio's reserved rights in the series. The license fee negotiation is, like all television industry negotiation, heavily influenced by the policies and precedents of the parties.[5] However, it is also often driven by complex financial modeling by both sides. The studio must determine the extent to which its network license agreement will allow it to effectively monetize the series with third parties, and whether these financial opportunities (alongside the network's license fee) will generate an appropriate return on the studio's investment. The network must determine what types of ratings (and resulting advertising sales) the show must achieve in order for the network to recoup its investment of license fees and marketing expenses in the series and show a profit of its own.

a. Initial License Fees

Scripted television is generally based on a deficit model, meaning that the initial license fee that a domestic network pays to a studio to commission a series is less than the full cost of production. That difference between cost and initial license fee is known as the "deficit," and it represents the studio's at-risk investment in the series (and the hole that the studio must climb out of, with revenues from media, territories, and exhibition windows beyond the initial network license, to show a profit).

The license fee for a series may be stated as a fixed dollar amount, or as a percentage of budget (although even when the license fee is a fixed dollar amount,

5 Policy and precedent are powerful forces in the television industry. Many companies maintain inflexible policies compelling them to always require certain deal terms or to never agree to certain concessions under any circumstances. Studios and networks may refuse a request that is reasonable for the situation, because it would "create a precedent" that unrelated parties in future theoretical deals may seek to take advantage of to demand more favorable terms.

that figure is negotiated with explicit consideration for the probable budget of the series). Broadcast networks tend to prefer to negotiate license fees in terms of dollars, while cable networks (including premium pay cable) and digital platforms are more likely to favor percentage-based license fees.[6] Ultimately, studios are primarily responsible for determining the budgets of their series, balancing the need to produce a compelling and high-quality product against the desire to limit the deficit that they must ultimately make up from other sources of revenue. However, where a network's license fee is calculated as a percentage of budget, the network generally exercises mutual control over production budgets.

For reference, the following budget ranges (exclusive of applicable tax credits) may be considered typical, although as always, the final number depends on the creative and financial appetite of the commissioning network (with the highest budgets usually found on broadcast network television, premium pay cable, and digital platforms, and the lowest budgets on basic cable), as well as the creative demands of the subject matter of the show (e.g., major effects-driven science fiction/fantasy vs. small-scale character and dialogue-driven comedy) and the number of episodes produced (with larger orders allowing fixed startup and construction costs to be amortized across a higher number of episodes).

Of course, there are (as always) outliers on all sides, with large-scale projects like Netflix's *The Get Down* (from Sony Pictures Television) and *Altered Carbon* (from Skydance Television) and HBO's *Vinyl* featuring reported production budgets in excess of $10 million per episode.

TABLE 8.1 Series Budget Ranges

Show Type	Pilot Budget	Series Budget[7]
30-minute comedy	$1 million–$4 million	$500,000–$3 million[8]
60-minute drama	$5 million–$12 million	$2 million–$6 million[9]

6 There is little explanation for the broadcast networks' preference for dollar-amount license fees beyond longstanding custom and practice.

7 A television season production budget typically consists of an "amortization budget" (which covers fixed costs associated with the season, such as principal set construction, which do not increase or decrease depending on the number of episodes produced) and a "pattern budget" (which covers episode-by-episode costs, based on assumed production parameters, such as the number of speaking parts in each episode and the number of days of on-location production vs. in-studio production). The total episodic budget is the pattern budget plus the amortization budget, amortized over the number of episodes actually produced, which is why the average per-episode expense goes down if more episodes are ordered and produced.

8 As of this writing, most comedies would fall in the $1 million to $2.5 million per episode range.

9 As of this writing, most dramas would fall into the $3 million to $4.5 million per episode range.

For a broadcast network comedy, the expected license fee would fall between $1 million and $1.75 million for pilot (likely representing 30% to 40% of the production cost), and between $750,000 and $1.25 million per episode for series (likely representing 50% to 60% of the production cost). For a broadcast network drama, the expected license fee would be between $3.5 million and $4 million for pilot (again, likely representing 30% to 40% of the production cost), and between $1,500,000 and $2,000,000 per episode for series (likely representing 40% to 50% of the production cost).

Because the secondary market value of a cable (even pay premium cable) series is generally expected to be less than that of a broadcast network series,[10] the market generally provides for lower deficits on cable productions. Depending on the extent of the rights granted and the holdbacks imposed on other exploitation, the expected license fee from the U.S. cable network is likely between 60% and 85% of budget (potentially subject to a cap that corresponds to a probable budget number). Additional license fees may also be pre-negotiated if the network insists on acquiring expansive digital rights.[11] Usually, the percentage license fee is calculated on the "net budget" (i.e., the budget, net of tax incentives or rebates obtained by the studio in connection with the production), although in some cases, it may be negotiated based on the "gross budget" (i.e., the budget without regard for tax incentives, in which case any tax incentives realized would directly and exclusively benefit the studio). For a cable comedy, the applicable license fee may be even higher, up to a full 100% of the budget (again, because of the diminished off-network revenue-generating opportunities for cable comedies, in particular).

Series produced for digital platforms such as Netflix and Amazon generally do not have deficits. These digital services have extensive international territorial footprints and an internal mandate to acquire sufficient rights to make their shows available across all or substantially all territories served by the platforms. In addition, these platforms tend to have long license terms and expansive exclusivity requirements, and make it difficult or functionally impossible for outside studios to license their shows to competing digital platforms, thereby diminishing or eliminating an important revenue source for each series.[12] When a

10 This diminution in value is a function of multiple factors, including reduced license fees from international broadcasters relative to those commanded for network series, and the probable unavailability of a cable syndication deal for a show that was exhibited, from inception, on cable.

11 See Section A.vi.b below.

12 To date, no series that originated on a streaming digital platform has been licensed for re-broadcast by a traditional broadcast or cable network (although Tornante Co., the studio behind Netflix's *BoJack Horseman*, reportedly shopped syndication rights to cable buyers in January 2018). Consequently, this market opportunity is currently considered speculative and difficult to value. However, it seems inevitable that some successful streaming series—particularly one that was licensed to Netflix or Amazon during the early years of the platforms' activity in original content, when their appetites for exclusivity were less voracious—will eventually make it to a traditional television platform. (On the other hand, when the holdbacks against traditional linear television exploitation of such series expire, Netflix or

studio negotiates a license agreement with a digital platform, it therefore seeks a license fee large enough to compensate it for the opportunity cost of diminished or eliminated licensing opportunities in international territories and secondary markets. This means that platforms like Netflix and Amazon pay license fees to outside studios that are typically substantially greater than the cost of production of the series, and those fees may ultimately represent substantially all of the revenue the studios reasonably expect to earn from their shows for the life of the series.[13] These are sometimes referred to as "cost-plus" deals, and the amount by which the license fee exceeds the show's cost is called the "premium." The premium may be stated as a percentage of budget or in flat dollar terms.

It is important to note that these high license fees—again, typically a substantial percentage above the cost of production—have driven Netflix and Amazon to invest increasingly heavily in developing and producing their own shows, without relying on outside studios. Acting as networks, they must pay more than 100% of the cost of any given series to obtain just the minimum subset of rights they need to feed their businesses worldwide. Acting as studios, they can control 100% of the rights in a series, worldwide, for the cost of production. Economically, it is obviously hugely advantageous to these platforms to produce and own their own content, rather than relying on outside suppliers. However, competition for the best programming from the best creative talent keeps these platforms in business with outside studios, despite the attendant costs—at least for the time being.

b. Breakage

The network may agree to pay extra amounts beyond its initial negotiated license fee in order to subsidize and incentivize the studio to enhance the production value and marketability of the series. This is called "breakage." Breakage may be paid, for example, to cover the costs of hiring well-known and sought-after actors, or to produce flashy event episodes that are more expensive than the pattern budget for the series would otherwise allow.

Breakage may be pre-negotiated, or addressed by the studio and network on an ongoing basis as proposed production enhancements arise. For instance, many network license agreements include a pre-negotiated "cast breakage" formula, by which the network agrees to pay, on top of its license fee, anywhere from 50% to 100% of incremental costs of the episodic series regular budget over a threshold amount. A typical formulation would be "50/50 over $250,000," meaning that, for every dollar in episodic series regular fees committed by the studio in excess of $250,000 per episode, the network will automatically enhance its initial

Amazon may ultimately choose to pay significant fees to their partner studios to preempt the availability of their original series on other platforms.)

13 For purposes of determining residuals obligations, applicability of distribution fees against revenues in backend calculation, and other accounting-related purposes, there is typically an internal allocation of this license fee between domestic and international rights.

license fee by 50 cents. In addition, for internal recordkeeping or precedential reasons, some networks choose to internally allocate a portion of the negotiated license fee to "breakage," even though it is fixed and negotiated from inception; such characterizations are largely cosmetic. More often, however, the studio and network will discuss production enhancements on a case-by-case basis, with networks covering anywhere from 50% to 100% of the proposed incremental expense, depending on the perceived value to the network of the enhancement.

c. Later Season License Fees

Although the practice is not completely ubiquitous, in most "extended term" (i.e., longer than 4/4.5 years, usually 7/7.5 years)[14] or "perpetual term" licenses, the network's license fee automatically increases—commencing in the fifth or sixth season of the series—to the studio's full cost of production. In other words, starting in the fifth season of a series, the studio moves to a zero-deficit production model, and its revenues from other sources are effectively pure profit. At this stage, the network reviews and approves the annual budgets for the series, and the studio remains responsible for any overages incurred relative to the ingoing approved budget (other than those also paid by the network as breakage), but the network bears 100% of the ingoing budgeted costs. This makes the fifth season an important benchmark for the studio to reach in terms of maximizing the profitability of a series (although the significant financial impact to the network of ordering a fifth season may prove an impediment to shows that are already at risk of cancellation at the end of their fourth seasons).[15] In some cases, an "extended term" or "perpetual term" license agreement may provide for further escalations in the license fee in even later seasons, to some multiple or amount in excess of cost of production, though such escalations are not as common as the move to a "cost of production" in the fifth or sixth season.

d. Success Bonuses

In addition to the license fee increase to cost of production in the fifth or sixth year, there are two main ways that license agreements (especially extended or perpetual term deals, which must compensate the studio for lost renegotiation

14 As explained in Section E.iv of Chapter 5, the notion of "half years" refers to series whose first season is ordered to production for a "mid-season start"—i.e., premiering during January to April, rather than September or October, of the applicable broadcast year.

15 Of course, this pre-negotiated contractual default does not prevent a network from negotiating with its studio partner for some relief from the expensive escalation to "cost of production" as a condition of the network's ordering a fifth season of a given series. From the studio's perspective, as described in Section C.i of Chapter 2, the ordering and production of a fifth season may also be vital to accessing lucrative downstream syndication opportunities; consequently, networks have significant leverage to force studios to compromise on their contractual license fees for the fifth season of a series in order to secure a doubtful fifth season order.

opportunity) reward a studio for the success of a series: ratings/rankings bonuses and deficit recoupment.

Ratings and rankings bonuses are additional payments from the network to the studio (often, but not always, on a per-episode basis) that are triggered by a series achieving certain average viewership benchmarks, as measured and published by the Nielsen Company (whose publications remain the standard in the television industry).[16] Such bonuses may be triggered by a series achieving minimum ratings figures, minimum rankings relative to other primetime television series, or both. They are often tiered, with bonuses that escalate as successively higher ratings or rankings thresholds are achieved. These bonuses may be payable starting in the fifth season of a series, or, in some cases, a studio may be able to negotiate for ratings/rankings bonuses that are accessible starting in the second or third season of a series. In addition, if a series hits specified ratings/rankings thresholds, the network may agree to automatic enhancements in the license fees payable for repeat broadcasts.[17]

"Deficit recoupment" refers to the network's reimbursement to the studio, typically in the fifth (or fifth and sixth) seasons of a series, of the studio's production deficits from the first four production seasons of the show. This mechanism simulates a common demand of studios when negotiating a license renewal/extension for a highly successful series entering its fifth season under a traditional 4/4.5 year term deal. Like the aforementioned bonuses, deficit recoupment may be conditioned, in whole or in part, on the show achieving specified Nielsen ratings or rankings. Because a network cannot directly control the deficits a studio chooses to undertake during the first four production seasons, deficit reimbursement may also be subject to negotiated episodic caps.

v. Minimum Orders

The network's right, pursuant to the license agreement, to order production of a season of a series is subject to a minimum episodic order.[18] For broadcast

16 Nieslen publishes multiple ratings metrics, and the advent of digital video recorder (DVR) technology has forced Nielsen to evolve how it measures ratings. The "Live" rating measures how many viewers watched a TV show as it aired in real time. "Live + Same Day" (or "Live + SD") adds to that count the viewers who watched recordings of the show by 3 a.m. the day after the initial broadcast. "Live + 3" and "Live + 7" ratings include viewers that watched the recorded show within the three days and seven days, respectively, following the initial broadcast of the show. Any time ratings are used as benchmarks or triggers, the deal must be clear as to which rating controls—Live, Live + SD, Live + 3, or Live + 7. Live + SD and Live + 3 are most commonly used.

17 See Section A.vi.a below.

18 Such minimums are important to the studio because the number of episodes produced can substantially impact the economics of a series. As discussed in Section A.iv.a above, the per-episode cost of a series goes down as the episodic order goes up, because certain fixed production costs can be amortized over a greater number of episodes. In addition, license fees are typically negotiated on a per-episode basis, so more episodes produced necessarily equates to more aggregate revenue. Consequently,

network shows, the standard is as follows: (1) for the first season, thirteen episodes (inclusive of the pilot), with an option to order a "back nine" of episodes if the show has a fall (rather than mid-season) start; (2) for the second season, twenty-two episodes if the first season had a fall start, or thirteen episodes (with another "back nine" option) if the first season had a mid-season start; and (3) for the third and subsequent seasons, twenty-two episodes. For cable and digital platforms, the applicable minimum orders are more specifically negotiated, according to the general exhibition patterns of the commissioning network and the financial demands on the studio for the specific project. Most studios seek to require at least twelve- or thirteen-episode annual orders (inclusive of the pilot for the first season), though many non-broadcast networks have moved increasingly toward shorter seasons, often ten episodes annually, and sometimes as few as eight episodes per season.[19] Because of the worsened amortization and diminished outside revenue prospects associated with such short orders, studios may demand particularly premium episodic license fees to compensate.

vi. Licensed Rights (Grant of Rights)

Any intellectual property license must define the scope of the rights being licensed, and network license agreements for television programs are no different. Network license agreements grant networks only specific enumerated rights, with all rights not covered by the grant of rights reserved by the studio (although potentially encumbered by a holdback).[20] For the most part, networks define the scope of the rights being granted according to the needs of their particular businesses, and studios adjust the pricing of the license fee accordingly, although every year brings a fresh push-and-pull between studios and networks, with networks seeking ever more expansive grants of rights while looking to avoid any associated increase in the license fees they must pay for such rights.

although the studio carries a higher aggregate deficit on a larger order, the episodic deficit is lower and easier to overcome. However, even with these minimum order requirements, networks often reserve the right to reduce their order, subject to paying certain shut-down/diminished amortization costs. In such cases, the studio would remain obligated to produce and deliver the reduced number of episodes (although the shortened order would render void the network's contractual options to order further seasons).

19 Cable networks have embraced such shorter production seasons for a variety of reasons, including, without limitation, the preferences of certain writer/creators who favor shorter and tighter serialized story arcs; the preferences of high-level actors who prefer shorter commitments (which allow them more time to pursue other opportunities in film, stage, and other media); the willingness of digital platforms to accept second-run licenses for series with shorter episodic runs than would be acceptable to traditional syndication licensees; the desire to avoid talent burnout from grueling television production schedules; and the opportunity to program schedules with a greater variety of short-run series (rather than a smaller number of longer-run series).

20 See Section A.viii below.

a. Network Exhibition and Runs

Most obviously, the network must obtain the right to exhibit the series on its own network in every way that network is delivered to customers. For broadcast networks, this means the over-the-air broadcast signals of affiliate stations, as well as authorized retransmissions by MVPDs; for cable networks, this primarily means MVPD carriage. As distribution technologies have evolved, however, the contractual definitions of "network exhibition" have grown more expansive, so as to cover any newly emerged technical delivery mechanisms on which a network may rely.[21] In general, regardless of technological means, in order to qualify as "network exhibition," the service must always bear certain characteristics based on the primary traditional network—for instance, the stream to the customer must be preprogrammed and linear (as opposed to "on demand"), and must be offered to the customer on the same basis as the primary network distribution (i.e., free for broadcast networks; subscription-supported and authenticated for cable networks, etc.). Separate from defining "network exhibition" with regard to their own networks, some networks also negotiate for the right to "repurpose" some of their permitted runs by exhibiting series episodes through affiliated sister networks (often for primarily promotional purposes).

Networks are generally limited to a finite number of "runs" (i.e., distinct, scheduled exhibitions) of the licensed episode of a series and must pay additional license fees (on the order of $25,000 to $50,000 per run) for repeats beyond a negotiated threshold. Some networks base the number of permitted runs, and the threshold for triggering repeat fees, on an episode-by-episode basis. Others define these limits and thresholds based on multiples of the total number of episodes ordered by the network in each season, with a sub-limit on repeats for any given episode. For broadcast networks, the limit usually amounts, by one of these means of calculation, to a cap of three to four runs per episode under the initial network license; for cable networks, the maximum number of runs is usually much higher (e.g., up to twelve runs), or even unlimited. In any event, at a minimum, the network is generally responsible for reimbursing the studio for any residuals obligations arising out of the network's repeat exhibition of series episodes, and repeat fees to the studio generally escalate the more reruns the network takes.

21 For example, some cable networks are now available not only through traditional MVPDs such as cable, satellite, and telecommunications providers, but also through Internet-based subscription services such as Sling TV and PlayStation Vue. For technological reasons, these "virtual MVPD" or "vMVPD" services do not meet the traditional technical or regulatory definitions of "MVPD," but offer functionally and substantively identical services to traditional MVPDs. Some networks also make their linear streams accessible to customers through their websites or dedicated mobile apps, as long as the customers authenticate themselves with confirmed MVPD subscriptions. Networks must take care to define "network exhibition" so as to ensure their ability to avail themselves of such new distribution opportunities, without losing access to the content they carry on their traditional streams.

b. Digital Rights (Traditional Licensees)

For the most part, network license agreements—particularly broadcast network license agreements—evolve seldom and slowly. Budgets, and therefore license fees, have crawled up over time (though not necessarily at the same rate), but little else has changed much over the years. Networks and studios that regularly do business together often simply duplicate their recently negotiated license agreements, plug in fresh numbers on a show-by-show basis, make a few incremental changes, and proceed. The huge exception to this trend, however, has been with respect to digital rights, which arguably represent the fastest-changing—and most economically impactful—area of constant negotiation (and renegotiation) between studios and networks.

In this context, "digital rights" refers to exploitation and distribution of a series to customers via the Internet, typically on an "on demand" (rather than preprogrammed/linear) basis, that does not fall within the definition of "network exhibition."[22] Digital rights may be exploited through various technological platforms—for instance, a network may make episodes of a series available to its customers on demand through the network's website (such as ABC.com) or through a dedicated mobile app (such as HBO Go or FX Now). Digital rights may also be exploited through an MVPD, rather than by the network directly; indeed, most MVPDs provide on-demand access to a significant number of shows that are exhibited by networks covered by the customer's MVPD subscription. This right (which is very valuable to the MVPD) must be granted to the MVPD by the network; and in turn, the network must obtain the applicable rights from the studio in order to pass them on to the MVPD. In general, the studio's grant of digital rights to the network explicitly requires that the digital rights be exploited on a platform that is owned and/or branded by the network, or by an MVPD that carries the network; thus, for instance, a network would not be permitted to obtain digital rights and sublicense them, for a fee, to Netflix. The primary exception to this requirement is that ABC, Fox, and NBC, which jointly own Hulu, regularly obtain the right to exercise their digital rights through Hulu (even though the Hulu service does not expressly carry ABC, Fox, or NBC branding).

For many years, the standard for digital rights was the so-called "rolling five" deal—the right to make available to customers, on an on-demand basis, up to five episodes of the series at a time, to enable customers who fall behind on a series to catch up on recent episodes. Under a "rolling five" deal, as any new episode after the fifth is made available to customers, an older one must be taken off-line. In addition, typically, if the network licensee is ad-supported (which is essentially true of all television networks other than premium pay channels like HBO), the network's streaming of its "rolling five" episodes would have to be

22 See Section A.vi.a above.

ad-supported as well. These rights were regarded by studios and networks alike as "companion rights" to the primary network license and granted without additional charge by the studio.

More recently, however, the battle has been over "stacking rights"—the right to make every episode of a given season of a series, without numerical limit, available to customers for "on demand" streaming while that season is ongoing. In order to meet growing customer demand for "on demand" viewing of their favorite television shows, networks have become increasingly aggressive in demanding in-season stacking rights for virtually all new series that they order to production. Although such stacking rights remain subject to the same branding requirements as traditional "rolling five" licenses (i.e., the rights must be exploited through a digital platform that expressly carries the branding of the licensee network [e.g., CBS All Access] or one of its partner MVPDs [e.g., TWC TV], other than special exceptions for Hulu) and are still considered "companion rights" to the primary network license, studios have succeeded in demanding supplemental license fees in exchange for these stacking rights. That said, the studios have also been largely dissatisfied with the license fees that networks—particularly broadcast networks—have been willing to assign to such rights.

Premium cable networks such as HBO and Showtime have been licensing extensive digital rights alongside their network exhibition rights for years. These networks embraced digital exploitation more rapidly than the broadcast networks and have, for several years, offered subscription-authenticated companion applications such as HBO Go and Showtime Anytime. The digital rights obtained by premium pay cable networks typically include not only in-season stacking rights, but also full out-of-season streaming rights (which may be granted on an exclusive or non-exclusive basis and which are priced out by the studio and network accordingly). As a result, these networks have been able to offer their subscribers library access to virtually every episode of every original series they have ever commissioned.

Digital rights have proven especially problematic to negotiate because of the unique challenges they represent for studios and networks alike. From the networks' perspective, the networks' efforts to reach their customers are constantly evolving, and networks are under significant market pressure to ensure that they can offer all of their programming to customers on as wide-ranging and consistent a basis as possible (even though that programming may be licensed from numerous studio partners with different, separately negotiated deals). Because networks can exploit only those rights that are expressly licensed to them, any change in their business model or distribution scheme can reveal major gaps in the rights they control, and studios can make these gaps extremely costly to fill.[23]

23 One major example of such an unanticipated rights gap, arising out of a change in business model, is that of Hulu, and its parents, the ABC, Fox, and NBC broadcast networks. As discussed here, studios have traditionally required that, where an ad-supported network obtains digital rights, it must exploit

On the other hand, from the studios' perspective, selling digital rights to third-party, second-window licensees has become a critical component of the overall business of making and distributing a television series. But the more expansively an initial network has exploited a series digitally, the less the studio can expect to earn in license fees from third-party digital licensees, who feel that the value of their rights has been diminished by the prior availability of the series on an on-demand basis. Because, as described in Section C.i of Chapter 1, digital buyers of content consider the prior streaming history of a television series in determining the license fees they are willing to pay for such series, studios often complain that network acquisition of stacking rights severely diminishes the license fees the studios can obtain from subsequent digital licensees (and that the supplemental license fees paid by networks for such stacking rights are too low to fully compensate the studios for that loss).[24] This significantly impacts the long-term profitability of the series.

With new technologies and business models emerging on a seemingly daily basis, digital rights promise to remain one of the most hotly negotiated elements of network license agreements in the years to come.

c. Digital Rights (Digital Platforms)

The foregoing discussion contemplates digital rights as "companion rights" to a traditional network television license. However, the parameters for digital rights are fundamentally different when the initial, first-run licensee is, itself, a digital platform.[25]

In such cases, the traditional notions of "network exhibition," or of finite "runs" and "repeats," are, by definition, not applicable. The primary rights being granted are the digital rights. Therefore, there are certainly no limits as to how many episodes the licensee may exhibit at any given time. Branding requirements for first-run digital licensees may be relaxed somewhat,[26] although restric-

those digital rights on an ad-supported basis as well. For many years, networks had little problem abiding by this requirement, even when the networks made shows available on Hulu (whose paid subscription service was also ad-supported, even while the company simultaneously offered a free ad-supported service, which was phased out in 2016). More recently, however, Hulu has sought to make its subscription offering more appealing to consumers by moving the service toward an ad-free experience. For this reason, these networks have begun to reject the traditional requirement that their digital rights must be exploited on an ad-supported basis.

24 Whether this alleged diminution in value to the third-party licensee from the initial network's exploitation of digital rights is factually true is debatable, but this is actually somewhat beside the point. The third-party licensees take the position that it is true, and reduce their spending accordingly, so the studio feels the impact of the alleged diminution regardless of the factual reality.

25 In such a case, the digital rights being granted may be referred to as "standalone" rights (because they are not tied to an underlying network television license).

26 For instance, from 2011 to 2014, Amazon operated its streaming business in the United Kingdom and Germany through an acquired subsidiary called LOVEFiLM, before finally folding the service into its self-branded Amazon Instant Video service in February 2014.

tions on sublicensing remain common. The license may also expressly prohibit or require the series to be offered on a subscription and/or ad-supported basis, and in general, studios—seeking to protect even speculative outside revenue generation opportunities—prefer to grant digital rights that are as narrow and specific to their licensee's then-current distribution model as possible. That said, the major digital platforms have sought to negotiate for flexibility to evolve their business models over time without losing the ability to continue to exhibit their original series.[27]

vii. License Territory and Term

All intellectual property licenses must specifically identify the territories and time periods that are within the scope of the license, and again, network license agreements are no exception.

For most U.S. networks, the applicable territory is the United States, its territories and possessions.[28] Puerto Rico and Bermuda are often included as part of the United States, and Puerto Rican and Bermudan rights may be subdivided between English-language rights (which are often included as part of a U.S. license) and Spanish-language rights (which are often excluded from U.S. licenses or granted only on a non-exclusive basis, so as to allow the studio to also include these rights in pan-Latin American licenses).

Some cable networks (such as Viacom's Comedy Central and MTV and Discovery Communications's Discovery networks) are also made available in a limited number of territories outside of the United States. Usually, the localized foreign version of a network is affiliated with and carries much of the same content as its American sibling, but it is not playing all of the same content at the same time as the American network. Sometimes, a network that is offered on one technological/economic basis in the United States (e.g., a premium pay cable network) is offered on a different technological/economic basis in other territories (e.g., as a standalone streaming service). In any event, when an American network has a foreign operation to sustain, it often concurrently obtains the rights it needs to support its international territories, with additional license fees negotiated according to the prevailing economic terms for such territories.

The major shift in territorial negotiation in recent years has been reflected, again, in licenses with digital platforms such as Netflix, Amazon, and Hulu. As of 2018, both Netflix and Amazon Prime Video are available in approximately 200 countries, including all major territories other than China (where, thanks in large part to government protectionism, no major American streaming services have launched, and a small group of successful local streaming services has

27 Again, consider Hulu's decision to strip ads from its paid subscription service.

28 Every territory also typically includes its military bases, and airlines and cruise ships that fly the flag of that country.

emerged to fill the vacuum). Hulu has made periodic overtures toward the international market, though its international expansion plan has been less decisive than that of its competitors. Although all of these services engage in licensing activity on a country-by-country basis, for their original, first-run programming, they generally require that studios grant them rights covering all territories that they serve and/or have plans to serve in the immediate future (which, for all intents and purposes with Netflix and Amazon, means the entire world). As discussed in Section A.iv.a above, these platforms' extensive geographic licensing mandates force them to pay high, cost-plus license fees to acquire original content from outside studios (whose high license fees are, in turn, driving the streaming companies to reduce their dependence on outside content providers and increase their capacities as studios as well as networks).

Finally, studios impose time limits on how long network licensees may exhibit series episodes. For broadcast networks, the exhibition term is typically coextensive with the series term: as soon as the network allows its option to order a new season to expire unexercised, it no longer has the right to broadcast old episodes of the series (although any negotiated holdbacks on outside exploitation[29] remain in full effect). For cable and digital platforms, the exhibition term typically extends for several years after the network's initial exhibition of the last original episode produced (with older seasons functionally being subject to a longer exhibition term than newer seasons, and the license for all seasons expiring at the same time). The precise number of years varies from network to network, and the license fee demands of the studio increase (albeit non-linearly) with the length of the term.

viii. Network Exclusivity

In general, a studio reserves for itself all rights it has not granted to its network licensee. These reserved rights become the basis of the studio's efforts to realize a profit by maximizing revenue-generating opportunities across media, territory, and time. However, the original network licensee has a significant interest in protecting its investment in a series (which investment amounts to a substantial percentage of the show's cost of production) by ensuring that, at least for some time, the network is the exclusive home of the content that its viewers want to consume. Consequently, every network license agreement includes a set of holdbacks, which restrict the timing on which a studio may exercise its reserved rights in a series.

In general, a studio may engage in non-primetime "off-network" or "syndication" licensing of a broadcast television series on a once-a-week basis commencing three years after the debut of the series, and on a more-than-once-a-week

29 See Section A.viii below.

basis commencing four years after the debut of the series. Such licenses may be granted to cable network licensees or to broadcast station licensees. For a cable series, comparable syndication windows generally apply, but only allowing for licensing to broadcast stations, not to competing cable networks during the term of the agreement. Similar holdbacks may be (but are not always) applicable to any linear television exhibition of a series that is initially produced for a digital platform.

In the early days of digital platforms such as Netflix and Amazon, off-network second-run exploitation of a conventional television series via SVOD or other digital platforms was subject to the same holdback window as traditionally applied to off-network linear television/syndication licensing. In more recent years, however, studios have been able to make the case that the availability of recent seasons of ongoing television series on streaming services is complementary, rather than cannibalistic, to the home network where new episodes debut.[30] Such concurrent availability presents opportunities for both series and viewers, allowing shows to find new audiences, while enabling new viewers to discover and quickly "catch up" with established, ongoing series without missing a beat. As a result—particularly in connection with heavily serialized (and therefore "binge-worthy") dramas—many networks now permit studios to make old seasons available through third-party streaming services as soon as thirty days before the subsequent season is set to premiere on the primary network. However, the willingness of a network to allow such "early SVOD" licensing may also depend on the extent to which the network maintains and relies on its own digital platform or service.[31]

Home video availability of a television series serves a similar "catch up" function for viewers (and, in any event, is not practical for a studio to pursue, on a season-by-season basis, until each season has been exhibited in full by its premiere network). Consequently, many networks (particularly cable networks) also permit studios to exploit home video rights (which include contemporary technologies such as DVD and Blu-ray), on a season-by-season basis, as soon as one to three months before the debut of the following season of the series. Distribution of individual series episodes via electronic sell-through ("EST")—the closest digital counterpart to traditional home video distribution—may be permitted even faster, as soon as a few hours after the initial network premiere of each episode. However, broadcast networks sometimes prefer to fully prohibit the studio

30 See Section C.i of Chapter 2.

31 For instance, for many years, HBO—which actively promotes the availability of its complete television library on its companion HBO Go digital service (and eventually launched its standalone HBO Now digital service with the same offering)—declined to make any of its shows available through third-party digital platforms. As of 2014, HBO announced a deal to make many of its classic, no-longer-current series available through Amazon Prime, but the network continues to jealously protect its exclusive digital distribution of current and more recent HBO series.

from pursuing home video distribution of a series until after the network has ceased to order new seasons.

Studios are generally free to exhibit any episode of a television series internationally, at any time, subject only to the U.S. network's right to make the initial worldwide premiere of each episode, on an episode-by-episode basis. "Ancillary rights," such as licensing and merchandising, soundtrack, and publishing rights can also generally be exploited by the studio freely, without holdback or reservation. The one exception to the foregoing statement about "ancillary rights" may be in connection with "derivative rights" (i.e., the right to produce or authorize the production of spinoff or sequel television series, theatrical motion pictures, stage plays, or other new productions), which are often frozen during the series term of the license agreement. In other words, as long as the network licensee continues ordering new seasons of the series, the studio may not exploit such derivative rights without the network's approval (which, in the case of derivative television series, would generally be granted by the network only if it were also the network licensee for the new series).[32]

ix. Revenue Backstops

Depending on the extent to which a network obtains unusually extensive rights, or imposes holdbacks or other restrictions on the studio's exploitation of its reserved rights under the network license agreement,[33] the studio may demand that the network guarantee a minimum level of revenue to the studio from the studio's exercise of the rights it has retained.

For instance, if a commissioning network obtains unusually extensive digital rights as part of its license, the studio will be concerned that its revenue from future domestic digital licenses will decrease. Similarly, if a network seeks to bolster the exclusivity under its deal by precluding the studio from making second-window syndication or digital licenses within the network's territory for an unusually long period of time, the studio may complain that such a holdback depresses the value of the studio's retained rights under the licensee.

The studio may condition its agreement to such terms on the network providing the studio with an economic "backstop," by which the network agrees to reimburse the studio for any shortfall between, on the one hand, its actual domestic distribution revenues, and, on the other hand, the revenues the studio would have expected to achieve absent the unusual license terms. (The benchmark for this "expected revenue" figure would be highly negotiated between the parties.) Studios may also seek such backstops from newer or less established networks, from which the studio's revenue prospects for international or

32 Such rights may also remain encumbered post-term, as explained in Section A.x below.
33 See Sections A.vi.b and A.viii above.

second-window domestic licensing are uncertain due to the initial licensee's lack of stature or unestablished value in the marketplace.

x. Subsequent Seasons and Derivative Productions

Studios looking to maximize a project's long-term prospects take care to protect their ability to seek out a new network licensee for future seasons, once the initial licensee decides to stop ordering the series.[34] Similarly, a studio may realize major additional value from a successful series by producing spinoffs, or even converting a series into a franchise with multiple iterations (such as *Law & Order* [NBC], *CSI* [CBS], *NCIS* [CBS], or Dick Wolf's *Chicago* franchise [NBC]). On the other hand, a network wants to take care to preserve its ability to retain control of future seasons of a successful series, even after the initial term of the license agreement has expired, and to establish itself as the natural home for any derivative productions of a successful series, even if that original series is no longer on the air.

Typically, these competing interests are resolved through post-term first negotiation and first refusal (or, occasionally, last refusal) rights. These procedural safeguards offer a network a meaningful advantage over competing networks when it comes to obtaining rights in subsequent seasons or derivative productions of a successful series, while at the same time protecting the studio's ability to monetize and maximize valuable rights if a show's original home network is uninterested in proceeding (or if the parties are unable to negotiate a deal).

xi. Network Approvals

Networks enjoy broad (and broadly stated) creative approval rights in connection with the series they commission. Such approval rights extend not only to the creative content of the show (including filming locations, production drafts of episodic scripts, and final cuts of produced episodes), but also to hiring (and firing) of key personnel engaged in connection with the series (including executive producers, directors, writers, series regulars, and major recurring guest actors). In addition, as discussed throughout Chapter 5, networks generally maintain exclusive authority over the granting of credits for series that appear on their air.

34 Studios have been able to extend the life cycles of numerous prominent series by finding them new homes after they were canceled by their original networks. For instance, Sony Pictures Television was able to extend the lives of series such as *Community* (canceled after five seasons on NBC; renewed for a sixth season by Yahoo!) and *Damages* (canceled after three seasons on FX; renewed for fourth and fifth seasons by DirecTV). Touchstone Television did the same for *Scrubs* (canceled after seven seasons on NBC; renewed for eighth and ninth seasons by ABC), while Warner Bros. Television did so for *Southland* (canceled after one season by NBC; renewed for four additional seasons by TNT).

The final creative content of a series is a result of an ongoing process of push and pull among producers/service providers, studio executives, and network executives. As between the service providers and the studio, in the event of a disagreement, the former must adhere to the directions of the latter. But as between the studio and the network, the parties must generally reach mutual understanding (or at least accommodation) with respect to all key creative matters, with neither side having the right to unilaterally designate or force creative choices against the other side's will—although in many cases, creative decisions may be forced (or creative disagreements effectively resolved) by the demands of budget, schedule, or other production exigencies.

xii. Network Promotional Rights

As discussed in Section B.iii of Chapter 1, one of the network's key roles in the television industry is to market its shows (and itself as a content destination) to the viewing public. To enable this function, the studio typically accords its network licensee broad rights to promote the availability of a series on the network's service, and, in connection with such promotion, to create (at the network's own expense) marketing materials (such as commercials, trailers, and print advertisements) that are technically built from and derivative of the underlying elements of the series. In addition, the network generally requires that the studio take reasonable steps, in its agreements with actors, writers, and other key service providers, to obtain the right to use such individuals' names and likenesses in the promotion of the series, and to require them to participate in publicity activities, as required by the network.[35]

Networks often directly finance, outside of the budget and license fees for the series, the creation of key marketing materials (such as series posters/key art and electronic press kits). In turn, studios often agree to cost-sharing arrangements with the networks, by which the studios reimburse the networks for a portion of these expenses in exchange for the right to use (and to authorize the studio's other international and downstream licensees to use) such network-financed/created marketing materials.

xiii. Product Integrations

Networks generally retain approval over any and all product integrations on their shows, including cashless "tradeout" deals (as described in Section B.vi.b of Chapter 1). In scripted programming, the studio generally receives and retains any fees paid by advertisers for product integrations (as well as the cost savings associated with tradeout deals), although the network and studio may alternatively agree

35 See Section E.xiii of Chapter 5.

to split such fees.[36] However, networks often demand control over the negotiation of product integration deals and typically require that an advertiser buy a specified amount of advertising time from the network in exchange for the network granting its approval of a proposed integration. This advertising revenue is retained solely by the network, and in many instances, the network may be solely responsible for negotiating and allocating the total compensation paid by the advertiser between the "media buy" (which is retained by the network) and the "integration fee" (which is shared with or retained by the studio).

xiv. Contingent Compensation

Assuming there is no co-production relationship between a network's affiliated studio and the lead production studio for a series,[37] the position of the network is that of licensee, and the studio remains the sole owner of the series (and, therefore, primary beneficiary of the upside in the series's success). Nevertheless, some networks—particularly cable networks—feel that they should be compensated for providing the initial platform (and financing most of the initial marketing/promotional expenses) that launch a series to success. Such networks may negotiate for a share of contingent compensation from the series, which allows them to share in the "profits" of the series in much the same way as the backend-earning rightsholders and talent/service providers (with contingent compensation that is calculated comparably).[38] The studio may require that such participations accorded to a network licensee fit within its typical cap (usually 35%) on total third-party participations, or that the network's participation be deducted "off-the-top" in calculating the talent's participations.[39]

B. Co-Production Agreements

A co-production is an arrangement between two studios to jointly produce, own, and distribute a television series.

In the U.S. television market, co-productions generally arise in two scenarios: when two different studios control separate elements (in the form of underlying rights, or writers, directors, or other talent who are subject to exclusive overall agreements) that they wish to join together to create a series; and when a studio

36 This is in contrast to the world of unscripted television, in which networks sometimes retain all, and typically no less than half, of product integration fees (in addition to retaining 100% of any associated advertiser media buys). In addition, for first-run syndicated programming—for which there is no commissioning network—the studio retains 100% of product integration fees, and may also extract similar commitments for associated media buys, from the studio's retained "barter" share of advertising inventory.

37 See Section B below.

38 See Chapter 6.

39 See Section G of Chapter 6.

seeks to license a series to a network with an affiliated studio arm. The latter scenario is the most common. Although a co-production is not legally a partnership, the two parties to a co-production agreement are commonly referred to as "co-production partners."[40]

As discussed in Section B.iii of Chapter 1, over time, most networks have developed a preference for owning their own content (either directly or through an affiliated entity).[41] In addition, as discussed in Section A.xiv above, most networks reason that, because it is their initial investment in promoting a series and bringing it to market that sets up a show for success, they should reap the long-term financial rewards of that success. Consequently, many networks will not agree to license a series from a third-party television studio unless they obtain (via their studio arms) a co-ownership position in the project. In such circumstances, to avoid a conflict of interest, the independent studio has unilateral authority to negotiate the license agreement with the network on behalf of the co-production.

The applicable co-production/ownership split may vary, but a 50/50 split is typical (and, going forward, this section will assume a 50/50 co-production in describing the applicable terms). A 50/50 co-producer generally pays 50% of the deficit, bears 50% of the risk, owns 50% of the copyright, and enjoys 50% of the upside from the production. A co-production is an inherently risk-mitigating structure (which logically means that it is therefore an upside-capping structure as well). From the perspective of a network-affiliated studio, however, acquiring a co-production stake in somebody else's project is often a particularly good investment[42]—and, depending on the timing of the co-production arrangement,

40 Such a co-production arrangement may become apparent to an eagle-eyed viewer based on the company logos that appear at the end of the credits for each series episode and can sometimes result in business partnerships between otherwise competitive entities. For example, CBS's long-running procedural drama, *Criminal Minds*, is a co-production between ABC Studios and CBS Television Studios. Co-production arrangements may even exist between studios from a single corporate family—for instance, FX's *American Crime Story* is a co-production of FX Productions and Fox 21 Television Studios (two studios that are part of the Fox media conglomerate). In addition, co-production arrangements may exist between unaffiliated companies with common interests, such as Warner Bros. Television and CBS Television Studios, which have partnered to produce a number of television series (including hits *Jane the Virgin* and *Crazy Ex-Girlfriend*) that are broadcast on the CW network (which is co-owned by CBS and Warner Bros.).

41 As discussed above, from the network's perspective, paying 100% of the cost of production to own 100% of the rights in a series is preferable to paying a license fee that represents a substantial portion of the cost of production in exchange for a limited subset of rights.

42 Applying even rough math, the economic efficiency to a network of obtaining a co-production position quickly becomes clear. As discussed in Section A.iv.a, the initial licensee fee for a project will often equal approximately 50% of its budget (with the remaining 50% constituting the series deficit). For that 50% contribution, the network will be a pure licensee, enjoying little or no upside in the ultimate success of the series across other territories and platforms. However, by paying an incremental 25% of 100% of the budget (i.e., 50% of the 50% deficit), the network (via its affiliated studio) can effectively obtain a 50% stake in the upside of the series. This economic efficiency becomes only

may be a particularly effective risk mitigation strategy. For instance, some networks will initially agree to develop a project with an outside studio on a pure license basis, but subsequently insist on entering into a co-production prior to ordering a pilot or series. In a world where few development projects are ordered to pilot and few pilots are ordered to series,[43] this effectively shifts 100% of the risk of development and/or pilot production onto the third-party studio, while allowing the network-affiliated studio to reap 50% of the upside once its sister network has decided it wants to move forward with a series. In addition, because the length of time a series remains on the air directly correlates to how much money it makes or loses for its studio, a network may be more likely to continue ordering a series that it owns in whole or in part than a series in which it has no ownership interest.

There are two primary categories of duties that must be allocated in a co-production agreement: which studio is responsible for leading physical production of the series, and which studio (or studios) control the distribution rights in the series. In addition, there are a number of economic terms related to these roles that must be negotiated in order to determine the flow of revenues from the series.

i. Lead Studio

The "lead studio" in a co-production is the studio that is responsible for managing physical production of the series. For the most part, the lead studio manages the production process as it would if it were the sole studio, but along the way, it must obtain the approval of its co-production partner of all budgets (and enhancements thereto) and key creative decisions (such as the casting of actors and hiring of writers and directors).[44] Because of the way co-production revenues are allocated, studios consider it desirable to be the lead studio. Where two studios enter into a co-production agreement after one of them has independently developed the project or otherwise engaged all of the key talent, the studio that commenced the development process generally gets to be the lead studio. Where two studios enter into a co-production arrangement at the very

more obvious for cable networks that ordinarily pay higher license fees, in the range of 75% of the initial series budget. For these networks, obtaining a 50% co-production position means covering an incremental 12.5% of 100% of the budget (i.e., 50% of the 25% deficit)—in other words, paying approximately 16.67% more money than the bare license fee (i.e., 87.6% vs. 75%), in exchange for a 50% stake in the series's success.

43 See Section A of Chapter 2.

44 Major decisions, such as total budget, casting choices, and the hiring and firing of key above-the-line personnel, are often subject to mutual approval without any contractual tiebreaker mechanism, forcing the parties to work together to resolve any disagreements. The absence of tiebreakers would be highly unusual in other fields, including theatrical feature films, that are less dominated by repeated business between a small number of major players.

outset of the development process, the choice of lead studio may be hotly negotiated, with the role generally going to the larger studio with superior bargaining power (or, in the event of an effective tie in that regard, to whichever studio contributes more—or the more important—elements to the production).

ii. Distribution Rights

The parties to a co-production agreement must allocate series distribution rights. In some cases, a single studio—often but not necessarily the lead studio—will control all of the distribution rights in the series, with the co-production partner's economic interest in the project essentially being passive. In many cases, however, distribution rights are divided between the co-production partners, typically on the basis of territory, with one partner controlling all distribution rights in the United States and/or Canada, and the other partner controlling all distribution rights throughout the rest of the world.[45] As explained in Section C of Chapter 2, conventional wisdom holds that the domestic market (and, in particular, the prospect of significant syndication revenue) is most valuable for comedies, while the international market is most valuable for dramas, and this assumption generally informs the positions two studios will take when negotiating for which studio controls which territory. However, a network-affiliated studio has an extra incentive to control domestic distribution rights, so that it can manage the amount of local distribution that may directly compete with its sister network's exhibition of a series. In order to induce the other side to give up distribution rights that one co-production partner wishes to control, that party may guarantee the other a minimum amount of revenue from the rights (which minimum may escalate depending on the number of seasons produced).

One unique area of negotiation concerns derivative rights. In some co-production agreements, the co-producers agree to effectively freeze the right to produce spinoff television series, theatrical feature films, or other separate productions based on the original television series, requiring the consent of both parties to proceed. Other co-production agreements permit one or both parties—usually the lead studio—to unilaterally force the development and production of a derivative project, with the other party having an option to participate as a co-producer, either on the same terms applicable to the original co-production or on new terms to be negotiated in good faith. If one of the parties to a co-production elects not to proceed as a partner in any new derivative production, it typically receives some passive participation in such derivative.

45 Ancillary rights such as soundtrack, music publishing, and merchandising, may be controlled by one of the co-production partners worldwide, or split between them according to their territorial controls over the general distribution of the series.

iii. Allocation of Revenues

The waterfall of revenues between co-production partners resembles that enshrined in a profit participation definition. In the simplest terms, it can be articulated as follows:

- Gross Receipts
- Distribution Fees
- Distribution Expenses
- Deficit
- Unapproved Overages
- Lead Studio Overhead
- Third-Party Participations
- Studio Net Proceeds

In practice, however, the revenue participation enjoyed by a co-production partner is simpler and cleaner than that applied to a profit participant. The counterintuitive deductions and exclusions that characterize a talent backend definition[46] (which are sometimes derisively referred to as "Hollywood Accounting") are largely stripped out of a co-production waterfall.

What follows is a deeper examination of each of the elements of this co-production waterfall.

a. Gross Receipts

As with a talent backend definition, "gross receipts" refers to all revenue received by (or credited to) a studio from its exploitation of a television series and all rights therein, from all sources. Unlike a talent backend definition, however, in a co-production agreement, "all" really means "all." Even if distribution rights are divided between the co-production partners, all revenues usually flow through a single joint waterfall. There are no artificially depressed imputed license fees. Home video revenues are accounted for at 100% of revenues received, rather than on a royalty basis (and any applicable distribution costs for such home video exploitation are deducted, at actual cost, as distribution expenses). To the extent that any revenues are excluded from "gross receipts" for purposes of the co-production waterfall, they are still accounted for in other ways. For instance, revenues from product placements/integrations, tax incentives, and copyright enforcement recoveries may be applied directly against the deficit (without either side deducting distribution fees or applying these amounts against distribution expenses), or otherwise distributed to the co-production partners outside of the waterfall according to their respective shares. Revenues from derivative

46 See Chapter 6.

productions may be excluded from gross receipts, but the parties will have otherwise negotiated controls, co-production rights, or passive participations applicable to such productions. Although issues may still arise when a co-production partner who controls certain distribution rights enters into licensing transactions with its affiliated entities or foregoes licensing opportunities in order to protect the interests of its sister network, for the most part, the accounting for gross receipts between co-production partners is clean.

b. Distribution Fees

As it does when accounting to profit participants, the studio that controls distribution rights deducts a distribution fee, off-the-top, from all revenues generated from the exploitation of rights under its control. If distribution rights are divided between co-production partners, each partner retains distribution fees from the revenues it generates from its own rights, and the distribution fee applicable to each side is usually the same. Between co-production partners, distribution fees range between 5% and 20%, with 10% being typical. As in talent backend definitions, there is typically no distribution fee charged on the initial network license.

c. Distribution Expenses

Deductions for distribution expenses operate more or less identically under a co-production agreement as under a profit participation definition. If distribution rights are divided between the co-production partners, each partner recoups its distribution expenses from the revenues it generates from its own exploitation of rights (including guild-mandated residuals) and remits the balance to flow through the rest of the waterfall on a fully cross-collateralized basis. Co-production partners may negotiate more successfully for caps on the other studio's distribution expenses; if such caps are agreed, they are typically set to 5% to 10% of the studio's gross receipts, excluding from such cap residuals and music clearance costs.

d. Deficit

As explained in Section A.iv.a above, the "deficit" is the difference between the cost of production of the series and the initial network license fee. Each of the co-production partners initially pays for a share of the deficit equal to its percentage interest in the co-production (again, usually 50/50). Once distribution fees and distribution expenses have been deducted, each partner recovers its share of the deficit from gross receipts on a *pro rata* basis (i.e., in proportion to its co-production interest). This distribution continues until each side has fully recovered its investment in the cost of production, although the recoupment of deficit contributions for each side is capped based on the ingoing production budgets of the series (subject to any further mutually approved budget enhancements).

e. Unapproved Overages

The co-production partners' deficit recoupment is capped based on the ingoing production budgets of the series. Consequently, to the extent the lead studio (which is responsible for managing production) overspent and incurred unapproved overages (i.e., costs in excess of the approved budget), it does not recover such expenses as part of the deficit recoupment phase of the waterfall (described in Section B.iii.d above).

However, after each side has fully recouped its respective share of the deficit, the lead studio may next recover the unapproved overages it initially bore during production of the series. Such recovery of unapproved overages is usually capped at an amount equal to 2% to 3% of the ingoing production budget of the series.[47] To the extent that the lead studio faces a runaway production and incurs overages in excess of this cap, it will be forced to bear such expenses solely out of its own share of revenues from the waterfall.

f. Lead Studio Overhead

After the lead studio recoups its unapproved overages (if any) from the waterfall, it is entitled to retain 100% of revenues, up to a specified percentage of the budget, as an overhead charge. This overhead charge represents the lead studio's compensation for its investment of time, effort, and overhead in managing the production, as well as its assumption of the risk of production overages (which it could only recoup from revenues in a later order of priority, and subject to cap). In co-production agreements, the lead studio's overhead charge is generally 5% or 7.5%, though in rare cases, may be as high as 10%. Sometimes, this percentage is subject to an artificial negotiated cap, or it may be set based on a percentage of the first season's budget, with flat increases for subsequent seasons that are not tied to the actual budgets of subsequent seasons (which will likely grow faster than such flat increases would provide). Note that in a co-production definition the studio deducts its overhead charge *after* the co-production partners have recovered their contributions to the cost of production, while in a talent profit participation definition the overhead charge is deducted *before* the studio recovers its cost of production. In addition, while a co-production waterfall does provide for an overhead deduction by the lead studio, neither of the partners in the co-production generally charge the other interest on their respective contributions to production or distribution expenses.

47 Anytime any deal term is specified as a percentage of the ingoing production budget, the parties must specify whether this percentage is calculated based on the budget net of applicable tax incentives (a lower number) or the gross budget without accounting for such incentives (a higher number).

g. Third-Party Participations

Finally, revenues from the series go to paying third-party participants—specifically talent and agency profit participants, whose backend interests are calculated on the basis described in Chapter 6. Effectively, the fact of the co-production does not impact the calculation or accounting of participations to talent, who will see the same backend payments they would have seen had there been no co-production. The backend definition used by the lead studio, which engages all of the talent, controls for the talent and agency participations on the series. In effect, the co-production partners bear the cost of these participations in proportion to their respective co-production shares (so, most likely, 50/50).

h. Studio Net Proceeds

Finally, whatever remains of gross receipts after all of the foregoing deductions constitutes the "studio net proceeds" of the series, and these are again divided between the co-production partners in proportion to their respective co-production shares (so, most likely, 50/50).

C. International Co-Productions and Co-Commissions

An increasingly significant category of co-productions is international co-productions. These are partnerships between studios in two different countries, rather than the typical co-production arrangement between two domestic studios. There are two primary reasons why U.S. studios enter into international co-productions: to access local production incentives in foreign countries and to produce shows as co-commissions for domestic and international broadcasters.

Some tax incentive programs are contingent upon stringent locality requirements with respect to either the content produced or the nationality of the producers involved. For example, Canada (and several provinces within Canada) offers tax incentives to American (and other non-Canadian) producers as an inducement for such producers to move production north of the border, but simultaneously offers an additional set of subsidies that can only be accessed by Canadian producers. France offers similar tax subsidies specifically for French producers. A co-production partnership with a local studio, which grants the local producer some or all of the legal copyright interest in the resulting production, allows an American studio to access specific incentive programs which would not be available to that studio if it independently produced its series within that country. Alternatively, a studio may nominally have the right to access a tax credit in a foreign country but be functionally precluded from monetizing such credit, perhaps because the credit is non-transferable and the studio does not have enough local tax liability to effectively realize the benefit. A co-production partnership with a local entity that can fully realize the benefit of the

tax incentive (and calculate a revenue-splitting arrangement with the American partner accordingly) offers a workaround to this challenge.

In addition, partnerships with local producers help American studios solicit concurrent commissions from an American network (generally sourced by the American studio) and a foreign network (generally sourced by the local studio). Local licensees in foreign countries may be particularly inclined, for cultural or regulatory reasons, to acquire content that is produced, at least in part, by local studios. Having two major licensees committed to a production from the outset increases the guaranteed license fees from the production, thereby decreasing the deficit (and therefore, the studio's risk). Alternatively, the guaranteed license fees from a foreign co-commissioner may allow the studio to decrease the license fee charged to the American network, thereby providing a bargain to the U.S. licensee that may induce it to commission a series it would not have been willing to commission at a higher price point. These factors have also made international co-productions and co-commissions (which, to be clear, are often but not necessarily co-productions) particularly appealing to many international content producers with major American presences, such as Gaumont International Television (the French-owned studio behind *Hannibal*, an international co-commission), Fabrik Entertainment (the German-owned studio behind AMC and Netflix's *The Killing*, an international co-commission, and FX's *The Comedians*, a co-production with FX Productions), and Atlantique Productions (the French-owned studio behind *The Transporter* TV series, an international co-commission for four different countries, and co-production with Canadian producer QVF). In April 2015, NBCUniversal International Television Production, German broadcaster RTL, and French broadcaster TF1 announced a landmark three-way co-production plan to produce U.S.-style, English-language procedural dramas in North America as concurrent commissions for RTL, TF1, and to-be-determined U.S. networks.

The structure and economics of international co-productions are generally similar to that described in Section B above for U.S. co-productions. The co-production partner based in the country where production takes place is usually, though not always, the lead studio (depending on the extent of its production capabilities). At a minimum, each partner typically controls distribution rights in its home territory, with distribution rights in other territories up for negotiation (according to which partner can likely most effectively monetize such rights). Compared to domestic co-productions, however, international co-productions are more likely to divide economic rights and responsibilities in shares other than 50/50, and more likely permit each co-production partner to retain 100% of the revenue from its distribution of the series in its own territories (rather than cross-collateralizing all revenue in shared waterfall).

9

SAMPLE ECONOMIC MODEL

Having explored the overall structure of the television industry and the basic parameters of the studio-network license relationship, we can now fully understand the type of basic financial model that studios use to evaluate the financial prospects of a series. Chart 3 is a sample financial model for a typical single-camera broadcast network comedy series, with projections for the economic prospects of the series in an immediate failure case (production of a "broken pilot" that is never ordered to series), a short-term failure case (cancellation after production of a single season consisting of the pilot plus twelve episodes), and two success cases (each assuming cancellation after production of six twenty-two-episode seasons).

The production costs assumed for the series are $4.6 million for the pilot, and the pilot license fee is $1.6 million, representing a $3 million deficit for pilot production.[1] In the "broken pilot" scenario, this is the studio's loss.

The first season is assumed to include production costs for twelve episodes (after pilot) of $2.25 million per episode, and license fees of $1.25 million per episode, resulting in a $12 million production deficit. No tax incentives appear to apply to the production. International revenue is minimal, assumed at only approximately $425,000 per episode over thirteen episodes (pilot + twelve). Such low revenue numbers are unsurprising, both because of the general challenge of effectively selling American comedies (especially single-camera comedies) internationally, and because the small supply of episodes would further depress licensee interest.[2] These modest international revenues are further offset by costs associated with international distribution, such as dubbing, subtitling, and delivery of materials to international licensees, as well as residuals from these international revenues owed to guild-represented talent. The studio assumes a modest

1 See Section A.iv.a above.
2 See Section C.ii of Chapter 2.

CHART 3 Sample Economic Model for Single-Camera Broadcast Network Comedy Series

		Fall Start		
			6 Seasons	6 Seasons
		1 Season	Base Case	High Case
	Pilot	12 Episodes	132 Episodes	132 Episodes
Revenues				
Network License Fees	$1.6	$15.0	$270.0	$270.0
Production Costs	($4.6)	($27.0)	($375.0)	($375.0)
Network Deficit	**(3.0)**	**(12.0)**	**(105.0)**	**(105.0)**
International TV Revenue	–	5.5	70.0	73.0
International TV Costs	–	(1.5)	(17.0)	(17.0)
Net International TV Contribution	–	**4.0**	**53.0**	**56.0**
Domestic Off-Net Revenue	–	–	200.0	315.0
Domestic Releasing and Marketing	–	(0.2)	(22.0)	(22.0)
Domestic Residuals	–	–	(41.0)	(49.0)
Domestic Off-Net Contribution	–	**(0.2)**	**137.0**	**244.0**
Home Entertainment Revenues	–	–	10.0	15.0
Home Entertainment Costs	–	–	(4.5)	(5.0)
DVD Contribution	–	–	**5.5**	**10.0**
Profit Participations	–	–	–	(41.0)
Series Profit Before Overhead	**($3.0)**	**($8.2)**	**$90.5**	**$164.0**

allocation of costs (only $200,000 total) for studio marketing expenses to support the show during its unsuccessful first season. Aggregating these numbers, the studio anticipates that, if it produces only thirteen episodes (inclusive of pilot) of the series before cancellation, it will lose $8.2 million on the project—an unsurprising result for a failed one-season show.[3]

The six-season success case is divided into two columns, reflecting two different strata of success—a "base case" and a "high case." (Not every six-season series is as successful as every other six-season series.) In either case, production costs are assumed to grow to an amortized average, over six seasons, of approximately $2.85 million per episode ($375 million over 132 episodes). This reflects assumed growth in the episodic cost of production over time. And in either case, license fees from the U.S. network have grown to an amortized average of approximately $2.05 million per episode ($270 million over 132 episodes). This

3 See Section B.ii of Chapter 1.

reflects both annual percentage growth in the license fee paid by the commissioning network and a jump in the license fee, commencing in the fifth production year, to actual cost of production.[4] International revenue has grown from approximately $425,000 to approximately $530,000 (base case) to $550,000 (high case) per episode—better than in the one-season scenario, given the relationship in the international market between a studio's ability to deliver many episodes of a series and the size of the license fees the studio may hope to command, but still comparatively modest, as may be expected of international revenues for a single-camera comedy. International releasing expenses—which are driven largely by guild residuals—have grown almost in proportion to the improved international revenue. But the major economic driver here is domestic distribution revenues, which are estimated at between approximately $1.52 million ($200 million over 132 episodes) and approximately $2.39 million ($315 million over 132 episodes) per episode. This reflects one or more lucrative domestic syndication sales (to cable network and/or broadcast station licensees), an opportunity which has been enabled by the studio's production of a significant number of episodes (over 100), and which represents the primary profit driver in the model, even after accounting for substantial distribution, marketing, and residuals expenses.[5] Home video revenues (which include EST sales) round out the model. The base case reflects a paper profit to the studio of $90.5 million, but from the backend participant's perspective, this "profit" is eaten up entirely by the studio's deductions for distribution fees, distribution expenses, overhead on production costs, and interest, as well as agency package expenses.[6] However, as shown above, the escalation from moderate success (particularly in the domestic distribution arena) to significant success effectively triggers substantial participations to the show's profit participants: of the $123 million of excess revenue assumed in the six-season "high case" vs. the six-season "base case," $41 million of that—nearly 35%—is paid to profit participants on the series.

One key consideration, not directly reflected in the model above, is the studio's allocated overhead (which is suggested by the model's reference to "Series Profit Before Overhead"). The figures above reflect the revenues and expenses that are uniquely attributable to a single television series. However, in order to produce that series in the first place, the studio must have maintained significant overhead expenses in the form of offices and other facilities, executive salaries, and other day-to-day costs of doing business. In order to thrive as a business, the studio must not only negotiate deals and produce projects with the expectation of making significant profits when a series succeeds; it must ensure that those

4 See Sections A.iv.a through A.iv.d of Chapter 8.
5 See Section C.i above of Chapter 2.
6 See Sections B through G of Chapter 6.

profits prove adequate even after the studio has recovered its ongoing costs of "keeping the lights on." Otherwise, from the perspective of the studio (or its parent company), it could just as easily fire everyone and invest its capital in mutual funds. Such internal overhead allocations are highly proprietary, prepared by the studios to guide their own decision-making process, but without any direct impact on (or transparency to) profit participants, co-production partners, or other entities to whom the studio may owe financial obligations in connection with a series.

10

UNSCRIPTED TELEVISION

The foregoing chapters of this book all specifically explore the world of *scripted* television development, production, and licensing. Unscripted television presents a host of unique business and legal issues, which would take an entire separate book to describe in detail. (In fact, several such texts exist.) However, in the interest of providing a more comprehensive perspective on the television business in general, this chapter highlights a small sample of major dealmaking concepts applicable to unscripted television development, production, and licensing, and in particular, notes major areas of departure from scripted television norms.

For clarity, "unscripted television" (sometimes used interchangeably with "reality television") broadly compasses several sub-genres, including "unstructured reality" or "documentary" (aka "docu-follow") series (e.g., *Deadliest Catch* and *Keeping Up with the Kardashians*), "structured reality" series (e.g., *Shark Tank* and *Mythbusters*), "reality competition" series (e.g., *The Voice* and *Top Chef*), game shows (e.g., *Jeopardy!* and *Family Feud*), and other "alternative" forms of programming such as late-night talk shows (e.g., *The Tonight Show* and *The Late Show*) and awards shows (e.g., the annual broadcasts of the Academy Awards and Golden Globes awards ceremonies).

A. Basics of Unscripted Television

Although unscripted television is thought of as a relatively recent phenomenon, in fact, television has prominently featured some version of "unscripted" programming for decades. Talk shows and game shows have been a staple of television since the inception of the medium, and iconic series such as *The Tonight Show* (talk) and *Jeopardy!* (game) have been in production continuously or semi-continuously since the 1950s and 1960s, respectively. MTV premiered *The Real*

World (often credited with launching the modern "reality television" genre) in 1992, and its sister series, *Road Rules* (often cited as the original "reality competition" series), in 1995. The fledgling Fox network launched *America's Most Wanted* in 1988, and the "docu-follow" template-setting *Cops* in 1989. Arguably, the iconic *American Idol* is a spiritual successor to Ted Mack's *The Original Amateur Hour*, which debuted on the (now obscure) DuMont Television Network in 1948 and was broadcast at various times by NBC, ABC, and CBS until its eventual cancellation in 1970.

The modern era of unscripted television, however, began around 2001, when a long-anticipated WGA strike forced the major broadcast networks to find ways to keep the airwaves rich with content without relying on the unionized force of professional television writers.[1] With the writers' strike looming, CBS launched *Survivor* and *Big Brother* in 2000 and *The Amazing Race* in 2001. Fox premiered *American Idol* in 2002, and ABC launched *The Bachelor* the same year.[2] These series, and the majority of other unscripted programs that have emerged in the years since their launch, differ from scripted series in a few essential systematic ways; these differences help explain both the initial appeal of unscripted programming circa 2001, and the significant proliferation of such programming since then.

First, unscripted programming is, on average, consistently less expensive to produce than scripted programming. A half-hour basic cable unscripted series can cost as little as $125,000 per half-hour episode to produce, and even a premium broadcast network primetime competition series typically costs only approximately $1 million to $1.5 million per one-hour episode to produce (although, for the highest-profile series with celebrity talent attached, such as music competition series *American Idol* and *The Voice*, talent costs can drive these budgets higher). Because these series can draw ratings that are competitive with far costlier scripted television programs (and in fact, for many years, *Survivor* and *American Idol* were among the most-watched shows on television in all genres), reality programming can offer networks an extremely economical programing option.

Second, unscripted television production relies less heavily on the major entertainment unions than scripted television production. Virtually all major scripted television programs produced in the United States are subject to agreements with at least four prominent entertainment guilds: SAG/AFTRA (representing on-camera talent), WGA (representing writers), DGA (representing directors), and IATSE (the International Alliance of Theatrical Stage Employees, representing most "below-the-line" crew). These unions carry with them various minimum

1 Some observers similarly credit the 1988 WGA strike for giving rise to *Cops* and *America's Most Wanted*.

2 Notably, of these five flagship franchises, all but one (*The Amazing Race*) was adapted from a preexisting European format. All five of these series remain on the air to this day. (Although Fox cancelled *American Idol* after fifteen seasons in 2015, ABC soon commissioned a revival, premiering in 2018.)

pay requirements, work rules, and residuals obligations that provide crucial pro-
tections for union-covered personnel, but necessarily make shows costlier and
more difficult to produce, and less profitable to exploit. Unscripted programs
can be far choosier than scripted programs with respect to what union entangle-
ments they must tolerate. Although much so-called "unscripted" or "reality"
programming features significant construction of storylines by producers and
editors, very few are so "written," in a technical sense, as to require the engage-
ment of WGA-represented writers.[3] Unscripted programs that feature only non-
acting documentary subjects or competitors, without a prominent on-camera
host or judge, can be produced without the involvement of SAG/AFTRA; and
even for those shows that must be subject to SAG/AFTRA contracts in order to
access union-covered hosting/judging talent, the protections of SAG/AFTRA
usually apply only to the professional performers and not to the non-professional
subjects or competitors. Finally, although high-budget game shows and studio-
based competition shows produced in glossy studio environments (sometimes
colloquially referred to as "shiny floor shows"), such as *$100,000 Pyramid* and
The Voice, are typically produced pursuant to DGA and IATSE contracts (and
using DGA and IATSE member crew), lower-budget documentary series and
programs that rely heavily on filming "in the field" (i.e., on location and not in
a studio environment) often rely on lower-paid non-union personnel (or union
members who are willing to work on a non-union basis).

Third, global viewership dynamics for unscripted programming differ from
those of scripted programming in ways that directly affect the basic business
assumptions around these shows. While, as described in Chapter 2, the moneti-
zation of scripted content is generally based on the maximization of value (and
repeated resale of a single product) across media, territory, and time, unscripted
content is not necessarily well-aligned with this market strategy. Although
unscripted series may command substantial ratings in their initial airings, they
tend to be less successful in reruns and syndication; the relative narrative simplic-
ity of these shows makes them less entertaining in repeat viewings, and com-
petition series in particular can be less interesting when the outcomes of the
competition are already known. As a result, these series have greater difficulty
attracting the interest of syndicators and digital licensees for second runs, and
the opportunities they do capture tend to be less lucrative. In addition, while
unscripted formats may hold broad appeal internationally, the specific television
series produced based on those formats usually do not. In other words, an Italian
audience may be interested to see twenty-five attractive young Italian women
competing for the affections of an eligible Italian bachelor (i.e., the basic set-up of
The Bachelor), but they will generally be less apt to watch a group of Americans

3 And again, the modern era of reality television was born of the anticipated unavailability of these
writers, due to the 2001 WGA strike.

competing in the same setting. Similarly, while a British audience may be fascinated to watch their British peers answer trivia questions posed by a British host for the opportunity to win one million British pounds (i.e., the basic set-up of *Who Wants to Be a Millionaire*, a format that was originally produced in the United Kingdom, not the United States), that same drama is somehow less compelling when it involves American contestants, answering American culturally specific questions delivered by an American host, for the opportunity to win one million American dollars. At the same time, the typical lower cost of production and reduced reliance on entertainment professionals (particularly writers and actors) associated with these shows makes them much easier for foreign producers to recreate locally, reducing the demand abroad for the American versions of these shows. In the aggregate, then, unscripted programs tend to be most valuable to the American networks that initially commission and exhibit them, and offer less downstream upside to producers.

Fourth, in light of the third factor described above, the basic prevailing business structure between producers and exhibitors of unscripted content in the United States is different from the scripted television norm. As described in Chapter 8, the studio behind a scripted television program typically licenses the series to the commissioning American network, granting finite rights for a finite term, and retains the balance of the available rights to resell in other media, territories, and time periods. The studio initially bears a "deficit" (i.e., a difference between the initial production cost of the series and the license fee paid by the commissioning network), and then makes up that deficit and earns its profit by selling off the remaining available rights. For unscripted series, on the other hand, the commissioning American network typically pays 100% of the approved ingoing budget of the series. In other words, the producer of an unscripted series usually bears no deficits; and in fact, virtually always charges the network up-front fees as part of the approved series budget. But, paying 100% of the cost of production (and essentially relieving the producer from any business risk), the network typically insists on owning 100% of the rights in the series. As a result, most agreements between unscripted producers and networks are not "licenses," but rather, "production services agreements" under which the network acquires complete ownership of the series and all rights therein on a "work-for-hire" basis.[4] Any downstream exploitation of the series is then managed by the network itself, which balances its desire to recoup its investment in the series against the value the network gains from being the exclusive exhibitor of a series (at least within the United States).[5]

4 In addition, because they own the series and the production companies may be expendable, many networks insist on directly negotiating and entering into agreements with on-camera performers or other key talent, rather than allowing the production company to do so. (In scripted television production, on the other hand, every talent deal is negotiated and entered into at the studio, rather than network, level.)

5 The key issues presented by such deals are discussed in Section D below.

The foregoing factors combined to make unscripted shows an appealing alternative for the broadcast networks in the early 2000s and maintain the status of unscripted series as an important component of such networks' programming portfolios to this day. Over the course of the 2000s, as many upstart cable networks sought to expand their original programming efforts, these same factors drew those networks toward unscripted content as their usual point of entry into original programming.[6]

At the same time, these factors make unscripted programming relatively unappealing and inefficient for major studios. As explained throughout this book, major studios are built to maximize the value from exploiting retained downstream rights, and their business models essentially demand that the studios occasionally find extremely lucrative hits to cover their high overhead costs and subsidize a higher volume of money-losing failed projects. In addition, major studios' agreements with the entertainment unions frequently limit their ability to produce shows on a non-union basis. As a result, while the scripted television business is dominated by a relatively small number of large studios (many of which are directly affiliated with networks, and nearly all of which are at least part of major media conglomerates), unscripted programming is primarily the domain of smaller independent producers.

B. Professional Talent Agreements

Broadly speaking, there are three classes of on-camera performers on unscripted series: non-celebrity, non-professional entertainers who are consistently featured in a "documentary"-type program (e.g., *The Deadliest Catch* or *Duck Dynasty*); non-celebrity, non-professional entertainers who compete on a game show or competition program (e.g., *American Idol* or *The Amazing Race*); and professional performers who appear as hosts, judges, or other types of presenters across all forms of unscripted programs. This section discusses major issues around deals for the third category of on-camera talent, i.e., professional performers; Section C below discusses major issues for non-celebrity participants in documentary and competition programs.

The agreements governing the services of hosts, judges, and other professional performers on unscripted programs are generally similar to those for scripted series regulars, the details of which are explored in Section E of Chapter 5. However, there are a few key distinctions unique to unscripted production that bear discussion here.

6 In later years, networks such as E! and Bravo, which built their brands on unscripted programming (such as *Keeping Up with the Kardashians* on E! and *Top Chef* on Bravo), have made efforts to expand into scripted programming (such as *The Royals* on E! and *Girlfriends' Guide to Divorce* on Bravo), with mixed results. Lifetime's flagship scripted series, *UnREAL*, is itself a dramatized look behind the scenes of a fictional unscripted dating series.

i. Fees

Historically, episodic fees for professional performers serving as hosts, judges, or other on-screen capacity on unscripted productions have been substantially lower than episodic acting fees for scripted series regulars. Although talent fees are frequently the single largest expense for an unscripted series, the generally "low budget" nature of unscripted production has generally limited the amounts paid to on-camera talent. In other words, while a scripted television series is often apt to seek out the highest-stature talent it can attract, and to pay whatever the market demands for that talent, an unscripted television series is more likely to content itself with the best talent it can afford, based on the budget. As a result, episodic hosting fees for professional performers on unscripted series are frequently in the $10,000 to $50,000 per episode range (compared to the long-established range of $25,000 to $125,000 per episode for scripted series regulars).

However, just as scripted television producers have recently paid significant premiums to attract high-stature theatrical talent, unscripted producers and networks are also increasingly courting (and paying a premium for) the highest-stature talent they can attract. For instance, in its early seasons, *American Idol* featured three then-relatively unknown judges: Paula Abdul (a musician and dancer who had not had a significant hit in roughly ten years), Randy Jackson (a little-known musician and producer), and Simon Cowell (an unknown-in-America music executive, entrepreneur, and budding English television personality). By comparison, ABC's 2018 revival features as judges superstar Katy Perry, country music star Luke Bryan, and pop icon Lionel Richie, a trio designed to compete with NBC's rotating cast of pop star judges on *The Voice*, which has included Christina Aguilera, Adam Levine, Blake Shelton, CeeLo Green, Shakira, Usher, Gwen Stefani, Pharrell Williams, Miley Cyrus, Alicia Keys, and Jennifer Hudson.

Similarly, game shows have long been hosted primarily by relatively low-profile comedians and professional presenters, such as Alex Trebek (*Jeopardy!*), Pat Sajak (*Wheel of Fortune*), and Chuck Woolery (*Love Connection*), whose primary claims to fame and fortune were often their game show hosting gigs. But the 2016 and 2017 broadcast seasons saw multiple new game shows formats launched and classic game show formats revived with major established talent as hosts, including Academy Award winners Alec Baldwin (*Match Game* on ABC) and Jamie Foxx (*Beat Shazam* on Fox), legendary rapper Snoop Dogg (*The Joker's Wild* on TNT), and feature film comic star Mike Myers (*The Gong Show* on ABC, albeit in the guise of fictional British TV presenter Tommy Maitland).

These major celebrities can command six-figure episodic hosting fees competitive with those paid to the highest-level scripted television stars (even though such game shows are typically produced at the rate of one to five episodes per day, as opposed to seven to nine days to produce a single episode of a scripted drama).

ii. Exclusivity

Performers on unscripted programs are typically subject to less stringent exclusivity requirements than scripted series regulars. As discussed in detail in Section E.xii of Chapter 5, most scripted series studios require series regulars to be substantially exclusive to their shows in television (subject to customary carveouts and further negotiated exceptions) and grant the studio "first priority" on the actor's services at all times. Historically, however, the lower episodic fees paid by unscripted producers has limited the extent of the exclusivity they could reasonably require. Although unscripted hosting and judging fees have grown in recent years, the established celebrities commanding such fees are more apt to view their participation in an unscripted series as a secondary commitment. Such celebrities would be reluctant to sign up for an unscripted television series that would compromise their ability to pursue their primary professional activities as actors, musicians, or otherwise.

As a result, on-camera talent agreements for unscripted series typically require exclusivity only in unscripted television programming. In-demand performers can negotiate for even more limited exclusivity, such as exclusivity in a specific sub-genre, especially if they have already established themselves as ubiquitous media personalities. For example, the host of an unscripted music competition program may be prohibited from hosting another music competition series, but could be permitted to host a talk show, game show, or even another non-music competition series. The host would also likely be free, in any event, to appear as an actor in any scripted program.

Such agreements for professional entertainers on unscripted productions also typically involve more complex negotiation regarding contractual priority on the performers' time, scheduling of production periods, and other terms related to the performer's ability to concurrently pursue other projects that would affect the performer's availability to render services for the unscripted series.

iii. Options

Like scripted series regular agreements, unscripted performer agreements must set out a certain number of options for the performer's services, and time periods during which those options must be exercised. Whereas the vast majority of scripted series regular agreements are for six years, the terms of unscripted series deals are often more freely negotiated, with shorter term deals (four years, or even fewer) being more common.

In addition, unscripted series deals typically have to differentiate more finely between and among "years," "seasons," and "cycles." The vast majority of scripted series produce and exhibit one season per year (often released on highly standardized broadcast calendars); as a result, the terms "season" and "year" can be used more or less interchangeably, with no substantive effect. Unscripted

series, however, typically take less time (as well as less money) to produce, and their formats make them more amenable to mass production (as opposed to scripted series, which may not have an unlimited supply of good writers' ideas to draw upon). As a result, successful unscripted series are typically produced in "cycles" that may or may not correspond to the regular broadcast calendar, and shows such as CBS's *Survivor* and *The Amazing Race* are typically exhibited at the rate of two cycles per year.

In light of this production pattern, agreements for on-camera talent on unscripted series must be clear with respect to whether they contemplate "years" or "cycles," whether the producer may require the talent to render services on multiple production cycles in any given year, and whether there are any limits with respect to how many episodes the talent can be required to work on before triggering a fee increase or exhausting a single "option" under the deal.

iv. Product Integrations

Because product integrations (which are discussed in greater detail in Section B.vi.b of Chapter 1) are more common in (and, in some cases, essential to the financial viability of) unscripted productions, it is often necessary to engage in more specific negotiation with professional performers around such practices. Hosts and judges of unscripted programs may routinely be called upon to describe, interact with, and speak positively about the products and services of brand partners. Some performers consider such services to be uncomfortably close to a personal endorsement. Other performers may not be uncomfortable with the practice, but feel that their personal endorsement, whether direct or implied, carries enough value that it should be separately compensated. Performers who enter into their own lucrative sponsorship and endorsement contracts may also be concerned with potential conflicts with their personal branding activity. Consequently, deals with professional performers on unscripted programs typically specifically set out the performer's obligation to cooperate with and participate in product integrations as part of their series services, and the parties tend to negotiate in greater detail regarding potential limitations on such services, and the efforts to be made on both sides to reconcile these services with the artist's personal sponsorship/endorsement activity.

C. Participant Agreements for Documentary and Competition Series

Agreements governing the services and appearances of non-celebrity participants in documentary and competition series are usually fairly sparsely negotiated. Professional hosts and judges typically have sophisticated agents, managers, and lawyers negotiating their deals; non-professional participants usually do not. Particularly well-known or talented hosts and judges may be highly coveted by

producers and networks; "docu-follow" subjects are typically one of many being considered by a network as the subject of a proposed television series, while game show and competition series participants are usually selected from among many thousands of applicants seeking the opportunity to appear. As a result, many such deals are altogether "contracts of adhesion," meaning that the producer will present a potential participant with an agreement and refuse to negotiate most or all of its terms. If the individual is interested in proceeding, they sign; if they are unwilling to sign, the producer or network moves on to someone else who is willing to accept the terms on the table.

Even if the terms of such agreements are not subject to significant negotiation, however, it is useful to review some of their key components.

i. Fees

The economic terms for non-professional entertainers participating in unscripted television programs are wildly different from those applicable to professional host/judge types.

For a new non-competition documentary series that follows non-celebrity individuals in their personal or professional lives (as is common on basic cable), the principal subjects of the series can expect to earn as little as $500 per episode, and certainly no more than $10,000 per episode, in their first contracts. Many episodic fees fall in the $1,000 to $2,500 per episode range. The subjects of these series are typically not professional entertainers and do not expect to earn their primary livings from their series appearance fees. The primary motivation for such individuals to participate in an unscripted television series is usually non-economic, e.g., to seek personal fame, to gain access to other entertainment industry opportunities, and/or to take advantage of the "free advertising" provided by an unscripted television program to promote and advance their non-entertainment business interests. The economic terms of their appearance deals tend to reflect this reality. That said, non-celebrities who are catapulted to fame by an extremely successful television series (such as the Robertson family of A&E's *Duck Dynasty* or the Thompson/Shannon family of TLC's *Here Comes Honey Boo Boo*) frequently negotiate for substantially greater fees to keep a show in production after their original contracts expire (or if afforded an earlier opportunity to renegotiate their deals).

On game shows and competition shows, the competitors typically appear for no fee whatsoever; their sole compensation is the opportunity to win whatever prize is at stake in the series (as well as the exposure and thrill of appearing on television).[7] This is true even for arcing competition series that follow a narrow-

7 The primary exception here is for competition series with a performance element, such as *American Idol* and *The Voice*. Singing and performing music on television is a class of services that is subject to

ing group of competitors over an entire season, such as *Survivor* or *Top Chef*, that may require participants to live in show-provided housing and work on the series on a substantially full-time basis for weeks or even months at a time. For such individuals, the applicable agreement will disclose (and require the participant to acknowledge and accept) all of the competition rules, prizing details, judging criteria (if any), and eligibility requirements.[8]

ii. Releases

The essential component of most appearance agreements for unscripted productions is a series of broad and expansive releases. Participants in unscripted television programs typically waive any and every claim they might otherwise be able to bring against the producer or network in connection with their appearance.

Because such programs are often edited to generate storylines with "heroes" and "villains" among the participants, many participants in unscripted series may consider their depiction to be unflattering, or even personally or professionally damaging. In addition, reality program participants may at times be unaware that they are being recorded, or may be recorded in personally compromised circumstances, such as while heavily inebriated. Producers and networks therefore obtain extensive waivers of any potential claims that may arise out of such depictions, including defamation, public disclosure of private facts, or violations of rights of privacy and publicity. Appearance agreements typically involve extensive disclaimers about the production's right to record the participant at virtually any time and to depict them in virtually any way; where a reality show involves putting participants in a home owned or rented by the production (e.g., *Big Brother*, *The Real World*, *The Bachelor*), the participants' agreements typically permit the producers to film the participants in secret anywhere on the premises. "Documentary" series agreements usually include broad permission for the production to access and film the participants in their homes and places of business. Participants may be asked to sign agreements by which they waive any claims for fraud or misrepresentation, should they later learn that the producers lied to them in any way, including about the very nature of the show in which they are

SAG/AFTRA's jurisdiction; as a result, many of these series actually treat the competitors as professional performers and pay them scale minimum episodic fees for each appearance over the course of a series.

8 For instance, many game show participant agreements provide that a winning contestant's prize is paid only if and when the applicable episode is actually exhibited, and may not be payable at all if the episode never airs. In addition, participants in various game and competition series must submit to background checks and submit extensive information about themselves to the production as part of the casting process, and may be deemed to forfeit their prizes if they are found to have lied. In general, in order to avoid any actual or apparent conflicts of interest, participants in game and competition series cannot have any significant personal or professional relationships with the entities or individuals involved in the production or exhibition of the series.

participating. Participants in competition shows with physical elements waive any claims for injury arising out of their participation in the series.

In short, the responsible producer of an unscripted television series considers the nature of the project, imagines every conceivable legal claim that a disgruntled participant, subject, or competitor could bring, and then requires that individual to waive any and all such claims as a condition of his or her participation in the series.

iii. Exclusivity

For documentary series and arcing competition series, producers and networks will typically seek from non-professional series subjects and competitors extremely broad exclusivity, perhaps encompassing full exclusivity in all of television, and such individuals seldom have the bargaining power to resist such demands. Where exclusivity is negotiated, the range of negotiation options is generally consistent with those set forth for professional hosts and judges in Section B.ii above.

The particulars of exclusivity may vary dramatically depending on the nature of the series, and of the participant. For instance, a real estate agent whose real estate business is the subject of a documentary series may be comfortable agreeing to exclusivity in all of television, while a professional stand-up comedian and aspiring comic actor/writer participating in a comedy competition series such as *Last Comic Standing* would be unwise to accept such terms. However, there is virtually always some measure of exclusivity demanded of such individuals. Even one-time competitors on game shows are typically required to agree not to appear on any other television programs, including any other game shows, for twelve to eighteen months following their appearance on a particular program.

iv. Options

For "documentary"-type unscripted programs that contemplate following an individual or individuals over an extended period of time (and across multiple seasons), the participant's agreement will include option terms comparable in form and substance to those applicable to the professional performers on unscripted series (as described in Section B.iii above).

v. Reverse Royalties

As noted in Section B.i above, many individuals choose to participate in unscripted television programs not because of the immediate appearance fees (which are typically low), but for the exposure that these shows can provide. At the same time, a popular sub-genre of documentary shows (often exhibited on the Bravo and E! networks) follows the personal and professional dramas

surrounding real-life businesses (and the entrepreneurs behind them), including real estate agencies (*Million Dollar Listing*), fashion companies (*The Rachel Zoe Project*), restaurants (*Vanderpump Rules*), fitness studios (*Hollywood Cycle*), and bars (*What Happens at the Abbey*). Networks and production companies are well aware of the value of the "free publicity" provided to the businesses featured in these programs and sometimes negotiate for a "reverse royalty," i.e., an amount owed by the subject of the series (either as an individual or a company) to the network or production company in exchange for the promotional value provided by the series. This payment may be calculated as a percentage of the company's or individual's revenue, a percentage of revenue earned in excess of a historical pre-series baseline, or even a share of equity in the subject's venture.

vi. Confidentiality and Publicity

Because the entertainment value of unscripted programs, especially arcing competition series, often relies heavily upon a sense of suspense and uncertainty about the outcomes, participants in such programs are generally subject to strict confidentiality requirements, prohibiting them from disclosing any information about the substance or outcomes of their appearances prior to the exhibition of the applicable episodes. To prevent participants from breaching these confidentiality requirements, participant agreements often provide for liquidated damages (i.e., contractually defined damages) of hundreds of thousands, or even millions, of dollars in the event of any unauthorized disclosures.

Participant agreements typically expressly affirm the production company and network's sole control over all publicity in connection with a series. Consistent with the confidentiality provisions of these agreements, participants are generally prohibited from engaging in any series publicity without the coordination and/or consent of the production company and network. At the same time, participants usually agree to cooperate with and participate in producer/network-coordinated publicity activities, such as by participating in interviews and talk show appearances arranged by the producer or network in support of the series.

D. Production Company Agreements

As noted in Section A above, the dominant form of relationship between unscripted content producers and networks is not a license agreement, but a production services agreement.[9] In such arrangements, the network pays the

9 In rare cases, especially powerful unscripted producers—particularly those who are affiliated with a major television studio that primarily produces scripted content on a license basis—may be able to negotiate for a co-production arrangement with the network (providing for shared ownership of the series and shared control of distribution rights), or even, in rarer cases, a license relationship (albeit one

production company 100% of the cost of production of the series (including a negotiated fee for the producer) and obtains 100% of the ownership of the series on a "work-for-hire" basis. Even starting from this presumption, however, there are a number of key terms open to negotiation between the network and production company.

i. Production Company Fees

The production company must negotiate with the network to determine the value of its budgeted production fee. These fees are, in most cases, contracted and calculated as a percentage of the series's ingoing approved budget. In negotiating these fees, there are five primary issues to account for.

The first issue is the applicable percentage of the budget. The prevailing industry standard, applicable in a substantial majority of cases, is 10%. However, in competitive situations, or where the production company is offering a substantial package of producing elements (e.g., significant celebrity attachments as producers) with whom it must share the production fee, the fee may be negotiated to a higher percentage, such as 12.5% or, in rare cases, 15%.

The second issue is the definition of "budget" for purposes of calculating the production fee, and in particular, the applicable exclusions from the calculation base. In other words, the parties may negotiate for a "10% production fee," but the question remains, "10% of *what*?" The network is incentivized to negotiate for the greatest number of exclusions; the production company seeks as few as possible. In nearly all cases, the defined "budget" for this purpose excludes the production company's own fee (i.e., to avoid compounding), any applicable agency package fee, subsequently-agreed network breakage amounts, overages, and prizing. Underlying rights/format fees,[10] if applicable, are also typically excluded. If the network agrees to treat any producers as "line-items" (as described below), the network may nevertheless seek to exclude such producers' fees from the "budget" for purposes of calculating the production fee. Many networks also insist on excluding legal and insurance charges, particularly when the production legal services for the series will be rendered by an outside lawyer or law firm (rather than by an in-house employee of the studio) and/or when the applicable fees are also calculated on a percentage-of-budget basis. Some networks insist on excluding principal on-camera talent fees, especially in cases where the network directly negotiates and controls the relationship with such talent.

The third issue is applicable floors and ceilings. On lower budget productions, producers may want to make the percentage-of-budget calculation subject to

that will vest the network with greater exhibition and/or distribution rights than it might typically expect to receive in a license agreement for a deficit-financed scripted series). Such arrangements are certainly the exception rather than the rule and are not discussed in great detail here.

10 See Section D.ii below.

a dollar-amount floor, in order to avoid accepting a production fee that is too low to appropriately compensate them for the effort and overhead required to produce the series (and the risk of overages in producing it).[11] On higher budget productions, networks may want to limit the extent to which the production fee can continue to grow in proportion to the budget and apply a hard-dollar cap. In either event, the applicable floors and/or ceilings are typically negotiated on a case-by-case basis, bearing in mind the parties' reasonable projections and assumptions about where the final ingoing budget of the first season of the series will likely land.

The fourth issue is the extent to which the production company must bear fees payable to certain service providers out of its negotiated production fee. Production companies frequently partner with individual producers on a project-by-project basis. Sometimes, these individual producers come up with the underlying idea around which a series is built. In other cases, they may provide unique access to talent or subjects, or otherwise provide expertise and connections that are vital to the success of the series concept. Production companies may also seek to partner with high-profile celebrities whose name recognition can help generate network and/or public interest in the series or attract the participation of other celebrities, even if the celebrity executive producer him or herself never actually performers on camera. Networks usually require that such producers (who generally render services on a non-exclusive and effectively part-time basis) be paid out of the production company's fee, so that the network does not bear any further cost for their fees. Anticipating this requirement, many production companies negotiate their agreements with such third-party producers based on a negotiated percentage split of the applicable production fee received from the network, which the production company is incentivized to maximize.

However, the production company may seek to negotiate for the right to separately account for fees to such producers outside of the production fee and within the network-approved (and funded) budget of the series. This is referred to as "line-iteming," and producers whose fees are accounted for in this fashion are said to be treated "on a line-item basis." For example, the fees payable to showrunners and other physical producers who render services on a substantially exclusive and full-time basis are generally and uncontroversially accounted for as line items. Although networks strongly resist treating any non-exclusive, part-time creative producers in this fashion, they may agree to do so for uniquely prolific and successful producers (such as Mark Burnett) or for celebrity executive producers (especially for those who are also appearing as hosts, judges, or other on-camera talent).

Finally, the production company and network must negotiate the applicable increases for the production company's budgeted fee. It is not uncommon for the

11 See Section D.iv below.

budget of a successful unscripted series to escalate somewhat dramatically in later seasons, as the success of the series drives the network to invest in enhancing it further. The production company would prefer to see its fee recalculated season-by-season (or, better yet, cycle-by-cycle) based on the new budgets, in order to take advantage of these ballooning production costs.[12] (Such rapid increases may also cause the fee calculation to run against any negotiated fee caps.) On the other hand, the network may require that the fee increase by fixed percentage amounts from the first cycle's calculated fee, allowing the company some appreciation in its compensation, but not necessarily in proportion to the growth in the series's budget.

ii. Format and Other Rights Fees

For the most part, on original unscripted series no separate compensation is paid in connection with the underlying "intellectual property" of the series (i.e., the series format).[13] In effect, the negotiated production company fee serves as compensation for both the underlying idea for the series and the services rendered by the production company in producing it. However, there are two main cases where a separate intellectual property fee may be payable as part of the budget: where the series is based on, or substantially incorporates into its title or format, some preexisting piece of intellectual property (e.g., Fox's *Beat Shazam* or CBS's *Candy Crush*); or where the series is based on a preexisting television format that has been imported from abroad or revived from a prior domestic series (e.g., ABC's *The Weakest Link*, based on a British series of the same name; or TNT's *The Joker's Wild*, based on a classic U.S. game show from the 1970s and 1980s).

Where applicable, fees for preexisting intellectual property are also commonly negotiated on a percentage-of-budget basis. Preexisting television formats typically command format fees equal to 5% of the budget, while non-format intellectual property (such as trademarks and non-TV game formats) are usually compensated at between 2.5% and 5% of the budget, according to their prominence and value and in the marketplace. If the preexisting format is owned by a third-party

12 On the other hand, this does entail the production company taking some risk that the series budget actually goes down in subsequent seasons or cycles, and the company's fee therefore falls with it. Although this is relatively uncommon, it can occur specifically in second cycles (when one-time set construction and other amortizable costs are not re-incurred), when per-cycle episodic orders are increased (which may result in a higher aggregate, but lower episodic, average budget and production fee), or on marginally successful series for which the production company seeks to induce a reluctant network to renew the series by working to reduce its expense.

13 If, as noted in Section C of Chapter 4, the extent of copyright/intellectual property protection for scripted series formats is up for debate, the protectability of unscripted formats is especially dubious. For some basics on copyright law that shed light on this issue, see Section A of Chapter 3. Again, the entertainment industry's general respect for formats and practice of engaging in format licensing are arguably as much a function of custom and norms as it is legal necessity.

company, it is paid to that third party as a show expense; if the production company itself owns the preexisting format, it can charge and retain the format fee for itself. The same issues around relevant definition of "budget" and negotiation of dollar-value floors and ceilings described above with respect to production company fees are also applicable to the negotiation of format/rights fees.

iii. Locks

Production company agreements are subject to the same types of negotiations around "locks" as non-writing executive producer agreements on scripted series.[14] Production companies may be locked for only a single season, for two seasons, for the life of the series, or for some more uniquely negotiated period of time. (For example, the production company may receive only a two-year lock, with the network's option to engage it for a third season, and a life lock automatically triggered if the network exercises its third season option.) The extent of the lock granted depends on the stature and track record of the production company, including any prior relationship between the specific production company and network; whether the production company originally generated the idea for the series and brought it to the network, versus if the network sought out the production company and attached it to a preexisting idea; and whether the series is new, versus if the production company is engaged to render production services on a preexisting series.

iv. Overages and Underages

Generally, once the ingoing budget for the season is determined and approved by the network, the production company is responsible for any unapproved overages (i.e., production costs in excess of the approved budget), subject to a limited number of negotiated exceptions. These exceptions almost always include breakage amounts approved by the network in writing and costs that are reimbursed by insurance, and may also include overage costs that are caused by third-party breaches of contract not caused by or contributed to by the production company, or costs that are caused by events of force majeure (i.e., "acts of god" such as war, earthquakes and major weather events, union strikes, and other events beyond any party's reasonable prediction or control).

However, the production company and network must also negotiate with respect to the treatment of underages, i.e., any negative difference between the amount allowed for in the ingoing budget and the actual amount spent by the production company on production costs. Networks frequently demand that all underages be retained by the network. In addition to saving the network money,

14 See Section C.iii of Chapter 5.

this arrangement also disincentivizes the production company from "padding" its initial proposed budget or intentionally skimping on production value in hopes of generating underages that it will get to retain.

If the network has the right to retain underages, this right is enforced by the network's right to audit the production company's expenses (and so the approved budget is referred to as "auditable"). Although the network will generally fund the approved budget to the production company on a mutually agreed cash flow schedule that limits the production company's need to go out-of-pocket to cover legitimate production expenses, some portion of the funding for the series (typically 5%, but potentially as much as 10%) is subject to an "audit holdback." In other words, the network withholds this portion of the approved budget and releases it to the production company only after undertaking an audit of the company's expenses, in order to verify that all of the amounts claimed by the production company were actually spent in connection with the series. (This holdback may itself be subject to automatic release if the network does not exercise its audit rights in a timely fashion, e.g., within sixty or ninety days following the delivery of the applicable cycle.)

Production companies, of course, prefer to retain any underages (in which case the budget would be referred to as "flat" or "non-auditable"). They will argue that the network was prepared to spend the full budget amount all along and that the network's retention of underages therefore amounts to an undue windfall, and that the opportunity to retain underages is fair compensation for the overage risk assumed by the production company. In addition, many production companies find production audits to be highly burdensome and time-consuming, and to give rise to maddening disputes with networks that seek to aggressively disallow costs that the company considers to be legitimate.

As a compromise, some production services agreements provide that series budgets are auditable (with the network retaining underages) for the first one, two, or three seasons of a series (when the true process and cost of producing the series is truly worked out through practical experience), and become flat/non-auditable thereafter. Retained underages can ultimately constitute an extremely important source of further revenue for the production company, particularly in latter seasons of a series, by which time the production company has developed considerable expertise and efficiency in producing the show and can find opportunities to retain underages without compromising production value.

v. Chargebacks

In addition to the revenue sources described above (i.e., production fees and, where applicable, format/rights fees and retained underages), "chargebacks" constitute a critical source of revenue for many unscripted production companies.

In addition to employing personnel with the creative and production expertise to manage the production of a series, many production companies own

significant property and infrastructure resources that are critical to any production. These may include office space; studios and other production spaces; editing bays and other costly computer hardware and software; and cameras, lighting, and other physical production necessities. If not provided by the production company, these materials would need to be purchased or rented from third parties; instead, the production company may provide them from its own stock and charge market rates for their rentals within the budget of the series. Generally, such in-house chargebacks must be disclosed to the network (especially if the budget is auditable, in which case undisclosed chargebacks may be disallowed in a production audit and unreimbursed). Over time, these chargebacks eventually amortize the production company's capital expense in obtaining the resources and then provide a further source of profit.

Larger production companies may also keep editors, producers, lawyers, and other essential production personnel on staff as salaried employees, on exclusive hold as consultants, or under exclusive "overall"-type deals.[15] If the company dedicates such individuals' time to a specific project on a substantially exclusive, full-time basis, it may also seek to charge the value of their services back to the network-funded budget at the market rates it would have otherwise paid for freelancers. Again, the production company generally must disclose such chargebacks to the network and obtain the network's approval on an individual-by-individual basis, or risk the network's disallowing of the costs in a subsequent production audit.

vi. Product Integrations

As described in Section B.vi.b of Chapter 1, product integrations are a particularly prominent feature of (and lucrative source of revenue from) unscripted programming. As a result, some networks are especially insistent about retaining 100% of revenue, both from traditional advertising sales and designated "integration fees," in connection with these arrangements (excluding only any out-of-pocket costs of actually implementing such integrations, if any).[16] On the other hand, the prominence of integrations in unscripted programming makes them particularly valuable for unscripted producers to share in, and it is ultimately the duty of the production company to execute on the integration as organically as possible. Therefore, while advertising revenue is generally acknowledged by all parties as sacrosanctly the network's to retain, savvy production companies negotiate hard for a share (typically 50%) of specified "product integration" fees. Production companies who participate actively in sourcing and courting

15 See Section A of Chapter 7.

16 This differs from the norm in scripted television, where the studio frequently retains product integration revenue (but not ad sales revenue) for itself entirely, or at worst agrees to split such fees with the network. See Section A.xiii of Chapter 8.

integration opportunities with partner brands have a particularly strong claim to share in the resulting revenues. However, even where the network agrees to split integration revenues with the production company, the network may retain the right to recoup certain expenses off-the-top prior to splitting, particularly any breakage or other network-paid overages.

vii. Backend

Because the network is typically the owner and distributor of most or all of the rights in an unscripted series, it occupies the position of a "studio" for purposes of calculating and accounting for contingent compensation to third parties, including the production company. For the most part, such backend is also characterized as "Modified Adjusted Gross Receipts" ("MAGR") or the comparable applicable concept and term for scripted series backend compensation, and the basics of its definition and calculation largely track those for scripted series (as set forth in Chapter 6).

Many networks have adopted the scripted television studio norm of 35% of MAGR being the maximum allocable "pool" of contingent compensation for any given series. Production companies may expect to negotiate for between 15% and 35% of MAGR, which, like the contingent compensation for non-writing executive producers on scripted series, will likely vest in thirds over production of a pilot, first season, and second season of the series.[17] The network will generally require the production company to bear any participations to third party out of its negotiated contingent compensation. As a result, as with upfront fees (as described in Section D.i above), many production companies negotiate their agreements with third-party creative producers to pay them a percentage of whatever contingent compensation the production company actually receives (if any) from the network.

Because, for purposes of contingent compensation, the network effectively occupies the role of both network and studio, it must follow the practice of studios selling their shows to affiliated networks (as described in Section A of Chapter 6) and impute a license fee for its own exhibition of the series. Ideally (to the production company), this imputed license fee is equal to the ingoing approved budget of the series; but in practice, most networks impute a license fee between 70% and 90% of the production cost of the series, leaving a 10% to 30% deficit that must be recouped from distribution revenues before any contingent compensation becomes payable. The MAGR definition would also specify the extent of network exhibition and/or distribution that is "bought out" entirely (i.e., not further accountable to the participant) by the imputed license fee. Frequently, the scope of the imputed license fee buy-out on an unscripted series is

17 See Section C.viii of Chapter 5.

much broader than what might be applicable to a scripted series, perhaps covering not only the network's direct linear exhibition of the series for an unlimited number of runs, but also all exhibition or distribution of the whole series on domestic digital platforms in perpetuity.

The production company may also attempt to negotiate for a reduced or eliminated overhead charge in the MAGR calculation, on the argument that it is the production company, and not the network, that is actually taxing its overhead and infrastructure in connection with the production of the series. Despite the logic of this argument, however, most networks retain the overhead charges typical of MAGR definitions.

As a result of the imputed deficit and MAGR-standard overhead and interest deductions, and the already limited second-run and international market value of unscripted series (as described in Section A above), it is very rare for profit participants in unscripted series to see any value from their negotiated contingent compensation.

viii. Reserved Rights

Although most network/production company deals presume the network's complete ownership of a series and control of all distribution rights in connection therewith, the production company may be able to negotiate to reserve certain rights, particularly where it can demonstrate the ability to effectively monetize and exploit such rights. In light of the unfavorable customary definitions of contingent compensation for unscripted series, such reservations of rights can prove critical to the production company's ability to extract true long-term value from its series.

The most critical potential reserved right is the underlying format of the series. As discussed in Section A above, the format of a series may hold broad appeal internationally, even where any particular local production based on that format would not. Although not all forms of unscripted series are amenable to formatting and re-adaptation—a documentary series whose entertainment value is based on a specific celebrity personality cannot be adapted as readily as a traditional game show—the most successful unscripted formats may be adapted into local versions in literally dozens of territories. For example, local versions of *Big Brother* have been produced in over fifty different countries. Each local version generates format fees[18] (and, potentially, contingent compensation) payable back to Endemol, the Dutch company that created and owns the *Big Brother* format.

To be clear, even if the production company successfully reserves format rights to a new original format, the network would likely claim a 50% economic interest (which would entitle it to receive 50% of format revenues generated

18 See Section D.ii above.

by the production company, after the company deducts customary distribution fees and recoups its distribution expenses off-the-top). Nevertheless, the production company's opportunity to retain those off-the-top distribution fees and the other 50% net share of format receipts could prove quite lucrative for years to come.[19] In addition, the production company's reservation of domestic (as well as international) format rights could enable it to revive the series format in a new domestic series after the original series is canceled (subject to negotiated holdbacks in favor of the original network, and revenue sharing as described above). As the recent trend of game show revivals demonstrates, this right can also prove very valuable over time.

In rarer cases, a production company with established relationships in certain territories (commonly other English-speaking territories such as Australia and the United Kingdom) may negotiate to reserve distribution rights in those territories (with an obligation to account back to the network for a share of the resulting distribution revenues, as it would for reserved format rights). As a lesser accommodation, the network may nominally retain control of distribution rights worldwide (and therefore the right to channel all distribution revenues worldwide through its unfavorable generally applicable MAGR formula) but agree to engage the production company as its distributor in the production company's territories of expertise (thereby at least allowing the production company to collect off-the-top distribution fees).

19 If the production company is unable to reserve format rights altogether, as a fallback, it may seek to negotiate, as part of its contingent compensation from the network, a "separate pot" format royalty. In this structure, the network would own and control the format and its distribution (both domestically and internationally), but the production company would be entitled to share in format revenues after the network deducts only distribution fees and format-related distribution expenses, and not any U.S. series-specific production or distribution expenses. In other words, the production company would see backend value from the network's distribution of the underlying series format, even if the original American series had not "broken even" (i.e., recouped the imputed deficit, overhead, and interest deductions) pursuant to the otherwise prevailing MAGR definition.

CONCLUSION

When FX's John Landgraf gave his well-regarded "Peak TV" talk in August 2015, his diagnosis of "simply too much television" also came with a prediction: "My sense is that 2015 or 2016 will represent peak TV in America, and that we'll begin to see declines coming the year after that and beyond." Yet, based on his own data, Landgraf's projections do not appear to have borne out: the final count of scripted series for 2017 was up over 15% from 2015, and knocking on the door of the stunning "500" milestone. Was Landgraf wrong about "Peak TV?"

First of all, it is important to remember than 500 series on television does not mean 500 *profitable* series on television, either for the studios producing the series or the networks exhibiting them. Market fragmentation reduces viewership, and with it, advertising revenue to networks. Networks with diminishing advertising revenues and increasing corporate pressure to order series from their sister studios seek to limit their license fee commitments. On the other hand, ballooning budgets (including skyrocketing fees for the highest-demand creators, actors, and underlying rightsholders), as series try to distinguish themselves in a crowded marketplace, mean that studios must derive ever-higher revenues just to break even. And all the while, sheer volume makes it harder for even quality shows to find audiences at all. Ultimately, one can reasonably expect that a majority of the roughly 500 series on television will lose money for their studios, networks, or both.

As for Landgraf's predicted deflation in the volume of original series production, a closer look at his seemingly bullish data (from Chart 1 in the Introduction) offers some troubling insights about what the industry may experience in the years ahead:

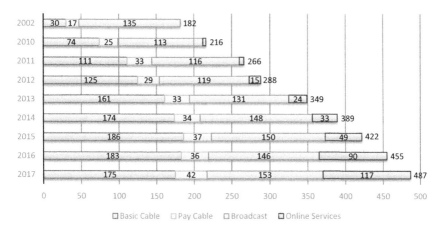

CHART 1 Volume of Original Scripted Television Series Production

Yes, overall scripted series production rose by 15% (or sixty-five series) between 2015 and 2017. And 2019 offers the prospect of Apple's entry into the market as a powerful (and exceedingly well-funded) new player. But 105% of that growth—yes, more than 100%—came from streaming platforms such as Netflix, Amazon, and Hulu, which saw their content offerings increase almost 2.4 times during that time period. Significantly, 2017 in particular was arguably Netflix's breakout year as a studio, rather than a pure network, and so much of the economic opportunity from its series growth has been centralized within Netflix alone (and does not spread wealth to the broader ecosystem of provider studios or MVPDs).

Among all other platforms (broadcast, basic cable, and pay cable) combined, production counts were actually down. Broadcast series counts grew modestly from 150 to 153 (following a dip to 146 in 2016), but this may not provide much reason for optimism: the broadcast television world has, for years, existed in a relatively stable equilibrium with four major national networks (ABC, CBS, Fox, and NBC). The daily primetime hours programmed by the major networks (generally 8 p.m. to 11 p.m.) have also remained consistent over the years. Any float in the number of scripted series is really a matter of the broadcast networks' minor reallocation among their investments in scripted vs. unscripted content (and, with unscripted content on broadcast networks facing ballooning celebrity-driven costs, the small shift toward scripted series comes as little surprise). Moreover, while the number of scripted series on broadcast television has remained relatively constant, the number of *new* series ordered each year has steadily decreased since 2013. Because the cost of launching a new series is particularly high, broadcast networks have been more content to renew somewhat middling performers (especially those from their affiliated studios), rather than to undertake the extraordinary cost of producing and marketing something new.

Basic cable scripted series production, in particular, shrank by 6% between 2015 and 2017 (and was down for each year-over-year period during that span). This may be the most significant statistic of all. While much attention is (and should be) paid to the tremendous impact of the streaming services in driving the evolution of the television business over the last five years, looking at a broader ten-to-fifteen-year time scale, the emergence of networks such as AMC, FX, and USA as high-volume providers of premium content has also been critical in driving the overall content boom in television. While the prospect of more networks joining this caste of premium platforms (e.g., Bravo with *Girlfriends' Guide to Divorce*; Lifetime with *UnREAL*; etc.) offered the opportunity for further sustained growth, these networks' efforts have proven more limited and tentative than the industry's early optimism would have suggested. Bravo's only two other forays into scripted programming, *Imposters* and *Odd Mom Out*, have made little impact critically or commercially, and the network continues to focus its resources on its homegrown stable of unscripted franchises. Lifetime has only released one low-profile original scripted drama as a follow-up to *UnREAL*, called *Mary Kills People*, which was actually an acquisition of a series initially produced for the Global network in Canada. (Two more scripted series are currently anticipated from Lifetime in the year ahead.) A&E canceled its well-reviewed *Bates Motel* in 2017, a decision that marked the network's exit from scripted series production altogether.

At the same time, while the industry still boasts record numbers of ongoing series on the air, networks have increasingly managed their spending by spreading out their series exhibition over time. Sometimes this means producing a single season in one production run, but exhibiting it as two separate seasons, or two separate half-seasons with an extra-long hiatus in between. (AMC took this approach in its exhibition of the fifth and final season of *Breaking Bad*, premiering the first half of the season in July 2012 and the second half in August 2013.) In other cases, networks simply allow particularly long breaks between production of consecutive seasons. For example, HBO premiered the seventh season of *Game of Thrones* in July 2017 and is expected to debut the show's eighth and final season nearly two years later, in April 2019. HBO took a similar break between the first season of *Westworld* (which premiered in October 2016) and the show's second season (which premiered in April 2018). On basic cable, FX debuted the first season of *Atlanta* in September 2016, and the second season returned in March 2018. These long lay-offs between seasons would have been unthinkable just a few years ago and present significant challenges for studios that need to manage option dates and talent availabilities. But they allow the producers and exhibitors of costly television series to amortize their investments over a longer period of time.

This deflation in the volume of series production has accompanied a broader industry moment of consolidation and contraction. One of the reasons the United States television industry has recently generated so many shows is because there have been more networks in general, and more networks focusing on original

content production, than ever before. Many of these networks have been very nichified in their content offerings but have survived because they exist as part of broader network portfolios owned by major media conglomerates such as Viacom and Disney. But secondary and tertiary networks are quickly falling by the wayside. In February 2017, Viacom (which boasted one of the widest portfolios of networks, and was dubbed by the *Wall Street Journal* as "the poster child of the supersize cable-television bundle") announced that it would re-focus itself on just six key brands: Comedy Central, BET, MTV, VH-1, CMT, and a new Paramount Network (which would launch as a rebrand of Viacom's male-centric Spike network). Participant Media's youth-focused Pivot network ceased operations in November 2016. NBCUniversal shut down its Esquire network in June 2017.

Not coincidentally, this winnowing of peripheral networks has taken place in a context of significant consolidation among MVPDs. In May 2014, AT&T announced its acquisition of DirecTV, bringing AT&T's U-verse offering and DirecTV's satellite business under a single corporate roof. (The transaction closed in July 2015.) In February 2014, Comcast (the largest cable MVPD provider in the country) attempted to merge with Time Warner Cable (the nation's second largest cable MVPD provider). When federal regulators took steps to block the transaction in 2015, Comcast backed out, and Time Warner Cable was promptly purchased by Charter Communications (then the third largest cable MVPD provider in America). That acquisition was completed in May 2016. There are any number of reasons why these MVPDs sought the scale and theoretical efficiencies that would come with such combinations, but certainly the greater bargaining power that these larger entities would have in carriage agreement negotiations with cable network and retransmission consent negotiations with broadcast stations helped motivate the deals.

Of course, this trend of consolidation has not been limited to MVPDs or to horizontal combinations among companies in the same type of business. In June 2016, Lionsgate announced its acquisition of premium cable network Starz; the deal closed in December 2016. In April 2018, after years of negotiations, T-Mobile and Sprint agreed to merge, an agreement that would leave just three major wireless carriers in the United States (of which the combined T-Mobile/Sprint would be the second largest); the transaction is pending regulatory approval. In October 2016, AT&T (fresh off of its acquisition of DirecTV) announced that it would acquire Time Warner in a transaction valued at a net $108.7 billion. The proposed combination closely resembled a similar merger, announced in December 2009 and completed in January 2011, between cable provider Comcast and content company NBCUniversal. While regulators ultimately approved the latter merger (subject to conditions and concessions negotiated by the FCC and Department of Justice), in November 2017, the Department of Justice sued to block AT&T's acquisition of Time Warner.[1] The litigation is currently pending, and AT&T and

1 Some observers considered the litigation politically motivated, in light of President Donald J. Trump's ongoing feud with the Time Warner-owned CNN.

Time Warner have indicated their intention to litigate vigorously for the right to complete their transaction, and to resist any requirement that they divest CNN.

In December 2017, Disney announced its acquisition of a substantial majority of 21st Century Fox's entertainment assets (and this purchase is also pending as of the submission of this manuscript).[2] The transaction contemplates that, after closing, the legacy Fox company would retain ownership only of its Fox Sports and Fox News cable networks, and the Fox broadcast network and stations (the latter of which could not be purchased by Disney, which also owns ABC and the ABC station group, under prevailing FCC rules). The transaction would give Disney ownership of Fox's stake in Hulu, making it the new majority owner of the streaming service. Notably, while Disney would not take over ownership of the Fox broadcast operation, it *would* acquire 20th Century Fox Television, the sister studio and primary content provider for the Fox broadcast network. The notion of a broadcast network left without a functioning sister studio has caused many observers to question the future of the Fox network. Some Fox executives have indicated an intention to build a new studio to support the network; others expect the network to focus on sports and unscripted programming (for which it generally does not rely on its sister studio in any event), while some analysts anticipate a subsequent sale of the Fox broadcast operations to an eligible buyer. In any event, while the specific end result is uncertain, significant change at Fox seems inevitable. Indeed, the main factor that could scuttle the Fox-Disney combination is a competing combination: as of May 2018, Comcast is reportedly securing financing to support an all-cash bid to trump Disney's all-stock deal and acquire Fox's primary entertainment assets. At the same time, Fox and Comcast both have outstanding offers to acquire European pay TV operator Sky (with Comcast looking like the likely winner in that competition, despite the fact that Fox already owns a significant minority stake in Sky).

This period of consolidation—which has already fundamentally transformed the landscape in which the television industry grew to its current "Peak TV" heights—may not be over yet. By January 2018, less than a month after Disney and Fox announced their deal, rumblings emerged of a potential merger between CBS and Viacom. CBS and Viacom had actually merged once before, in 1999, in a $35.6 billion deal that was, at the time, the biggest deal of its type ever. In 2006, the companies split back apart, albeit with some assets having been reallocated between the two. In mid-2016, Shari Redstone (the daughter and successor of media magnate Sumner Redstone), still the dominant shareholder of both CBS and Viacom (through National Amusements, the movie exhibition company her father built), indicated her desire that CBS and Viacom re-merge. By the end of 2016, Redstone dropped her demands, but the bombshell of the Fox/Disney combination quickly renewed chatter of a CBS-Viacom re-combination (which Redstone appears to continue to favor). In February 2018, CBS and Viacom each announced

2 More cynical observers might suggest that regulatory approval seems overwhelmingly likely in light of the fact that, shortly after the deal was announced, President Trump personally called Fox's Rupert Murdoch to congratulate him on the transaction.

the formation of special committees to formally explore a potential merger. By May 2018, however, contentious wrangling among the parties over the valuation of Viacom and the proposed leadership of the combined company threatened to scuttle negotiations, with CBS going so far as to sue National Amusements, its own parent company, in an effort to resist the deal. As of publication, the merger negotiations and litigation are both pending.

These companies have sought opportunities to band together, in part, as a means of weathering the challenges presented by evolving consumer preferences for how they receive (and pay) for their content experiences. It is hard to overstate the impact that cord cutting has had, and continues to have, on the industry. According to estimates released by research firm eMarketer in September 2017, by the end of 2017, a total of 22.2 million U.S. adults would have "cut the cable" on their traditional MVPD packages, while the number of "cord-nevers" (consumers, usually younger, who have never subscribed to a pay television service) would rise to 34.4 million. In short, the widespread availability of high-quality, high-speed broadband Internet services has enabled customers to piece together, on an a la carte basis, a content experience that is at once more affordable and more narrowly tailored to their interests. And the upcoming rollout in the United States of high-bandwidth 5G (or "fifth generation") wireless mobile Internet infrastructure may accelerate this trend further by increasing competition and service quality in the broadband market.

The industry's traditional power players have responded to cord cutting, in part, by following the customers to where they are going: online. In so doing, however, while the companies have gotten bigger and bigger (both horizontally and vertically), the service offerings have gotten smaller and smaller. "Virtual MVPDs"— subscription services that function over the Internet, often integrating with and offered through third-party devices (e.g., smart televisions and set-top boxes like the Apple TV), that provide MVPD-like multi-channel programming services (without meeting the technical regulatory definitions of "MVPD"s)—have grown in availability and popularity. Hulu, YouTube, Sony PlayStation, and Dish Network all now offer services of this nature and carry some of the most popular and essential networks as part of their bundles. But these vMVPDs have systematically focused on offering so-called "skinny bundles" of fifteen to thirty channels (rather than traditional cable bundles of 200 to 500 channels), which allows them to offer their services at a significantly lower price point than traditional cable or satellite packages. (The trend toward smaller multi-channel packages further contextualizes Viacom's decision to shift its corporate strategy from a broad network portfolio to one that is more narrowly focused on a small group of distinct core brands.)

This narrowing, however, threatens to challenge some of the core economic assumptions on which the television industry (and indeed, much of the entertainment and media industries more generally) are built. Television has traditionally been a business of cross-subsidization. And for some companies, particularly heavily integrated and infrastructure-intensive service providers, consolidation creates a new opportunity for cross-subsidization. For example, AT&T excludes streaming of its DirecTV service from mobile data caps for its AT&T Wireless

customers. Comcast and Spectrum offer landline telephone service at a loss in order to encourage customers to subscribe to more lucrative television and broadband service packages (the so-called "Triple Play" service offering).

But for others, consolidation threatens to upend companies' typical strategies for managing risk and seeking upside. Media conglomerates have invested in new and niche cable network offerings on the assumption that they could obtain carriage for these services as part of package deals for their most desirable networks. Networks and studios have taken losses on multiple unsuccessful or marginally successful series, essentially punching lottery tickets to find the mega-hit series that would cover their other losses and provide them with their operating profit for years to come. The winnowing of networks, and the resulting reduction of inventory space for new programming, limits opportunities for such cross-subsidization. The increasing prevalence of lower-margin productions for rights-hungry international digital platforms also limits opportunities for any project to become wildly and disproportionately successful and profitable. This loss of upside, in turn, limits studios' capacity to absorb (far more frequent) losses from unsuccessful projects.

The resulting squeezes will be felt most acutely by the few remaining independent players in the marketplace. Ever since the breakdown of the "Financial Interest and Syndication" or "fin-syn" regulatory regime in the late 1980s and early 1990s (which opened the door to the major broadcast networks owning their own content), networks have embraced the economic opportunity that comes with being owners, and not merely licensees, of the content on their air. (This is also another prime example of cross-subsidization in action: given that a successful television series is generally more profitable for a network in its early years, and more profitable for a studio in its later years, then an integrated studio/network operation can essentially smooth out the swing of financial interests, and capture both profit centers for itself.) Many independent content providers went out of business altogether in the post-fin-syn world, and those who survived and thrived have had to develop strategies to endure—investing in developing content for unproven upstart networks without their own studio operations, embracing unscripted productions that offer more opportunity for scrappy low-overhead businesses, and/or simply working to develop content that is so undeniably good and desirable that networks cannot refuse it (often by paying for desirable underlying intellectual property or exclusive relationships with high-demand creators).

Even before the ongoing merger craze, independent providers began feeling pressure from buyers, whose ever-widening ambitions in the digital space, international footprints, and obligations to support affiliated companies (e.g., CBS's investment in CBS All Access; the other broadcast networks' investment in Hulu; and a wide array of network-specific streaming application offerings) caused them to make ever more expansive demands for distribution and exhibition rights (without necessarily offering significantly greater compensation for those additional rights). These more expansive demands for rights have undermined the traditional content revenue model of maximizing opportunities across

media, territory, and time, because content owners are left with fewer rights to monetize (and more restrictions on those rights they do retain).

But the current climate of contraction and consolidation has only further diminished the opportunities for independent providers to maximize their revenues across media, territory, and time, and challenged the more specific strategies these providers have used to navigate an already brutal marketplace. Big buyers with diverse, multifaceted businesses have even more expansive demands for rights (and even more bargaining power to satisfy those demands without paying a significant premium), leaving less upside for providers, when they can make a sale at all. And indeed, just making that sale is becoming increasingly challenging. Fewer networks means fewer new networks that need to be built up by motivated outside providers. At the same time, the centralization of resources within a few large companies means that even new networks have access to provider studios, while established networks have more "sister studios" from which to draw their content without having to look to outside providers. (For instance, in a post-Disney/Fox merger world, the ABC network could order series from ABC Studios, ABC Signature Studios, 20th Century Fox Television, or Fox 21 Studios, and in each instance, ABC would be buying from an affiliated studio, and the larger corporate body would still get the full benefit of the arrangement.)

So where does opportunity lie in a post-"Peak TV" world?

One place to look is abroad. The television industries in major territories such as the United Kingdom, France, Germany, Canada, Italy, South Korea, and China grow more sophisticated and better funded with each passing year. In the past, broadcasters in these countries may have been content to program their channels with a combination of imported high-end series that were developed and produced specifically for the American market, and lower-budget, lower-quality local productions. In more recent years, however, these territories have shown increasing demand for premium productions that are tailored, at least in part, to their audiences (and a willingness to pay for more substantial involvement in the development and production of internationally oriented series).

For several years, entrepreneurial foreign producers such as Gaumont International Television, Fabrik Entertainment, and Atlantique Productions have found success with international co-productions and co-commissions, producing high-profile series that were not obviously foreign imports (the way that the British origins of shows like *Downton Abbey* and *Sherlock* were always apparent to American audiences). For example, when *The Young Pope*, a richly produced series starring Jude Law as a youthful pontiff, premiered on HBO in January 2017, few viewers likely realized that it had been produced by a group of French, Spanish, and Italian companies that solicited simultaneous commissions from HBO in the U.S. and Canada, Canal+ in France, and Sky Atlantic in the United Kingdom, Germany, Austria, and Italy.

Given the growing challenges in the American market, U.S. producers have begun to make similarly entrepreneurial efforts to reach across the ocean, where

growing budgets and license fees can make the extra effort worthwhile. NBCUniversal was an early mover, announcing a three-way co-production plan with German broadcaster RTL and French broadcaster TF1 all the way back in April 2015. More recently, several other major American producers have followed suit. In February 2017, Lionsgate Television President Sandra Stern gave a keynote address in which she advertised the company's active efforts to find international co-production and co-commission partners. In April 2017, HBO and Sky announced a $250 million joint development and production fund to produce high-end dramas with both American and European audiences in mind. And in late 2017 and early 2018, Sony Pictures Television brought to audiences the anthology series *Philip K. Dick's Electric Dreams*, a co-commission of Channel 4 in the United Kingdom and Amazon in the United States and other territories, which was filmed partially in the United States and partially in the United Kingdom, and which even premiered in the United Kingdom nearly four months before its Amazon debut.

For those whose reach may not extend across oceans, the solution may be to go small. In a world filled with massive entities, mid-size players may suffer, but smaller and nimbler companies may continue to find opportunity. The world of short-form digital content continues to confuse and elude most major conglomerates, whose efforts as both platforms and producers have been uneven at best. Warner Bros. has seen some success with its Super Deluxe comedy website and production studio (an independently operated subsidiary of Time Warner's Turner Broadcasting unit) and Blue Ribbon Content (the Warner Bros. Television Group's digital and low-budget series production unit). YouTube has managed to preserve a robust, dynamic, creator-driven ecosystem on its platform, although the company's efforts to participate in that ecosystem as anything other than a passive platform-provider have been costly, inconsistent, and frequently controversial.

The big guys' records in small-scale digital only get more dismal from there. Disney's much heralded acquisition of Maker Studios in 2014, which ultimately cost the company $675 million, is widely understood to have been a huge failure, and by 2017, Disney had largely transformed Maker into a marketing engine for its other assets. Warner Bros.'s 2016 acquisition of Machinima seems to have been much less troubled (and, at a valuation just under $100 million, much cheaper), but thus far has not created the scale and value some had hoped to see. Sony's Crackle AVOD service has persevered for years without ever drawing a major audience, and its flagship series, Jerry Seinfeld's *Comedians in Cars Getting Coffee*, left the platform for Netflix in 2017. NBC launched its comedy-focused Seeso subscription streaming service in January 2016 and shuttered it in November 2017. ABC's own digital effort, a series of short-form comedy series available exclusively on ABC.com and through the ABC mobile application under the "ABCd" (or ABC Digital) banner, was even more short-lived, launching in July 2016 and quietly abandoned by January 2017.

Simply finding a stable platform in the digital space has proven challenging, as Seeso was not the only new platform to come and go in recent years. Comcast's

Watchable service, an app-based advertiser-supported free streaming service, launched in 2015 but never found a large audience; by late 2017, Comcast quietly let it be known that it would no longer invest in original content for the platform, signaling a likely end to the project in the near future. Fullscreen's similar app-based over-the-top subscription streaming service launched in April 2016 and survived only until November 2017, with the company indicating that it would re-focus its efforts on developing and producing original content for third-party platforms. Business Insider reported in April 2017 that Verizon had spent $200 million on original content in 2016, plus an additional $80 million in marketing expenses, to support its fledgling advertising-supported Go90 service— and wound up with only 2.1 million monthly app users, and 155 layoffs, to show for it. (Nevertheless, Verizon seems dedicated to figuring out the business, committing to producing 1,400 hours of original content in 2018 and continuing to order new series from providers such as Warner Bros.' Blue Ribbon Content unit.) In short, launching an over-the-top services requires huge investment in content, infrastructure, and marketing, and the companies who have been able to make it work have enjoyed some combination of first-mover advantage (Netflix), industry affiliate subsidization (Hulu, via its ownership structure), or massive deployable resources and complementary lines of business (Amazon and Apple).

Outside of the traditional television-like world of premium production for Netflix, Amazon, and Hulu (which has been dominated by traditional major television studios), the companies that seem to have done best in the digital ecosystem are ones like Funny or Die and AwesomenessTV, which have straddled the line between traditional and digital media, and which, critically, have stayed relatively small, distributing their content across a variety of third-party channels while avoiding business lines with cost-intensive investments in overhead, infrastructure and technology, and marketing. (Even these companies, however, have experienced challenges scaling their businesses and have endured rounds of layoffs.) This area of the market resembles unscripted programming, where the major players have also largely ceded the territory to smaller, low-overhead operations with greater expertise in scrappily efficient production (and greater tolerance for relatively low profit margins).

Ultimately, however, the greatest opportunities to come lie just outside of our current field of vision. Television has long been a uniquely innovative and entrepreneurial corner of the broader entertainment industry, with constant experimentation in business and technical models leading to the discovery of new opportunities. (It is also an industry that substantially rewards first-mover advantage, with innovators like Netflix and HBO inventing new business models, taking advantage of the rest of the industry's initial failure to fully understand and value what they were doing, and cementing dominant market positions that have allowed them to largely fend off challenges from newcomers.)

The current era of "Peak TV" was built on a series of tectonic shifts in the marketplace. Some of these, like the steady improvement in quality of and access

to broadband Internet service, were relatively predictable. Others—like the invention of a new secondary exhibition window (in the form of Netflix and Amazon, which started out as a DVD mailing service and online retailer, respectively), and a massive influx of capital from titans of the exceedingly well-funded technology industry—were less obvious in advance, but have quickly become so ingrained in the fabric of the industry that we can already hardly imagine it without them.

Ultimately, the next era in television will be defined as the last one was: not by further incremental tinkering with existing business and technological models, but by bold invention of new ones. And the norms described in this book will help set the templates for how business gets done in that new world, even as, in the hands of creative dealmakers, they evolve to meet that world's unique demands and opportunities.

GLOSSARY

100/5 Royalty. A standard rerun formula for episodic royalties, most commonly in the context of broadcast network series. It means that the holder of the royalty receives additional payments equal to 20% of the initial royalty amount, payable for each of the first five reruns of the applicable episode (i.e., a further 100% of the royalty over five reruns, hence, 100/5).

12/6 Proration. A standard proration formula applicable to series sales bonuses. It means that the full bonus is payable based on the production of twelve series episodes (excluding the pilot), with proration downward for smaller production runs, and no bonus payable for fewer than six episodes produced.

3/3/10 Package. A standard traditional formula for agency package commissions, comprised of three elements: (1) an up-front budgeted fee equal to 3% of the initial domestic network license fee; (2) an additional fee, equal to the first 3% fee, which is deferred and payable (if ever) out of the "Net Proceeds" of the series; and (3) a backend equal to 10% of MAGR (generally on the same definition as the most favorable definition accorded by the studio to any of the agency's clients on the project, but with no third-party participations of any kind taken off-the-top).

5/2.5 Royalty. A standard royalty formula granted to actors in connection with merchandising. It means that the actor receives 5% of the studio's "net merchandising receipts" (the studio's merchandising receipts, less distribution fees for the studio or its subdistributors, and out-of-pocket expenses), reducible by royalties granted to other actors featured on the same piece of merchandise to a floor of 2.5% of the studio's "net merchandising receipts" from each such product.

5/7 Holdback. A standard holdback formula in underlying rights deals, providing that specified reserved rights are "held back" (i.e., may not be exploited) until the earlier of five years following the initial exhibition of a production based on the property, or seven years following the execution of the rights agreement.

Above-the-Line. A category of production costs that covers writing and underlying rights fees, plus fees payable to the major talent (i.e., actors, writers, directors, and producers) who centrally influence and guide the creative process. The term refers to the traditional format of budget "top sheets," which displayed these costs above a literal line.

Active Integration. A form of product integration in which the characters on screen actively touch and use the advertiser's products, the products' logos are visible and reasonably conspicuous on screen, and characters may go so far as to mention the products by brand name in dialogue.

Actual Malice. A legal requirement for defamation liability, derived from the First Amendment, that applies when the allegedly defamed individual is a public figure. It requires that, in order to be liable, the speaker knew that his or her statement was false or acted with reckless disregard for the statement's truth or falsity.

Affiliation Agreement. An agreement entered into between an independently owned local broadcast station (i.e., one that is not owned by one of the four major broadcast networks) and a broadcast network, by which the station gains access to such network's programming and agrees to terms around the sharing of revenue and advertising inventory.

Agency Package Commission. A payment made to a talent agency, out of the budget and profits of a television series, in exchange for the agency's efforts in bringing together the key creative elements of the project, or alternatively, as a condition of the engagement of a single particularly significant element that is represented by the agency.

Agent. A representative of motion picture or television talent (e.g., actors, writers, directors, producers, etc.) whose principal role is to find work for his or her client.

Allied and Ancillary Rights (or Subsidiary Rights). A set of rights to use and/or exploit elements of a copyrighted work, beyond the distribution and exhibition of the actual work. Prominent examples include licensing and merchandising, soundtracks, music publishing, novelization, theme park, and live stage rights. As a technical matter, these may include derivative/subsequent production rights, although such rights are typically addressed separately.

Arcing Competition Series. A type of unscripted competition program that follows a narrowing group of competitors over an entire season, such as *Survivor* or *Top Chef.* A distinct type of format from, for example, traditional game shows that bring in new contestants for each episode, or for which only a single returning champion returns from episode to episode.

AVOD. "Advertising-Supported Video On Demand," i.e., customer access to one or more pieces of on-demand streaming content, which is provided at no charge to the customer but is accompanied by advertisements.

Backend. A colloquial term for defined contingent compensation or participation in the contractually defined profits of a series.

Backstop. A slang term for a minimum revenue guarantee. In the context of network license and co-production agreements, it refers to a network or co-production partner's obligation to reimburse the other party for any shortfall between the party's actual revenues from exploiting certain specified rights, on the one hand, and contractually defined revenue benchmarks for those same rights, on the other hand.

Barter. An agreement, often included as part of a syndication license between a studio and a broadcast station, by which the studio that produces and distributes the show gets the right to sell, for its own benefit, some portion of the available advertising time during the program.

Below-the-Line. All production costs other than "above-the-line" costs, including physical production expenses, and services fees for editors, camera operators, electricians, carpenters, and the dozens of other types of crew members who participate in production.

Best Seller Bonus. In an option/purchase agreement for a book that has not yet been published, a negotiated escalation to the purchase price triggered by the book's appearances on the New York Times Best Sellers list.

Bite. A network's option to order production of a pilot and/or series, and/or the option to engage a service provider in connection with such a production. Depending on the type of network, it may be based on a standard broadcast calendar, or a negotiated period of months.

Blind Script. A firm (i.e., guaranteed, non-contingent) deal to pay a writer to write a pilot script based on a to-be-determined, mutually approved creative concept, whether or not the studio is ultimately able to enter into an agreement with a network to develop the project.

Branded Content. Audiovisual content (often short-form digital series) that is produced in partnership with, and primarily or entirely at the expense of, major brands who wish to feature one or more of their products.

Breakage. Extra amounts paid by a network, beyond its initial negotiated license fee, in order to subsidize and incentivize the studio to enhance the production value and marketability of the series.

Breaking the Season. A slang term to describe the process by which the writers in the writer's room of a television series determine the overarching narrative and character arcs for the season, before the individual writers and writing teams are assigned specific episodes to write.

Broken Pilot. A produced pilot that is not ordered to series.

Business Affairs Executive. An individual, usually (but not always) a lawyer with years of dealmaking experience, who negotiates the substantive terms of a company's key business agreements.

Cable Syndication. The licensing of library episodes of existing television series for reruns on a basic cable network.

Carriage Agreement. An agreement by which an MVPD agrees to pay a network some portion of its collected subscriber fees in exchange for the MVPD's right to include the network as part of its channel offering to customers.

Chargebacks. A budgeted charge payable to a production company in exchange for the company's provision of certain critical production resources owned by the company (e.g., office space; studios and other production spaces; editing bays and other costly computer hardware and software; and cameras, lighting, and other physical production necessities), which, if not provided by the company, would have to be obtained from a third-party. Such costs are typically charged at market rates and passed through to the financier of the series, most often in the context of unscripted productions.

Classic Merchandise. Merchandising that is based solely on the intellectual property elements of a preexisting work (such as a book or comic book), without incorporating any of the specific original intellectual property elements of a series that may be produced based on that underlying work.

Clearance. The process of obtaining licenses (or making a legal determination that a license is not needed) for the depiction of material that appears on-camera, such as real-life company names featured in plot and/or dialogue, or logos on wardrobe, props, and/or set dressing.

Commercial Tie-Ins. An arrangement between a show and a brand, by which the brand provides advertising for the show as part of advertising its own products.

Companion (Digital/Streaming) Rights. Additional digital/streaming rights that are granted to a network licensee, beyond the standard rights necessary for the network's linear exhibition of the series, to allow the network to provide its viewers with convenient digital access to the show, e.g., through a network-owned on-demand streaming application and/or through an MVPD-run VOD service.

Consulting 1:1 (or Consulting One-for-One). Shorthand for a deal term, typical in agreements with television producers, providing for the producer to be engaged as a consultant on a pay-or-play basis for one year for each year that the individual had previously rendered executive producer services on the program.

Consulting Producer. A producing credit of ambiguous hierarchical stature, which may be granted to writer/producers who are working on a part-time basis or otherwise below their usual rank and/or pay. This credit may also be accorded, as a higher-level option than "Executive Consultant," to an underlying rightsholder who agrees to render ongoing consulting services as part of an option/purchase agreement for rights he or she controls.

Contingent Compensation (or Contingent Participation or Profit Participation). A contractual financial interest in the contractually defined "profits" of a series, granted as a key substantive term in various types of agreements for writers, producers, directors, underlying rightsholders, and sometimes actors.

Contract of Adhesion. An agreement that is presented on a take-it-or-leave-it basis, where the party with superior bargaining power refuses to negotiate most or all of its terms.

Co-Production Agreement. An arrangement between two studios to jointly produce, own, and distribute a television series.

Copyright. The core intellectual property asset of the content industry, protecting "original works of authorship fixed in any tangible medium of expression," including: (1) literary works; (2) musical works, including any accompanying words; (3) dramatic works, including any accompanying music; (4) pantomimes and choreographic works; (5) pictorial, graphic, and sculptural works; (6) motion pictures and other audiovisual works; (7) sound recordings; and (8) architectural works. The owner of a copyright exclusively enjoys four basic rights (which include the exclusive right to authorize others to exploit these rights): (1) to copy or reproduce the copyrighted work; (2) to prepare derivative works based upon the copyrighted work; (3) to distribute the copyrighted work; and (4) to publicly perform or display the copyrighted work.

Cord Cutting. The phenomenon of consumers canceling their subscriptions to traditional cable, satellite, and other MVPD services in favor of consuming content through a variety of free over-the-air and Internet-based subscription services.

Cost of Production. The actual, out-of-pocket, third-party costs paid out by a studio to produce a television series.

Cost-Plus Deal. A license agreement, typically between a studio and a streaming service with an international footprint (such as Netflix or Amazon), in which the up-front license fee exceeds the cost of production of the series.

Cross-Collateralization. In the participations accounting context, the extent to which revenues and expenses from separate categories of exploitation are aggregated with one another for purposes of determining whether expenses have been recouped and participations are due. In the context of an overall term deal, the extent to which the guarantees paid and fees recouped in separate years of the deal are aggregated with one another for purposes of determining the vig and the availability of fresh cash.

Defamation. The general term for a legal claim involving injury to an individual's reputation arising out of the publication of false statements about the individual. Sometimes referred to colloquially as "libel" or "slander."

Deficit. The difference between the cost of a series and the initial license fee paid by the commissioning network, representing the studio's at-risk investment in the series.

Deficit Recoupment. A negotiated term of network license agreements providing for the network's reimbursement to the studio, typically in the fifth (or fifth and sixth) seasons of a series, of the studio's production deficits from the first four production seasons of the show.

DGA. The Directors Guild of America, the union representing professional directors working in the U.S. television industry.

Digital Rights. In a license agreement with a traditional broadcast or cable network, exploitation and distribution of a series to customers via the Internet, typically on an "on demand" (rather than preprogrammed/linear) basis, that does not fall within the definition of "network exhibition." In a license agreement with a digital platform, the direct exhibition rights granted to the licensee.

Distribution Expenses. All expenses incurred by a studio in the process of distributing a television series, including, without limitation, advertising and marketing expenses; costs for subtitling or dubbing of foreign versions; the expense of duplicating and transporting physical materials to licensees; clearance fees that have not otherwise been accounted for as production costs; residuals and reuse fees payable to talent pursuant to applicable union collective bargaining agreements; costs of enforcement (including intellectual property and audit litigation); and other so-called "off-the-tops" (referring to checking, collection, currency conversion, and certain tax [but not income tax] expenses).

Distribution Fees. A defined percentage of revenues received from nearly all sources, which the studio retains as compensation for its investment of time, effort, overhead, and other resources in the process of distributing a television series.

Double Banger (or Triple Banger). A "double banger" is a 40+ foot trailer with two separate side-by-side private compartments for use as dressing rooms by actors or other high-level crew members. A "triple banger" is a similar trailer, but with three smaller compartments, rather than two larger ones.

Drop Down. The right of an individual who is under contract to render exclusive or first priority services (such as a showrunner) to reduce their level of contractually required services (e.g., to part-time and/or non-exclusive services), for a lower fee.

End Credits (or End Titles). The credits that roll at the end of an episode of television, where most cast and crew are accorded credit.

Errors and Omissions Policy. An insurance policy that provides coverage against liability for claims of copyright and trademark infringement, defamation, violation of the rights of privacy and publicity, and comparable claims.

ERT. "Electronic Rental," i.e., a temporary time-limited download/viewing right, akin to the rental of a traditional physical DVD or Blu-ray. A sub-category of TVOD.

EST. "Electronic Sell-Through," i.e., a permanent download of an episode or series, akin to the purchase of a traditional physical DVD or Blu-ray that the customer gets to keep. A sub-category of TVOD.

Excluded Advertising. A contractually defined subset of "paid advertising" for a series that is excluded from the definition of "paid advertising," for purposes of a studio satisfying its obligations to a credit recipient (such as an actor) with respect to according credit in advertising for a series. This category frequently includes, e.g., television and radio commercials.

Extended Term. A sub-category of broadcast network license agreements that provides for seven-year (or seven-and-a-half-year) terms, thereby delaying the point at which the network may face a costly renegotiation with the studio to a point that few series have the longevity to achieve.

Fair Use. An affirmative defense to a claim of copyright infringement, derived from the First Amendment, which allows limited use of a copyrighted work without compensation or liability to the copyright owner. In considering a claim of fair use, courts look at four elements: (1) the purpose and character of the use, including whether such use is of a commercial nature or is for nonprofit educational purposes; (2) the nature of the copyrighted work; (3) the amount and substantiality of the portion used in relation to the copyrighted work as a whole; and (4) the effect of the use upon the potential market for or value of the copyrighted work.

False Designation of Origin (or False Endorsement). A trademark-type claim, which may be asserted under the federal Lanham Act or corresponding state laws, based on a defendant's alleged misuse of material (e.g., a celebrity name or likeness, or a product or corporate name, slogan, logo, or other text or visual identifiers) that is publicly identifiable with the plaintiff and its business but that is not actually registered as a trademark.

False Light. A privacy-based tort claim closely related to defamation, which creates liability for a defendant who widely publishes a statement that identifies the plaintiff and places the plaintiff in a "false light" that would be highly offensive to a reasonable person. Many states understand "false light" claims to be based on implications, rather than outright factual statements (which would likely be the subject of a defamation claim).

FCC. The Federal Communications Commission, i.e., the principal government regulatory agency overseeing the television industry, by virtue of its exclusive jurisdiction over the granting and transfer of broadcasting licenses and its role in regulating certain aspects of the cable and broadband industries.

Firm Script. A guaranteed, non-contingent deal to pay a writer to write a pilot script based on a specific creative concept, whether or not the studio is ultimately able to enter into an agreement with a network to develop the project.

First Look Deal. An agreement by which a writer/producer, producer/director, or, most often, non-writing producer grants a studio an exclusive first opportunity to develop and produce projects that are created, owned, or controlled by that individual/company, before the individual/company may present any such projects to another studio or network for consideration. The "first look deal" usually provides for pre-negotiated terms that automatically apply if the studio wishes to proceed with development, although, especially in the context of a staffing deal, it may simply be a first negotiation right, with the eventual substantive terms being subject to good faith negotiation.

First Negotiation (or First Opportunity or First Opp or FN or ROFN). A contractual requirement that the seller of rights must undergo exclusive good faith negotiations with the holder of the first negotiation right, before the seller may negotiate with other interested parties.

First Priority. A class of services that gives an employer studio the general right to require the individual to render services when and where required by the studio, with the individual's services for third parties being subject to the individual's commitment to satisfy his or her obligations to the first-priority employer.

First Refusal (or FR or ROFR). A contractual requirement providing that, if the seller of rights is prepared to accept terms less favorable to the seller than those last offered by the holder of the first refusal right (or, alternatively, less favorable than those last demanded by the seller), then, prior to accepting the deal, the seller must give the first refusal holder an opportunity to purchase the rights on those same terms. This right is typically granted alongside a first negotiation right.

First-Run Syndication. Licensed broadcasts of first-run original content produced by third-party studios or production companies directly for broadcast stations without an intermediary commissioning network, frequently in the genres of daytime talk shows and daytime game shows.

Force Majeure. "Acts of god" (such as war, earthquakes and major weather events, union strikes, and other events beyond any party's reasonable prediction or control) that may serve to extend time periods or excuse the performance of obligations under a contract.

Format. The overall concept and branding of a copyrighted television program, including general story, setting, and characterization, but not including the specific scripts and/or shot episodes of the original series.

Format Fees. Fees payable to the owner of a television format in exchange for the right to create a local television series based on the format of an existing show.

Fresh Cash. In the context of an overall term deal, additional payments due to the talent in excess of the minimum guarantee under the deal (i.e., payments that are not recouped against the guarantee).

Frozen Rights. Rights that are reserved but that are unexploitable by both the buyer and the seller under an option/purchase agreement unless the parties are able to reach some future agreement on the terms for the "unfreezing" and exploitation of the rights, or the "freeze" otherwise expires according to the terms of the contract (and the rights revert to the sole control of one of the parties).

FVOD. "Free Video On Demand," i.e., access to digital content without a direct charge, subscription charge, or requirement of viewing ads.

Generic Spinoff. A spinoff television series that includes as a principal character one or more principal characters who appear in the original series, or the underlying work on which the original series is based.

Gross Budget. The production budget (i.e., anticipated cost of production) of a television series, without regard for any applicable tax incentives.

Gross Receipts. A contractually defined term to capture the accountable revenue received by (or credited to) a studio from its exploitation of a television series and all rights therein, from all sources. In the context of talent profit participations (as opposed to co-production waterfalls), it may exclude certain revenues or provide for special accounting terms (e.g., a royalty) for certain types of revenues.

Holdback. A contractual agreement not to exploit reserved rights in a piece of intellectual property until a specified amount of time has passed or some triggering event has occurred.

IATSE. The International Alliance of Theatrical Stage Employees, the union representing most "below-the-line" crew working in the U.S. television industry.

Idea Theft. A patchwork of state law actions available to plaintiffs who believe their ideas have been unjustly stolen, primarily a claim of breach of implied contract, on the theory that a studio's decision to hear a pitch implies a commitment that it will not use the idea presented without entering into some kind of agreement with the pitching party for rights and/or services.

If/Come. An agreement by which a studio negotiates writing and producing terms for a writer to develop a specific creative concept, but the entire agreement (and all financial commitments) are contingent on the studio, in turn, selling that idea to a third-party network licensee (which will contribute to the development costs of the project).

Imputed License Fee. A contractually defined amount, used by a studio calculating contingent compensation due to profit participants, that represents the revenues received by the studio from an affiliated network licensee.

In the Field. Production of a television program on location and not in a studio environment, often associated with lower-budget unscripted documentary series.

Independent Studio. A television studio that has no corporate relationship, or only a high attenuated corporate affiliation, with a network.

Initial Domestic License. The original license agreement entered into between a studio and the commissioning U.S. network, providing for the production of a television series.

Intentional Infliction of Emotional Distress. A tort claim whose elements are: (1) an intentional act by the defendant; (2) the defendant's conduct was extreme and outrageous (beyond the standards of civilized decency); and (3) the plaintiff suffered severe emotional distress (as manifested by physical symptoms, a demonstrated lack of productivity, or a medically diagnosed mental disorder) that was caused by the plaintiff's act.

Last Refusal (or LR or ROLR). A somewhat uncommon and burdensome contractual right, also granted alongside a first negotiation right, which requires that the seller of rights give the last refusal holder a final opportunity to accept the terms of any deal that the seller is prepared to enter into with a third party, even if the third party has offered the seller more favorable terms than were ever offered by the last refusal holder.

Laverne & Shirley Credit. A form of joint first-position credit granted to two co-leads, in which both credits appear on a single card, with one name positioned to the bottom-left and the other to the upper-right.

Lead Studio. In a co-production arrangement, the studio that is responsible for managing physical production of the series.

Libel. Written or otherwise fixed and recorded defamation.

Libel-Proof. A legal term for an individual whose reputation is so tainted that he or she can no longer sustain claims for defamation, at least with regard to certain subjects.

License Agreement. An agreement between a studio and a network or other licensee, by which the studio grants the network/licensee specified, limited rights in the series, for a specified territory and period of time, in exchange for negotiated compensation.

License Fee. The base compensation payable by a network or other licensee to a studio in connection with a license agreement.

Life Lock. A guarantee (potentially subject to specified conditions) that an individual will receive payment of his or her episodic fees for all episodes produced for the entire run of a television series.

Life Rights Agreement. A waiver of claims that may otherwise be brought by an individual who is depicted without his or her consent in a television series.

Likelihood of Consumer Confusion. The key concept that must be proven in order to establish liability for trademark infringement. In assessing the likelihood of consumer confusion, courts consider: (1) the strength of the plaintiff's mark; (2) the similarity of the marks; (3) proximity of the products and their competitiveness with one another; (4) evidence that the plaintiff might "bridge the gap" by developing a product for sale in the defendant's market; (5) evidence of actual consumer confusion; (6) evidence

that the defendant adopted or used a mark in bad faith; (7) the respective quality of the parties' products; and (8) sophistication of consumers in the relevant market.

Linear Exhibition. Exhibition of a continuous pre-programmed stream of content that is accessed by the customer by dipping into the stream at any given time, without the customer having on-demand control over what he or she watches and when.

Liquidated Damages. Contractually defined and pre-agreed damages, which are often used in contracts when it would be difficult or impossible to accurately measure the real-world economic harm of a given contractual breach (such as a breach of confidentiality obligations).

Literary Agent or Manager. An agent or manager who specializes in representing writers, directors, and/or producers, as opposed to actors.

Live + Same Day ["SD"] (or Live + 3, or Live + 7). Categories of television ratings published by the Nielsen Company, measuring the number of viewers who watched a given television program as it aired in real time or by 3 a.m. the day after the initial broadcast (for Live + SD), or within three or seven days after the initial broadcast (for Live + 3 and Live + 7, respectively).

Lock. The period of time for which a writing or non-writing producer's fees are guaranteed, if the series is actually produced for that long, whether or not the individual's services are actually used.

Logo Credit (or Company Credit). A logo that appears after the end credits at the end of each episode of a television series, which bears the name of the "production company" of a showrunner or high-level non-writing executive producer.

MAGR. "Modified Adjusted Gross Receipts," a common term for the principal form of defined contingent compensation accorded to profit participants in television series. Different studios may use different terms for this concept, including "Modified Gross Receipts" or "Contingent Proceeds."

Main Titles. An opening title/credit sequence that precedes the actual action of each episode of a television series, which may be elaborately animated or produced. This term may also be used somewhat interchangeably with "opening titles."

Manager. A representative of motion picture or television talent (e.g., actors, writers, directors, producers, etc.) whose principal role is to counsel clients on their careers and/or to serve as creative partners on clients' projects, but not necessarily (or at least officially) to procure employment for the client.

Modified Two-Year Lock (or Two-Year Warner Lock). An initial one-year lock that automatically expands to cover the second season of the series if the studio fails to exercise its "pay-or-play" right (i.e., termination without cause) prior to the completion of the individual's services on the first season.

Multi-Camera Comedy. The traditional form of television comedy (such as *The Mary Tyler Moore Show* or *Friends*), characterized by: (1) filming before

a live studio audience (with multiple cameras simultaneously filming each take of each scene); (2) use of a small number of stage-built sets; (3) frequent reliance on laugh tracks; (4) a more "old school" or "classic" feel to audiences; and (5) generally lower production costs, relative to single-camera comedies.

Must Carry. The right of a broadcast station, pursuant to the 1992 United States Cable Television Consumer Protection and Competition Act, to compel an MVPD to offer the station to local subscribers in their markets for no compensation paid to or by the MVPD.

MVPD. Multichannel video primary distributors (MVPDs), i.e. cable, satellite, and telecommunications providers that sell to consumers subscriptions for packages of various television networks.

Net Budget. The gross budget of a series, after deducting tax incentives or rebates obtained (or anticipated) by the studio in connection with the production.

Network. A business that aggregates content and markets and exhibits that content to customers, but is not necessarily the producer or owner of the content that it exhibits.

Newsworthy. A legal concept, derived from the First Amendment, that identifies "matters of legitimate public concern." If true facts are deemed to be newsworthy, then the publication of those facts cannot be the basis of liability for the tort of public disclosure of private facts.

Nominative Fair Use. A defense to a claim of trademark infringement, derived from the First Amendment, which allows the public to freely use a protected trademark to literally describe the product or service underlying a mark. In considering a claim of nominative fair use, courts look at three elements: (1) the product or service in question must be one not readily identifiable without use of the trademark; (2) only so much of the mark may be used as is reasonably necessary to identify the product or service; and (3) the user must do nothing that would, in conjunction with the mark, suggest sponsorship or endorsement by the trademark holder.

Non-Writing Producer. An individual who is not a writer but who serves an important role in the creative development and/or physical production of a television series. This category may include individuals who scour the marketplace for interesting pitches from writers and underlying properties to adapt and bring to studios; individuals with close relationships with key talent who can attract prominent writers, directors, or actors to a project; directors who work on the production of a series on an ongoing basis even when not personally directing a particular episode; and managers or other close confidantes and creative partners of writers, rightsholders, star actors, or other key creative elements.

Off-Network. A term that generally describes a studio's distribution/exploitation of a television series outside of the original commissioning network.

It frequently refers more narrowly to *television* exhibition of the series off of the original network, and may be used interchangeably with "syndication."

Off-the-Top. A term that refers to the deduction of expenses as part of a contractually defined contingent participation formula in order to calculate a specific accounting unit in which a profit participant has a share (e.g., "Modified Adjusted Gross Receipts"). As a plural noun, "off-the-tops" may also refer to a specific sub-category of distribution expenses that includes checking, collection, currency conversion, and certain tax (but not income tax) expenses.

Online Video Distribution. The FCC's preferred regulatory term for the market most people refer to as "streaming" or "digital video."

Opening Titles. Credits that appear at the beginning of each episode of a television series, with text superimposed over the actual filmed action of the episode. This term may also be used somewhat interchangeably with "main titles."

Option. In the context of an option/purchase agreement, the buyer's right to purchase the negotiated rights. In the context of a services agreement, the studio/employer's right to require an individual to continue rendering services on a television series (usually a subsequent season) on pre-negotiated terms.

Option/Purchase Agreement. An agreement by which a buyer (in the television context, typically a studio) acquires the exclusive and irrevocable right, for a specified period of time, to purchase certain specified rights in a given property, on pre-negotiated terms.

Overages. Production costs incurred by a studio in excess of the ingoing budget for a production.

Overall Deal (or Overall Term Deal). An agreement by which a studio obtains the fully exclusive services of an individual for the term of the agreement.

Overhead. In the context of profit participation or co-production waterfall definitions, a percentage of production costs (usually 10% to 15% for talent participants, and 5% to 7.5% in co-production agreements) deducted by the studio from a television series's gross receipts, as compensation to the studio for the in-house salaries, offices, and other overhead expenses used in the studio's production business. As a more general term, "overhead" identifies such salaries, facilities costs, and other general operating expenses of a business (which are not related to any specific production).

Override. A distribution fee charged by a studio on the gross receipts generated by a subdistributor, over and above the distribution fee charged by the subdistributor, as compensation to the studio for the effort and expense of managing and monitoring the subdistributor.

Over-the-Top. A catch-all term for content services that users access through their general-purpose Internet subscriptions, without relying on a separate,

service-specific technological system (such as the coaxial cables that underlie cable television or fiber-optic cables used by telecommunications-based television providers).

Owned & Operated (or O&O). A local broadcast station that is directly owned and operated by the national broadcast network whose programming it carries.

Packageable Element. An agency-represented individual, such as a writer/creator who is qualified to showrun his or her own series or a particularly prolific and well-established non-writing producer, who is sufficiently high-stature and in-demand to warrant paying the agency a partial or full agency package commission solely on the basis of the agency's representation of that single individual creative element.

Paid Advertising. A contractual defined term that identifies what type of advertising activity is deemed to be a "paid ad" (as opposed to, e.g., an "excluded ad") for purposes of a studio satisfying its obligations to a credit recipient (such as an actor) with respect to according credit in advertising for a series.

Passive Integration. A form of product integration in which a product or logo appears visibly but passively on screen during a program, without the characters on screen actively touching, using, mentioning, or otherwise interacting with the product.

Pay-or-Play. A guarantee that an individual will be paid some specified amount, whether or not the artist's services are actually required or used by the hiring party. May also be used as a verb to describe terminating a service provider without legal cause.

Peak TV. A term coined by FX Networks Chief Executive Officer John Landgraf, in an August 2015 presentation to the Television Critics Association, to describe the current era of prolific television programming, characterized by: (1) a high volume of series being produced and exhibited; (2) significant fragmentation of the television audience; (3) escalating production budgets and fees for the most valuable talent on the most premium productions; (4) the prevalence of low-cost programming alternatives from parties unwilling or unable to compete in the blockbuster arms race; and (5) significant disruption and innovation in business and exhibition models.

Penalty. A significant payment, negotiated as part of a development deal between a network and studio, owed by the network to the studio in the event the network elects not to proceed to production of a pilot and/or series.

Picking Up. A slang term for exercising an option. It may be used to refer to a network exercising its option to order production of a pilot and/or series (first or subsequent seasons), or a studio exercising its option to purchase a property or to engage an individual to render services on such pilot and/or series.

Pilot (or Prototype). A standalone episode of a television series that is used to establish and demonstrate the style and content of a proposed television

series, and to persuade a network to order production of a full season's worth of episodes for that series.

Pilot Commitment. A commitment by a network to order (and pay its applicable license fee/cost share for) the production of a pilot. This term may sometimes be used interchangeably with "put pilot."

Pitch. As a noun, it refers to a verbalized idea for a new series that has not been reduced to a written screenplay. As a verb, "pitch" refers to the act of trying to sell a project to a buyer (e.g., a writer may pitch a studio; and a studio and writer may jointly pitch a network).

Planted Spinoff. A spinoff television series that follows a character who is introduced anew into the original series in order to set that character up for his or her own series, e.g., the character of Mork from Ork, played by Robin Williams, who appeared in a single episode of *Happy Days* before being spun off into the series *Mork & Mindy*.

Point. A slang term for a single percentage point of contingent compensation (in television, typically MAGR).

Polish. A less labor-intensive revision to a screenplay, in which changes are made to dialogue, narration, or action, but without altering the basic story-line or interrelationship of characters in the script.

Position (or Priority). The right of one prospective employer to require the services of an individual, as, where and when required by that employer, relative to the potentially competing right of a different employer to require the same individual to render services for the third-party employer.

Premium. In a cost-plus deal, the amount by which the license fee exceeds the show's cost.

Product Integration (or Product Placement). A broad term capturing the paid use, depiction, and/or mention of an advertiser's product within a television show (or other filmed entertainment).

Production Company. A company that manages the physical production of a series (i.e., the day-to-day management of all of the human and physical resources that go into the production process), without necessarily owning the intellectual property in the produced series. Alternatively, "production company" may refer to a company brand for a prominent individual writer, director, or non-writing producer (who may work in conjunction with a creative assistant or executive on that individual's payroll).

Pro Rata. Proportionate.

Public Disclosure of Private Facts. A privacy-based tort claim whose elements are: (1) a public disclosure by a defendant; (2) of one or more facts about the plaintiff that were private; (3) whose publication was offensive to a reasonable person of ordinary sensibilities; and (4) where the facts being published are not newsworthy.

Public Domain. The status of a once-copyrighted work whose copyright has expired, or otherwise terminated for technical reasons applicable to

older works under the 1909 Copyright Act. A "public domain" work may be used freely by any member of the public without permission from or compensation to the original copyright owner. The term "public domain" may also be used to identify material that is not eligible for copyright protection and therefore also free to use, such as facts.

Purchase Price. The pre-negotiated amount paid by the optioning party to acquire the rights under option in an option/purchase agreement.

Put Pilot. A sub-category of "pilot commitments" for which the network owes the studio a further penalty if it declines to order a series following production of the pilot. However, this term may casually be used interchangeably with "pilot commitment."

Ratings and Rankings Bonuses. Additional payments from the network to the studio pursuant to a network license agreement (often, but not always, on a per-episode basis) that are triggered by a series achieving certain average viewership benchmarks, as measured and published by the Nielsen Company.

Recoupability. The extent to which guaranteed compensation under an overall deal may be treated as a pre-payment of, or an advance against, fees that may be actually earned by the talent for services rendered during the term of the overall deal.

Reserved Rights. Those rights in a piece of intellectual property that are excluded from the grant of rights under an option/purchase agreement and that are therefore "reserved to" the seller/grantor of rights (e.g., the author of a book).

Residuals. Payments payable to talent, as a percentage of revenues received by a studio from international and other secondary exploitation of a series, pursuant to applicable union collective bargaining agreements.

Retransmission Consent. The right of a broadcast station, pursuant to the 1992 United States Cable Television Consumer Protection and Competition Act, to negotiate with an MVPD for economic and/or non-economic compensation from the MVPD in exchange for allowing the MVPD to include the station in packages for local subscribers.

Reverse Retransmission. The practice of broadcast stations sharing with their affiliated networks some portion of the retransmission consent fees they receive from MVPDs.

Reverse Royalty. In the context of unscripted documentary series that follow the personal and professional dramas surrounding real-life businesses, an amount owed by the subject of the series (either as an individual or a company) to the network or production company in exchange for the promotional value provided by the series.

Reversion. Following the acquisition of rights pursuant to an option/purchase agreement, the return of certain rights to the original rightsholder/grantor after a specified period of time, depending on whether or to what extent programming has actually been produced based on the granted rights.

Right of Publicity. An individual's commercial right, derived from the more general legal right of privacy, to control the use of his or her name, likeness, or other indicia of identity in commerce. The elements of a claim for infringement of the right of publicity are: (1) the defendant's use of the plaintiff's identity; (2) the defendant's appropriation of the plaintiff's identity to the defendant's advantage, commercial or otherwise; (3) the absence of consent from the plaintiff; and (4) injury to the plaintiff.

Roll a Deal. A studio's decision to postpone the commencement of a writer's services under a firm script deal by up to twelve months, into the next development season. The decision and right to roll a deal may be based on the writer's professional unavailability, or, if the deal permits, the studio's convenience and discretion.

Rolling Five. A common standard of companion digital rights for licenses to traditional broadcast or cable networks, granting the network the right to make available to customers up to five episodes of the series at a time on an on-demand basis, to enable customers who fall behind on a series to catch up on recent episodes.

Royalty (or Passive Royalty). A passive (i.e., no-services-required) episodic payment that is usually granted to an individual or rightsholder pursuant to an option/purchase agreement for underlying rights, the agreement with the pilot writer/series creator, and/or the pilot director agreement.

Run. A distinct scheduled exhibition of an episode of a television series. A typical network license agreement with a traditional broadcast or cable network will typically limit the network to a specified number of runs for each episode of the series, or allow the network to make additional runs in exchange for additional license fee payments.

SAG/AFTRA. The Screen Actors Guild/American Federation of Television and Radio Artists, the union representing professional actors and other on-camera performers working in the U.S. television industry.

Scenes A Faire. "Stock scenes" and other creative elements that are expected for a particular genre and are not protectable under copyright.

Separate Pot. A royalty or profit participation in a specified category of rights (most commonly merchandising), for which the applicable revenues and expenses are not cross-collateralized with revenues and expenses from other rights or from the production and distribution of the series generally.

Separated Rights. Certain allied and ancillary rights (including stage, theatrical, publication, and merchandising rights) that are automatically reserved to the writer/creator of an original television series under the WGA Basic Agreement, unless the commissioning studio satisfies the upset price for the pilot script and purchases the separated rights from the writer in a separate negotiated document.

Series Commitment (or Straight-to-Series Order). A commitment by a network to order (and pay its applicable license fee/cost share for) the

production of the first season's worth of episodes of a proposed television series, without going through a pilot step.

Series Regular. One of the six to ten lead actors (or more in later seasons of a series) who are most central to a show's creative content and who enter into complex, multi-year deals that firmly establish the television series as their primary employment obligation for as long as the studio and network maintain options for the actor's services and wish to continue to employ them.

Series Sales Bonus. A bonus payment payable in the event a series is ordered to production of its first season (or, in rarer cases, subsequent seasons). These bonuses are commonly granted in connection with option/purchase agreements for underlying rights, writing/writer-producer agreements, and pilot director agreements, and may also be agreed to for non-writing producers.

Series Term. The number of consecutive, dependent options held by the network to order additional seasons of a series pursuant to a network license agreement.

Set-Up. The act of entering into an agreement with a network to develop and/or produce a new television series.

Shiny Floor Show. A high-budget game show or studio-based competition show produced in a glossy studio environment, such as *$100,000 Pyramid* or *The Voice*.

Shopping Agreement. An agreement by which the parties agree to jointly develop and market a project, and agree that neither party will enter into a further agreement with a studio in connection with the project unless the other party also successfully negotiates a deal for itself.

Showrunner. The lead individual creative force guiding the production of a television series, with primary responsibility for generating story arcs, leading large teams of writers and other production personnel, understanding and managing budgets and schedules, and otherwise coordinating with studio and network executives. The showrunner is typically a writer, and frequently/ideally the writer who wrote the pilot script and created the series (if that individual is senior and experienced enough to be able to handle the role).

Single-Camera Comedy. The more contemporary and recently fashionable style of television comedy (such as *The Office* or *Modern Family*), characterized by: (1) more location (rather than stage) filming; (2) lack of live audiences and laugh tracks; (3) a more "premium" feel to audiences; and (4) generally higher production costs, relative to multi-camera comedies.

Slander. Spoken defamation.

Source Credit. Credit accorded to the underlying work from which a series is adapted, e.g., "Based on the novel by [AUTHOR]."

Spec Script. A fully written script prepared by a writer "on spec," i.e., independently and without guaranteed compensation, in order to help the writer convince a studio to develop the project.

Special Purpose Vehicle (or SPV). A one-off subsidiary of a larger studio, through which the studio elects to enter into all of the relevant contracts for the production of a series. Such SPVs may be favored by studios for reasons of liability management, union obligation management, and/or tax and accounting preferences, among other considerations.

Stacking Rights. The right, granted to a network pursuant to a license agreement, to make every episode of a given season of a series (without numerical limit) available to customers for "on demand" streaming while that season is ongoing.

Staff Writer. The junior-most rank of television writer.

Staffing. The process of engaging writers and writer/producers to join the writer's room of a series. The term "staffing writer" may be used to refer to a writer or writer/producer who is engaged to work on a series, but who is not the series creator or showrunner.

Story. Literary or dramatic material indicating the basic characterization of the principal characters and primary storyline of a script, but without detailed dialogue or scenes sufficient to constitute a complete teleplay.

Story Editor. The second most junior rank of television writer, and the first that is subject to the WGA Basic Agreement's more favorable "Article 14" provisions governing "Writers Employed in Additional Capacities."

Straight Offer. A firm offer of employment to an actor for a (usually series regular) role, without the requirement that the actor submit to a "test" process.

Studio. The entity responsible for the financing, development, production, and distribution of television productions, and the core rightsholder for such productions, typically controlling every facet of their worldwide exploitation.

Subdistributor. A third-party distributor that is engaged by a studio to assist the studio in distributing a series in media or territories where the primary studio lacks the necessary resources, relationships, or expertise to effectively distribute the applicable rights itself.

Subsequent Productions (or Derivative Productions). A broad term for additional audiovisual productions that feature or are based on the plot, main characters, or other principal elements of a television series, including, without limitation, television sequels and prequels, television spin-offs, and theatrical feature films based on a television series.

Substantial Similarity. A key legal factor for determining liability for copyright infringement, addressing whether a defendant's work is so similar to a plaintiff's as to amount to actionable improper appropriation.

Substantial Truth. In defamation law, the concept that a disputed statement or depiction need not be perfectly accurate in every conceivable way in order to be immune from defamation liability, so long as it is *substantially* true.

SVOD. "Subscription Video On Demand," i.e., authenticated access for paying subscribers to a library of on-demand streaming content.

Syndication Agreement. A catch-all term for the television licensing of episodes of a television series other than to an initial commissioning network, usually in reference to licensing to broadcast stations. If the license is for library episodes of an existing television series that was previously exhibited by a network, the more specific term "second-run syndication" may apply. If the license is to a cable network, it may be referred to as "cable syndication." If the license is for an original series, it is typically referred to by the more specific term "first-run syndication."

Talent. A catch-all term covering all major creative contributors to a series (e.g., actors, writers, directors, producers); or, more specifically, a reference to actors in particular.

Talent Agent or Manager. A catch-all term covering agents and managers who represent various types of creative professionals (e.g., actors, writers, directors, producers); or, more specifically, agents and managers who specialize in representing actors in particular.

Tax Incentives. A catch-all term for tax credit, rebate, and/or exemption programs that have the effect of lowering a studio's effective out-of-pocket cost to produce a television series, which are instituted by local and national governments to incentivize studios to produce projects within their jurisdictions.

Television. The distribution of audiovisual content to individual consumers, at times and locations and on devices of their own choosing.

Tenpercentery. A slang term for talent agencies, referring to the standard 10% commission they charge on all revenues earned by their clients.

Test Option. An agreement between a studio and an actor, granting the studio a short-term option to engage the actor to render acting services on pre-negotiated terms for the series pilot (or, if there is no pilot, first season). Test options are typically simultaneously negotiated with multiple actors auditioning for a single role so that the studio can choose among multiple options and have a locked deal firmly in place with the actor it decides to hire.

Tethered Download. A download (rather than stream) of content by a customer of an SVOD service, by which the customer receives permanent or semi-permanent access to the content off-line so long as the customer maintains an active subscription.

Third-Party Participations. Contingent compensation payments owed or made to third parties other than a specific profit participant, whose payments may be deducted by the studio as expenses and therefore reduce the amounts payable to that specific profit participant.

Top-of-Show. A SAG/AFTRA-defined flat rate for "major role performers" that buys out all services required from the actor for a single episode's work.

Trademark. A limited property right in a particular word, phrase, or symbol that is used to identify an individual or company as the source of a given product or service.

Tradeout. An agreement by which an advertiser provides a television production with free products that can be used as wardrobe, set dressing, or props on screen (thereby saving the studio the expense of buying or renting such items), but does not provide any separate compensation to the studio, or receive any separate assurances about the nature and extent of the show's depiction of the brand's products.

Transformative Use (or Transformation). In right of publicity law, a balancing test derived from the First Amendment, which may eliminate liability for the unauthorized use of an individual's name, likeness, or other indicia of identity so long as the defendant has sufficiently "transformed" that celebrity's identity. In considering a claim of transformative use, courts look at five elements: (1) whether the celebrity likeness is one of the raw materials from which an original work is synthesized; (2) whether the work is primarily the defendant's own expression if the expression is something other than the likeness of the celebrity; (3) whether literal and imitative or creative elements predominate in the work; (4) whether the marketability and economic value of the challenged work derives primarily from the fame of the celebrity depicted; and (5) whether the artist's skill and talent has been manifestly subordinated to the overall goal of creating a conventional portrait of a celebrity so as to commercially exploit the celebrity's fame. In a fair use analysis under copyright law, "transformation" also refers to a critical element of how courts evaluate the "purpose and character" of the defendant's use of a copyrighted work (i.e., the first and arguably most important factor of the four-factor fair use test).

TVOD. "Transactional Video On Demand," i.e., paid access to content online, with purchase and/or rental fees paid on a specific product-by-product basis (rather than for a blanket subscription to a library of content).

Unscripted Television. A blanket term, sometimes used interchangeably with "reality television," that broadly encompasses several sub-genres, including "unstructured reality" or "documentary" (aka "docu-follow") series (e.g., *Deadliest Catch* and *Keeping Up with the Kardashians*), "structured reality" series (e.g., *Shark Tank* and *Mythbusters*), "reality competition" series (e.g., *The Voice* and *Top Chef*), game shows (e.g., *Jeopardy!* and *Family Feud*), and other "alternative" forms of programming such as late-night talk shows (e.g., *The Tonight Show* and *The Late Show*) and awards shows (e.g., the annual broadcasts of the Academy Awards and Golden Globes awards ceremonies).

Upfront. An event thrown by a television network, attended by talent, press, and major advertisers, during which the network announces its newest series for the upcoming season and solicits commitments from advertisers.

Upset Price. A WGA-determined minimum writing fee or script purchase price that, if paid, allows the studio to buy out certain "separated rights"

that are otherwise automatically reserved to the writer/creator of an original television series under the WGA Basic Agreement.

Vig. A colloquial term for the difference between an individual's guaranteed compensation under an overall term deal and the amount recouped against the guarantee based on the individual's actual services during the term of the deal.

Virtual MVPD (or vMVPD). Subscription services that function over the Internet, often integrating with and offered through third-party devices (e.g., smart televisions and set-top boxes like the Apple TV), that provide MVPD-like multi-channel programming services but do not meet the technical regulatory definitions of "MVPD"s.

VOD. "Video On Demand," a somewhat ambiguous term that may be used as a catch-all for all forms of video on demand (e.g., AVOD, SVOD, TVOD, etc.); as a synonym for "ERT"; or to refer more narrowly to a free or ad-supported form of ERT that is offered through MVPD set-top boxes in connection with the customer's subscription to a television network included in his or her cable/satellite package.

Waterfall. The flow of distribution revenues through a series of deductions pursuant to a contractually defined formula, as is applicable for talent profit participants or between co-production partners in a television series.

WGA. The Writers Guild of America, the union representing professional writers working in the U.S. television industry.

WGA Credit Determination. The process by which the WGA, which has exclusive jurisdiction over the final determination of writing credits for any film or television episode, determines the credited writer of any given script. In the case of a pilot script, this decision typically determines who receives "created by" credit in connection with the resulting series.

Work-for-Hire (or Work-Made-for-Hire or WFH). A concept arising under U.S. copyright law, which designates the employer of a party or parties creating intellectual property (e.g., writers, directors, and actors) to be the legal author and owner, from inception, of the copyright (and other intellectual property rights) of the employees' work.

Writer's Room. A group of writers and writer/producers who, together, determine the story for a season of television, write the individual scripts for the season's episodes, and serve as key lieutenants to the showrunner in that individual's creative leadership of the production. The term may also refer to the literal physical room in which the writers meet to engage in major creative discussions as a group.

BIBLIOGRAPHY/CASE LISTING

Articles

Adalian, Josef, *There Were Over 400 Scripted TV Shows on the Air in 2015*, VULTURE, Dec. 16, 2015

Adalian, Josef & Maria Elena Fernandez, *The Business of Too Much TV*, VULTURE, May 18, 2016

Andreeva, Nellie & David Robb, *The TV Guest Actor Pay Squeeze: Recurring Are the New Regulars, Guest Stars Become Day Players*, DEADLINE HOLLYWOOD, Dec. 18, 2015

Barnes, Brookes, *Disney Makes $52.4 Billion Deal for 21st Century Fox in Big Bet on Streaming*, NEW YORK TIMES, Dec. 14, 2017

Barnes, Brookes & Tiffany Hsu, *What Disney Is Getting From Fox*, NEW YORK TIMES, Dec. 14, 2017

Castillo, Michelle, *Disney Will Pull Its Movies from Netflix and Start Its Own Streaming Services*, CNBC, Aug. 8, 2017

Faultline, *EU Axes Geo-Blocking: Upsets Studios, Delights Consumers*, THE REGISTER, May 29, 2017

Fleming Jr., Mike, *Why Rights Wrangling Is Crazy Business*, DEADLINE HOLLYWOOD, Apr. 26, 2010

Flint, Joe, *Era of Peak TV Continues With 487 Scripted Shows in 2017*, WALL STREET JOURNAL, Jan. 5, 2018

Flint, Joe, *Peak TV Still Going Strong With 455 Scripted Shows in 2016*, WALL STREET JOURNAL, Dec. 21, 2016

Fung, Brian, *Comcast: This Is Why Regulators Should Approve the Time Warner Cable Merger*, THE WASHINGTON POST, Mar. 3, 2014

Gelles, David, *Washington Has Delivered a Tangled Message on AT&T's Power*, NEW YORK TIMES, Nov. 21, 2017

Gold, Hadas, *Disney-Fox Deal Would Be a Media and Entertainment Earthquake*, CNN, Dec. 13, 2017

Goldberg, Lesley, *How HBO's "Big Little Lies" Stars Leveraged Apple for Big Paydays*, THE HOLLYWOOD REPORTER, Jan. 17, 2018

Goldberg, Lesley, *Robert De Niro's Making How Much?! TV Is Becoming an ATM for Top Talent*, THE HOLLYWOOD REPORTER, Nov. 17, 2016

Goldberg, Lesley, *TV Upfronts by the Numbers: Total Volume Hits 5-Year Low*, THE HOLLYWOOD REPORTER, May 18, 2017

Hagey, Keach, *Viacom to Narrow Focus to Six Key Cable-TV Channels*, WALL STREET JOURNAL, Feb. 8, 2017

Holloway, Daniel, *FX's John Landgraf: Peak TV Was Media-Circus "Sideshow" in 2017*, VARIETY, Jan. 5, 2018

James, Meg & James F. Peltz, *Massive Disney-Fox Deal Expected to Get Close Antitrust Scrutiny*, LOS ANGELES TIMES, Dec. 14, 2017

Littleton, Cynthia, *FX Networks Chief John Landgraf: "There Is Simply Too Much Television"*, VARIETY, Aug. 7, 2015

Littleton, Cynthia, *Peak TV: The Count of Scripted Series in 2017 So Far*, VARIETY, Aug. 9, 2017

Littleton, Cynthia, *TV Salaries Revealed, From Ellen DeGeneres to Katy Perry and the Rock*, VARIETY, Aug. 22, 2017

Lyons, Daniel, *The Disney-Fox Merger and the Future of Old and New Media*, AEIDEAS, Dec. 21, 2017

Masters, Kim, *The Netflix Backlash: Why Hollywood Fears a Content Monopoly*, THE HOLLYWOOD REPORTER, Sep. 14, 2016

Polone, Gavin, *Gavin Polone on TV's Dirty Secret: Your Agent Gets Money for Nothing*, THE HOLLYWOOD REPORTER, Mar. 26, 2015

Rodriguez, Ashley, *In a World Without TV Sets, What Do We Call TV?*, QUARTZ, Oct. 4, 2017

Rodriguez, Ashley, *The End of "Peak TV" Must Finally, Mercifully Be Nigh*, QUARTZ, Jan. 13, 2018

Rose, Lacey, *Ellen Pompeo, TV's $20 Million Woman, Reveals Her Behind-the-Scenes Fight for "What I Deserve"*, THE HOLLYWOOD REPORTER, Jan. 17, 2018

Rose, Lacey & Marisa Guthrie, *FX Chief John Landgraf on Content Bubble: "This Is Simply Too Much Television"*, THE HOLLYWOOD REPORTER, Aug. 7, 2015

Santorelli, Michael J., *Why the AT&T-Time Warner Merger Makes Sense*, NEW YORK TIMES, Nov. 16, 2017

Schwindt, Oriana, *Lionsgate, Starz Close $4.4 Billion Acquisition*, VARIETY, Dec. 8, 2016

Spangler, Todd, *Cord-Cutting Explodes: 22 Million U.S. Adults Will Have Canceled Cable, Satellite TV by End of 2017*, VARIETY, Sep. 13, 2017

Stewart, James B., *With AT&T and Time Warner, Battle Lines Form for an Epic Antitrust Case*, NEW YORK TIMES, Nov. 16, 2017

Teffer, Peter, *EU Bans "Geo-Blocking'"—But Not (Yet) for Audiovisual*, EU OBSERVER, Nov. 21, 2017

Waxman, Sharon, *Hollywood in 2018: The Old Order Ends, a New One Rises*, THE WRAP, Dec. 31, 2017

Cases

A.A. Hoehling v. Universal City Studios, Inc., 618 F.2d 972 (2d Cir. 1980)

ABKCO Music, Inc. v. Harrisongs Music, Ltd., 722 F. 2d 988 (2d Cir. 1983)

Adjmi v. DLT Entertainment Ltd., 97 F.Supp.3d 512 (S.D.N.Y. 2015)

Alexander v. Haley, 460 F. Supp. 40 (S.D.N.Y. 1978)

Alexander v. Murdoch, 2011 WL 2802899 (S.D.N.Y. 2011)

Allen v. National Video, Inc., 610 F. Supp. 612 (S.D.N.Y. 1985)

American Broadcasting Companies, Inc. v. Aereo, 134 S.Ct. 2498 (2014)

Apfel v. Prudential-Bache Securities, Inc., 616 N.E.2d 1095 (N.Y. 1993)

Baer v. Chase, 392 F.3d 609 (3d Cir. 2004)

Blanch v. Koons, 467 F.3d 244 (2d Cir. 2006)

Boisson v. Banian, Ltd., 273 F.3d 262 (2d Cir. 2001)

Campbell v. Acuff-Rose Music, Inc., 510 U.S. 569 (1994)

Cariou v. Prince, 714 F.3d 694 (2d Cir. 2013)

Carson v. Here's Johnny Portable Toilets, Inc., 698 F.2d 831 (6th Cir. 1983)

Cassese v. Fox Broadcasting Company, No. B217655 (Cal. Ct. App. Aug. 10, 2010)

Celador Intern., Inc. v. Walt Disney Co., 347 F.Supp.2d 846 (C.D. Cal. 2004)

Celador Intern. Ltd. v. ABC, No. 11–55104 (9th Cir. Dec. 3, 2012)

Comedy III Productions, Inc. v. Gary Saderup, Inc., 25 Cal.4th 387 (2001)

Crane v. Poetic Productions Ltd., 593 F.Supp.2d 585 (S.D.N.Y. 2009)

DC Comics v. Towle, 989 F.Supp.2d 948 (C.D. Cal. 2013)

De Havilland v. FX Networks, No. B285629 (Cal. Ct. App. Mar. 26, 2018)

Desny v. Wilder, 299 P. 2d 257 (Cal. 1956)

Dr. Seuss Enters., L.P. v. ComicMix LLC, No. 16CV2779-JLS (BGS) (S.D. Cal. June 9, 2017)

Dr. Seuss Enters., L.P. v. Penguin Books USA, Inc., 109 F.3d 1394 (9th Cir. 1997)

Feist Publications, Inc. v. Rural Telephone Service Co., 499 U.S. 340 (1991)

Gable v. National Broadcasting Co., 727 F.Supp.2d 815 (C.D. Cal 2010)

Marathon Entertainment, Inc. v. Blasi, 174 P. 3d 741 (Cal. 2008)

Mattel, Inc. v. MCA Records, Inc., 296 F. 3d 894 (9th Cir. 2002)

Maxtone-Graham v. Burtchaell, 803 F.2d 1253 (2d Cir. 1986)

Metro-Goldwyn Mayer, Inc. v. American Honda Motor Co., 900 F. Supp. 1287 (C.D. Cal. 1995)

Midler v. Ford Motor Co., 849 F.2d 460 (9th Cir. 1988)

Motschenbacher v. R.J. Reynolds Tobacco Co., 498 F.2d 821 (9th Cir. 1974)

Murray v. National Broadcasting Company, Inc., 844 F.2d 988 (2d Cir. 1988)

Nadel v. Play-By-Play Toys & Novelties, Inc., 208 F.3d 368 (2d Cir. 2000)

National Conference of Personal Managers, Inc. v. Brown, Case No. CV 12–09620 (C.D. Cal. Aug. 13, 2015)

New Kids on the Block v. New America Publishing, Inc., 971 F.2d 302 (9th Cir. 1992)

Nichols v. Universal Pictures Corp., 45 F.2d 119 (2d Cir. 1930)

Playboy Enterprises, Inc. v. Welles, 279 F.3d 796 (9th Cir. 2002)

Pokemon Company International, Inc. v. Jones, 2016 WL 1643989 (W.D. Wash 2016)

Polaroid Corp. v. Polarad Electronics, Corp., 287 F.2d 492 (2d Cir. 1961)

Rice v. Fox Broadcasting Co., 330 F. 3d 1170 (9th Cir. 2003)

Rogers v. Grimaldi, 875 F.2d 994 (9th Cir. 1989)

Rogers v. Koons, 960 F.2d 301 (2d Cir. 1992)

Rossi v. Photoglou, No. G0482026 (Cal. Ct. App. Sep. 29, 2014)

Sarver v. Chartier, 813 F.3d 891 (9th Cir. 2016)

Seltzer v. Green Day, Inc., 725 F.3d 1170, 1177 (9th Cir. 2013)

Sid & Marty Kroft Television Productions, Inc. v. McDonald's Corp., 562 F.2d 1157 (9th Cir. 1977)

Solis v. Blancarte, TAC-27089 (Cal. Lab. Com. Sep. 30, 2013)

Steinberg v. Columbia Pictures Industries, Inc., 663 F. Supp. 706 (S.D.N.Y. 1987)

Three Boys Music Corp. v. Bolton, 212 F.3d 477 (9th Cir. 2000)

Titan Sports, Inc. v. Turner Broadcasting Systems, Inc., 981 F. Supp. 65 (D. Conn. 1997)

Toho Co., Ltd. v. William Morrow and Co., Inc., 33 F. Supp. 2d 1206 (C.D. Cal. 1998)

Turner Broadcasting v. Federal Communications Commission, 520 U.S. 180 (1997)

Ty, Inc. v. GMA Accessories, Inc., 132 F.3d 1167 (7th Cir. 1997)

Tyne v. Time Warner Entertainment Co., 901 So.2d 802 (2005)

Waits v. Frito-Lay, Inc., 978 F.2d 1093 (9th Cir. 1992)

Warner Bros. Pictures v. Columbia Broadcasting System, 216 F. 2d 945 (9th Cir. 1954)

White v. Samsung, 971 F.2d 1395 (9th Cir. 1992)

ACKNOWLEDGMENTS

Thanks are first due to the many friends and colleagues who generously provided valuable feedback on portions of the manuscript for this book. A few brave souls even reviewed entire drafts. In particular, my sincerest gratitude goes to Nick La Terza, Lisa Wang, and Brian Pearl, for their extraordinarily exhaustive and helpful comments. Dan Scharf, Jorge Fernandez, and Steve LeBlang also provided many useful suggestions and assisted with critical fact-checking and research.

Special thanks go to Kirk Schroder and Jay Shanker, whose invitation to contribute a chapter to their excellent collection on entertainment law helped prove to me that there really was a whole book floating around in my head after all. They are also due to Simon Jacobs and John Makowski at Focal Press, whose patience and guidance helped ensure that, after all was said and done, we ended up with an actual book, and not a half-finished dust-binned manuscript.

This book also would not exist without the advice, support, and patience of numerous friends, family, and colleagues, who have supported me in my professional development generally, and sometimes in the writing of this text specifically. Bert Fields has been a mentor and a patron to me in all phases of my career. Matt Galsor transformed me from a mostly useless law school graduate into a real entertainment lawyer. Jeff Frost transformed me from an entertainment lawyer into a real entertainment executive (and Matt Bickell further transformed me into one that could read and understand an economic model). David Goldman and Amy Powell have generously given me every opportunity to continue to thrive and grow in that role.

No one has done more to encourage me to be a big, structural thinker, and to keep one foot in the classroom as well as one in the boardroom, than Stuart Brotman (whose insights on the entertainment and media industries have been invaluable to me). Dean Martha Minow (whose father Newton, as Chairman of

the FCC, famously referred to commercial television programming as a "vast wasteland" in a 1961 address) and Dean John Manning have also been relentlessly positive and supportive of my dual identity as an academic and a professional.

The observations contained throughout this book, and the style of their presentation, were honed over hours of work with brilliant and committed students in my courses at Harvard Law School, UCLA School of Law, and Southwestern Law School. There is no surer way to be forced to understand a topic than to have to teach it to students as good as mine.

Thank you to my parents Roman and Ada Basin for their lifelong support, and in particular, to my mother Ada, who would never let me forget it I failed to mention her here (and who will probably still have plenty to say about this particular form of acknowledgment).

Finally, the specialest of thanks go to my wife Lisa, who is still the constant around which I organize and make sense of my world.

INDEX

68843930R00179